The Practical Handbook for the Emerging Artist

The Practical Handbook for the Emerging Artist

ENHANCED

SECOND EDITION

MARGARET R. LAZZARI
School of Fine Arts
University of Southern California

WADSWORTH
CENGAGE Learning

Australia • Brazil • Japan • Korea • Mexico • Singapore • Spain • United Kingdom • United States

The Practical Handbook for The Emerging Artist, Enhanced Second Edition

Margaret R. Lazzari

Senior Publisher: Clark Baxter

Acquisitions Editor: Clark Baxter

Senior Development Editor: Sharon Adams Poore

Assistant Editor: Kimberly Apfelbaum

Editorial Assistant: Ashley Bargende

Media Editor: Wendy Constantine

Marketing Manager: Diane Wenckebach

Marketing Communications Manager: Heather Baxley

Content Project Management: Pre-Press PMG

Senior Art Director: Cate Rickard Barr

Senior Print Buyer: Julio Esperas

Cover Designer: Gary Regaglia

Cover Image: Margaret R. Lazzari

Compositor: Pre-Press PMG

Credits appear on pages 321–326, which constitute a continuation of the copyright page.

For product information and technology assistance, contact us at **Cengage Learning Customer & Sales Support, 1-800-354-9706**

For permission to use material from this text or product, submit all requests online at **www.cengage.com/permissions**

Further permissions questions can be emailed to **permissionrequest@cengage.com**

Library of Congress Control Number: 2009939893

ISBN-13: 978-0-495-91026-8

ISBN-10: 0-495-91026-0

Wadsworth
20 Davis Drive
Belmont, CA 94002
USA

Cengage Learning is a leading provider of customized learning solutions with office locations around the globe, including Singapore, the United Kingdom, Australia, Mexico, Brazil, and Japan. Locate your local office at **www.cengage.com/global**

Cengage Learning products are represented in Canada by Nelson Education, Ltd.

To learn more about Wadsworth, visit **www.cengage.com/wadsworth**

Purchase any of our products at your local college store or at our preferred online store **www.cengagebrain.com**

Printed in the United States of America
2 3 4 5 6 20 19 18 17 16

*To Anna E. Lazzari,
Frances A. McDaniel, and
James J. Lazzari, my first
mentors and friends*

Preface

A rtists do more than just make art. They deal with a multitude of practical concerns, such as negotiating art world structures, finding jobs, applying for grants, paying taxes, keeping records, drafting contracts, documenting artwork, securing copyrights, and so on. These can be enormous challenges for emerging artists.

This book is the first to focus on issues concerning visual artists in the early years of their professional lives. It presents the career options and practical information they need in an organized, detailed manner. Reference books provide some of this information, but emerging artists would have to exert considerable effort to piece it together. Other books cover practical matters for artists, but address the established artist, or only those artists who show in commercial galleries. This book was written for emerging artists who are still in school or who are outside of academia. It addresses artists living both in and outside major art centers. It covers the needs of artists working either in traditional media or in new genres, as well as those making controversial or experimental work.

The book is composed of seventeen chapters, divided into five parts:

- **Part I: Groundwork** contains two chapters that focus on emerging artists' artwork, studio practice, and ways to develop ties with professionals in the art field.

- The six chapters in **Part II: Getting Your Work Out and Seen** cover the many options for showing work, including galleries, museums, festivals, online sites, and artist-initiated projects. Included are detailed descriptions outlining how to produce visual and written documentation of artwork, how to package written proposals for showing work, and how to self-sponsor an exhibition or self-produce a performance in any kind of venue.

- **Part III: Positions of Influence** describes how artists can function as art professionals while maintaining their own art production. The three chapters focus on art writing, curating, and creating an artist-run art space.

- **Part IV: Financial Concerns** contains detailed information on the business, legal, and financial aspects of an art career. Chapter 12 deals with the kinds of jobs sought by artists, and ways to find them. Chapter 13 covers grants, while Chapter 14 describes other forms of funding, including commissions, public art programs, art organizations, and corporate support. Chapter 15 deals with health issues, insurance, record keeping, taxes, the legalities of copyright, and freedom of expression issues.

- **Part V: Education** has two chapters covering the kinds of training and education artists can undertake. Chapter 16 presents the benefits of pursuing a Master of Fine Arts degree, ways to research graduate schools, and criteria for choosing the best situation for each individual's circumstances. Other educational opportunities are covered in Chapter 17, such as residencies, art academies, community colleges, online educational resources, and master degrees other than the MFA.

Certain features make the information in this book particularly helpful and accessible. There are many "how-to" guides that give detailed instruction on writing resumés, preparing press releases, creating digital images, drafting contracts, etc. These instructions are supplemented by illustrations and sample documents for even greater clarity. The appendix lists online resources, organizations, agencies, and services of benefit to artists. The annotated bibliography gives the names of reference books and resource material, and brief descriptions of what each contains. And finally, each chapter concludes with an interview in which artists describe their career and personal experiences, to help to "flesh out" the factual material in the book. These artists represent a wide range of backgrounds, working in different media and at different stages of their professional lives.

There are no absolute answers in this book. Getting an art career started involves a cluster of activities, with artists moving on many options at once. You decide which are best for you.

Acknowledgments

It has been such a pleasure to write the second edition of this book! I enjoyed the entire process of building on and refining the work I did for the first edition. Major areas of new material have been added, including information on online resources for artists, digital technology, and artist-initiated projects. Much more has been updated.

I wish to acknowledge the many persons who contributed specifically to the second edition. First, my thanks to those artists and art professionals whose interviews follow each chapter. They were all so generous with their time and their insights, and their contributions enrich the book immeasurably. Second, I wish to thank

Nicole Cohen, who helped me review the first edition material and made valuable suggestions for the second edition. Thanks also to Robert Wedemeyer, who took the photographs for Chapter 5, and to Sandra Low, who transcribed the interview tapes.

Many other friends and colleagues gave important advice and recommendations. My thanks goes to Jeffrey Abt, Associate Professor of Art and Art History at Wayne State University; Susan Brenner, Associate Professor of Art at the University of North Carolina–Charlotte; Barbara Elwood, Assistant to the Provost, Pratt Institute, Brooklyn, New York; Alex Gray, Director of the Archipenko Foundation in Woodstock, New York; Stan Hunter, Los Angeles-based artist and educator; Gwenda Joyce and Dan Addington, Gwenda Jay/Addington Gallery, Chicago; Janice Ledgerwood, artist and educator in Los Angeles; Caryl Levy, Assistant Director of the Public Art Program at the University of Southern California; Louis Marak, Professor of Art at Humboldt State University; Chris Miles, artist, writer, and educator in Los Angeles; Karen Moss, Director of Exhibitions and Public Programs at the San Francisco Art Institute; Hillary Mushkin, artist and Digital Media Arts instructor at Orange Coast College in Southern California; Rosalyn Schwartz, Associate Professor of Art at the University of Illinois Urbana–Champaign; Erling Sjovold, Professor of Art at the University of Richmond; Laurel Vogl, Chair of the Art Department at Fort Lewis College; Mary Weidner, Professor of Art at Carnegie–Mellon University; and David Yamamoto, Photography Technician for the USC School of Fine Arts.

Thanks also to the School of Fine Arts at the University of Southern California for the Faculty Research and Development Grant, which provided funds to support the revision of this text. A very special thanks to dean Ruth Weisberg, who has been a real mentor to me.

I also want to express gratitude to those who contributed substantially to the first edition of the book, including Karen Atkinson, Virginia LeRossignol Blades, Cecelia Davidson, Lauren Evans, Joyce Savio Herleth, and Penelope Jones.

Acquisitions editor John R. Swanson and editorial assistant Melinda Bonnell of Harcourt College Publishers worked with me to develop this second edition. Their support and enthusiasm helped bring the project to fruition. I am very grateful to them.

Finally, thanks as always to my husband, Michael Dean, for all the large and small ways he helped, and for his practical advice and moral support. And to our daughter, Julia Rose, for making me think outside the box.

Brief Contents

Contents

5 Documenting Your Work 71

6 Presenting Your Work to Art Professionals or Clients 115

7 Researching Galleries, Museums, and Other Art Venues 133

Groundwork

The bulk of this book presents options for emerging artists and explains structures and systems in the art world. Before addressing these topics, it is essential to give consideration to your artwork and your art-making practice, because they form the foundation for the rest of the discussion to follow.

Chapter 1 discusses ways to develop bodies of work, evaluate your results, and identify your audience.

The theme of Chapter 2 provides an underlying message for the rest of the book: Don't go it alone. Build a strong network of friends and supporters. Make alliances and work with others toward common goals.

The Artwork Is
Most Important

This chapter focuses on your artwork. The reason is as follows: This book contains many, many suggestions for ways to advance your art career. Which ones make sense for you? Your choices should be based on your artwork itself.

This chapter poses several questions. What is the nature of your artwork? What media do you use? With which ideas do you deal? Who do you want to see your work? In answering these questions, you define what is distinct and characteristic about your own artwork. You get a clearer picture of what you are doing, which will help you make intelligent choices about where and how to show your work. A more significant consequence is that you will likely come to a deeper understanding of your own involvement and commitment to making art. Your art is the foundation on which to build the rest of your art practice.

As you read this, remember to gravitate toward what is stimulating for you. Be creative, be critical, be thoughtful, and enjoy what you do.

Developing Your Artwork

Many artists feel strongly, even passionately, about their work. They may identify with Leon Golub, a prominent New York artist who has exhibited his work widely in the United States and Europe. He is nearly eighty years old and still actively engaged in his career. Golub said:

> Most artists feel that what they are doing is not the same old dead thing, but they are really moving it ahead. . . . [They] need to feel that their work still has an edge, an artistic tension. I've never wanted to, nor would [I] even know how to, do relatively placid

meditative work. I don't have it in me. Artists have to pick out those ideas, themes, subjects, techniques—whatever it is—that excite them, incite them, demand their attention. They have to have a sustaining belief.

Your reasons may be different from Golub's but still, you are moved to make artwork. Now, how can you hone your work to make it even better?

A Body of Work

First, begin to develop one or more cohesive bodies of work. A body of work is a series that deals with a cluster of kindred ideas. For some artists, a body of work is connected only by ideas. Individual pieces within the body of work may look different, and the art itself may include a wide range of objects, media, and techniques. For other artists, a body of work is regularized and formally similar. For example, you may make a group of paintings that are the same size, same media, similar imagery, and perhaps, even similar coloring.

Whatever the case, a body of work is important because it can effectively communicate your ideas to your audience. Unrelated works give mixed or confusing messages. In addition, a coherent body of work gives curators and dealers confidence in you as an artist.

How do you build a body of work? Some artists use something like the procedure below to create a new series or reinvigorate works in progress:

- Build on work you have already done. Stick with a set of ideas, but try to find new or better ways to express them.
- Join art discussion groups or critique groups, to get ideas and suggestions from other artists.
- Immerse yourself in art by going to museums, galleries, and art talks. Read art books and magazines regularly.
- Keep a journal of all interesting material you find in the course of your studies, your reading, or your everyday life. Include articles or images from many disciplines to provide a rich source of ideas for artwork.

Work Schedule

As you begin to develop your art, set aside sufficient time to work. Time is one of your most valuable resources. Design a work schedule and be disciplined about sticking to it. Take your work time seriously, and protect it from interruptions or encroachment. The time you devote to your work is legitimate and important. Set specific goals that you want to achieve during each work session. As you work, examine how your art is developing. Ask yourself what you can do to make it stronger. Do you find it interesting? Do you like it?

Establish a place to work. Start making your art as soon as you have a space that is reasonably usable. You may not need a separate studio with a high ceiling, white walls, and skylight, which is the traditional place where artists work. Artists such as René Magritte and Joseph Cornell worked in their homes. What kind of workplace is absolutely necessary for you? Can you be productive in your garage, in a spare

room, or on your kitchen table? There is no one kind of studio that meets every artist's needs. A printmaker's workspace is different from that of a computer artist. As you begin working, read the "Health and Safety" section in Chapter 15, so that your workspace does not pose hazards to you or others.

Feedback

Get a lot of feedback as you are making your art. Until others see your work and understand your ideas, your job as an artist is only half completed. Artwork is both an object and an exchange; art exists between its maker and its audience. As your work progresses, you need to know how well your messages are coming through. In school, you had a built-in community for this purpose: your teachers and the other students. Out of school, you need to develop a regular group of intelligent, perceptive individuals who spend time with your work and listen to your ideas as you refine them. Have these persons come in often to see your work. Make them into a social group for yourself, so that you enjoy the time with them.

Describing Your Art

As your artwork progresses and bodies of work develop, you should return to the questions asked at the beginning of this chapter:

1. What kind of work do you make?
2. What does your work "say"?
3. Who is your intended audience?

Let's answer the first one. It is important to summarize what you do so that others can understand it.

Formal Issues

First, it helps if you place your work in a category. Yours probably falls into one of the following four, although some kinds of artwork may overlap areas:

- **Visual arts** include traditional media such as paint, printmaking, sculpture, and ceramics.
- **Media arts** encompass photographic processes, film, video, multimedia works, computer art, projected imagery, and any other new technological media. Bookworks and guerrilla art that rely on technology may also fall in this category.
- **Site-specific installation and public art** are either temporary or permanent artworks that are incorporated into the design or history of a particular place.
- **Performance** is a time-based media that often uses the human body as the vehicle for artistic expression. There is no permanent art object created, only the performance itself, although there are usually videotapes or photographs of the work, and artists may make objects for use in performance.

Traditional visual arts are considered to be "object oriented," because often such art tends to be unique, permanent aesthetic objects. Performance and media arts are often called "nonobject oriented," because there is no single unique object for sale and there may or may not be market motivation for artists making such work. Although these distinctions are simplistic, artwork does fall along a continuum between more-physical and less-physical manifestations. Is your art making object-oriented or not?

Scale is another important factor for describing your artwork. On one end of the scale continuum is monumental work and large-scale productions. This includes murals, large-scale sculpture, or elaborate performance pieces. If you are interested in large-scale work, you generally need a site and funding before you begin. With large-scale art, much of your time is devoted to making models, maquettes, or detailed written proposals. However, if the scale of your work is smaller, you go directly to making the actual work of art on speculation. You complete the work first and then hope to interest others in it later.

Content

Next, what can you tell your audience about what your art "says"? You need a conceptual overview of your ideas and the ability to communicate that overview to others. Articulating the themes behind your work is of primary importance. This includes describing your subject matter, the broader array of associated ideas, and how your work embodies and communicates them. You also need to refer to the larger social and cultural context that influences the understanding of your work. If this task is difficult for you, try the following steps to help you identify major themes within your work:

- Take a long view of your work rather than focusing exclusively on the pieces just finished. Looking back on old work, most artists can see persistent themes emerge.
- Find artists whose work is closely related to yours. Read their artist statements, catalog essays, and reviews of their artwork. How are the ideas behind their work described and discussed? Take from these writings the ideas that are pertinent to your work.
- Have people familiar with your work describe what it means to them. Get the responses of all kinds of individuals, including non-art persons, artists, and art professionals (see below for more on art professionals).

Begin collecting ideas, and keep notes on those that seem pertinent to your work. Later, in Chapter 5, we study how to turn these insights into a formal artist statement.

Your Target Audience

Finally, you should be able to identify your intended audience and how this audience encounters your artwork. Audiences are usually grouped by some identifying factor, such as age, gender, economic class, ethnic origin, level of education, or geographic location. Examples of audiences might include young professionals,

college communities, or senior citizens. Although most artists might wish ideally for an unlimited audience for their work, in fact artwork exists within time and space constraints. These determine to a great extent who is going to be able to see your work.

Many artists make their work for those individuals who regularly visit established art spaces, such as galleries and museums. However, some artists seek other venues and audiences. Artists working in new technologies may submit video for public access cable television broadcast, distribute their computer-based work via the Internet or hold public screenings for their work. All these have the potential to reach a specific audience that differs from the gallery-going public. Even among painters, whose work seems to fit comfortably in museum and gallery settings, some make murals so that their work is seen by the general public. So, again, who is your audience?

Promoting Your Work

One bit of reality that all artists face is the need to promote your art. Many artists spend as much as fifty percent of their creative time in self-promotion. That kind of investment is necessary, because few artists are "discovered" without any effort on their part. Think of self-promotion as part of your creative work, because, in fact, it is. Approach it with the same energy and inventiveness as you approach your art. Find ways to enjoy this part of the process.

Promoting your work includes all kinds of tasks. Some of the more clerical ones include building mailing lists, documenting your work, and writing resumés. Others include researching exhibition opportunities and making connections within the art world. Chapters 3 through 8 deal with these topics, and Chapters 12 through 15 cover various job, grant, legal, and business topics. The important thing to remember is that all this is a necessary part of art making. If you have only ten hours per week to devote to your art, then five should be devoted to making art and five devoted to promoting it.

In promoting your work, you will probably encounter art professionals. They are jurors, curators, gallery owners, art dealers, art writers, and public art administrators—all the professionals who judge the value of an artist's work. They determine who will get shows, who will receive art commissions, and whose work will get reviewed in magazines and newspapers. Obviously, these art professionals can have a great impact on your art career. We talk much more about all these individuals throughout this book, as well as their interactions and expectations of artists.

Promoting your work not only takes time, but also persistence and confidence. You can become discouraged, because you will be rejected sometimes. But you can also make some great friends and professional associates as you work on your career. They can be wonderful additions to your life.

This chapter has given you guidelines for developing your art, a first step for your art career. Chapter 2 deals with more groundwork, specifically how to make connections and get information to help you as an artist.

artist interview

JOHN BALDESSARI

Source: Photo © Luciano Perna, 1991.

John Baldessari is a conceptual artist, photographer, maker of books, and video- and filmmaker, whose work has been widely shown throughout the United States, Europe, and Asia. He has been an extremely influential teacher, especially during his many years at California Institute for the Arts and currently University of California–Los Angeles. Here, he talks about early career issues and art making.

Can you talk a little about your early art career?

The last art school I had attended was in the Los Angeles area. I got frustrated—I was a painter at the time and I felt like I was painting like everyone else I knew was painting. I moved back to San Diego and I started teaching high school and felt pretty isolated there. But looking back, I think it was good because I just painted. I didn't have anybody around to influence me and had a four- or five-year purging of my system. I seriously questioned everything I believed about art. I had nobody to impress, nobody to see my work, so I just pretty much did what I wanted. At that moment, I had resigned myself to an existence of teaching high school, painting when I could, being married, having a family, and that would be about it. I had always fantasized about teaching at a college or university, and I had applied for jobs. But it just didn't happen.

But the right thing happened at the right time.

Because after you worked throughout that period of isolation, you did begin teaching in colleges and made contacts in Los Angeles, New York, and Europe. Your career really began to move forward.

Well, I think if you wanted to draw any lesson out of it all, it is that you never, never give up on chance. But on the other hand, you've got to be prepared when chance strikes.

The Overlap Series: Street Scene and Reclining Person (with Shoes)

When I started teaching college and then later moved to Los Angeles, that brought me a change of context. I was in contact with a group of professional artists that I would not have known otherwise. I followed up on some suggestions and went to New York and talked to various people and eventually made contact with a gallery. Then on the basis of showing in New York, a German critic looked at my work and covered it in German newspapers and got me in contact with a gallery in Dusseldorf. That brought me exposure in Europe. You can see how things have snowballed.

What do you think are important qualities for students and for emerging artists?

When I teach young artists, I try to give them the strength of their convictions and to have the confidence of their own ideas and not think, "Oh, God, I can't do this because everybody will think I'm crazy." Artists need to use all their strengths and diminish all their weaknesses.

Competitiveness is important. Sometimes, the very best students aren't quite so successful in the long run, because they've always been told that they're good. Knowing that, they often don't work as hard as the students on the next tier down, who are very competitive and want to be up there with the best and so they're fighting all the time.

What about changing "fashions" within the art world?

You're not always going to be in fashion because fashion changes. It's so fickle.

It helps quite often if you are not recognized as the best. Especially in school, because things get recognized in school that often aren't worth recognizing. As an artist, it seems to me that if you can stay slightly in the wings, you have a better chance of survival than if the spotlight is upon you. If you get a lot of attention quickly, you can be dismissed just as quickly. I think if you receive gradual attention, you have a better chance of staying in the game.

You once said, "I don't think art has to be defined by money."

The best artists in the world probably make less money than a decent plumber. If you're going into the arts for money, that's not a good idea. There are cases of remarkable financial successes, but they are so few. The norm is artists plugging along at another job. And trying to keep their habit afloat.

Do you have any thoughts about sustaining one's work over the long haul?

You've got to continue regardless of any kind of recognition or attention. One primary concern would be growing and developing and getting one's vision clearer or richer. If you do that and you're not repeating yourself, you're going to be of continuing interest to your fellow artists.

I remember when I was in art school, it seemed everybody else knew that to do art, you do this, you do this, you do this, and finally you ended up with art. But I don't know how I got things done. I got them done, but I couldn't see that there was any orderly process to it. I think when nobody's around, nobody's watching, and nobody's cares, you say, what the hell? I'm just gonna do it.

It's absolutely imperative that the art one does is the art one believes in. That sounds pretty maudlin, but quite often we do the art we think the world wants to see, for whatever reasons, and it may not really. The art that you might really want to do but don't do because people would think you were bonkers, that's going to come out eventually, so you might as well attend to it right away.

What are the most satisfying aspects of your work as an artist? What are the true inner rewards?

You can look back at your work and sort of metaphorically think of one's work like children. You have this whole birthing process, and maybe it's going to be stillborn when you do it, or it doesn't last very long, or maybe it's going to die in a week or two weeks. Another birth metaphor, but a bizarre one, is Dr. Frankenstein. You really are trying to infuse inert matter with life. And like Dr. Frankenstein, it can often go awry. Your intentions just didn't come out right.

The wonderful thing about art is that it "leaves home." Somebody buys it, or perhaps it goes somewhere, and you no longer have access to it. It's just kind of weird, because when it happens, it's like a child who's left home and you hope that, when you see them again, they've done well and you still like them. And that they mature and they've held up. It is sometimes scary to see work that you haven't seen for years. But I think with luck, any good artist is going to have a half dozen works or more, and when they see that work again, they just think, "Wow, that's amazing that I did that!"

Those works are like touchstones that you keep on trying to achieve again. And you think that if you did it then, maybe you can do it again. And they keep you going.

So it's really the work in the end. The real satisfaction is seeing the work that's held up. And you keep working because you'd like to get it right once more.

Making
Connections

The foundation you need to lay for your art career has two elements. The first is creating work that is important to you personally, as we saw in Chapter 1. The second is building a network of associates who will help you get information that you need for your career and help you get your work validated.

Although most artists realize that hard work and dedication are needed to make art, fewer anticipate the amount of social interaction required.

Validation

Validation means that your work is seen and acknowledged by others to be significant and meaningful either socially, aesthetically, or politically. How does your art become recognized as such?

Museums and Commercial Galleries

One way is to bring your work to the attention of persons within the museum/gallery system, such as curators, dealers, and critics. These individuals are art professionals who fill the social role of evaluating, displaying, buying, selling, and preserving artwork. The galleries we are talking about here are commercial galleries, which are private businesses that depend on the revenue from sales to survive.

Artists in the museum/gallery system fall into a pyramid, with many struggling for recognition at the bottom and only a few successful artists at the top. Success is ultimately measured financially and positionally—what sells, to whom, and where the work is placed. In this system, artists expect eventually to live off the sale of their work and see it collected by museums and wealthy individuals. For a few, this happens. Artists try to have their work shown in the most prestigious commercial

galleries and museums, reviewed in prominent publications, and collected by well-known collectors. Second-tier galleries or publications are seen as stepping-stones to better places.

Museums and commercial galleries claim to recognize artwork of "quality" regardless of its style or content. However, a brief look at recent history shows that mainstream art has been dominated by a series of styles: 1950s abstract expressionism, 1960s pop art, 1970s minimalism, and in the 1980s, neoexpressionist painting and text-and-image photography. Gallery and museum success may come more easily to artists working in the current styles, and more slowly for those who do not.

Other Forms of Validation

Some artists do not seek validations from the museum/gallery system. They may want a different audience for their work from those who go to galleries and museums. Some do art that is not particularly saleable through galleries, such as video art or performance. Others make mass-produced art or site-specific or monumental work, such as murals or art in public places, which physically does not fit into the gallery. Others may deal with content that might not be broadly acceptable.

Validations for these artists may not come through the traditional gallery/museum system. Instead, they often seek other venues. They must identify the audience who is interested in their issues and find ways to bring the work to them. To reach audiences, artists may be very creative and flexible about where they show their work. They may show in commercial galleries but also show at university galleries, community centers, or storefronts. They may reproduce their works in newsletters or project images on the sides of buildings at night. They might exhibit their work in the back of a rental truck for a weekend or rent a hotel room for a one-night exhibition. Their art may exist only on the Web. They may do community-based projects.

For these artists, an exhibit is usually not merely a stepping-stone to something better, because of the emphasis on communicating issues rather than achieving sales. These artists rarely expect to make a living solely from the sale of their work. (For more on the kinds of jobs that artists seek to supplement their incomes, see Chapter 12, "Jobs.") Buying and selling of artwork is de-emphasized, so the esteem given artists for their work is not built on financial success. Rather, it comes from creating a forum for ideas, reaching an audience, or creating a social "scene."

There is no clear dividing line between these different methods of validations. Often curators are very interested in artwork done outside of museums and commercial galleries. Artists as well as arts professionals cross over between these areas. For example, the artist Barry McGee is known as Twist for his graffiti work that appeared on the streets in the San Francisco area. More recently, he has painted his artwork directly on the walls of the Armand Hammer Museum and in a number of commercial galleries (see the Barry McGee artist interview in Chapter 3). In the 1980s, the artist Cindy Sherman worked as a secretary at Artists Space in New York City, where she wore outfits that she used in her early photographs that

imitated B-movie stills. After a few years of daily "performing" at Artists Space, she was given a show there. Eventually her work was shown in major museums.

However you seek validation, you will depend on the participation of others. This part of art making is not something an artist can do entirely alone. You work within others—other artists, arts professionals, your audience—to help you reach your goals.

Sources of Information

You need to be connected to information sources to find out about career opportunities in art. You need current news about upcoming exhibitions, competitions, grants, jobs, lectures, artist residencies, studio rentals, and so on.

Print Sources

In print, there are many national, regional, and local art magazines that help artists keep up with critical theory, news, and current exhibitions. In addition to their articles, many artists find useful information in the announcements and classified ads sections of these publications. Art magazines are available at large newsstands, university libraries, art supply stores, and by subscription.

Online Sources

Online sources of information are common. One example is Arts Wire (www.artswire.org), a site devoted to art information for individual artists and arts organizations. With Arts Wire, artists can read art news, subscribe to a host of online art publications, and participate in discussion groups. Information on job and grant opportunities is also listed, as we discuss more in later chapters. A related site is the Visual Artists Information Hotline (www.artswire.org/nyfa/vaih), a free information service for artists in all media, listing resources that facilitate their work. Both Arts Wire and the Visual Artists Information Hotline are services of the New York Foundation for the Arts. World Wide Art Resources has current art news, gallery listings, and museums listing at www.wwar.com. The Art Deadlines list (artdeadlineslist.com) is a subscription site. For $24 per year, you have access to comprehensive listings for exhibitions opportunities, grants, jobs, residencies, and percent-for-the-arts programs.

You can get online information that is more focused on your area through your state art agency's Web site. Every state has a federal- and state-funded agency devoted to promoting the arts within its boundaries. Most have Web sites full of helpful listings for artists. For example, the Ohio Arts Council's Web site (www.oac.state.oh.us) has a wealth of information and resources for artists living in Ohio. Not only do they list opportunities and information for the entire state, but they also post arts programs sponsored by Ohio cities. They list upcoming Ohio cultural festivals and art events. They publish links to other Internet art sites, both public and private.

Other states maintain comparable Web sites. To find the Web site for the art agency in your state, go to the National Assembly of State Art Agencies

(www.nasaa-arts.org). They have links to all the art agencies across the United States.

Word-of-Mouth

Magazines and Web sites are undoubtedly great sources of art information. However, you need to supplement them with the information you get by word-of-mouth while keeping in touch with other artists and art professionals. The information you get this way is usually more timely and tailored to your individual situation and therefore ultimately more likely to benefit you. Also, you may hear about many funding and job opportunities that are never advertised in print or are not posted in the particular publications you happen to read. Also, when you talk to people, you are able to communicate your goals, and therefore they can respond appropriately.

But keeping in touch socially and professionally not only enables you to pick up passing information. You also become known as a person to others. You are no longer simply another anonymous artist sending mail, but a familiar face, a known entity. Your chances of finding good art opportunities increase dramatically with personal contact.

Artist Alliances

Whatever art path you take, find people to help you in your work. This means building for yourself a cooperative network of artists, art professionals, and ordinary intelligent, perceptive persons. You can begin making these connections by going to art events, receptions, openings, and lectures. However, you can more quickly build an effective network by consciously developing a tighter group of persons with whom you will work. You ask these individuals for help when you need it, giving help back to them when asked, and share information with them about career opportunities, such as jobs, exhibitions, and contacts. By building these alliances, you work for your success and the success of others at the same time and help each other achieve common goals. The following are suggestions for different kinds of alliances that other artists have tried with success.

Collaborations

Collaborations consist of two or more artists jointly producing a work that both own and for which both receive equal credit. Collaborations can exist for one project only or for many. In ongoing collaborations, the participants produce a series of works, forge a collective artistic identity, and usually become known under the collaborative name. Collaborations come in many forms. Some long-term collaborations have fixed members, whereas others operate around a small core that is joined by outsiders on a project-by-project basis.

The collaborative identity in some cases is very strong, as is the case with the Guerrilla Girls, a group of anonymous artists and art professionals who fight

discrimination (www.guerrillagirls.com). In particular, the Guerrilla Girls create posters, advertisements, and videos criticizing the art world's unfair treatment of women and ethnic minorities (Figure 2-1). In protest demonstrations and performances, they wear gorilla masks to maintain their anonymity. Another collaborative is ®™ark, pronounced "Artmark" (www.rtmark.com), a corporation composed of many anonymous individuals who seek to improve the cultural life of their "shareholders."

Far from keeping their members anonymous, other collaborations are called by the names of their members, such as Komar and Melamid, Russian émigrés painting in the social realist style, who also have been interested in sponsoring global collaborative projects. Another prominent artist team from Britain is Gilbert and George. Marina Abramovic and Ulay were a collaborative pair of performance artists who worked in the 1980s.

Artists may choose to work collaboratively because the ideas generated may be richer and the work attempted more ambitious than one person could do alone. If you are considering working in a collaboration, let the nature of your group develop organically. Attempt one project and evaluate the results. If there is a second project, try to avoid some of the pitfalls you discovered in the first. After that,

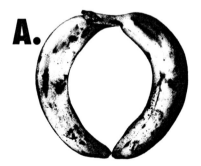

Q. HOW MANY WORKS BY WOMEN ARTISTS WERE IN THE ANDY WARHOL* AND TREMAINE AUCTIONS AT SOTHEBY'S?

A.

*The Contemporary Art Auction

Please send $ and comments to: **GUERRILLA GIRLS** CONSCIENCE OF THE ART WORLD
Box 1056 Cooper Sta. NY, NY 10276

FIGURE 2-1 | Guerrilla Girls poster

Other Guerrilla Girls posters protest low pay, limited job opportunities, and fewer exhibitions for women artists.

you may consider some long-term commitments together. From the very beginning, however, you and your collaborators need to come to an understanding on the following points:

- How does the group come to critical decisions? How are ideas proposed and developed? Who makes visual decisions?
- Who does the labor? Who builds a piece, transports and installs it, and stores it for future exhibits?
- Who funds the project?
- Who does the clerical work? Who is responsible for paying bills, keeping images of the groups' work, maintaining the group's resumé, and sending out proposals?
- Who owns the actual objects created? Are the works for sale? How much? How are proceeds divided?
- Who owns ideas proposed by the group but never actually realized? Can individuals unilaterally use these ideas if the group is temporarily inactive or disbanded?

Artists' Groups

Artists groups are loose organizations composed of several artists who meet on a regular basis to exchange advice and offer support to each other. Exchanging mail lists, jointly maintaining equipment such as computers or shop tools, or regularly sharing information about shows and jobs can be mutually beneficial to members of a small group. They may form a co-op to share workshop or studio space. In some cases, these groups critique each other's work and help develop ideas.

An artists' group can contain a broad and diverse circle of friends. Include persons older and younger than you, of different economic, racial, and cultural backgrounds, and of different gender and sexual orientation. Include not only artists but also writers, art professionals, business people, and perceptive persons from any profession. For example, choreographers, audio technicians, construction workers, and psychologists may be helpful if you are planning a performance, installation, or video. Given their diverse backgrounds, these persons will provide you with help and feedback from many different points of view. Note the persons with whom you work well, with whom you have some kind of common goal, or whom you enjoy as a person. Find individuals who reciprocate when you give them help. If you are still in school, note the students you admire, trust, and find reliable, and keep working with them after graduation.

Artist Organizations

There are two kinds of artist organizations: local and national. In some respects, local artists organizations are like extensions of artists' groups. They can provide artists with a community, give support and advice, and pass on information about jobs, exhibition opportunities, and so on. Although some local art organizations simply hold

meetings, others are quite ambitious, maintaining exhibition spaces and sponsoring programs and workshops. An example is Side Street Projects in Los Angeles (www.sidestreet.org), an artist-supporting organization with a theater, an extensive exhibitions program, woodshop, technical expertise network, artist directory, and so on. Some local art organizations have more specific missions, such as the Guadalupe Cultural Arts Center in San Antonio (www.guadalupeculturalarts.org), which is dedicated to preserving and promoting Latino, Chicano, and Native American culture. We hear more about the No Name artists collective in the interview with Christi Atkinson at the end of this chapter.

How can you find local artists' organizations? They are in most cities and can be found by asking other artists or by inquiring at galleries, libraries, art supply stores, or college art departments. You can also check the Web site of your state's art agency, which will likely list local organizations. Again, you can find your state's art agency site at www.nasaa-arts.org.

There are also large national artists organizations. They do not serve local interests, but they can have far-reaching influence on issues of national concern. Through large organizations, artists can exert informed and persistent pressure to bring about change in areas of concern to them. For example, studies show that historically women and minorities in the art world had fewer exhibition opportunities, less pay for their work, and less print coverage. Their situation improved only after organizations and their supporters protested. Some national organizations have worked to change tax laws that may be unfair to artists. Others work on freedom of expression issues (see Chapter 15). Arts Wire (www.artswire.org) lists its organizational members' Web sites, which serves as a great introduction to what is available for you. Let us look at a couple of national art organizations now.

The College Art Association (www.collegeart.org) is a national organization that furthers scholarship and excellence in art and art history, both in teaching and in practice. The organization sponsors a national conference and publishes educational materials, job listings, and guides to graduate schools. It offers many other benefits, such as group insurance and discounts on publications. Membership is open to all artists, not only those affiliated with a college.

A loose network of more than forty independent organizations of Volunteer Lawyers for the Arts provides their members with legal advice at greatly reduced cost or for free. They also sponsor workshops on artists' issues with legal ramifications, such as information on the copyright laws, gallery-artist legislation, contracts, and working with agents. They assist organizations in filing for nonprofit status. For more information, visit the Web site of the New York chapter or do an online search for "volunteer lawyers for the arts" to find a chapter near you.

The Women's Caucus for Art (www.nationalwca.com) is dedicated to expanding opportunities and recognition for women in visual arts professions. The Women's Caucus has more than thirty chapters in the United States. National Artists Equity Association has active chapters in a few U.S. cities (www.artists-equity.org).

Some national arts organizations are composed of other arts organizations. They are media-based, such as the National Alliance for Media Arts and Culture (www.namac.org), which encourages film, video, audio, and online/multimedia

arts. Other organizations are devoted to particular political agendas or groups, such as the National Association of Latino Arts and Culture (www.nalac.org).

Government Art Agencies

You might want to investigate the possibilities of working with government arts councils. These include cultural affairs departments and city, county, or state arts agencies. These government offices are in charge of tax-based cultural support and often use advisory committees composed of artists, collectors, and art professionals to supervise their programs. They may sponsor exhibitions, grant programs, scholarship competitions, and educational programming. States and some larger cities operate their public arts program through these departments. Serving on committees for these departments gives you an excellent education on public support for the arts and enables you to make contacts with art professionals. By calling the offices of these agencies and departments, you can find out the roles that artists play in their operations. Other places to work for change are artist committees in museums or private arts agencies or the board of a museum.

Other Organizations

Look into all kinds of organizations as you reach out to make connections. You might consider working with political activist groups that support causes you care about. For example, if you are concerned about pollution, your contribution as an artist to an environmental group may be invaluable. Through such organizations, you can build a community of persons who may support other aspects of your art career and at the same time effecting needed change. What causes do you care about?

Skills Needed When Working with Groups

A few skills are helpful if you become involved in organizations.

Communication. Talking clearly, listening, and understanding are absolutely essential:

- When someone else is talking, pay close attention.
- To ensure understanding, paraphrase or repeat important points when talking to another person.
- Have a firm grasp of your own ideas.
- Use language that the other persons can understand. If your language positions yourself on a different level, you may gain followers but will not have found a peer group.

Setting Goals. It is important that the group has a sense of progress. To achieve this, the group should focus on the following:

- Goals should be set.
- Major goals should be broken down into intermediate steps.

- Deadlines need to be set for completing each step.
- All involved persons should develop and agree on the working plan and timeline.
- Plans should be flexible and periodically revised as the group moves closer to its goal.

Negotiations and Compromise. You also need negotiation skills when working with groups. Your sense of your own power is essential in negotiation. And you do have power, because power resides in every individual, based on their personal conviction, in the justness of a cause, in financial resources, in persuasive ability, and in persistence. Also, seek the support of others to gain greater strength and credibility for your position. In any challenging situation, ask your friends and supporters to help supply you with information you need to frame your arguments better and to propose solutions. Finally, time: If you are willing to put in enough time, talking to people, clarifying what you want, trying to convince them, tying up their time, and in some cases simply outlasting them, you will often be successful in negotiation.

Another important component in negotiation, however, is compromise. To come to an agreement, both sides must gain something. But before compromising, mentally establish your bottom line, where you are actually willing to settle as distinct from your initial bargaining position. If you are negotiating on behalf of a group of people, you need to know what the entire group considers the bottom line.

Leadership. All groups need leaders. Sometimes people avoid leadership positions, fearing the exposure, responsibility, and demands on their time. However, effective leaders neither make all the decisions nor do all the work themselves. Rather, they oversee the group as it reaches its goals. If you are a group leader, budget the time you are willing to devote to an organization and hold firmly to that limit. You may find that you actually enjoy being a leader.

The one task that does fall to group leaders is running meetings. Leaders must ensure that when the group meets, it sticks to achieving its stated goals and moves forward on its timetable to accomplish intermediate steps or group members will feel as if their time is wasted. At your meetings, everyone should know beforehand what you intend to accomplish and remain focused during the time together. Circulate an agenda before the meeting. At the meeting,

- Recap minutes from the last meeting first.
- Next, address projects in progress to make sure they are completed in a timely manner.
- Proceed then to new items. Allowing for some flexibility, list who will speak on what topic, for how long, and in what order.
- Do not let one person monopolize the meeting, especially if this keeps others from making reports that they have prepared.
- When a problem arises that cannot be resolved in a few minutes, ask a small group to work on it and report back at the next meeting.
- Respect others' commitments and end your meetings on time.

Mentors

One final kind of artist alliance or relationship must be mentioned. A *mentor* is a loyal tutor, advisor, teacher, or friend who has your best interest at heart and is willing to help you in your art career. A mentor should genuinely respect you and your work and believe in your potential. Often, mentors will be older and at a more advanced point in their career, having achieved some success in the art world. They can help you through difficult problems, advise you on ways to approach your career, suggest contacts that you can make, introduce you to art professionals, and recommend you for positions and exhibitions.

A mentor relationship might develop with a particularly helpful instructor, with other artists, or with art professionals. This relationship can be formalized or very informal, depending on you and your mentor. You might meet on a regular basis to discuss your work. Or you can meet as needed, when you want someone to help you with an application or to review materials you are sending to galleries.

A mentoring relationship is invaluable to emerging artists, not only because it provides practical help but also because it gives you emotional support and important insights into the more complex dimensions of being an artist. Thus, a mentor can act as a role model and lend moral support as emerging artists develop. Such a relationship cannot be forced into being or invented as needed. But you should be alert to the possibility of it developing when circumstances allow. You may have several mentors at different stages of your career.

Rupert Garcia is a painter and professor who lives in Oakland, California. Two mentors helped him early in his career, and he, in turn, has mentored others.

> I have helped other artists with their work, wrote recommendations, and tried to find opportunities for them. And I wrote catalog essays and brochure essays and have made silkscreen posters for the art exhibitions. I didn't flaunt that I knew I was a mentor. I kept a very low profile because I wanted to continue the sense of friendship and not have people respect me too much. That creates too much of a distance and I didn't want that to happen.
>
> I do mentoring because this is what wasn't there for me in college, except for two people. I believe in myself, I believe in my work, and what I am doing as an artist is as right as it could possibly be. And I would like, in some way, to share that with other people and, in particular, younger artists. What I get out of it is simply the joy of seeing young people grow, and I really mean that in the profound sense of the word.

You have responsibilities to your mentor, as artist, professor, and art dean Ruth Weisberg shows:

> If you have a mentor, the best thing you can do is be successful, because both you and your mentor are invested in your success. Never make your mentor look bad. Several years ago, I recommended someone for a job who was rude at the interview. I never, never recommended that person again.
>
> Keep in contact with your mentor, not necessarily demanding contact, but a note every once in a while, where you are, if you are searching for a job. It is good to know

that! Recently I wanted to pass information on to someone terrific but was frustrated because I didn't have her phone number. Well, I'll send her a note, but that is creating work for me, so I am just somewhat less likely to do it. You must always assume your mentor is very busy, so you want to make it easy for them. If you want a letter of recommendation, always send a resumé. And it also feels real good to be thanked.

The mentoring relationship may gradually become a two-way street, with you eventually becoming a peer to your mentor, giving help and support back to that person. Also, you should be aware at any stage of your career of the possibility of your acting as a mentor. You already have more experience than others who are just starting. You could be a great help to them if you choose to be.

Making Things Happen

You have power to make things happen for your art career. If you need a group of artists to exchange critiques and share opportunities, then join an artists' organization or start one. If there are some artists you admire, then have your organization invite them to give talks, participate in a panel discussion, or speak at a one-day symposium. When the artists come to speak, arrange to take them to dinner and get to know them.

If there is no lecture series or symposium, then start one. Get others to help. If there are no exhibition opportunities, find a space and organize a show (see Chapters 3 and 4). Being an artist means being creative in many aspects of your career.

artist interview

CHRISTI ATKINSON

Program Director, No Name Exhibitions @ the Soap Factory.

Source: Photo by Dan Dennehy.

Christi Atkinson is the director of programs for No Name Exhibitions @ the Soap Factory, an artists organization and alternative space in Minneapolis, Minnesota. She is also assistant director of education at the Walker Art Center in Minneapolis, in charge of teen programs.

I was interested in hearing about your work with No Name Exhibitions.

No Name is an artists-started space that is more than eleven years old. It was started for artists with "no name"—emerging artists—hence, our name.

I've been with No Name for about eight years as a curator. I did my own art for many years while supporting myself with museum work, but eventually I realized that I was no longer interested in putting my things in the public, but I was interested in putting other art in the public. That's why I work at No Name.

No Name is an all-volunteer organization, isn't it?

Until about 1998, it was entirely volunteer run. No Name functions pretty collaboratively with lots of group decision-making processes—essentially whoever shows up at the meetings helps make the decisions for what's going to happen. All the job positions, except the executive director and myself, are elected at an annual meeting, which is open to the public—everyone present gets a vote. There are all kinds of jobs, of course, from gallery sitting, graphics, gallery preparator, or press relations.

We now have a small stipend for three of the key positions, but No Name is still primarily all volunteer. We run on the principle that if you want to see something happen, then come in and propose it and get other people to get on board with you to make it happen.

What are the advantages of volunteering?

When artists volunteer with No Name, they are getting access to this huge network of other artists. There's this informal exchange of important information—this grant's coming up, this studio's open, I like your work, we should collaborate, and so on. It's a community of people to have dinner with and potentially be friends with. That's the original reason I joined. I had just moved here from New York and didn't know anyone. My whole original circle of friends came from No Name.

The other advantage from volunteering is that No Name is very much a teaching organization. Everyone who comes in learns many skills. People have gone on from here to use their experience for paying jobs in museums, galleries, or alternative spaces. They've been hired as executive directors, curators, and facilities managers.

Even if artists don't take an official position or job with us, they still have the opportunity to learn. Artists are allowed to be involved as much as they want with their exhibition. They can help develop show concepts and themes, what the graphics are going to look like, how to do a press release, how to contact the press, how to do a mailing. It's power given to them. Not only can they now put on their own show, they also have the knowledge to oversee their exhibitions at other spaces—they will know when things aren't being done right.

The traditional view of artists is that they work in isolation and certainly some do work that way. But no matter how you work, being an artist can be lonely. Sometimes I think the main thing you get is that this huge communal group effort can be an unbelievably rewarding and energizing thing in your life. It's hard to find that type of experience now days. There is something that's incredible about all these people just showing up and all these shows constantly going on. It's a really cool and indescribable feeling.

How has No Name changed since 1998?

We originally had a gallery in a small storefront space down in the downtown warehouse district, but the area went through gentrification. Almost all the galleries left, and we were kicked out. We went to a new space across the river and just as the rent doubled on that place, one of our volunteers found out about this old soap factory that the Pillsbury Corporation wanted to donate to a nonprofit. So we applied for it and suddenly became owners of a huge 48,000-square-foot building. It's an extraordinary building, and it's an extraordinary location, right on the Mississippi River.

It must be pretty spectacular.

It's great, but—! The building has no heat, no elevator, barely any plumbing, and minimal electricity. All four floors of the building were also filled up to our ankles with lard. Black, disgusting, rotting lard. There were holes in the roof as big as chairs, so there was literally standing rotten water on top of all this black lard. We had to get volunteers in there and shovel it out.

How were you able to use such a space?

The first year or two, we just used the building as it was and it was amazing. We even had shows in the middle of winter when it was thirty below and people would come! It got a lot of attention. We stopped that though, because at Minnesota winter temperatures there were endless problems—artists got frostbite, paint wouldn't dry, glue wouldn't work.

Did you finally get heat and electricity?

No. Our first priority was to replace the roof to stop the deterioration of the building, so we got a new roof about three years ago. We just raised another $100,000 for some electrical and plumbing issues. All the plumbing in the whole building needs to be redone. We just finished putting in a toilet and sink in November 2000, but since there's no heat, we can't turn the water on to test it until May. And we've had lots of safety issues that have been more important than heat—like the sprinkler system, railings, dangerous electricity, fire exits . . . endless stuff.

Installation view of an exhibition curated by Christi Atkinson at No Name Exhibitions @ the Soap Factory
Artist: Kelly Nipper; Title: norma—a piece for conditioner.

Source: Photo by Beverly Free.

We love having the building, but it was way more than we bargained for. With the added responsibility of owning a decrepit building, it's gone way beyond a volunteer job. We are now trying to figure out how to have a few stipend staff—a director, a program director, and a curator—and still be a primarily volunteer-run organization.

So No Name is now in a period of evolution?

Yes. It's very challenging, because we haven't found any models for what we want to do. There aren't many volunteer organizations that have even lasted as long as No Name, because of burnout. And I think that's one of the miracles of No Name.

With our new building, we're attracting more attention. We are now able to present more artists, not only local emerging artists, but also national and a few international artists. We occasionally will show established artists, too, if they want to come in and do something that is really experimental for them.

Eventually, we would like this building to be a center for many nonprofits, not just No Name. That's a huge desire, but the reality is that keeping No Name afloat and getting the building up to code has been all-consuming.

Has this changed your work as curator?

I used to be able to spend time conceiving exhibitions, recruiting artists, doing lots of studio visits, and inviting other people in town to co-curate or guest curate. But for the last two years, putting together an exhibition now means a committee of volunteers and myself choosing through submissions that No Name receives. This is great for some exhibitions, but I'm not real happy with that being our primary option right now. There is a real need to figure out how to get back to a way in which the staff has time for visioning, planning, and continually pushing No Name into new and interesting territory.

I've changed my title from curator to program director because of the change in how I'm able to work. Also with all the programs that we now have—exhibitions, performing arts, film and video, special events, and building rentals—I am the one who is trying to oversee everything that's happening in the building. I still curate one or two shows a year, but the irony is that as we've gotten bigger, it's become less and less about curating and more and more about administration and keeping No Name running.

If you're an artist seeking to volunteer with an art organization, how can you avoid burnout?

Well, volunteer organizations can consume all your time. I hate to say it, but No Name has eaten up lots of people. But I actually think the artists do better than the non-artists, because their focus is still on becoming an artist—and to make it as an artist, you've got to be crystal clear about that being your priority. Artists end up volunteering in a way, I think, that is healthy and reasonable.

PART **II**

Getting Your
Work Out
and Seen

The chapters in Part II contain practical information on showing your work in many different circumstances. Chapter 3 focuses on exhibiting art in many kinds of sites, outside of museums and galleries. Chapter 4 tells you how to put together your own exhibition or performance, including compiling mailing lists, designing announcements, developing press material, and installing art.

The next two chapters deal with making records of your work. Chapter 5 has detailed information on documenting your artwork, both visually and verbally. In Chapter 6, you will learn about Web sites, image portfolios, proposal packets, and other ways to present your work.

Chapters 7 and 8 cover established art venues: commercial galleries, museums, media centers, alternative spaces, and so on. How can you find out about them? How do you know which ones are likely to be good places for your work? What can you expect if you have a show in one of these spaces?

Remember always to solicit the help of your friends and mentors as you look for ways to get your work out, and get it seen.

Taking Control
of Showing
Your Work

Options for Exhibition Sites

As an artist, you have many options for places to show your work. Many artists exhibit/perform their work in galleries and museums, which we discuss in Chapters 7 and 8. But in this chapter, we focus on the wide range of possibilities open to you, besides galleries and museums.

Exhibition and performance opportunities are available in everyday locations. For example, a house is a potential exhibition or performance site:

- Artists can rent an inexpensive apartment and turn it into a gallery.
- The front room or basement of a house can be turned into an exhibition or performance space.
- Temporary exhibitions can be installed simultaneously in a number of homes and open to the public for one or two weekends.

Commercial sites offer even more possibilities. Vacant stores or empty store windows are great temporary exhibition sites. When the weather is mild, parking lots can be used for performances or projected artwork, such as film, still images, or video. The following locations also have potential:

- Government buildings
- Malls
- Public buildings, including libraries, schools, and train stations
- Commercial sites such as cafes, hair salons, bookstores, furniture stores
- Yards, parks, beaches, or empty fields
- Rooftops of buildings
- Storage spaces in storage buildings

- Loft spaces
- Concert hall walls and performance spaces
- Image projections on billboards, walls, or other sites
- Swap meet rental spaces
- Newspaper advertising space
- Rented trucks, with roving exhibitions in back

Consider the artist, Billy Curmano, who used the Mississippi River as a performance space for ten years, from the mid-1980s through mid-1990s. He swam the length of the river in stages to call attention to humans' strained relations with their natural world.

You can develop a reputation and a following if you regularly organize art events in sites such as those above. Two Los Angeles-based artists, Arzu Arda Kosar and Nicole Cohen, did a series of seven events in places as far-flung as Wellington, New Zealand, and Istanbul, Turkey, in addition to Los Angeles and New York (see the artist interview in Chapter 10 with Arzu Arda Kosar and Nicole Cohen). They received grant funds to support their series. Like them, you may find that you can get financial support for ongoing projects. Universities, grant agencies, state art agencies, and museums have all recently funded such work.

Why would artists want to show in these kinds of places? There are several reasons. These sites are attractive to emerging artists for their first exhibitions or performances because the spaces are accessible to them. Established artists like these sites because their work becomes site-specific and enriched in these places. Even artists who show their work in galleries will participate in these events because it gives them the opportunity to do a piece that may be very different from what they could do in the gallery. These events give artists a sense of community. It also makes their work public in a way that is not possible with a gallery.

Before showing your work in any site, consider the following:

- Does my art fit well with these surroundings?
- What audience is already here who will see my work?
- How much money (if any) will it likely cost to make a site suitable for exhibitions?
- Is there sufficient security?
- Are lighting, utilities, and restrooms adequate?
- Will people coming from across town be able to find this location?

Once you have decided on a space, you may have to negotiate with the owner of the site to use it for art. You may have to secure the permission of neighbors. This kind of community interaction takes time but may have its rewards. Consider the comments of Karen Atkinson, an artist, art activist, and director of Side Street Projects, an artist organization and workshop:

> Getting permission involves a community effort. Even with a project in a storefront window, you have to deal with the owner of the building, unless you find an abandoned structure. We have done slide projects in offices and commercial spaces by day, that then shut down and become art galleries from dusk to midnight. The collaborative element

educates people who know nothing about art. There is something interesting in the way artists have completely separated themselves from the rest of society. The critique of elitism has its pros and cons, but art is not a part of our cultural lives anymore. People don't understand what we do. Some artists think that you have to become simple when you speak to the public, but I think that is unnecessary and dangerous to talk down to your audience. The idea of sharing what we do is a completely different strategy.

Sites for Performance Art

Performance artists can also use unconventional sites. Many previously listed sites work well for self-produced performances, including government buildings, malls, public buildings, commercial sites, parks, beaches, and lofts. Other possibilities are:

- Community centers or recreation centers
- Religious venues
- Clubs
- Theaters
- Dance studios
- Broadcast media, such as public access cable TV and public radio

Not all of these venues may be appropriate for the performance you might do, but some may provide for your basic needs. Evaluate the potential performance sites, deciding what qualities are essential for you. Some spaces may charge fees or require insurance.

- *Physical space:* Are ceilings, floors, seating, exits, and sight lines adequate?
- *Lighting:* Can you sufficiently control lighting with existing windows and light fixtures?
- *Sound:* Are the acoustics and sound systems adequate?
- *Utilities:* Are electricity, heat/air conditioning, water, and restrooms sufficient?
- *Personnel:* Are there any maintenance persons, technical or clerical staff, security guards, or other persons you might need?
- *Availability:* Check for both rehearsal and performance times.

If you are looking at theaters or auditoriums, see if the stage and tech booth meet your needs. Ask if other equipment is available, such as video or audio decks, data projectors, film projectors, ladders, extension cords, and outlets.

Of course, your performance may have a completely different set of needs. Take Curmano's *Swimmin' the River,* mentioned at the beginning of this chapter. His equipment needs have included such diverse items as boats, marine radios, water snake repellent, and barrier cream to protect himself from water pollution. He was assisted by forty volunteer crews who have become part of the piece.

Web-Based Exhibitions

Artists more and more are turning to the Internet as a venue for exhibiting work. Here, we are not talking about self-promotional Web sites that artists may maintain

for publicizing their work; those are covered in Chapter 6. Rather, these sites are specifically designed as exhibitions with particular themes and of a limited duration. Most often, these sites host several "shows" at once, either group shows or individual exhibitions for a number of artists.

Web-based exhibition sites require a large set of skills, including the abilities to develop an identity and a vision for the project, to curate (see Chapter 10), to design effective graphics, and to maintain a Web site. Your Web site is a time-based work, and so you need to be aware of flow, sequencing, transitions, and so on. Of course, as with any big project, you can get others to help you with this.

When showing art on the Web, the audience you reach will tend to be younger, as older people are less likely to browse the Web. Also, you need to be aware that only certain kinds of art look good on the small, low-resolution computer screen. The following are considerations regarding art:

- Fine detail may be lost on the computer screen.
- It is hard to adequately display sculpture, even if you show multiple views.
- You have no color control; the calibration on everyone's computer monitor is different.
- Scale is hard to convey, as small and big works tend to all appear the same.
- Your site will look different on different people's computers, depending on their browser software.

One example of Web exhibition sites is *Striking Distance* (www.eloupe.com), published by Timothy Silverlake and edited by Mitchell Syrop.

Guerrilla Art

Guerrilla activity is nonsanctioned artwork that is done anonymously and appears without warning in public places. Its purpose may be political protest, social critique, or subversion. It may or may not be obviously artwork, as we see in the article reproduced in Figure 3-1. It almost always addresses a particular audience in a specific site. There is no formula for making guerrilla art, which by definition falls outside the status quo. It sometimes falls outside the law: Be aware of local regulations on trespassing and vandalism. The 1980s saw an explosion of guerrilla art that has continued through today.

Some guerrilla art is done on a grand scale. Gordon Matta-Clark cut large L-shapes, rectangles, and circles out of abandoned New York buildings in the 1970s. The cuts created new passages and light shafts through floors, ceilings, and walls, opening up the buildings and making visible their structures. The first cuttings were made in abandoned buildings without the owners' permission, with Matta-Clark running the danger of possible police and gang confrontations. Later, Matta-Clark moved into the mainstream art world and cut buildings under the auspices of gallery director Holly Solomon, the Paris Biennale, and the Museum of Contemporary Art in Chicago. The large chunks of walls and floors that

'Repent/Sin' is new option at crosswalks

NEW YORK (AP) – to the befuddlement and amusement of New York pedestrians, someone is doctoring electric crosswalk signs to flash commands such as REPENT/SIN and CONFORM/CONSUME instead of WALK/DON'T WALK.

Traffic officials have two questions — WHO? and WHY? — and a direction of their own: STOP.

"This could be dangerous," said Lisa Daglian, Transportation Department spokeswoman. "Someone could get hurt if they're looking at one of those signs while trying to cross the street.

"It's not a good message to tourists either," she added.

No, this isn't Kansas. Not with someone — guerrilla artist? prankster? urban terrorist? — climbing up light poles, unscrewing the grille on the light, removing the lens stenciled WALK and DON'T WALK, and replacing it with one bearing an ambiguous message.

Although Daglian said it was unclear how many lights had been tampered with, she cited three cases.

She was insistent: "This is not a creative outlet. It's confusing people."

FIGURE 3-1 | Article on guerrilla art

Source: Article from *The Outlook*, October 5, 1993, page 4C.

Matta-Clark cut away were often displayed in commercial galleries, as were the photographs documenting the cuts that pierced the building.

Guerrilla art frequently has taken the form of posters, signs, drawings, or graffiti. For example, the Guerrilla Girls, formed in 1985 by a group of anonymous women artists and art professionals, produced a number of famous posters, billboards, magazine ads, bumper stickers, slides, videotapes, and performances documenting the art world's poor record in showing the work of women and ethnic minorities (see Figure 2-1). In guerrilla fashion, the works would appear or the performances occur at discriminatory art events and openings. Another well-known guerrilla poster artist is Robbie Conal, whose works have critiqued the U.S. political system for more than fifteen years.

Another kind of guerrilla art is "billboard correction." Guerrilla artists change existing outdoor advertisements. In one example, a group called the Billboard Liberation Front altered a "Think Different" billboard from a recent Apple Computer advertising campaign to read "Think Disillusioned." Other billboard corrections are documented at www.billboardliberation.com. Billboard corrections are likely to be illegal.

The last kind of guerrilla art we discuss may be the most common. Graffiti can be considered vandalism, gang activity, or the purest urban art form, depending on who is talking. An interview with graffiti artist Barry McGee appears at the end of

this chapter. Another artist, Shepard Fairey, has distributed stickers via the Web with images of the late wrestler, Andre the Giant, at www.obeygiant.com. The Giant stickers are marked by distinct graphics, but essentially deal with absurdity, the culture of consumption, and urban paranoia.

The relationship between the prominent guerrilla artists and the rest of society is complex. At the same time that they question or challenge the status quo, their works may be absorbed into the mainstream culture. Guerrilla art satisfies the official art world's constant thirst for the new or its desire to appear politically liberal. While Robbie Conal's nocturnal volunteers were plastering his posters on walls, fences, and construction sites, his large thickly painted oil portraits were displayed and sold in commercial galleries. As an art student, Keith Haring anonymously produced a number of colored-chalk graffiti drawings in the New York subway. Many drawings were lost, but as the fame of his graffiti images spread, Haring moved into mainstream art and executed his imagery with paint on canvas.

Options for Artists in Small Cities and Rural Areas

Artists living in small cities or rural areas have a different kind of challenge in exhibiting their work. We are not talking here about prominent artists such as the ceramist Ken Price, who lives both in Los Angeles and Taos, New Mexico. We are focusing on artists who are still searching for adequate public exposure in places where galleries are few and far between.

You may try finding outlets for your art in large urban centers, even if you live far from one. If you do, it is helpful if your work is easy to ship and store. Large, heavy pieces are expensive to crate and transport cross-country, which may become an economic burden to you. Also, large sculptural pieces are hard to store, so galleries cannot keep such work on hand for any length of time and try to sell it.

Small towns and rural areas tend to have lower property prices, and therefore you may be able to buy a building for a studio. Older buildings that are still sound may not be viable for commercial use anymore but may be very suited to your needs. You may have enough space to sublet studios to other artists and perhaps support an exhibition or performance space (see Chapter 15). Your place may become a center for artists and art events.

You may choose to develop art events in nongallery sites. Of course, the options we listed at the start of this chapter are available to artists in more remote areas. Where do people congregate? Where will work get the most exposure?

The National Endowment for the Arts (www.arts.endow.gov) supports seven regional arts organizations with missions to foster the arts across the country. Regional and state art agencies promote the proliferation of art in areas other than the major art centers such as New York, Los Angeles, Chicago, and other large U.S. cities. Look at their Web sites for support they may give in small towns and rural areas. Likewise, state art agencies try to spread their resources throughout the state. You may have less competition if you work outside major art centers.

A remote location might be an important condition or even an asset for the art you make. Site-specific works and earthworks are examples of this. Walter de Maria's *Lightning Field,* constructed from 1971 to 1977, is a grid of 400 evenly-spaced stainless-steel poles in a large open field in New Mexico. It is a moving and spectacular work that takes advantage of the frequent summertime afternoon electrical storms in the area. Local controversies may be an impetus for works of art, a strategy sometimes used by environmental artists. Dominique Mazeaud pulled trash out of the polluted Rio Grande River every day for seven years in the late 1980s as a performance art piece and a way to bring attention to the river's dreadful condition.

Most towns support small museums and cultural centers. You may be in a particularly good position to take advantage of those sites. Ken Little, a sculptor who teaches at the University of Texas at San Antonio, has also lived in Montana and Utah. He remarked:

> Away from major cultural centers, there is a whole level of smaller art museums and art communities that basically don't have very good budgets and need to get art to show. I encourage my students to contact these art museums and university galleries in towns anywhere from 40,000 to 250,000 people. They may go for contemporary art, depending on the curators or directors there, who are just starting out themselves. Eventually some of those people are going to be at the bigger museums. It helps when you have networked with these people starting their careers also, and then over the years maintain your connection with them. Things will work out if you keep working and the work is good.

Check for other outlets for your work in the community where you live.

artist interview

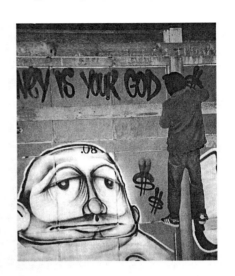

BARRY McGEE

Barry McGee is a San Francisco-based artist who makes commissioned and unsanctioned public art. He received a BFA in painting and print-making from the San Francisco Art Institute. He has had many national and international exhibitions of his work.

Random von NotHaus, a University of Southern California art student who does graffiti and makes graffiti-based art, participated in this conversation.

When did you start doing graffiti work?

I had always done a lot of drawing, but I started doing graffiti on the streets in 1984. I had a friend who always carried spray paint in the side panels of his vespa. At every stoplight, he would get off his scooter and spray paint his name, "Zotz." Inside the "O" was a crazy cowboy character. I asked, "What the hell are you doing?" and he said, "I'm doing graffiti. This is what everyone's doing in New York right now." I had no idea; it was really shocking to me. But then within a week, I was doing the same thing.

Why?

There are rebellious aspects to it that I like. It's completely against the system, to some degree, and people genuinely hate it. In today's contemporary society with so much information and advertising, it interests me that there's something out there that still really gets at people.

If I'm going to be confronted with a Marlboro billboard coming out of my house, I feel it's fair, if not my right, to throw a Christmas ornament filled with paint at it. I can sympathize with people who are really upset with graffiti. But at the same time, these billboards are now covering entire buildings with no opposition. This, to me, is the worst graffiti.

Your graffiti work has some pretty fabulous drawings.

I have done things that people respond to, but recently I have been interested in things people tend to hate. Everyone can always applaud a colorful, beautiful mural, even if it's done in spray paint, but—

Random: *The tags?*

The tags really get at people, and it's that really quick energy that I like a lot. Some tags are the most beautiful thing on earth.

This seems contradictory with the work you do in the gallery.

Many graffiti artists in New York in the 1980s went straight from painting on trains to painting right onto canvas, making okay money and then, suddenly, the rug gets pulled underneath them. I was always and still am very skeptical of the art world.

FIGURE 3-3 | Untitled

Source: Photo courtesy of Barry McGee.

But in the early 1990s when I was doing tons of stuff on the street, a local non-profit, the Luggage Store, asked me to do some stuff indoors. I said, "Sure, I'll do it, as long as I can do it right on the wall and it'd get painted over afterward."

Random: *So you really like that it's on the wall? It's there, and it's gone.*

I do. I like how things are remembered, or part of your memory bank. It's more interesting in that state than something that's been collected and cherished. Obviously, I have slides of most things that I have done, but I also feel really glad I don't have a lot of those paintings too.

If somebody gives me a hundred-foot wall, I could do it in a week or so and feel totally loose and free with it. But if somebody gives me a two-foot by two-foot piece of wood and it's sitting in my studio, I'm just stuck. There's something really freeing about knowing it's going to be gone. Does that make sense?

Yes. But you do make objects, too.

Yes, I make objects that sometimes sell and support me as an artist. At the same time, I'm still not really comfortable with all aspects of art ownership.

Random: *That someone can collect your work and own a piece?*

I'm not totally against it, but I have some reservations about it. I know it's also how the whole art system works. I'm trying to figure out the best way for me to maintain some type of integrity with the work. I guess I'm always hyper-aware of how my reputation is with, say a thirteen-year-old kid on the street or with you, Random. That's just as important to me as any patron or curator.

Random: *Barry, just your general thoughts about art on the street—who really sees it? Is it for the other graffiti artists to see?*

It's kind of strange, because it operates off being seen and not being seen. I know a lot of people who don't have anything to do with graffiti who talk about the stuff that's around the city. I think there are a lot of stereotypes about who people think does this work and who actually sees it. It's as American as apple pie and baseball.

It is easy for something on the street to get sucked up and exploited.

Yeah, especially in this day and age. It can happen before you even know it. I'm super protective that way. I want it to be recognized as something, but not labeled and then marketed as another dumb trend that gets used as an ad campaign. Disgusting.

Here in San Francisco, most graffiti is around bus stops that have ads in them. They get all tagged on, and then the tags get cleaned off, and the only thing left is

the ad, which is the furthest thing from the truth to me. The ad is there being manipulative, trying to be relevant and hip. They have millions of dollars to spend on this ad campaign. And then there's a young kid there who's standing next to it who can change the ad into a thirty-nine cent special with a few swipes of a marker. I like that there are things you can still do that simply, that mess with the people who seem to have the power. Even if it's a tag, that's way more important to me than an ad campaign or whatever someone's trying to sell.

Random: *What about your commission work? The things people have asked you to do?*

With graffiti, you end up in places you would never imagine being and you act accordingly with the space and the size.

I was recently in Japan involved in a weeklong event with several other artists. I didn't know what I was getting into—I asked them for some big white panel trucks, but somehow, through translation, I ended up with three cars, an Audi, a Saab, and some Toyota sedan. And I looked at the situation and thought, "Okay . . . that's a far cry from a truck, but I'll do something with it." Another graffiti artist, Amaze, and I painted the cars day and night for a week, making them as beautiful as we possibly could—and then we destroyed them in less than three minutes, demolition derby style. That was really satisfying.

Was it a spectacle, with a big audience?

Yes. We put on helmets and just literally went at each other. There was smoke, broken glass, crunching metal. I'm not sure, but I think that it might have had something to do with art. There's nothing wrong with making something and someone else having it and keeping it and exchanging money—it's what I do. But I still have tendencies to make work and then completely destroy it and there's nothing left over.

From all your experience, what advice would you give to a group of students?

Make your own rules. I think art's getting into a really weird place now where all the lines are blurring and you can come in from almost any direction. It doesn't even really matter.

I've met many curators who are my age or younger. There's a kind of changing of the guard, finally. I have gone to meet a curator on my bicycle and they'll be on a skateboard. When we go to my studio, I don't feel like I have to clean up or present my best work or "Look at this new canvas I'm working on."

The more I've been involved with the art world, I realize that there are a few people who are controlling things. There are many things I see that I still don't like. I try to hold my ground and hopefully change it.

Why did you decide to do the interview for this book?

I liked all the different views of the artists. It covers a whole range of the completely established, blue-chip artists and goes all the way down. If I could represent the bottom, I'll definitely be in there. There are so many kids who are super-talented. Whatever I can do to move some of the mystery aside along the way, even if it's for one or two kids, I would do it in a second.

The art instruction in schools is pretty lousy today. For a kid to be excited about doing graffiti, art, whatever—which has color, form, structure, everything that you use in art—to me, that's not such a bad thing. Kids are always naturally interested in the arts. But there is no support system for them. A lot of kids that I know, their whole interest in art started with graffiti. And if it's given enough room to grow, it can become something amazing.

Random: *Maybe one last question—were there any stumbling blocks you experienced along the way?*

Someone is always dropping those things in front of me. I think sometimes I take myself too seriously about art. As soon as I try to make everything perfect or doing it the right way (whatever that is), I realize that those are the things that hang me up the most. When I was just using my intuition, with anything—working in a gallery or working indoors—it always seemed to work best that way. Rather than asking, is this the right way?

Your Show

This chapter tells you how to put together an exhibit or produce a performance. Included is information on compiling mailing lists, designing and sending announcements, writing press releases, preparing the exhibition site, and installing the exhibition. Also, performance-specific concerns are addressed. This chapter presumes that you are going to do all the work yourself or are supervising friends and associates who are helping you.

You can use this information in many circumstances. It is applicable when showing in non-art sites such as those covered in Chapter 3. It also helps when showing at galleries that may have no staff. You may also refer to this chapter if you belong to a cooperative gallery, in which artist-members are the staff.

The advantage of organizing your own show is that you have creative control. But you also may have all the work to do, too. Before you jump into a self-sponsored show or self-produced performance, estimate out how much money and time will be required. Ask your mentors for advice. Putting together your own show may take a lot of time and may be costly. How much can you afford? Stick to that, and do not overextend yourself. Consider a group rather than solo exhibition, and have all the participating artists share the work and resources. Fortunately, a group show is likely to attract more art professionals and a bigger audience.

Exhibition Calendar

The following checklist lays out the major tasks you will have to complete for your self-sponsored exhibit or self-produced performance. It is meant to be a brief

timetable outlining what you have to do, and when. More detailed information about completing each task comes later in this chapter.

If the sheer volume of work that needs to be done seems daunting, don't give up. Ask for help or trade services as a way to achieve your goals.

Site: Work out an agreement with the space's owner, and put the agreement in writing. What changes can be done to the site? How much does it have to be restored afterward? Who is responsible for doing that work and for paying for materials? When will the space be available? Is there any staff? Does the owner's insurance cover your event? Are utilities sufficient?

The Show: What are the exact dates of the show? When is art to be installed and de-installed? Who is participating? Are participating artists expected to contribute funds or work for the show? Is there any reimbursement for their expenses?

Publicity: What kinds of announcements and press releases will be prepared for the show? Who will design the announcement and work with printers? Who writes and sends the press releases? Who pays for printing and postage? Who provides mailing lists?

Now let's consider specific tasks and when they need to be completed. The calendar below presumes that you have several months to prepare for a show. Often, however, opportunities for emerging artists come with only a few weeks' warning; for example, you may get a chance for a show due to a last-minute cancellation. In such a case, obviously, your timetable is compressed.

Several months before your exhibition or performance
Develop or update your mailing lists.
Exhibition:

- Acquire a map of the gallery.
- Draw to scale how you will place existing work in the gallery.
- Plan new pieces for the exhibit, if needed.

Performance:

- Begin scripting, casting, developing audiovisual materials.

Three months before
Photograph one of your artworks for the announcement.
Publicity to art magazines:

- Write and send the press release.
- Make copies of your announcement image to send with press releases.

Six weeks before
Prepare your announcements:

- Design announcement and prepare camera-ready artwork.

- Make price comparisons on printers.
- Have announcement printed.

Recruit individuals to be gallery attendants, ticket takers, ushers, bartenders, and so on, if needed.

Four weeks before
Distribute publicity:

- Mail press releases to the print media and radio stations.
- Mail your announcements if using bulk mail.

Three weeks before
Exhibition:

- Prepare artwork to be installed.
- Frame works if necessary.

Performance:

- Arrange for a photographer to document the piece.

Two weeks to ten days before
More publicity:

- Send press releases to broadcast media.
- Send follow-up press releases to print media.
- Make phone calls to art writers.
- Mail your announcements if using first-class mail.

Assemble press kits.
Performance:

- Set schedule for performance rehearsals.
- Design and duplicate a simple program.

One week before
Evaluate the condition of the exhibition site.
Exhibition:

- Prepare supplementary materials.
- Update your resumé (see Chapter 5).
- Write artist's statement to be placed at the exhibition (see Chapter 5).
- Photocopy past reviews of your work.
- Prepare the exhibition list, with titles, dates, media, and prices.
- Prepare signage for show.

Publicity:

- E-mail announcements to your mailing list.

Two to four days before the opening
Exhibition installation:

- Paint and patch gallery walls.
- Acquire necessary hardware for installing exhibit.
- Install exhibit.
- Set lights.
- Prepare artwork labels.
- Purchase a guest book for names and addresses.
- Acquire reception supplies.

Performance:

- Do tech rehearsal, coordinating performers with sound and light.

Publicity:

- Once again, e-mail announcements to your mailing list.

Opening day
Performance:

- Do sound and light checks.
- Check the condition of the stage and the audience areas.

Mailing Lists

You need to build and maintain your own mailing list. It is key to getting a good turnout for your performance or exhibition. With group shows, combine your mailing list with those of all participating artists to attract a larger audience. For shows at galleries and institutions, your mailing list is still essential, even though these spaces maintain their own lists of supporters and press persons. Supplementing their lists with yours is surely worthwhile, because most individuals are interested in artists and artwork rather than the art space per se. Subdivide your mailing list into at least three categories, as outlined below.

Press List

The first category in your mailing list is the press list, the individuals who receive press releases. The following are the broadcast and print media that should receive press releases from you:

National art magazines

Regional and local art magazines

Metropolitan daily newspapers

Alternative press and free weekly papers

Neighborhood newspapers

College newspapers

Radio stations

Television stations

Online lists of art events

Online publications that review art exhibitions

Although it is beneficial to include national publications in your press list, you should concentrate on local magazines and newspapers that are more likely to review emerging artists.

Some big daily newspapers have both citywide editions and also local editions with special sections covering particular neighborhoods. If so, you need the mailing address of both the citywide art editor and the arts/culture editors in local editions. Do some research before your exhibition on alternative, free weekly newspapers and small local newspapers that cover art exhibits at commercial galleries and colleges in the area of your exhibition. If you are exhibiting at a university, add the address of the university newspaper.

Many local and regional publications have calendar listings of art exhibitions. To be listed, you need to send a separate press release specifically to the editor who compiles the calendar at these publications. Most publications post the deadlines for submissions at the beginning or end of their calendar sections.

Make sure your mailing list includes the art and the calendar editors by their professional titles and names, and are not simply addressed to "Editor." The publisher's address and editors' names are located in the masthead, which usually can be found near the front of the publication (or on the editorial page in a newspaper).

You should also try to compile the names and addresses of individual writers. As you read art reviews over time, you will recognize that certain writers may be sympathetic to your work and should be put on your mailing list. Also add any writers whom you have personally met or who have already reviewed your work. Send press releases to writers at their publications only if they are regular writers. If they contribute articles irregularly, try to get their home addresses and send materials there, because publications may or may not forward mail to them.

You should send exhibition announcements as well as press releases to writers and editors, especially if your announcement contains an image of your artwork and your press release did not.

Art Professionals

Art professionals comprise the second category on your mailing list. Send them announcements of your exhibition. This category includes:

Museum directors

Curators, both independent and institutional

Commercial gallery dealers

Academics

Other artists

Art collectors

Keep these individuals apprised of your work, so that they may include your work in any future show they curate. Announcements should be sent to all commercial galleries in the area. Send announcements also to galleries in other cities if you would like to show with them. Local and out-of-town curators should receive announcements if you know them to be interested in your kind of artwork.

Personal Supporters

The last category on the mailing list is comprised of the individuals to whom you send announcements. This includes collectors and supporters who have purchased your work in the past or who have helped your career. Also, you should include friends, family, and acquaintances who are interested in you and your work. All these individuals may be interested in further supporting your career. The fact that you continue to be an active artist is heartening to them.

Maintaining a Mailing List

As you accumulate names and addresses, you need to "address" the problem of maintaining your mailing list. Although building, outputting, and updating mailing lists is time-consuming, using a database program on a personal computer makes the task manageable. Database programs allow you to make a separate entry for each person's name, address, phone number, and e-mail address and to specify to which category of mailing list they belong. You can also add nonprinting information and notes about persons on your list, such as past reviews they have written or works they have collected. The database program can sort and print out your mailing list in different ways:

- Alphabetically, for easier address changes and deletions.
- By zip code, if you are sending announcements via bulk mail.
- By category, if you wish to send out only part of your list, for example, sending press releases to the press.
- By e-mail or by regular mail addresses.

You can update your computer-based mailing list by adding new addresses, deleting expired ones, and making address changes, leaving the rest of your entries undisturbed. Plan to keep expanding your mailing list. Trade lists with other artists, and collect e-mail addresses from other individuals' art announcements.

There are many different kinds of database software available through retail computer stores, in catalogs, or on the Internet. You can also use hypertext software for mailing lists, although database programs can store more information per entry and have more sorting capability. Computer printers can print your mailing list directly onto self-stick labels, which are easily affixed to envelopes.

Before personal computers were so common, mailing lists were kept on index cards or in address books. Addresses on announcements were handwritten or typed onto standard sheets of paper and then photocopied onto self-stick labels. All these methods are terribly labor-intensive. Although you might have to invest some time to put your mailing list on a computer in the beginning, you can quickly generate your list every time you subsequently need it. If you do not have a computer nor know how to use database software, make an alliance and trade work with someone who can provide you with computer access and support.

Announcements

Show announcements, along with press releases, are your most important publicity. Sending a well-designed announcement to everyone on an extensive mailing list is an excellent way to get your work known to art professionals. As a form of advertisement, your announcement communicates information about your work, specifically in words, and more subtly through images, typeface, and composition.

Your announcement must cover the following key points:

Artist(s)' name(s)

Name of exhibit or performance

Dates

Name of gallery, location, or Web site

Address

Phone number or e-mail address

Regular gallery hours, for exhibitions

Reception date and time, if any

The bulk of the following discussion is dedicated to what you need to know to get announcements printed and mailed. Remember, though, that you should also send e-mail announcements. They are much less expensive than printed announcements, and you can send them more than once to remind people of your show.

Designing Announcements

Let us turn now to a discussion on printed announcements. What do you need to know about design? What printers should you use? How can you contain costs? Cost, of course, is especially important if you are producing your own show. Three basic factors affect the cost of announcements.

- Design fees
- Printing cost
- Postage

A good design for your announcement is most important, as it is both effective publicity and cost-efficient. You can hire (or trade work) with a graphic designer, but be sure to tell them clearly what you want.

- Use visuals rather than words as much as possible to describe what you want.
- Show examples of other graphic works you admire.
- Have a sample of the type font you want used.
- Show color samples if you will be printing in color; asking for "green" when there are thousands of variations is not sufficiently specific.
- Make thumbnail sketches if you want a particular layout.
- Provide a printout and disk with all the text information that should go on the announcement.

The designer should generate a good-quality color computer print so that you can approve the basic design and proof copies to check for any subsequent changes. If you are paying for the design, you may be billed both for the original design and later changes or corrections. Some designers charge by the hour, but many charge per job.

You can avoid design fees if you design your own announcement. You can do this if you are good at graphics, which is not necessarily the same as being a competent artist. Save and study memorable announcements from other artists. Sketch several possible designs and ask other artists and mentors to review your ideas. Read graphics books for design suggestions. Keep the type simple. Use only one font, with variations if needed, unless using several fonts is essential to your design (Figure 4-1). Prioritize your text, so that your audience can easily "get" the important information. Keep all text at least one-half inch from the edges of the announcement, or your text may look too crowded in its space.

FIGURE 4-1

Examples of Different Type Faces

At the top are examples of variations within a single type family, Helvetica. Below are examples of different typefaces.

This is a sample of Helvetica.
This is a sample of Helvetica Narrow.
This is a sample of Helvetica Extra Compressed.
This is a sample of Helvetica Black.
This is a sample of Helvetica Ultra Compressed.
This is a sample of Helvetica Bold.
This is a sample of Helvetica Oblique.
This is a sample of Helvetica Inserat.

This font is called Benguiat Frisky
This font is called Cooper Black
This font is called Phyllis Italic
This font is called Lucida Casual
This font is called Graphite Light

Printers

Printing quality and printing costs vary depending on the kind of printer you use. Consider the visual appearance that each kind of printer can provide for you and at what cost.

Postcard Printers

Many artists today use inexpensive postcard printers for their announcements. Postcard printers specify a few different formats that they support. The most common format is a full-color image on front of a postcard, with black-only text on the back. Other common formats include single-fold or double-fold brochures, with a certain number of color images with pre-set sizes. You have very little control on printing quality with postcard printers. They print many different postcards in a single batch, with little or no choice in different kinds of paper. You send them a digital image at correct resolution with a separate text file, and shortly afterward your cards are delivered. The cost is very reasonable, as low as $100 for 500 small cards. Larger sizes are more costly. Some postcard printers are:

Modern Postcard (www.modernpostcard.com)

PrintingForLess.com (www.printingforless.com)

Clark Cards (www.clarkcards.com)

1-800-Postcards (www.1800POSTCARDS.com)

Check the Web sites of these suppliers for their current price lists, specifications, and instructions.

Commercial Printers

You may also have your announcement printed at a regular commercial printer in your area. There are several advantages to this. Your color control is much better, you have a wide range of paper choices, and you can inspect a press proof for color quality. You have more control over the product and more guarantees for satisfactory results. Your costs will be higher, however.

If you go to a regular commercial printer, be aware that certain features will increase the cost of your product. The cheapest announcements to print consist only of *line art*, which includes type, line drawing, and any graphic elements that can be rendered as black lines on a white background (Figure 4-2). *Continuous-tone art* is any image or graphic containing middle tones, of which photographs are the most common example (Figure 4-2). Announcements with continuous-tone art are more expensive to print.

The number of printed *colors* in your announcement affects printing costs. *One-color printing*, the least expensive, refers to any one color of ink on any one color of paper. Thus, black ink on white paper, blue ink on yellow paper, or purple on orange are all examples of one-color printing. One-color printing, with line art only, is the least expensive announcement to produce, and with a good design, such an

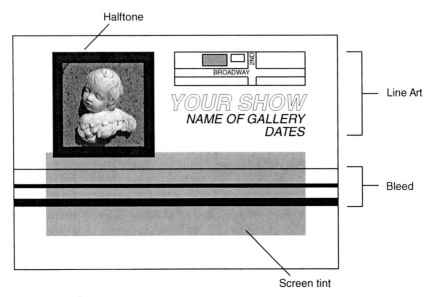

FIGURE 4-2 | **Examples of Line Art, Halftone, Screen Tint, and Bleed**

These features will affect the cost of printing your announcement.

announcement can be distinctive and effective. To give more variety in one-color printing, your color can be used full-strength or screened to appear as its paler tints (Figure 4-2). *Two-color printing* refers to printing any two colors of ink, their combinations, and screen tints of one or both, onto any one color of paper. Two-color printing can appear to be quite colorful. It has, however, higher printing costs than one-color printing. Likewise, every additional color will increase overall costs. *Four-color printing*, sometimes also called full-color printing, refers to printing cyan, yellow, magenta, and black inks to reproduce color photographs. These four inks are called the *process colors*.

Using a *bleed* increases printing costs. A bleed is any graphic or text that appears to run off the edge of your announcement (Figure 4-2). Because all printed material with bleeds must be trimmed after printing is completed, bleeds increase labor cost and paper cost in trimmed and wasted paper. In addition, any *special effect*—such as embossing, die-cutting, perforation, inserts, gluing, or varnishing—will increase printing costs of your announcement.

Paper

The price of paper can add considerably to your overall printing cost. *Stock* is the paper used to print your announcement. Factors affecting cost are weight, content, finish, and special qualities, but these factors also affect the look and feel of your announcement and therefore how it is perceived. Selecting paper is an aesthetic

choice, and the tactile and visual qualities of the paper should be an appropriate reflection of your work. You can select and purchase the paper for your announcement at the printer, as most printers carry a limited amount of stock on hand, or order what you want.

- *Weight:* The heavier the paper, the more expensive it is. Weight is given as the weight in pounds of a ream, which is five hundred sheets of paper in a basic size. Choose heavier paper for postcard announcements or for announcements that feel and look more substantial. For example, cover stock generally comes in 50-lb and 80-lb weights.
- *Content:* Rag papers are more expensive than wood-pulp papers. Again, you may choose to use rag paper if its feel, or tactile sensation, is important.
- *Finish:* Coated stock tends to be costlier than uncoated stock. However, you probably need to use coated stock if your announcement has four-color process printing, if you want to retain color saturation, or if your design has fine detail that needs to be crisp and sharp. Conversely, if you want lower contrast, softer edges, and lower color saturation, uncoated stock will give those effects due to a greater absorption of ink. Other available paper finishes include enamel, linen, and laid. In addition, paper may be cold-pressed for an open finish and feel or hot-pressed for a smoother, harder finish. *Specialty papers*, such as metallics, are more expensive than plain paper.

Postage

The cost of mailing your announcements can vary tremendously, depending on the class of delivery you need. You must know how your announcements will be mailed as you begin to design them, because each class has size and weight limitations. Check with the U.S. Postal Service for current postal rates and regulations at www.usps.com.

Bulk Rate

Bulk mail rates are the least expensive of all options offered by the U.S. Postal Service. However, bulk mail must conform to a list of criteria or the special rate cannot be used. Here are some of the regulations surrounding bulk mail:

- Bulk mail postcards must be rectangular, at least 3.5×5 inches and no more than 4×6 inches in size. They must be at least 0.007-inch thick, printed on minimum 60 lb paper stock.
- Maximum size for bulk mail letters is 6.125×11.5 inches.

Each item must display the bulk mail permit, or indicia, in the upper right corner and the return address of the holder of the permit in the upper left corner (Figure 4-3). The post office prefers that the indicia be printed in black. The address area must be 3.5×3.5 inches and must be blank except for the address and the indicia.

- You must have at least two hundred identical items to qualify to do a bulk mailing.
- No personalized notes may be written on any items.

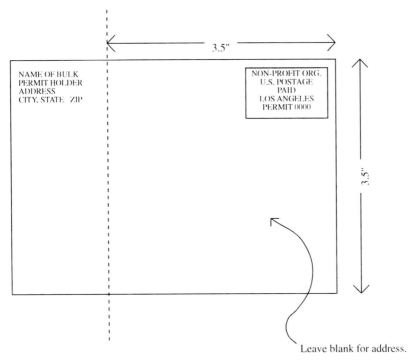

NAME OF BULK
PERMIT HOLDER
ADDRESS
CITY, STATE ZIP

NON-PROFIT ORG.
U.S. POSTAGE
PAID
LOS ANGELES
PERMIT 0000

Leave blank for address.

FIGURE 4-3 | **Postcard Format for Bulk Mailing**

This is the address side of the announcement. An image of your work may be printed on the reverse side.

- Bulk mail must be presorted, bundled, and color-coded according to U.S. Postal Service regulations. The Postal Service supplies written instructions, and sometimes classes, on bulk mail procedures.
- Bulk mail must be delivered to special post office locations.

Bulk mailing can be done only with a bulk mail permit. There is an annual fee for bulk mail permits. Nonprofit tax-exempt organizations have even lower bulk mail rates.

With bulk mail, it is impossible to predict exact delivery date, which may take two days or up to one month. Also, although bulk mailing costs the least amount in postage per item, a lot of labor and knowledge is required to do a bulk mailing. If done improperly, the Postal Service may refuse to deliver the announcements. You may want to research mailing service businesses to handle a large mailing. Also, evaluate whether first-class mail may be cheaper and easier after all.

First-Class

First-class postage is the most expensive per item but also the most reliable and quickest mail service. First-class presorted is a less expensive rate than regular first

class. You must have at least five hundred pieces, sort them by zip code with at least ten pieces per zip code, and sent with precanceled stamps or endorsed "Presorted First Class." Again, check with the Postal Service for current rates and regulations to make sure you qualify for this service.

Postcards no larger than 3 × 5 inches in size can be mailed first class at a reduced rate. Larger postcards mailed first class must carry regular letter postage.

Press Release and Press Kit

Press releases notify the press about upcoming art exhibits and events. For print and online media, they provide information to arts calendars and invite critics to write about your work. For broadcast media, they are used for announcements of upcoming events or perhaps to instigate an on-air interview. Press kits are more complete documentations of your work that are given to writers when they come to review your exhibition or performance.

Press Release

A press release is a one- or two-page document full of factual information. It answers the questions "who?", "what?", "where?", and "when?"

Writing a Press Release

The following belongs at the top of the press release in the order given below:

Date of the press release

Name of the exhibit or performance

Name(s) of the artists(s), if less than four are exhibiting; otherwise write something such as "a group show of eight artists"

Exhibition curator, if any

Name of the gallery

Dates of the exhibit or performance

Reception time and date, if any

Put this information in list form, using bold letters or caps to emphasize it.

Next comes the body of the press release. Write in an interesting and engaging style. As New Orleans photographer Steven Forster said:

The press release is a major tool that is extremely important. The first two sentences of the press release are the killers. That's what they are going to pick up from, and that's how they're going to decide whether they want to read the rest of the thing or not.

For a solo performance or exhibit, the first paragraph of text should summarize the event. The next paragraph should flesh out the important aspects of your artwork; this part can be condensed from your artist's statement (see Chapter 5). You may also include other paragraphs with the following optional information: listings of

your professional accomplishments, your other important exhibits or perfor-
mances, major collections in which your work is included, comparisons of your
work to other artists, or quotes from published reviews, catalog essays, or remarks
by noted curators about your work.

For a group show or series of performances, the press release begins also with
factual information. Next comes a short summary paragraph, with the names of
participating artists and the curator, if applicable. Following paragraphs should dis-
cuss the exhibition theme, including a short quote stating the curator's point of
view. If possible, the work of each artist should be covered in one or two sentences.
When there are simply too many artists to do so, then lengthen the discussion of
the theme and describe some examples. If you have planned any related events,
such as workshops or artists' talks, list the time, date, place, and participants. Also,
acknowledge any group, individual, business, or foundation that provided support.

All press releases should conclude with:

The address or location, with directions and parking information if needed

Regular gallery hours for exhibitions

Name and telephone number of a person to contact for more information

Ticket prices and reservations telephone number for panel discussions,
performances, or other art events with admission charge

Telephone number to call for complimentary press tickets if you charge
admission

Style and Format

Figure 4-4 shows an example of a standard press release, printed on gallery letter-
head. A press release is one or two pages in length, with all text double-spaced.
Make sure your layout has ample spacing and short paragraphs for easy reading.
The factual information at the beginning of the press release should be readable at
a glance. Use outline form, large-size type, capital letters, bold letters, or underlin-
ing to emphasize this information.

Remember that the press release is a not a personal statement. Whether you
write it or not, the press release always refers to you in the third person, using "the
artist, Catherine Liu," or "Ms. Liu," or "Liu's work." The language in the press re-
lease should be readable and informative, without esoteric terms or references.
However, what you do write should be complete and reflect the essential qualities
of your work. Sometimes, the language in a press release later appears verbatim in a
review or article about the work.

Copying and Sending Press Releases

Print out your press releases on high-quality paper. If letterhead is available, use
that. Some artists include an image of their work with their press release to better
convey an impression of its qualities. If your exhibition announcements have an
image and are available already, send one with each press release. If not, include an-
other image, either a color print or a photo-quality computer printout.

G W E N D A J A Y GJA A D D I N G T O N

FOR IMMEDIATE RELEASE

EXHIBITION: KWANG-YOUNG CHUN, "Aggregations"
DATES: April 27 through May 30, 2000
OPENING: Friday, April 27, 5–8 P.M.
HOURS: 10:30–6:00 P.M., Tuesday–Saturday

 The Gwenda Jay/Addington Gallery is pleased to present "Aggregations," a show of recent work by Kwang-Young Chun. The basic structural unit of Kwang-Young Chun work is a small geometric form. Created by carefully wrapping Korean mulberry paper, it exists as the common foundation for an endless variety of compositions.

 The wrapped pieces that are the basis of these structures are themselves unique objects with rich associations. Mulberry paper holds symbolic significance in Korea. Valued for its historical qualities, it has become a symbol of Korean nationality. Like others of his generation, Chun was intimately familiar with mulberry paper in his childhood. "This paper is so special for me," he says, "because it contains the sorrows and joys of our routines." Before the Korean War and the advent of modern medicine, Chun often visited a close relative who was an herbal doctor. Medicines hung from the ceiling, wrapped in mulberry paper inscribed with invocations for good health. The medicine bundles that once crowded that ceiling are the spiritual ancestors of the wrapped pieces that are now so meticulously placed in Chun's "Aggregations."

 Kwang-Young Chun's work is increasingly present in the United States, reflecting our interest in incorporating an Asian aesthetic into Western culture. His work has recently been added to major American collections including the Whitney Museum of American Art. Chun was selected this year as the sole recipient of Korea's National Artist of the Year Award, and will be featured in a one-person exhibition this summer at the National Museum of Contemporary Fine Art in Seoul, Korea.

For more information, please contact Dan Addington at (312)-664-3406.

704 North Wells
Chicago IL 60610
tel 312 664 3406
fax 312 664 3388
www.gwendajay.com
gwendajay@rivernorth.net

FIGURE 4-4 | **Sample Press Release**

This press release describes a two-person show.

 Mail your press releases via first-class mail. Send one to all appropriate newspapers, local weeklies, art publications, free papers, university papers, radio stations, and online art listings. For smaller publications, you may want to try hand-delivering the press release. You may get more coverage if you make a personal contact with the assignments editor.

Press Kit

When writers or critics are going to write an article on your performance or exhibition, you should provide them with press kits, which are packets of information containing the following (when applicable):

- A copy of your press release.
- An announcement.
- An artist's statement or curator's statement.
- Copies of past reviews of your work.
- Copies of programs from past performances.
- Artist(s) resumé(s), for individual and small group exhibitions.
- A sheet with brief biographies of all participating artists, for large group exhibitions or performances.
- A CD with files of your work that can be used for reproduction.

These items should be arranged in a large envelope or folder. On the outside, place a label with your name and number or those of a contact person. Usually, three to five press kits are sufficient, but be prepared to make more if needed.

Installing Your Exhibition

This section presents current conventions for displaying traditional visual artwork or media work in a gallery-like setting. Feel free to vary from these general rules, should you wish a different effect from your show.

Preparing the Site

For art that hangs on the wall, evaluate the condition of the exhibition site before your show. If you are showing someplace that is not a gallery, you may be faced with a great deal of work. The condition of the walls is critical for most traditional visual work. In extreme cases, you actually may have to build walls to finish a "raw" space or build partitions to divide a large space. If so, you need wood or metal wall studs for framing; drywall (4-foot × 8-foot sheets) for the wall surfaces; drywall nails, tape, and mud for smoothing over the seams; and paint for the finished surface. Building walls is costly, takes a great deal of time, and requires some experience to get a good finish. Get help if you have never built walls before.

Hopefully, your exhibition site needs only cosmetic touch-up. Patch any nail holes or small wall tears from previous exhibits with Spackle, using a putty knife to apply it and sandpaper to smooth it once it is dry. Conventionally, the walls in galleries are painted cool white.

Check the lighting. Ideally, the site will have track lighting, with plenty of fixtures to illuminate as many pieces as you want to include in your exhibit. Non-gallery spaces frequently do not have track lighting, however, and may only have incandescent bulbs or fluorescent light. In these cases, the lighting may be bright and harsh and utterly flood the room or conversely may be so sparse and dim as to

barely illuminate the place. You may need supplementary lighting to illuminate the artwork. Artificial illumination should be a constant, balanced white light or slightly warm light. The greenish tint and flickering common with fluorescent lighting is generally considered undesirable for viewing artwork. Check hardware stores for fixtures that can be temporarily installed in your space, such as clip-on light fixtures and quartz lamps.

Installing Artwork

For works that hang on walls, you need a hammer, hangers, long ruler, tape measure, and stud finder. Although lightweight works can be hung almost anywhere on the wall, heavy works must be supported on substantial nails driven into studs. For hanging framed work, screwdrivers, screws, and picture-hanging wire may also be needed, plus a plumb bob or level to help hang pictures evenly on the wall.

The conventional rules for spacing artwork on walls is to leave as much space to each side of a work as the work is wide and to hang all works in a horizontal line around the room. Thus, a three-foot-wide painting would have three feet of space on either side between it and its neighbors. For pieces of varying size, average the width of the works to determine spacing (Figure 4-5). Conventionally, paintings are hung with their centers slightly below five feet from the floor. Alternatively, artwork may be hung salon style, in which case pieces can be stacked vertically and horizontally (Figure 4-6).

Sculptural works can be placed directly on the floor, on a pedestal, or mounted on the wall. Installations occupy the floor space.

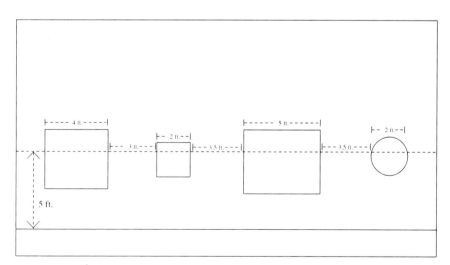

FIGURE 4-5 | **Conventional Installation**
Conventional-style for installing flat artwork.

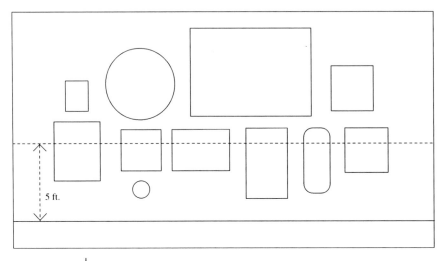

5 ft.

FIGURE 4-6 | **Salon-Style Installation**

Salon-style for installing flat artwork.

Lighting

When everything is in place, set lights to illuminate each work. You should choose between using spotlights or floodlights. Spotlights are more focused and will brilliantly illuminate a small area of your art, while leaving the surroundings dark. Exhibits lit only with spotlights tend to be more dramatic, with high contrast between dark and light areas in the gallery. Conversely, if you light your exhibition with floodlights, the room as a whole will be much more evenly illuminated, both the artwork and the walls behind. What effect do you want?

When lighting art on walls, watch for glare off shiny or glass surfaces. Illuminating wall works from a high angle of incidence usually eliminates most glare, whereas lighting from across the room, at a low angle of incidence, increases it (Figure 4-7). In addition, a low angle of incidence will likely result in spectators casting their own shadows on works they are trying to view. Illuminate sculpture from several sides, so all parts are visible and the work does not cast a single long dark shadow. Although each sculptural piece must be evaluated separately for best illumination, lights on sculpture often should be from both high and low angles of incidence (Figure 4-8).

Considerations for Media Works

Media works, such as video or computer-based art, have different display requirements. Room illumination should be kept relatively low so that the images on the monitor can be seen more easily. Seating of some sort is usually provided for video viewing, unless the video is part of an installation that is meant to be viewed from

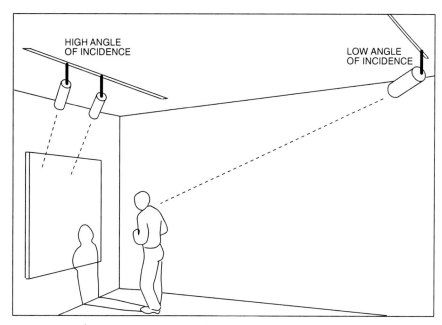

FIGURE 4-7 | **Avoiding Glare and Cast Shadows**

To avoid glare and cast shadows, light artwork on the wall from a high angle of incidence.

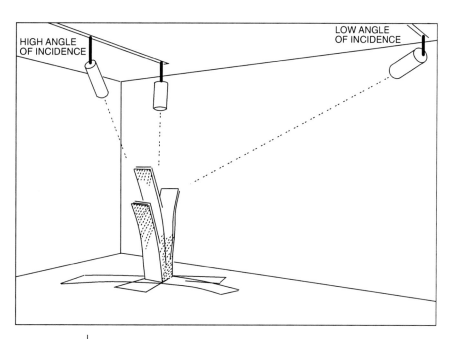

FIGURE 4-8 | **Lighting Sculpture**

Light sculpture from both high and low angles of incidence.

many angles. For video display, tape over buttons on the VCR that your audience should not touch. People sometimes interact with machines in ways that you do not want. Security is really an issue with any media works, as television monitors and computer equipment are so costly. Even if you secure big equipment, your mouse or your VCR's remote control may be stolen.

Signage and Didactic Material

Generally, artists provide a variety of written material at the exhibit, including a resumé, artist statement, copies of past reviews, exhibition list, and acknowledgments. These materials should be clearly reproduced and placed in a binder on a front table or reception desk. Sometimes, the artist statement is enlarged and displayed on the wall. If you choose to do that, make sure the statement is printed on a quality printer, with clear, well-aligned type large enough to read from a few feet away, and displayed on mat board or under glass.

You need to generate an exhibition list, which is a sheet of bond paper containing the name, date, size, medium, and optionally the price of each work. The entries on the exhibition list are numbered to correspond to numerals placed on the walls to the right side of each work, usually three or so feet from the floor. If you want to use wall labels, you do not need an exhibition list. With wall labels, you make a small card to go next to each work that contains the name of the work and optionally the date and medium. Size and price are usually omitted on wall labels. The type again should look sharp, and the labels should be mounted on mat board or under Plexiglas.

If any persons, organizations, or businesses assisted you in making the work or sponsoring the exhibition, acknowledge them on a separate card displayed somewhere in the exhibition, perhaps near your artist's statement or your name at the entry. Have a guest book available in that area for the entire run of the show for signatures and addresses of those who attended.

Signage is important. External signage should be plentiful, especially if your exhibit is in an unusual site. Make it easy for the public to find your exhibit. Inside, the artist's name and/or the name of the exhibit usually appear in large type at the front of the exhibit. Custom-made large vinyl letters are available through specialty printers for this purpose. Or, with an opaque projector, you can enlarge a small title, project it on the wall, trace around the letters, and paint them by hand. You need a steady hand to give hand-painted letters a professional look. Paint signage with latex paint, which is easy to paint over once your exhibition is down.

Refreshments

Minimal refreshment at a reception is a beverage served in plastic cups. It can escalate from there to an elaborate spread with snacks, finger foods, cut vegetables, hors d'oeuvres, and desserts. If you plan to serve alcoholic beverages, check first with your site. Many colleges, community centers, and churches have restrictions. If outdoors, check local ordinances about serving and consuming alcohol in public.

Arrange for someone else to be in charge of the refreshments. You should not be watching the cheese dip during the reception for your show.

Preparing for a Performance

Performance may be as simple as one person speaking or as elaborate as a full-blown theatrical piece. Either way, the element of staging—where, when, and how the audience meets the performer—is critical and requires preparations different from those of traditional art exhibitions.

Preparations

All performances, simple or elaborate, are group efforts. In addition to performers, you may need technical personnel to operate sound and lighting equipment, artistic personnel such as composers or perhaps even a director, and perhaps house personnel to manage the audience. Getting everyone to work together requires time, practice, and social skills: listening, communicating, building group consensus, getting help, and delegating tasks. What kinds of individuals do you need to make your performance work?

If you are performing at an unconventional site, check on the following:

- Is the space available for both rehearsals and performances?
- Can you make changes to the space, such as covering windows?
- Is there sufficient seating?
- What audiovisual or sound equipment is needed?
- Is the lighting adequate?
- Is there any backup equipment?
- Are there tools, extension cords, plug adaptors, extra tapes, a ladder, and so on?

Your rehearsals should be well organized and start and stop on time. You may be able to pull together a simple performance in a few weeks, but long-range planning is necessary for elaborate performances, when you may have to contend with script writing, casting, choreography, recording audiotapes, and preparing written and visual materials. For your rehearsals:

- Distribute the rehearsal and performance schedule to all participants.
- Have scripts ready.
- Coordinate audiovisuals and lighting with performers.
- Have a photographer document your performance at a rehearsal to avoid disrupting the actual performance.
- Make video documentation during two rehearsals.

Programs

You may want to provide programs for your audience. If possible, make your program a few days before the performance, to reflect last-minute changes. If you

include performers' biographies, having them write their own, within a specific word limit, is preferable to you writing them. Then, they can present themselves as they choose. Programs can be simple and can be printed or photocopied on regular bond paper. Make and keep extra programs for future press kits or grant proposals. Credits should include the following:

Name of the performance

Performers

Author(s)

Location and dates of performance

Artistic personnel

Technical personnel

Acknowledgment of any person, business, or organization that provided support

Brief artists' statement, if possible

Short biographies of the performers, if possible

artist interview

MICHAEL McCAFFREY

Michael McCaffrey was born in Glasgow, Scotland, received his M.F.A. from the University of Illinois at Urbana–Champaign in 1996, and is currently working as an artist in Chicago. He and David Roman run the Standard Gallery (www.standardgallery.com).

When and why did you open Standard Gallery?

We started up in November 2000 on a whim. David Roman, a photographer friend, had this fairly large storefront apartment with a big front room that's a blank white cube. One evening we were having a couple of beers and I suggested that it seemed like a perfect hybrid—an apartment gallery. That was a relatively obscure notion in Chicago at the time.

We didn't try to hide the fact that someone lived there. But it took us a while to figure out how to use the space. There's a second room to the gallery that is also David's living room. We set up our bar for the first opening in that living room, and of course that being the bar, a lot of people congregated there. We had left David's own personal artworks on the wall and people kept looking at them and enjoying them more than the actual gallery work.

So, a lightbulb went off in our heads, like ding! We should use this as part of the gallery. We'd been ambivalent to that because we'd figured it was part of the house and that was therefore not legitimate gallery space. Then we realized, well, that's exactly what it should be.

How would you describe the work you show?

After the first show, we decided not to be everything for everyone. We wanted the gallery to have a pretty narrow and precise focus. First of all, we show only

Untitled #20,
48" × 48", 2000.
Enamel on Sinatra.

unknown people. I know it's not a new idea, but actually, in Chicago, it's fairly original.

We also decided that we would show work that was always well-manufactured, always technically well-conceived, so that although you may have philosophical disagreements with the overall aims of the work, you couldn't really have a radical technical quarrel with it. The work has a fairly cool, clean, minimal aesthetic, although not always. It's process-based abstraction. It's abstraction derived through some sort of mediated process. And that's taken the form of photography, sculpture, painting—a whole range of media.

If we changed the style of work we show every week, we figured that would be just a recipe for more work for us. We don't have time for that. And it actually might water down the overall effect of the gallery. It's a heck of a lot easier to market yourself when you only have one face, if you like.

Had you hoped that running a gallery would give you introductions into the art world?

We figured there's a chance that might happen. However, we thought it would take a long time to build up our legitimacy and that at first people might not see us as being really serious. But the local press, such as the *Chicago Reader*, started writing about us. That's pretty far down the food chain in terms of critical press, but

it's also probably one of the most widely distributed in the city. People started coming.

In the gallery, we also try to show people who were relatively local. That's for practicality. Number one, it's easier and cheaper in terms of shipping. And number two, we wanted to develop personal relationships with our artists because we see this as a collaborative venture. We're artists ourselves. And we don't really want to work remotely with people we don't know.

Personal relations really are important, aren't they?

In art school there is no course students take to sharpen up their charm factor. Everyone has their own story of how they broke into the art world, but my own feeling is that behind all those different stories, most of it comes back to who you know. It helps to have good work, but it certainly doesn't cement anything. It helps a lot more to have personal relationships with people.

When we want to get to know the artists we show, we are hoping to get more exposure for ourselves as well. We want to build up and become part of a network of artists and be able to promote ourselves. The gallery has actually helped our careers in ways that were off-limits when we were just artists. Namely, we have a significant cache with the local powers that be—the critics, the dealers, and so on.

Standard Gallery is in an apartment in a residential area, and it's not in any kind of art gallery district either.

We're one block away from a major intersection, on a street that has never entered the common consciousness. It certainly is possible that it could be a disadvantage. But it is located in a trendier part of town, so there are a lot of people locally who would be interested in going to galleries.

When people have made the effort to come out, they're actually quite surprised and I think pleased by what they find. My feeling is that there isn't any benefit to having a lot of galleries being close to each other when they have actually no relationship to each other. Galleries don't do a lot of joint planning, anyway.

In some ways, being a little bit of a maverick is advantageous at this stage, especially if you're a startup, especially if you're young, especially if you're an artist yourself. If you buck the trend, it can actually help you.

Is it a goal of yours that the gallery make money?

I think, at least here, when people start out in their own small space—maybe artist-run or low-budget or whatever—most of them assume that they're never gonna make money out of it. And you have to cut corners to get away with as few costs as possible.

And my feeling is that the typical logic that being low-budget means it's gonna be crappy isn't necessarily true in this day and age. I think you can do quite good

stuff for very cheap if you're smart enough. We have a Web site and a letterhead, which is easy to produce and create an image for yourself that is above and beyond the reality of your circumstances. Image is absolutely everything in the art world, and substance is a whole other issue.

When artists open galleries, many of them believe that it's probably healthier in terms of your aesthetic not to be business oriented, as if the work is of higher quality if you're not concerned with its retail aspect. I don't agree. David and I decided that there was every reason to marry together our aesthetic needs and our financial needs, if you like. And we decided from the beginning that if we couldn't make this work as a business venture, we weren't going to pour our own money into it. That was bad business. Our first year, we basically broke even.

What have you done to make the business succeed?

All you need is one or two things to give you a kick start—a favorable review by someone who might do a favorable review again, or a good sale by a collector who might generate another sale in the future.

We always try to sell; a lot of people are very reticent about the selling, about the whole transaction of making a sale, but we've always tried to engage it, you know.

We already knew who the collectors were. But until the gallery, we didn't have an introduction to them. It comes out when you start talking to these people that it's a hell of a small world and you've actually got more in common than you would think, instead of the intimidation factor, which is often there.

Staying focused on the kind of work we show is also important. We can try to reengage interest from the people who were interested in an earlier show. It's one way in which we try to marry the aesthetic aims of the gallery and the business aims. No one else shows our kind of work out here, and the people in Chicago have responded to it. It fits their idea of contemporary living or something.

I think in the art world, a lot of things are long term, cumulative, you know. Very little is immediate and satisfactory.

So Standard Gallery is a long-term project?

David signed a new lease so we got to do it for another year. Our ambitions are longer term, absolutely.

How do you get everything done? You have another job, too.

Well, that's a part of it, the old story of balancing all that. Being an artist—the part that you want to do—takes up the least part of your week and the part you don't want to do (probably the job part) takes up the most.

I used to teach a lot in temporary positions, but I gave it up because I couldn't be bothered working without any benefits or contracts anymore. So now I work at

a museum. The gallery can take up a lot of time but it can also be run fairly quickly. That's why it's essential to have a focus on just one very small area.

Does it work that the gallery is only open on Saturday?

Galleries have most of their traffic on opening night. So it's not a great disadvantage that we're only open on a Saturday. The problem is getting the quote-unquote "important" people in here on a Saturday because obviously a lot of them have other plans for the weekend. Like a critic will say, "Well, I'm not coming to your gallery if you only open up on a Saturday," because somehow Saturday was not a gallery day for them, you know. But one of us lives here, so you're welcome to come by anytime. Just ring the doorbell.

5

Documenting
Your Work

You need to document your art and your accomplishments. This is done primarily with resumés, artists' statements, and visual documentation. This chapter tells you how to create all these. In addition, the end of this chapter has suggestions for keeping other documents about your career, including copies of reviews and past show announcements.

The next chapter, "Presenting Your Work," is a continuation of this one. In it, we talk about how you assemble all this "raw" documentation to create portfolios, proposal packets, or Web sites. Then, it can be used to secure future exhibitions or performances or to apply for grants, residencies, jobs, or graduate school.

Resumés

Your resumé summarizes your professional art activities and past accomplishments. It represents you to the public. Often, art professionals see it before they ever meet you and decide from it whether they want to pursue further contact. As you go through this book, you will see that resumés are necessary when applying for jobs, grants, and graduate school and also when trying to get a show in a commercial gallery or write for an art publication. For now, however, let us focus on writing the resumé.

Elements of Your First Resumé

The following list contains major areas that you should include on your first resumé when you have just finished school or have just begun your professional career:

Name

Address

Telephone number

E-mail address

Education: List the name of your university, the name of your degree(s) and area of specialization, and year received (BA, Painting, 1999; or MFA, New Media, 2001). If you graduated with honors, include that here.

Exhibitions or performances: Organize your exhibitions or performances according to year, with the most recent first. List the event's name, followed with the site and the city where it is located. Indicate if each exhibition was individual, group, or juried.

An individual exhibit can be one you had by yourself, or one with no more than two other artists, each exhibiting in separate areas of the gallery. A group exhibit is organized by a curator, usually along a single theme, and all artists works are intermingled with the others. A juried exhibit is a publicized competition, in which a juror selects work from images submitted by artists accompanied by an application form and usually an entry fee. If the exhibit was juried or curated by a prominent art professional, list the name of that person on your resumé.

If you have recently graduated or are still in school, include college- and graduate-level student exhibits. You should also list exhibitions scheduled in the near future. Include exhibits in nongallery public spaces, such as libraries, community centers, and government buildings.

Awards and grants: Include academic scholarships or awards received in juried exhibitions.

Exhibition reviews and articles: Reviews and articles should be listed in alphabetical order by author, or by title when no author is given. Use correct bibliographic form, including page number, section, volume, and number, and indicate whether illustrations of your work were used. The following fictitious examples show correct form for articles with one author, two authors, and no listed author:

> Fujito, Shellany. "Exchange Shows with Japan." *Artweek,* May 1, 2000, pp. 2–3.
>
> Lister, Josine A., and Javier Cruz. "New Shows at the Forum." *Washington Post,* April 10, 2000, Sec. E, p. 4, col. 2. (Reproduction)
>
> "Two Performances of Exceptional Impact." *St. Louis Riverfront Times,* August 19, 1999, p. 18, col. 3.

You can list any published writing that includes your name, for example, if your name was mentioned in a review of a group show. Include articles that appeared in college newspapers and in alternative press or free publications, in addition to reviews in daily papers.

Collections: Include any museum or corporate collection that has purchased your work and any prominent private collections. List the city and state where these collections are located. Include other private collections sparingly, and avoid listing your relatives as collectors.

Art-related employment: List all art-related and design-related work experience. List dates of employment and job responsibilities.

Other experience: Include all jobs of more than four months' length that show you to be hardworking, responsible, experienced, or skilled. List the dates of employment. List any unpaid activity or experience that may show you to be unusually sophisticated or knowledgeable. Examples might include internships, travel, research, volunteer work, or creative ventures.

References: List three or four individuals who have agreed to serve as references on your artwork, background, or character. After the name and title/position of the referee, put their institution/business. See "Privacy Issues" below before including their addresses and phone numbers. If you must send out a resumé but as yet have asked no one to be a reference, simply write "References Available on Request" at the bottom of your resumé. This buys you about one week's time to line up individuals to be references for you. See Chapter 12 for more on letters of recommendation.

Later Resumés

Your first resumé will look different from later ones you write. As you gain experience in the art world and have more exhibitions and other accomplishments, you will need to add more categories to organize your entries. The list below contains likely categories for the resumé you write after a few years of activity:

Current position: If you work as an art professional, include this immediately after your name and address. List your position, the name of the institution, and how long you have worked there.

Exhibitions: After you have at least six listings in this category, you may want to break them into these separate subheadings: (1) Individual Exhibitions; (2) Group Exhibitions; and (3) Juried Exhibitions. When your exhibition record becomes much longer, you may drop old listings, including, for example, only exhibits from the past five or ten years or only exhibits in museums and galleries. Eventually, you may choose to drop the category of Juried Exhibitions altogether.

However, keep track of all your exhibitions even if they do not appear in your resumé, because sometimes you may wish to supply a complete list. For example, academic resumés can be long, and you may need a complete list of your exhibits if you want to be hired or promoted as a teacher.

Gallery representation: List the names and addresses of galleries that represent your work. "Representation" is a long-term relationship with a commercial gallery, which is explained in Chapter 8.

Published books, catalog essays, and reviews: List in bibliographic form everything you have written.

Professional activities: Include here all arts organizations in which you have been an officer, all arts events that you have organized, and professional committees

of which you have been a member. Mention any exhibits you curated, with name of exhibit, location, and date.

Professional or academic conferences: If you were a speaker, moderator, or panelist at any local, regional, or national art conference, include that here.

Maintaining and Editing Your Resumé

Your resumé is not one single document. It is a flexible mass of information that you can condense to one page, if necessary, or longer if need be. When compiling your resumé, use the computer and enter the data in its most complete form. Update it every six months or so to keep it current. Then, when you apply for a particular job or submit work for an exhibition, you should custom-edit your resumé listings. For example, you need the categories "Art-Related Employment" and "Other Experience" when you apply for jobs, but not when you are trying to get a show. Likewise, "References" are needed when applying for jobs, grants, or graduate school, but not on a resumé you send to a gallery or museum about your artwork. Figure 5-1 is an example of a complete resumé; Figures 5-2 and 5-3 are resumés edited for specific purposes.

Privacy Issues

Your resumé can be a public document, so consider where it is going before you include personal information. If your resumé will be on the reception desk during an art show, you should omit your address and phone number from the top, because you have no idea who will see it. Also, ask your references if they wish to have their addresses and phone numbers printed on your resumé under any circumstance. You can always supply that information later as the need arises.

Resumé Format

Art resumés differ from standard business resumés. Your art resumé can be as long as necessary to convey all pertinent information, in contrast to a standard business resumé that is usually only one or two pages in length. However, never "pad" your resumé nor give people more information than they want. Business resumés often list your age and marital status, but these items are rarely put on art resumés. Also, business resumés often list an objective directly under your name, saying something similar to "to work as a marketing consultant for a large manufacturing company" or "to become a land surveyor supervisor." This form is rarely if ever used on art resumés.

The most recent information is placed first under each resumé heading. In bibliographic listings, periods and commas precede quotation marks at the ends of article titles. Avoid spelling, grammar, and punctuation errors by using the computer spell-checker or the services of a proofreader. Do not abbreviate on your most complete, formal resumé, except in bibliographic areas. If on shorter resumés you do abbreviate to save space, then abbreviate consistently.

Design your resumé so that the headings are emphasized and the information following is contained in easily read blocks. Leave space between headings. Avoid large masses of text. At the most, use two different type fonts within the same

MARIA APARICIO
6935 Figueroa Street
Houston, Texas 77027
(713) 555-5555
email@email.net
www.site.org/~site

CURRENT POSITION:
Instructor, Part-time (2000-), Art Department, University of South Texas, Houston.
Courses taught: Painting I, Drawing I, Drawing II

EDUCATION:
M. F. A., Painting, Texas State University, Conroe. 1998
B. A., Art, with emphasis in Painting and Drawing, Clearwater College, San Antonio.
1994. Magna Cum Laude.

INDIVIDUAL EXHIBITIONS:
"New Paintings," Mazon-Winter Gallery, Houston. (scheduled for November 2002).
"Figure and the Ground," Burroughs School, Houston. 2000
"New Figurative Works," Bluestein Gallery, Texas State University, Conroe. 1998

SELECTED GROUP EXHIBITIONS:
"Earth Works," Carpenter College, Chicago. 2001
"Painting and Drawing in Texas," Owen Mills Gallery, San Antonio. 2001
"Summer Group Show," Mazon-Winter Gallery, Houston. 2000
"Summer Group Show," Mazon-Winter Gallery, Houston. 1999
"Small Works," Carpenter College, Chicago. 1997

SELECTED JURIED EXHIBITIONS:
"Acid + Rain: Artists Respond to the Environmental Crisis," University of Central
Arizona, Phoenix. 2000. Juror: Hilda Mayer, Curator, Atlanta Museum. Catalog.
"Power," Dallas Art Space. 1999. Juror: William Kozak, Critic, *Dallas Report*.
"Survey of American Oil Painting," Houston Contemporary Art Center. 1999. Juror:
Marin Mazon, Director, Mazon-Winter Gallery, Houston.

AWARDS AND GRANTS:
Ann Stinson Award for Outstanding Arts Graduate. Texas State University. 1997

COLLECTIONS:
Venus Corporation, San Antonio.
Western Bank Corporation, Houston.
Carpenter College, Chicago.

WORK AND OTHER PROFESSIONAL EXPERIENCE:
Preparator, Central Texas Regional Museum, Austin. 1996-1997
Art Instructor, San Antonio Teen Camp. 1994.
Gallery Attendant, Heckal Gallery, San Antonio. 1994.

REVIEWS OF EXHIBITIONS:
Birdsong, Eleana. "'Acid + Rain' Etched in Souls," University of Central Arizona *Campus
Chronicle*, April 19, 2000, p. 12. Reproduction.
Hart, Mi-Lin. "Overview of Gallery Group Shows," Houston *Times*, Calendar Section,
August 2, 1999, p. E4.

FIGURE 5-1 | Sample Complete Resumé

This document contains all the resumé information for a fictional artist a few years out of graduate school. Usually, you would edit and format this document to create resumés for specific purposes.

GALLERY REPRESENTATION:
Mazon-Winter Gallery, 9975 Westheimer, Houston, Texas 77038

PUBLISHED ARTICLES:
"New at the Contemporary," *Houston Weekly Underground*, May 4, 2001, p. 38.
"Survey of Still Life: Review of the Scot Smithson Exhibition," *Houston Weekly Underground*, March 18, 2001, p. 37.
"Where is Painting within the Austin City Limits?" *Austin ArtsMagazine*, Vol. 3, No. 1, January 2000, p. 14.

PROFESSIONAL ACTIVITIES:
Exhibitions Chair, League of Arts, Houston. 1999-2000
Publicity Committee Co-Chair, Southern Environmental Action, Houston. 1999.

PROFESSIONAL OR ACADEMIC CONFERENCES:
Panelist: "Artists Speak Out on the Environment"
2000 Annual Conference of Environmental Organizations, Washington DC.

REFERENCES:
David Wong, Chair (713) 555-5555
Art Department email@email.net
University of South Texas
Linyard Hall Room 302
Houston, Texas 77123

Linette Marguer, Professor of Painting (512) 555-5555
Department of Art email@email.net
Texas State University
1350 Crockett Drive
Austin, Texas 78792

Lucius Long, Director (512) 555-5555
Central Texas Regional Museum email @email.net
1881 Farm Road
Austin, Texas 78740

Marin Mazon, Director (713) 555-5555
Mazon-Winter Gallery email@email.net
9975 Westheimer
Houston, Texas 77038

Luther Bill, Associate Professor (210) 555-5555
Art Department email@email.net
Clearwater College
6600 City Line
San Antonio, Texas 78110

FIGURE 5-1 | **continued**

MARIA APARICIO 6935 Figueroa Street
 Houston, Texas 77027
 (713) 555-5555
 email@email.net
 www.site.org/~site

WORK EXPERIENCE:
Instructor, Part-time (2000-), Art Department, University of South Texas,
 Houston. Courses taught: Painting I, Drawing I, Drawing II
Preparator, Central Texas Regional Museum, Austin. 1996-1997
Art Instructor, San Antonio Teen Camp. 1994.
Gallery Attendant, Heckal Gallery, San Antonio. 1994.

EDUCATION:
M. F. A., Painting, Texas State University, Conroe. 1998
B. A., Art, with emphasis in Painting and Drawing, Clearwater College, San
 Antonio. 1994. Magna Cum Laude.

SELECTED EXHIBITIONS:
"New Paintings," Mazon-Winter Gallery, Houston. (scheduled for November
 2002).
"Figure and the Ground," Burroughs School, Houston. 2000
"Earth Works," Carpenter College, Chicago. 2001 (Group)
"Painting and Drawing in Texas," Owen Mills Gallery, San Antonio. 2001 (Group)
"Summer Group Show," Mazon-Winter Gallery, Houston. 2000 (Group)

PUBLISHED ARTICLES:
"New at the Contemporary," *Houston Weekly Underground*, May 4, 2001, p. 38.
"Survey of Still Life: Review of the Scot Smithson Exhibition," *Houston Weekly
 Underground*, March 18, 2001, p. 37.
"Where is Painting within the Austin City Limits?" *Austin ArtsMagazine*, Vol. 3,
 No. 1, January 2000, p. 14.

PROFESSIONAL ACTIVITIES:
Exhibitions Chair, League of Arts, Houston. 1999-2000
Publicity Committee Co-Chair, Southern Environmental Action, Houston. 1999.

REFERENCES:
David Wong, Chair (713) 555-5555
Art Department, University of South Texas email@email.net
Linyard Hall Room 302
Houston, Texas 77123

Linette Marguer, Professor of Painting (512) 555-5555
Department of Art, Texas State University email@email.net
1350 Crockett Drive
Austin, Texas 78792

Lucius Long, Director (512) 555-5555
Central Texas Regional Museum email @email.net
1881 Farm Road
Austin, Texas 78740

FIGURE 5-2 | Resumé for a Job Application

A resumé for a job application, edited down and formatted from the complete resumé in
Figure 5-1.

MARIA APARICIO

6935 Figueroa Street
Houston, Texas 77027
(713) 555-5555
email@email.net
www.site.org/~site

Instructor, Part-time (2000-), Art Department, University of South Texas, Houston.
 Courses taught: Painting I, Drawing I, Drawing II
M. F. A., Painting, Texas State University, Conroe. 1998

INDIVIDUAL EXHIBITIONS:
 "New Paintings," Mazon-Winter Gallery, Houston. (scheduled for November
 2002).
 "Figure and the Ground," Burroughs School, Houston. 2000
 "New Figurative Works," Bluestein Gallery, Texas State University, 1998

SELECTED GROUP EXHIBITIONS:
 "Earth Works," Carpenter College, Chicago. 2001
 "Painting and Drawing in Texas," Owen Mills Gallery, San Antonio. 2001
 "Summer Group Show," Mazon-Winter Gallery, Houston. 2000
 "Summer Group Show," Mazon-Winter Gallery, Houston. 1999
 "Small Works," Carpenter College, Chicago. 1997

SELECTED JURIED EXHIBITIONS:
 "Acid + Rain: Artists Respond to the Environmental Crisis," University of
 Central Arizona, Phoenix. 2000. Juror: Hilda Mayer, Curator, Atlanta
 Museum. Catalog.
 "Power," Dallas Art Space. 1999. Juror: William Kozak, Critic, *Dallas Report*.
 "Survey of American Oil Painting," Houston Contemporary Art Center. 1999.
 Juror: Marin Mazon, Director, Mazon-Winter Gallery, Houston.

COLLECTIONS:
 Venus Corporation, San Antonio.
 Western Bank Corporation, Houston.
 Carpenter College, Chicago.

REVIEWS OF EXHIBITIONS:
 Birdsong, Eleana. "'Acid + Rain' Etched in Souls," University of Central Arizona
 Campus Chronicle, April 19, 2000, p. 12. Reproduction.
 Hart, Mi-Lin. "Overview of Gallery Group Shows," Houston *Times*, Calendar
 Section, August 2, 1999, p. E4.

GALLERY REPRESENTATION:
Mazon-Winter Gallery, 9975 Westheimer, Houston, Texas 77038

PUBLISHED ARTICLES:
 "New at the Contemporary," *Houston Weekly Underground*, May 4, 2001, p. 38.
 "Survey of Still Life: Review of the Scot Smithson Exhibition," *Houston Weekly
 Underground*, March 18, 2001, p. 37.
 "Where is Painting within the Austin City Limits?" *Austin ArtsMagazine*, Vol. 3,
 No. 1, January 2000, p. 14.

FIGURE 5-3 | Resumé for Curators and Dealers

A resumé for sending to curators and dealers, edited down and formatted from the
complete resumé in Figure 5-1.

resumé; one type font is even better. You can create variety by using boldface, italics, capital letters, or underlining within the same font.

Your resumé should be as clean, sharp, and readable as possible. Therefore, print your resumé on a laser or high-quality ink-jet printer. When making copies, use a good photocopy machine with a clean glass plate and plenty of toner. Copy onto paper with some rag content so that the paper has a distinct weight and feel. Standard resumés are copied onto white paper. If you wish, you may use a neutral or pastel paper with a distinct finish, such as linen. Resumés on fluorescent or bright papers may be considered silly.

If you wish, you may design an unconventional resumé for yourself. Then, the re-sumé is an expressive tool, with a distinctive style and content meant to reflect your personality or artwork. Your resumé may then stand out from the rest, but there is a risk that you will be perceived as unprofessional or unsophisticated. If you decide to use a nonstandard resumé, make sure it works well for you. Show it to your friends, mentors, or some knowledgeable art individuals. What are their reactions?

Artist Statement and Proposals

Artists are often asked to supply written statements about their work. They may cover work that you have already done or work that you propose to do.

Artist Statement

The artist statement is a general introduction to the work you have already made. These elements are part of most artist statements:

- The basic themes of your work, briefly explained in two or three sentences
- How these themes are embodied in your work

Succeeding paragraphs may cover some of the following points, if they are impor-tant in your work:

- Why you created this work
- How you expect the audience to react to your work
- How this work differs or grows from your previous work
- Where your work fits with current contemporary art
- How your work fits with other art in a particular group show or series of performances
- Sources for your imagery
- Artists whom you admire or artists working with similar themes

You may include quotes about your work from published reviews, from catalog essays, or from curator's statements.

Writing Style

An artist statement should be clear and direct. The tone of your statement should be expressive of your work. If appropriate to your work, you may choose a

personal style, using the emotional tone as a hook to grab your audience. Many individuals are not interested in simply seeing a performance or purchasing an object but also want to know the artist's state of mind. The following excerpt is expressive in tone:

> My painted figures confront you with sullen stares of disenchantment, alienation, and fear. Harsh bloody marks line their faces, like war paint, wounds, or self-inflicted scarring.

Or you may choose to write in a more reserved style, with a theoretical, academic, or analytic tone if it is an accurate reflection of your work.

> I am interested in positioning my work as both painting and as signifier of style. A recent *Art in America* article by Hal Foster reflects some of the conceptual basis of my work. Examining the current resurgence of abstract painting, Foster found that it functions as simulation and, as such, recalls a style of art without engaging in the ideas and conflicts inherent in that style.

You might also write humorous, antagonistic, or political statements. Choose the best vehicle for the understanding of your work. In any case, refer to yourself in the first person, not as "the artist." The artist statement should feel as if it comes from you.

Most artist statements are about one page in length. The statement is usually double spaced, in 10- or 12-point type, printed on plain paper, with your name and date at the bottom. There is no need for fancy fonts or elaborate formatting. Legibility and efficiency are more important.

Uses for Artists' Statements

Artists' statements can be included with job applications, grant applications, or when sending images to a gallery. If your statement is available at your exhibition, you should place it in a binder at the desk with the list of works in the exhibit, your resumé, and copies of reviews. Or you might enlarge the statement and place it on the wall, usually mounted on mat board. For performance, a short version of your statement could appear in the program.

As your work develops, you will probably need more than one artist statement to cover different bodies of work. Save all your artists statements on disk to use when referring to older work. Statements can be expanded into multipage essays if needed to supply to a critic writing about your work or appended to a job application.

Some artists choose not to write an artist statement, believing that the work "speaks for itself." Others find statements to be pretentious or superfluous. Remember, however, that your audience might easily misunderstand your work. The general public is often ignorant about art. When you include your statement at an exhibition, they will seek it out for a frame of reference. But also, you will find that many gallery directors, gallery employees, reviewers, teachers, and curators will rely on your statements to understand and evaluate your work. And statements may be required for some job, grant, and graduate school applications.

Writing Proposal Statements

A proposal statement describes work that you plan to do versus what you already have done. A proposal is related to the artist statement in that both deal with formal and conceptual aspects of your work. Often, you address not only the proposed work, but the context in which it would be seen.

You need proposal statements when you apply for grants (see Chapter 13) or commissions (Chapter 14). They are often needed for first-round proposals for public art projects (also covered in Chapter 14). Proposal statements are necessary if you need to get funding for large-scale projects or permission to locate art at a certain site.

The degree of specificity required in proposal statements varies with different situations. Most will contain the following:

- Themes you will explore
- Kind of artwork you will do (e.g., a series of paintings, an installation)
- Way the work fits with the given theme or site
- Media you will use
- Rough idea of any unusual requirements in terms of the space (e.g., temporary walls, electrical needs, lighting)

The purpose of this proposal statement is to explain your project. Write clearly and concisely. Cover all important points accurately without exaggeration. Remember that this is merely the verbal component of a complete proposal packet, which will contain a lot of other documents, such as timetables, budgets, models, and drawings. Preparing a complete proposal packet will be covered in Chapter 6.

Dealing with Writer's Block

Some artists experience writer's block when composing an artist statement or proposal. In some cases, they are so close to the work that they cannot summarize their thoughts in a few paragraphs. There are ways to overcome this. You can tape record a conversation between yourself and another artist as you talk about your work. You can keep notes on the comments of other artists critiquing your work. You can jot down quickly everything you can think to say about your work. If you keep a journal, review the ideas that you find in there.

Transcribe, organize, and edit this raw material. Fill in any missing ideas. Proofread for grammar, spelling, and punctuation errors. Once finished, have mentors, other artists, or critics review your statement. Or, have a professional writer or editor review it with you.

Visual Documentation

Over the years, it is likely that more art professionals will see documentation of your artwork than will ever see your artwork in person. Curators, jurors, and collectors often review digital images or videos before ever seeing actual work. Therefore, you need high-quality reproductions of your work. In addition, you will need reproductions for announcements and for critics who will write about your work in publications.

FIGURE 5-4
Lights for Indoor Shooting

Photofloods, reflectors, and a light stand.

Artists face a range of issues when documenting their work. We look first at considerations associated with photographing flat artwork, and then sculpture. Next, we cover performance art, and finally, visual documentation for new media.

Remember that your visual documentation is not the same thing as your actual work. Some art looks better in documentation than it does "in person," whereas for other art it is harder to do justice to the piece. Also, as you photograph, your attention to detail makes a difference. Carelessness usually means inferior results, which make your work look bad, regardless of how wonderful it may actually be. And that is bad for you.

Photographing your own artwork can save you money because most professional photographers charge approximately $50 per hour. Even so, you may want to hire a professional photographer in special cases—for example, when (1) the work is extremely large and hard to light evenly, (2) the work is shiny and difficult to light without glare, (3) the space where the work is located is small and you may need special lenses to capture the image.

To make your own visual documentation, you need:

- a digital camera;
- a hand-held incident light meter (optional);
- a tripod;
- an 18% Gray Card, available from photographic supply stores, to help determine exposure and adjust lighting ratios;
- lights for indoor shooting: lamps, reflectors, and stands (Figure 5–4).

Digital Images

Features of Digital Cameras

Digital cameras come at a wide range of costs with a range of possible features. Single lens reflex (SLR) cameras have "through the lens" viewfinders and interchangeable lenses that easily attach onto the camera body. SLR cameras allow you to

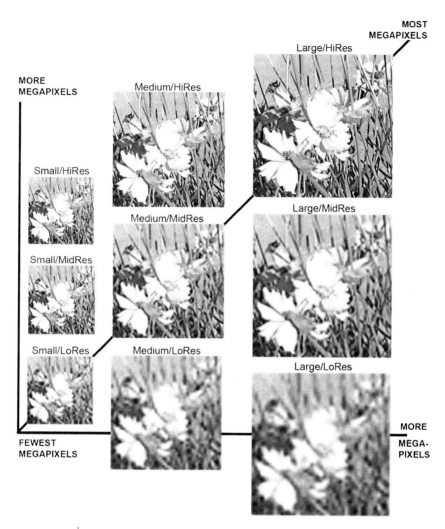

FIGURE 5-5 | Image Size and Quality

Few megapixels can give satisfactory results for small images, but large images with few megapixels look grainy. More megapixels give both large and detailed images.

adjust your exposure according to a variety of parameters that you control. SLR cameras are usually large.

More compact are the "point-and-shoot" cameras. The lens and camera body are a single unit. The viewfinder only gives you an approximation of what the camera sees, because it is off to the side from the lens. These cameras are used most often in the automatic setting, which means the camera determines the exposure without your control.

You can use an SLR or point-and-shoot camera to photograph your artwork. The SLR camera gives you the greatest degree of control and is most favored by professional photographers. The point-and-shoot camera is fine to use if it has a good lens. However, you probably should not use very small, ultra-compact cameras, which often have fewer features and are harder to manage, and thus may not give good results for photographing artwork.

Megapixels. Each digital camera is capable of recording your photograph with a certain number of megapixels, each of which is 1,000,000 pixels or particles of visual information in the entire area of the image. A six-megapixel image (approximately 6,000,000 pixels) would be broken down into length and width dimensions, such as 3000 pixels x 2000 pixels. For small low resolution images, like a picture on the Web, you need fewer megapixels. More megapixels result in larger, highly-detailed images (Figure 5–5). However, be aware that higher megapixel cameras require more care in setting up your camera and focusing, because your image will be soft if you are off a bit in your set up.

Photographer error not equipment inadequacies like too few megapixels, is most often the cause of soft or fuzzy documentation. Your camera was crooked, your focus was a bit off, your tripod was bumped, you jiggled the camera when pressing the shutter release, etc. Take care to avoid those problems.

Bear in mind that a 6 or 7 megapixel camera will give you good documentation for almost all your needs. Artists may want higher resolutions if their original artwork is digital photography, but generally not for documentation purposes. Also, you do not gain all that much greater resolution by going from, say, a 7 to an 8 megapixel camera. You can see this later in this chapter in the section on *Making Digital Images Usable*, which has more information on megapixels needed for various end uses of your images.

File Size, Formats, and Compression. Digital cameras have settings that allow you to choose a Large, Medium, or Small file size for the picture you will be taking. Digital cameras also allow you to make selections regarding image quality or resolution. The most common format for digital photographs is JPG ("jay-peg"), and your camera will give you image quality options like "High," "Middle," and "Low," or some variation on that theme. JPG files are all compressed to some extent, and are considered "loss-y," which means that some data is lost when the image is saved. "High" quality means less data is lost, while the "Low" setting discards much more data. However, the "Low" image file is smaller and requires less memory in your camera (Figure 5.5).

In addition, some of the more professional cameras allow you to save your files as "raw," which is a loss-less format, and so gives the best quality. As a general rule, you should photograph your artwork on the raw setting and save that file in a permanent image archive.

To find out about how digital file sizes translate into hardcopy prints, see the *Resized Images* section later in this chapter.

White Balance. Digital cameras have settings that enable you to get whites to look white even when photographing under widely different conditions. Automatic White Balance (AWB) lets your camera set the white balance internally.

Other options include Incandescent, Fluorescent, Direct Sunlight, Flash, Cloudy, or Shade. For best results, manually set your white balance to match the kinds of lights that illuminate your artwork. Most lights in galleries are incandescent.

Lenses. If your digital camera has interchangeable lenses, use a regular or telephoto lens for an image of your artwork with little or no distortion. Wide angle lenses, especially extreme ones, have a fish eye effect around the edges of the image. Use the wide angle lens if you absolutely need it to show your entire work.

Lights, Stands, and Tripods

Lights. To light your artwork, use photoflood lamps in aluminum reflectors. The lamps should not be regular household bulbs, nor ordinary floodlights. Unlike photoflood lamps, these daily-use lights are not made to give off an even or consistent light, and may have temperature and brightness variations among the same type of bulb by the same manufacturer. Therefore, always use photofloods that you purchase through a photo supply vendor.

Use photofloods rather than spotlights for a broader, more even illumination. Spotlights deliver more focused light, which may result in hot spots on your artwork, surrounded by areas of less illumination. Two photoflood lamps are enough to light flat artwork less than four feet in either dimension. For larger artworks, use four lamps, two on each side, with one above another. The top lamp on each side will light the top of your artwork; the bottom ones light lower areas.

Unless you want to create a color shift in your photograph, always use the same kinds of lamps when lighting an artwork. Mixing kinds of lights may result in a noticeable color shift in your photo documentation, even if that shift was not apparent to the naked eye.

Traditional photofloods were tungsten filament lamps. These lamps emit more light when fresh than after they have been used for even a few hours. In addition, the light emitted by photoflood bulbs becomes increasingly yellow with use. You will have difficulty lighting your work evenly if you use one fresh photoflood with an old one. Use pairs of traditional photofloods together until the color shift makes them unusable. They last five to 15 hours.

More recently, photofloods are usually tungsten-halogen lamps. These lights deliver more illumination than traditional photofloods, and do not have the color shift to yellow as they age. These are good choices for photoflood lamps.

You can also use electronic flash to light artwork while photographing. Flash or strobes deliver a bright, intense burst of balanced light that gives good results for visual documentation. However, flash does not allow you to carefully set up your lights and to check for even illumination before shooting. You also cannot check beforehand for glare. Therefore, in the rest of this chapter when covering ways to photograph artwork, photofloods are discussed instead of flash.

Most photographers avoid fluorescent lights for photographing artworks. Fluorescent lamps generally do not produce evenly-colored light across the visible spectrum. You may find that in your photographs taken with fluorescent lights that certain shades of red may not show as well as they should, or that certain greens may be emphasized.

Stands and Reflectors. Photoflood lamps give off a tremendous amount of heat and can melt or short the socket. Therefore, make sure you are using fixtures rated durable enough for 500-watt bulbs. Photofloods emit light in all directions, so it is necessary to use reflectors to direct light towards your artwork. The insides of reflectors usually have a matte or brushed metal finish, to avoid creating hot spots on your artwork.

Reflectors come with clamps or with fittings for light stands. Either works fine. Light stands have telescoping center poles that make it easy to raise or lower your lights. Clamp lights can be secured onto chair backs or some other convenient piece of furniture.

Tripods. Tripods enable you to set up your shot carefully and eliminate the shakes that occur with hand held shots. Use a sturdy tripod with a quick release plate that attaches to the bottom of your camera. The tripod head should rotate in three directions. Some tripods have hooks near the bottom for attaching weights, a handy feature that adds stability if you are photographing outside in breezy conditions.

Preparing to Photograph Flat Artwork Indoors

Getting Ready. Photographing artwork indoors, with controlled lighting, is the method preferred by most artists and professional photographers.

Always photograph unframed artwork, unless the frame is an integral part of the idea behind your work. Frames are usually unnecessary distractions. Also, Plexiglas or glass coverings may cause glare that obscures your work.

Photograph flat artwork on a clean black, white, or gray wall, or pin a clean cloth or roll of paper the wall. Stay away from brightly colored walls or objects that may reflect unwanted colors on your artwork. If you photograph art against cluttered backgrounds, you will have more work later to clean up the image in the computer with an image-editing program (Figure 5–6).

Place your camera on a sturdy tripod pointing directly to the center of your flat artwork. Make sure the back plane of your camera is parallel to the plane of your artwork (Figures 5–7 and 5–8). Look carefully through your viewfinder to see if the artwork is well framed and properly aligned with the camera (Figure 5–9). If your artwork is rectangular, you easily can see if the edges of the art are parallel to the edges of the viewfinder, indicating correct alignment. This is a really important step. Take the time necessary to get it right. Leave a small amount of border around the edges of your work. For very large works, show the floor or the ceiling to indicate scale.

Non-aligned art looks like a parallelogram, a phenomenon called "keystoning." While you can clean up alignment mistakes later with an image-editing program, that may end up being more work for you. However, a misaligned camera may also give you an image that is in focus in some areas, and out of focus in others. That problem is very difficult to correct.

Lighting Art with Photoflood Lamps. Light your artwork carefully, because this radically affects the quality of the end result. Block off from your artwork any strong light source other than photofloods. However, it is not necessary to eliminate low-level

FIGURE 5-6 Cluttered or Messy Backgrounds

Cluttered or messy backgrounds are distracting and should be eliminated.

ambient light where you are working, because photofloods are powerful enough to overcome the color-altering effects of weak indirect light from other sources.

First, place your lamps at a 45-degree angle to the picture surface. Place them far enough back that you avoid obvious "hot spots" or bright areas on your work. One rule of thumb is to position lights a picture's width away from the center of the artwork. Make sure your lights are placed even with the camera; you should not be able to see either lamp through the viewfinder of your camera (Figure 5–10).

After your lights are placed properly, then cross-aim them to evenly distribute the light across the surface of the artwork. Aim the right lamp toward the left edge of the artwork, and the left lamp towards the right edge (Figure 5–11). Look through the camera viewfinder. If there is a little glare, moving the lights to an angle less than 45 degrees may reduce it.

Bounce Lighting. When art is large or shiny, aiming your photoflood lamps directly at the works can cause a lot of glare (Figure 5–12). You may need to indirectly illuminate such pieces. You can bounce light off a white ceiling or off large white sheets of mat boards to create indirect lighting (Figure 5–13). It often takes a bit longer to light your work evenly and sufficiently by bouncing.

Determining Exposure. Now you are ready to use your light meter to determine whether you have evenly lit your work and which exposure you should use. You

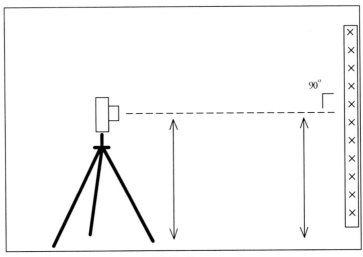

UNIFORM HEIGHT

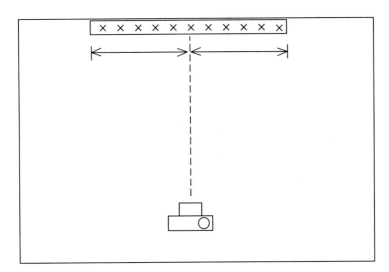

FIGURE 5-7 | **Correct Camera Alignment**

At the top of the page, the side-view diagram shows correct alignment of artwork with the camera. The bottom diagram shows a top view of the camera centered on the artwork.

can use a hand-held incident light meter, which registers the light falling on a subject. Take meter readings at all four corners and at the center of your work. Make sure your own shadow does not interfere with your readings.

Alternately, you can check your camera's built-in reflective light meter, which measures light reflected from a surface. Hold an 18% gray card at one corner of your

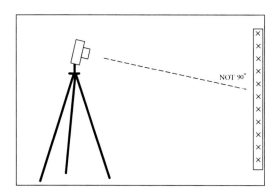

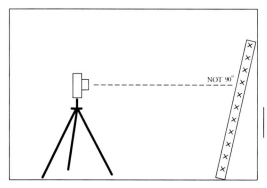

FIGURE 5-8
Incorrect Camera Alignment

The artwork is not parallel to the camera back.

FIGURE 5-9 | **Checking for Alignment**

None of these examples is well aligned. The left and right examples show keystoning. The center one has too much border around the artwork.

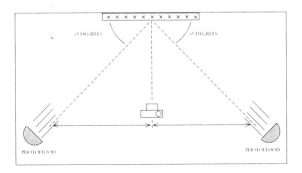

FIGURE 5-IO | **Rough Placement of Photoflood**

Top view diagram showing rough placement of photoflood lamps for making images of artwork. Place your lamps at a 45 degree angle from the surface of flat artwork. Make sure the lamps are two artwork-widths apart.

FIGURE 5-II

Lighting

By aiming the photofloods across the center of flat artwork, you light it more evenly. Check your work carefully through the viewfinder, and readjust lights if you see glare or hotspots.

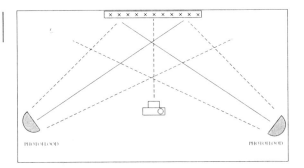

FIGURE 5-I2

Glare

Glare on artwork shows up as white lines or areas in dark colors.

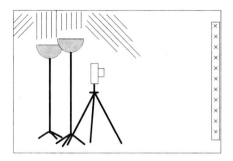

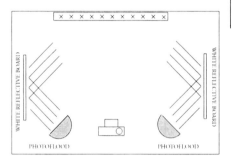

FIGURE 5-13

Two Ways to Bounce Light to Illuminate Your Artwork

The diagram at top shows a side view with light bounced off a white ceiling to softly illuminate the entire room. The bottom diagram is a view from above, with the artwork lit by bouncing light off white surfaces.

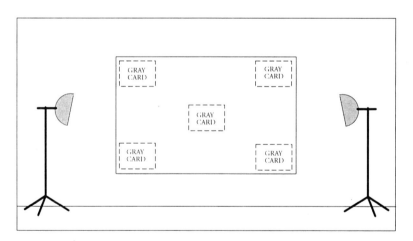

FIGURE 5-14 | **Determining Exposure**

Front view of a large artwork, showing where to place the gray card for reading light levels to ensure that the artwork is evenly lit.

work, and place the camera so the gray card fills the camera's viewfinder. Press the shutter release half way, and then note the reading. Again, keep your own shadow out of the way. Repeat this process for other three corners, and for the center of your work (Figure 5–14).

FIGURE 5-15 | **Lighting Adjustments**

On the left, the artwork is evenly lit, whereas on the right, the lighting is very uneven. Look for a consistent tone in the background to help you properly light your work.

FIGURE 5-16 | **Checking For Even Lighting with Shadows**

On the left, one shadow is darker than the other, indicating that one light is closer than the other. On the right, the lights are in the correct position because the shadows are nearly equal.

If all five of your meter readings are the same, or very close, you are ready to begin shooting. If not, adjust the lamps to provide more illumination to darker areas (Figure 5–15). Make your gray card readings again, until the lighting is even.

One other trick you can try when placing lights is to check if cast shadows appear equal (Figure 5–16). Hold the eraser end of a pencil against the wall where the

artwork will hang when photographed. When lights are well placed, both shadows should look very much the same.

Taking Pictures

Now you are ready to begin photographing your work. Set your camera to the AUTO setting, if you want the camera to determine the best exposure for you. Some cameras have only the AUTO setting, and it often works quite well. However, you can control the exposure on other cameras, and this may give you superior results. Use either the M (Manual) setting to control both the exposure time and aperture you are using, or use the A (Aperture) setting to specify an aperture and let your camera determine the exposure time.

In all cases, you want to photograph using an aperture opening around f/8. The lowest f/stop settings give poorer results because the camera aperture is wide open and the edges of the lens usually soften the picture more than the more central part of the lens. Very small aperture openings (high f/stops) can also result in soft images due to diffraction. After setting your f/stop, adjust your shutter speed wherever necessary to give the proper exposure. Because you will be using a tripod, you can use either a fast or slow shutter speed and the image will be sharp.

Focus carefully. Take the time necessary to do this right. If your artwork lacks strong tonal contrasts and edges, you may find it difficult to focus. Simply place a piece of paper with a pencil line on it on the surface of the work and focus on that.

Use the timer on your camera to avoid blurring your picture because you may jiggle the camera when pressing to shutter button. With the timer, your photograph is taken a few seconds after the button is pressed, which is sufficient time for any camera movement to subside.

You may want to bracket your exposures if your artwork is very light, is very dark, or has high contrasts. To bracket, shoot several additional exposures above and below the f/stop indicated with the light meter and the gray card. This helps get a great exposure for a dark work with important details in shadows or, conversely, a pale artwork with subtle variations in the light tones (Figure 5–17).

Take detail shots if your artwork has some important textural or narrative details not apparent in an overall shot (Figure 5–18). Detail shots really help to convey the subtle characteristics of your work.

Photographing Sculpture Indoors

When photographing objects that do not hang on the wall (for simplicity, called "sculpture"), you again need a clean, uncluttered space that shows the work clearly. Consider the color, texture, and tone of the sculpture, and place it against a contrasting background (Figure 5–19). Many artists drape gray seamless photo backdrop paper behind their sculpture when photographing. This paper comes in long rolls and various widths. This eliminates the edge between floor and wall, and provides subtle tonal variation behind the work. A smooth sweep with the paper gives a gradual transition from vertical to horizontal surfaces, rather than an abrupt edge. Place the artwork well forward of the curve in the paper (Figure 5–20).

FIGURE 5-17
Reproductions with Brackets

A group of reproductions that shows bracketing.

FIGURE 5-18
Detail Shots

Detail shots can reveal subtleties not visible in an overall shot.

FIGURE 5-19 | Choosing the Background

Artwork can look different whether placed against a white or black background.

FIGURE 5-20 | Seamless paper

Gray seamless photo backdrop paper gives nice results when photographing small or mid-sized sculpture.

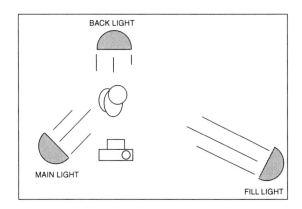

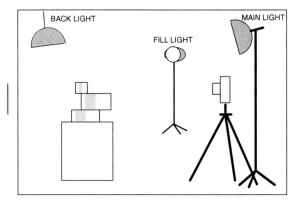

FIGURE 5-21
Three-Photoflood Lighting

Lighting a sculpture with three photofloods, shown from a top view and a side view.

Placing Your Lights. When photographing sculpture, it is important to light your artwork to emphasize volume and depth. Unlike flat artwork, which you try to light as evenly as possible, it is important to light sculpture unevenly to show its volume. Depending upon the size of your sculpture, you can use one to three lights.

When using three lights (Figure 5–21), the main light is placed closest to the artwork and provides primary illumination. It is set to one side of the sculpture to emphasize the dimensionality of the work; facets facing toward it are most brightly lit. The fill light is placed opposite the main light and farther away from the artwork, to subtly illuminate shadow areas to show some detail. The ratio of illumination between bright and dark surfaces should be at least 1:2 and no more than 1:4. To determine this ratio, go in very close to your sculpture on its less-lit side and get a light-meter reading by pressing the camera's shutter release half way. Then, move to the lit side of your sculpture, come in close again, and get a meter reading off the bright surface. (As always, make sure your shadow does not interfere with your meter reading.) Compare the results. The main light should illuminate the sculpture at least two times (one f/stop) and no more that four times (two f/stops) as brightly as the fill light.

If you have a third photoflood, use it as a backlight to create depth by shining it down from the rear. This highlights the artwork's shape and distinguishes it from the background. Experiment with its exact placement to find what effects you like best. Check the viewfinder carefully before photographing to make sure the stand and cord from the backlight do not show up in the photograph (Figure 5–21). If using only two lights, eliminate the backlight and place the work in front of a clean background, which will provide some bounce light on the work (Figure 5–22).

One floodlight can sufficiently illuminate sculpture if a white surface opposite the floodlight bounces light back and acts as a fill light. White mat or foamcore boards work well for this task (Figure 5–23). This set up works best with small sculptures. For big works, the light will have to be placed far away to evenly illuminate one side of your art, and you also need a very big foamcore board to bounce enough light all over the dim side.

With whatever lighting step up you use, avoid large, long, or prominent shadows. Adjust your lights, or move the sculpture away from the background wall to eliminate distracting shadows looming behind it (Figure 5–24).

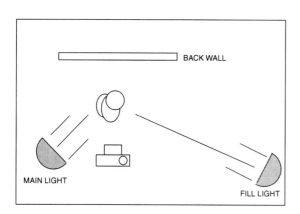

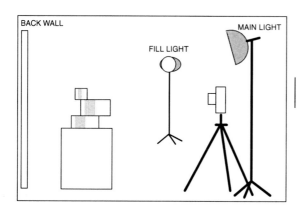

FIGURE 5-22

Two-Photoflood Lighting

Lighting sculpture with two photofloods, shown from a top view and a side view. Light bounding off the back wall replaces the backlight in Figure 5-21.

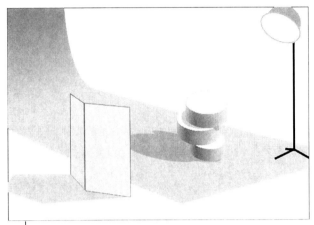

FIGURE 5-23 | **One Floodlight and Bounced Light**

For small sculptures, you can use one floodlight and white foamcore board. Arrange the board so that it bounces light from the floodlight onto the dark sided of the sculpture.

FIGURE 5-24
Dark Shadows

Avoid overly large, dark shadows
in the background.

Point of View. You can make the same object look large or small in a photograph, depending on the placement of the camera relative to the object. A low camera angle will make your object appear larger, while shooting down from a high position will seem to shrink the same object. When photographing artwork, you should position your camera to most accurately reflect how individuals view the work when it is displayed (Figure 5–25).

FIGURE 5-25 | Camera Angle

The scale of the object appears to change when you raise or lower the camera's point of view. Try to photograph your work at the angle at which it is usually seen.

FIGURE 5-26

Aperture

This image was shot with the aperture wide open while focusing on the closest area of the object. As a result, the back edges are out of focus. Avoid this by focusing toward the middle of the object, and using a mid-range aperture.

Exposure and Focus. For sculpture, the correct exposure will be the average of the light-side and dark-side meter readings, but you may want to bracket your exposure. Use a mid-range aperture (Figure 5–26). Focus at a point about one-third of the way into the work. Take detail shots to show surface texture and various views.

Photographing Artwork Outdoors

Photographing artwork outdoors means that you do not need photofloods. Try to photograph between 10 am and 2 pm for balanced white light. However, there are a variety of disadvantages to photographing outdoors:

- Haze or occasional clouds will affect your light levels.
- Wind can knock over your camera, lights, and artwork.
- Glare is more common on painting or sculpture surfaces.

- Reflected colors from vegetation, pavement, and buildings may affect the overall color in your photograph.
- Later, you may need to eliminate background clutter in an image editing program.

When photographing outdoors, keep the sun over your shoulder (Figure 5–27). Do not shoot in the shade, which may result in a distinct blue cast on your image. Non-reflective gray or black drop cloth around the work will reduce glare and color reflections from surrounding surfaces. Illuminate shadow areas of sculpture with bounce light or fill lights. Use an 18% gray card to read light levels.

For art that is installed outside and intended to be seen in that setting, your documentation should show some of the surroundings. Check all possible views for the ones that best show the piece. Consider also your point of view: Does the sculpture look better from down low or up high on a ladder or nearby building? Of course, do not forget to use fill light in the shadow areas.

Installations

Photographing installations incorporates the principles of photographing flat artwork and sculpture. However, there are a few added considerations to remember. Give careful thought to the best way that images can represent your installation.

- Take several shots in sequence to establish how the viewer encounters and moves through the installation. Thus, you should photograph how the installation looks at its entrance. Then, photograph the installation at various points as the viewer would see it.
- Take both distant shots to record overall impressions and detail shots to highlight particularly effective areas.

Consider supplementing your still images with a video of your installation, especially if there is a time-based, sequential, kinetic, or sound element to the work. For book art, kinetic sculpture, sound pieces, or installation, video communicates more about the work and shows how the viewer would actually encounter the piece. The quality of digital video is generally lower than that of digital still images, with less resolution, more grain in low light, and less color saturation. For more on photographing time-based work, see the sections on *Documenting Performance* and *New Media Documentation*.

Making Digital Images Usable

You have photographed your artwork. The next step is to make the digital images usable.

First, before you do anything else, archive one copy of all the images of your artwork as they come out of the camera. Store these files on an external storage medium, off the hard drive of your computer. Make a copy of each image for editing.

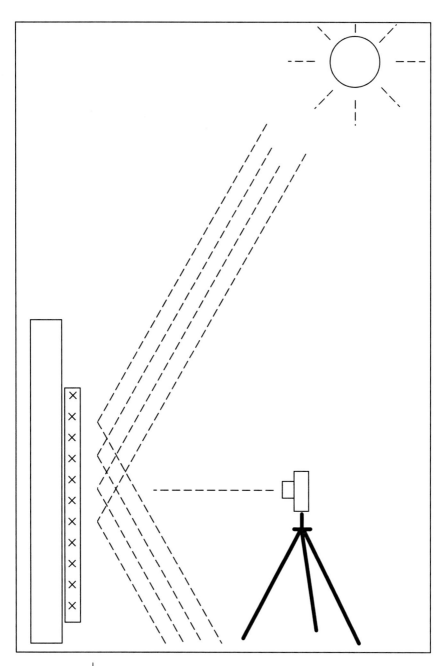

FIGURE 5-27 | **Outdoor Photography**

Side view of flat artwork on an outdoor wall, with the sun over your shoulder and high enough to avoid glare, as you photograph your work.

Editing your Images

Open copies of digital images with an image editing program like Adobe Photoshop. Correct the following as needed for each image:

- Keystoning: If your rectangular artwork looks like a trapezoid, use the "Skew" command to drag the corners until the work looks square.
- Correct Contrast: As they come out of the camera, digital images are low contrast, so that the shadows are not totally dark and the highlights have some detail. Use the "Levels" command to make sure your image's tonal range extends from black to white.
- Correct Overall Color Balance: Choose an area of your image that should be neutrally colored, for example, the background if it is white, black, or gray. Sample this area with the Eyedropper tool to get readings on the RGB levels. RGB (Red/Green/Blue) are the component colors of your digital image, and if they are all at the same level in the neutral areas, then the overall color balance is likely good. If any one of the RGB readings is significantly higher than the others, then the overall color balance needs to be corrected by lowering the amount of that color in the image.
- Correct Individual Colors: View your image critically to see if certain colors are overly bright or too dull. You can modify specific colors in your image by using the "Adjustments>Selective Color" command.
- Crop image: Remove excess background, but don't crop right up to the edges of the artwork because then your image looks like a detail. Keep a border around your artwork.
- Retouch: Use the "Rubber Stamp" tool to remove unwanted details or flaws.
- Sharpen: Editing your images in Photoshop might cause them to lose a bit of their sharpness. Use the "Smart Sharpen" or "Unsharp Mask" commands to crisp up your images.
- Add Information: Increase the size of the "Canvas" for your image so that there is a thin strip of white space at the bottom. Using the "Text" tool, type in your name, the title of the artwork, the size, the medium, and the date of completion.

Save this file in the largest format possible and keep it in a folder with other Master files. Do no further editing on this Master file, but make copies of this when necessary for all your image needs. This Master file will be the cleanest, largest, most detailed, most refined version of your image that you have.

Resized Images

Resized images are used for posting to the Web, emailing, and hard copy printing. When resizing your images, work off a copy of your Master file, so that you do not accidentally save a low-resolution version of your image over your Master file.

You need low-resolution images for posting on the Web and for emailing to curators or collectors. The files for emailing should be less than 100K in size. For posting to the web, resize the image to 96 dpi (dots per inch), which is the native resolution of computer monitors. Set the length and width to the dimensions you want.

Megapixels	Possible Image Sizes (in Pixels)	Maximum Size of 200-dpi Prints (in Inches)	Maximum Size of 300-dpi Prints (in Inches)
4	2300 × 1700	11.5 × 8.5	7.6 × 5.6
	2450 × 1600	12 × 8	8.6 × 5.3
5	2600 × 1900	13 × 9.5	8.6 × 6.3
6	2800 × 2100	14 × 10.5	9.3 × 7
	3000 × 2000	15 × 10	10 × 6.6
7	3000 × 2300	15 × 11.5	10 × 7.6
	3300 × 2100	16.5 × 10.5	11 × 7
8	3250 × 2450	16 × 12	11 × 8
	3500 × 2300	17.5 × 11.5	11.6 × 7.6
11	4000 × 2700	20 × 13.5	13.3 × 9
12	4200 × 2800	21 × 14	14 × 9.3

Images have to be resized when they are to be printed. For your home printer, you need to set the length and width of the image to the inch dimensions that you want, and make sure you have between 200 and 300 dpi for good results. Dots per inch is a measure of resolution for printers, versus megapixels, which is a measure of resolution for cameras. For commercially-printed catalogs, brochures, or magazines, usually you need a 300 dpi file set to the specified dimensions.

Different cameras vary in the way they divide megapixels into length and width dimensions. For example, in one camera, a 6 megapixel full-frame image will be 3000 × 2000 pixels, or a 3:2 ratio, while another camera might default to approximately 2800 × 2100 pixels, which is a 4:3 ratio. Check your manual to find out what proportions are available for full-frame images with your particular digital camera. (Of course, subsequent cropping will alter these fixed dimensions.) Once you know the length and width of your image in pixels, divide each dimension by the printer resolution to find out the resulting size. For example, if you are making a 300 dpi print from a 2800 × 2100 pixel image, divide 2800 by 300 (result: 9.3) and divide 2100 by 300 (result: 7). In this situation, your printed image can be a maximum of 9.3 × 7 inches at 300 dpi without loss of quality.

The chart below translates megapixels into the size of high-quality images that can be made at 200 dpi and at 300 dpi. All measurements are approximate. Estimate for numbers in between. Please note, however, that if you need a very large print, frequently you can get satisfactory results with less than 300 dpi because your audience will view such works from a greater distance.

Documenting Performance

Making Still Images of Performances

Making still images of performances is a very different task from photographing static work. With static art, you control the lighting environment so that every image has been exposed consistently and the colors are balanced. You set up your work, frame it, and focus with care. By contrast, performance presents a moving target for the photographer and may be dramatically lit. You may be photographing bright sequences, dark sequences, and situations with colored lighting. The subjects, rather than being inanimate, are living persons with their own ideas, schedules, and willingness to cooperate. Control is much harder to maintain.

Communication is essential in this process, whether you are the photographer explaining what you want from the performers or the performer trying to direct the photographer to get certain effects. Talk through everything thoroughly and clearly. Photograph during the first full dress rehearsal, when all lights are in place and when you can take time to set up certain shots. If something goes wrong, then you may have a chance to shoot again during subsequent rehearsals. If you take still images during the actual performance, you must stay out of the way and take whatever you can get.

Staging Your Shots. What specific shots do you want? Select pivotal and important scenes. Decide from what angle the photograph should be made, when you want close-ups, whether you generally want tight framing, or whether you prefer to see the background surrounding the performer. If someone else is photographing for you, provide him or her with a script or explain how to frame each image.

Then, decide what you want your performers to do for each shot. If you photograph a rehearsal in progress, you may get more dynamic results. On the downside, some images may be blurred or poorly framed, with an occasional hand or head cut off. In addition, photographing this way means that you cannot make exposure readings before shots. If there are great variations in lighting in the performance, you could miss some shots.

Your other option is to simulate particular moments in the performance and then have the performers freeze, allowing the photographer time to frame, take meter readings, and take a few bracketing shots. The disadvantage is that the images may look more stilted, a little less animated. Most importantly, your documentation should adequately convey the look and feel of the performance. Therefore, two things to avoid are artistic but misleading shots and promotional, portrait-like, or overly staged shots.

Lighting. Color balance can be tricky, especially if special effect lighting or theatrical lighting is used in the performance. There may be dramatic color effects at times when the light should appear colored and not balanced, whereas with photographing traditional visual work, balanced white light has become the convention and standard and what art professionals expect. Documentation of performances should convey planned color effects.

However, you want to avoid documentation that is tainted because of color imbalance in the ambient light. In other words, your camera is sensitive to general light shifts caused by incandescent or fluorescent lights, whereas human vision compensates for these shifts. For example, although humans immersed in warm light can see a fairly full range of color, a photograph will record and isolate that warm shift, giving everything a distinct yellow cast. In such cases, blues may appear as either green or black. If you are photographing a performance in unknown circumstances or have not worked under particular lights before, try a couple of different white balance settings and compare the resulting shots.

Light levels are as challenging to photograph in performance as color shifts. Some sequences may be dark, and some brightly lit. Again, the consistent lighting used for photographing traditional work would interfere with the integrity of the performance, so the varying light levels should be maintained. In some cases, the exposures should not be the same from image to image. However, you must take care that the lighting is not so dramatic that your photographs are too dark or washed out. The human eye can see a much wider range of detail in shadows and in bright lights than the camera can record.

Therefore, stop down so that brightly lit areas are not washed out. And try to even out drastic contrasts between light and dark areas by bouncing light to illuminate shadows. Use a hand-held or camera light meter for readings in both light and dark areas. If the light and dark areas differ by three or more f/stops, you need to even out the illumination. If that cannot be done, decide which area is most significant, and expose for that. For difficult shots, try bracketing.

To get the best results, use a tripod if you can. If you need to work with a hand-held camera, set your camera's ISO to a higher number to get better images of moving subjects in low light situations.

Documenting Performance with Video

The least expensive and easiest way to video-document a performance is to put one video camera on a tripod and let it run through the whole performance. Unfortunately, videos made with this method look extremely boring to viewers used to seeing panning, dramatic cuts, close-ups, and distant shots in television programming. You should use two cameras to give different points of view and to vary the shots. This requires you to script or organize your video shoot beforehand, and afterward edit the takes into one final version. You have to be a video artist of sorts if you are a performance artist doing your own documentation. Digital video is edited on the computer in programs such as iMovie, Final Cut, or Adobe Premiere Pro. If you need instruction, community colleges often offer video courses for a reasonable fee.

If you don't have a video background and all this seems daunting, possibly the best way to get video documentation for your performance is by bartering with someone who owns video equipment and trade some sort of work with them.

New Media Documentation

Artists face different challenges in documenting works in video, film, electronic art, time-based art, sound art, or web-based art. All these media require hardware for viewing the work, and although some of it is common, others are not. Before you send documentation of your work, you need to find out what formats your recipient can support.

Film or Video

If you are a film or video artist, you need to have documentation of your work in various lengths. Of course, you need individual files of each work, in its full length. However, you also need a short, two-minute excerpt from the full work that captures the tone and feel for the entire piece. For each piece, you should have a two to three sentence summary that accompanies it whenever you send it out, whether in full-length or two-minute format. Each piece also needs some identifying information, including:

- name of artist (or artists, in cases of collaborative works);
- title of work;
- date of completion;
- black and white/color, sound/silent;
- total length of work in minutes and seconds;
- if collaborative, the role you played in creating the work.

You also will need compilation CDs or DVDs containing excerpts of several of your works. For these, organize your segments so that the viewer will play the works you most want seen. On the CD's or DVD's menu, list the names of each work and their full length, and then list the length of the excerpt and indicate its placement within the whole work. Use QuickTime, AVI, or MPG formats for moving images. Generally, your documentation should have sufficient resolution to display well on a computer monitor or television screen. 600 × 400 pixels often work well. 720 × 480 pixels is a common high resolution, but files this size require more memory and take longer to download from disk. Label the face of your CD or DVD with your name, the names of works included, the platform used (PC or Mac), and the program(s) used to generate the works.

Electronic or Web-Based Art

As with film and video art, provide the entire art piece with your documentation, but also create an excerpt that allows your viewer to understand the work without having to see the entire thing. That excerpt can be a series of screen shots with descriptive captions. Or you may want to create a short digital video that simulates the experience of the overall work.

FIGURE 5-28
Shutter Speeds

Use a shutter speed of 1/30 of a second when photographing off a television screen. (Still is from Robert Wedemeyer's "Head Film," 1990, originally on Super-8.)

FIGURE 5-29
Wrong Shutter Speed

The wrong shutter speed will result in images with dark bands or double exposures.

Still Images of Time-Based Work

Often you need still images of your film, video, or computer-based interactive pieces. All stills should be JPG files. You may want some screen shots, as well, which you can make either through the computer, or with a camera set up in front of a monitor. You may have to experiment with shutter speeds to get the effect you want when photographing projected light or light from monitors. For example, if you photograph a traditional TV screen, you need to set your camera's shutter speed around 1/30 of a second, a speed that allows the TV screen to be completely refreshed (Figure 5–28). If you use too fast a shutter speed, only part of your screen image shows up (Figure 5–29). Conversely, you should avoid slow shutter speeds too, because the results will be nearly white or double images. Use a tripod to avoid blurring. For computer monitors, again go with slower shutter speeds, so that colors look normal.

Other Documentation

Documenting with Photographic Film

Some artists continue to use slide film to document their artwork (see the interview with Anne Bray at the end of this chapter). Slide film provides better detail and color saturation than most affordable digital cameras, and some artists prefer that. Slides were the standard documentation media for many years, and most artists working before 2004 are likely to have some of their documentation on slides. However, most artists today use digital documentation for their artwork.

Exhibition Publicity

In addition to your resume, artist statement, and visual documentation, you should keep any publicity that has been generated from your past shows or performances. This would include:

- announcements of the events;
- exhibition brochures or curator's statements;
- programs for performances;
- reviews.

Retain 10 to 20 extra copies of announcements, and up to 50 if there is an image of your work on the announcement. You can use old announcements in packets about your work, as we see in Chapter 6.

During the run of some exhibitions, there may be free brochures available to those who come to the gallery. These brochures may contain images of your work or may contain a curator's statement. Keep extra copies for yourself for the future. For any performance of which you were a part, retain extra programs.

If your art event was reviewed, keep at least one copy of the review as it originally appeared, whether in print or online. Some reviews are spread across two or more pages of a publication. If so, make a copy, cut it apart, and recompose the review so it fits compactly onto a single piece of paper. Make multiple photocopies of your reviews, and be sure to include the name of the publication, the date, and the page on which the review appeared.

Organizing Digital Files
and Other Documentation

Over time, you will find that you quickly accumulate hundreds of files and scraps of paper about yourself and your artwork. Organize your materials so that they are easy for you to find.

One way to organize digital files is to have two major folders for:

- written Documentation, which includes resumes, statements, and reviews.
- visual Documentation, which includes all still images and movie files.

Within these folders, create subfolders that make sense for your work. For example, you can sort based on the year that the works were created. Here is a breakdown for 2008. Each year would have the same breakdown:

 2008
 Written Documentation
 Visual Documentation
 Archived Images
 Master Files
 Low Resolution Images

Another system is based on series of works. Use the titles of your artworks and the titles of the series as a way to organize your files. A hypothetical example for an abstract painter would look something like the following:

 Monochromatic Abstractions
 Written Documentation
 Visual Documentation
 Archived Images
 Master Files
 Low Resolution Images
 Geometric Abstractions
 Written Documentation
 Visual Documentation, etc.

Whatever system you use, be sure not only to have your files on the computer hard drive, but also to have a separate backup of everything, either on an external hard drive or on disks.

Keep your exhibition publicity in folders that are organized according to the same kind of system you use for your digital files. Then cross-referencing your documentation is easy.

artist interview

ANNE BRAY

Anne Bray is a performance, video and installation artist living in Los Angeles. She is the director of Freewaves. She teaches at the Claremont Colleges and at the University of Southern California.

What should artists do about storing their documentation?

No form of documentation is permanent. It's best to keep it in multiple forms—on different hard drives and storage media types. Label everything so you know what it is. And store everything away in a safe, cool, clean place.

I have a house on a hill, and one part of the house stays the same temperature almost all year round, day and night. You're also looking for that place in your house or studio that stays the most even. You don't want those changes.

Should artists just plan on redoing their documentation on a regular basis?

Yes. Documentation should be regularly upgraded to the most current standards. Everything is moving toward digital formats. You now need to really understand different digital image file types and compression. At the most basic level, you must be able to create high, medium and low resolution jpegs (300, 150 and 72 dpi). And of course, the storage medium of your documentation will keep evolving—CD, DVD and hard drives.

Luckily, it's no longer outrageously expensive to buy a computer that can handle digital video editing and DVD burning.

What role do slides play as documentation for artists?

I think slides still make the best-looking images. You can dupe them and convert into a digital format. To my knowledge, the resolution that you're getting with slides hasn't been replaced by affordable digital cameras yet. I do slides and then digitize the ones I like. It depends on the type and quality of camera one can get access to.

Even for time-based work, still images are important?

Yes. You need great looking still images. With documentation, you're still trying to inspire people to select your work, whether it's a panel or a show or project or job. Nothing does it better than a strong image.

I've sat on a lot of selection panels, and I've never seen anyone with bad images really get anything. To me, it's a reflection of how you feel about your own work and the degree of respect you give it is then implied in your documentation. And then that's how other people are going to treat the work thereafter.

I photograph my own installations. And I never found anyone else that covers them the way I wanted to. When I have professional photographers come in, I walk them through my installation or whatever. I get the shots lined up in my

Double Burning Jagged Extremities Installation, 15′ × 25′ × 5′, 1998
Source: Installation by Anne Bray amd Molly Cleator.

35mm, and tell them, "Do these shots and then do whatever else you want to do." They think of shots that I wouldn't have thought of.

But when I'm choosing my angle, there's a reason. I will align something in the foreground with something in the background because, thematically, they tie together. Visually, I know the relationships I want to show.

So before making documentation, walk around the piece with a camera just to see what it looks like through that camera. Then search for that one image that's going to tell the most.

What about detail shots?

You've got to be able to synthesize your work to basically one image. But you need others as backup, as details. If you submit work to panels, you can show a few, like ten, twenty.

For lectures, I previously used mainly slides and video, with the slides in the same order as my video. Projected slides are big and still have the best resolution, while the video shows the sound and the walkthrough quality. More and more, for convenience, I use the internet—streaming video and images that are posted online. I don't think there is one standard anymore—people are using lots of different media now and it's best if you are able to produce your documentation in various forms to accommodate them—CDs, DVDs, streaming video, slides, online images, Web sites.

You've done a lot of video documentation of performance work.

I did it for four years at LACE (Los Angeles Contemporary Exhibitions) and loved it. For my own work, I would try to record the performance during the tech walkthrough. Then I would try to do the piece for the photographer and video maker—it's a lot of stopping and starting—"What angle should I be at? What's important to get here?" Then I go through it, again, section by section. Then I would also have them record the live event.

For the video, I want the audience reaction and the energy that happens from that live event. A video camera in the front row that's on a tripod is pretty unobtrusive.

You can get other people to help you document performance work, especially if you know a videomaker that does other areas, like documentary or narrative. It's a real way to engage them in an interesting artistic process. They see some great performances.

Any advice on setting up shots?

I think the right way to document a piece is different with every work. You have to decide what qualities are absolutely essential to convey. If you've got an installation with really long, tight corridor, then walk that corridor ten times with a video camera just getting that feeling of that long corridor. And then let the other things fall

where they may. If you need to roll with your video camera, put a tripod on an AV cart with really nice wheels. Or sit in a wheelchair while someone pushes you around.

And make sure it looks good on a video screen. Even if it's not totally accurate to the piece, or you have to move something. For example, long thin things don't look good on a video screen. I would go with the stronger image, and then describe in your writing the accurate version.

Yes. The documentation is not the same thing as the art work. It is different altogether.

It's a piece unto itself. I'm sorry to say that, because that means a lot more work. It's good to document both in digital video and with high quality still images. You want to capture both the 2D and 3D experience of the work.

How do you edit your video documentation?

I use a digital video camera and pull it right into the video editing software, Final Cut Pro, but iMovie would work for many cases. Then I go through it at home, keeping a log and highlight things I like. Then I might reduce it again. I want to get very clear on what I want, and get a two minute sample that I can send. Panels will really only look at two minutes. No one believes that. No one wants to make a two minute video. But if you make a three minute video of your work, the panel will miss the last minute.

It doesn't always work that way. I did an hour and a half piece that I love, and I got it down to eight minutes. And I show the eight-minute version. And if they don't want to look at eight minutes, that's OK. But every minute, it's really changing.

When editing, don't try to imitate Hollywood. And at the same time, it helps if there is some kind of visual match between shots. It just can't be chunk, chunk, chunk. You've got to soften the blows.

I don't think it is essential to always keep things in chronological order. Do you need to build a sequence or can you just go with things that are visually related to each other? Go for visual matches. If you're having a lot of trouble doing this, try drawing the last frame of each shot and then drawing the next frame and put them all on index cards. Try different line-ups and keep changing the order. You want to avoid a lot of fades and blacks between shots. If you can make good visual matches, it keeps the action up—go, go, next.

And for the final edit?

Once I have made all the artistic decisions, I like to get a second opinion from an editor. Even though I can now edit my own work on my home computer, editors have a really good eye and can help you solve some of the rough spots.

What about written documentation?

It's your job to present your work in the strongest light. Your writing needs to be positive and in active voice. Every word has to be spelled right, and you have to be brief, realistic, succinct, clear. By being positive, I don't mean Pollyanna—if your work is dealing with very difficult issues, you can state the problem, but how are you actively addressing that issue? Label everything clearly.

Much of the documentation that artists make eventually ends up on their Web site. Will you give a few suggestions about how artists need to organize their material for this task?

Think about your audiences and how those audiences (plural) will be experiencing the site. Galleries, grad school administrators, collaborators, grant officers, editors, art lovers, friends, etc. The color, clarity, site structure, and aesthetics of your site should be consistent with your work.

Also, look at a lot of artist sites and find good examples. Figure out what makes them good and incorporate those qualities into your site.

What should artists keep in mind while working with designers on their Web sites?

Look at the designers' work. Do they have a track record of developing sites that make visual and functional sense for their clients? Look at the designer's aesthetic and what that communicates. Avoid corporate aesthetics.

Anything else emerging artists might want to know?

I think that emerging artists might think that if they're famous, then they'll get the grant, or exhibition or whatever. If they're not famous, they won't. But every panel I've been on, the panelists have been looking for the new, interesting talent. Always. They see that as their job.

The other is, if they could possibly serve on any panel, like at their school when they're selecting next year's students—just watch the process. Watch all those projectors showing all those images simultaneously, and ask, "How would I fare in a process like that?"

And if you are applying for something, read and follow the instructions. It's totally legit to call up the administrator and ask about anything. That's the administrator's job, to answer those questions. But it will make them angry if you haven't read them at all.

(Technical advice from Charlene Boehne.)

Presenting Your Work to Art Professionals or Clients

Chapter 5 was devoted to making documentation—digital images, slides, videos, compact disks (CD), artists' statements, and so on. You should read that chapter before proceeding here.

This chapter covers how you assemble all that documentation into portfolios, Web sites, or proposal packets. These things introduce your work to art to curators, dealers, gallery directors, possible clients, or collectors. Hopefully, these "introductions" may lead to an exhibition, a commission, or a grant. Or, you may also use them to keep individuals up to date on your recent accomplishments.

There are two primary ways to give in-depth introductions to work you have already done:

- Maintaining a Web site on your work
- Sending a portfolio containing copies of your written and visual documentation

There are alternatives to sending portfolios of your work, and we discuss them in this chapter.

This chapter also contains a section on preparing proposal packets for work that you propose to do versus presenting your finished work.

What is covered in this chapter is only the assembling of proposal packets, Web sites, and portfolios. But for advice about how to use them for your career, look to these upcoming chapters:

Chapter 7, "Researching Galleries, Museums, and Other Art Venues," helps you decide which commercial galleries, university galleries, alternative spaces, performances spaces, media centers, or local museums may be interested in your work.

Chapter 13, "Grants," helps you pull together the materials you need to apply for a grant.

Chapter 14, "Other Financial Support," covers the basics of public art programs and private commissions. It also has a section on soliciting support for your project from businesses.

Chapter 16, "The Master of Fine Arts Degree," provides guidance on applying to graduate schools.

Also, at the end of this chapter, we cover face-to-face meetings with clients and arts professionals, which often result from your having sent out proposals or portfolios. How should such meetings be organized? What should they accomplish?

Your Web Site

A Web site devoted to your career is a great way to have information about your work publicly available. Below are your basic considerations when starting a Web site.

Evaluating Other Artists' Web Sites

The best way to determine what you might want for your Web site is to visit those of other artists that are already online. Get a list together of the artists whose work you like, and critically examine their Web sites.

There is considerable variety of artist web sites. Some artists do not even maintain one, but let their galleries post images of recent artwork and other publicity. Other artists participate in online registries run by arts organizations that collect and feature the works of many artists. Online art galleries are different in that they feature and promote the works of selected artists only.

Of the artists who have created and maintain their own Web sites, some have very simple, bare-bones pages, while others have complex sites with a lot of information and images. Artists may treat their Web sites as archives of their artwork and records of their achievements. Others may treat them like blogs, where they more casually present what's going on, who has been visiting their studios, where they have been, and the ideas with which they are working now. Almost all artists use their Web sites to put out their contact information.

While browsing, look at the formal qualities of the Web pages and their designs. How is the entire site organized? What is the ratio of blank space to text and image? How many images do they use per page? What kinds of images are effective? Does it flow well? What backgrounds are used? Is the text readable? What is the right amount of text for most pages? How many links are effective? Make note of the sites you like, and plan on copying their features for your own Web site.

Plan Your Web Site

Here are some basic questions you need to answer as you begin to plan your Web site.

- What are you trying to accomplish with a Web site?
- Whom do you envision as your audience?
- How much time do you have to plan, build, and later maintain a Web site?
- How much control do you want to have on the way your work is presented on the Web?

Your answers to those questions will help you pick the best route for building a Web site. These include 1) building your own; 2) hiring a professional designer/ programmer; or 3) having a page in a larger Web site or registry. If you choose 3), research your options well, because such sites vary tremendously in the services they offer. Some host individual sites, while others provide links. Some are free, some are curated, and others request an annual fee. With some, you would have to conform to the site's limitations on design and size.

Both of the other two options (build it yourself or hiring a professional) require that you do preliminary planning before beginning. Create a flowchart indicating what elements you want in your Web site and where you want them to be. Figure 6-1 shows a sample flow chart for a fictional artist's Web site.

The home page should be very striking and would usually include a strong image of your work. In addition, it should contain the name of your site, plus links to the major subdivisions within it. These major subdivisions should reflect the important areas of your career. Obviously, your artwork itself comprises one of those important areas. Do you also write about art? Do you organize or curate shows? What else do you do related to art? All these comprise major categories in your Web site.

Plan how to link your various pages. Where are the logical connections? Don't forget to place a link at the end of every page to return your viewers to your home page.

What is the general look you want for your site? Do you prefer the clean and simple? Do you want large images that fill the screen or one small one per page surrounded by wide margins? Perhaps you would like a very busy page, with animated insets and flashing pictures.

Building Your Web Site

You can build a simple, serviceable Web site with one of several commercial Web authoring software packages that are fairly easy to use. Or you can write the code for your Web site with HTML or Java Script. There are several online resources that can give you both advice on how to design your site and programming instructions for HTML. Other sites have sample scripts that you can download and easily modify to suit your tastes. Search for "free HTML programming" or "HTML tutorial." Remember to resize your JPEG image files to the screen resolution of 96 pixels per inch, at the length and width you want on screen. Higher

FIGURE 6-1 | **Sample Flow Chart of an Artist's Web Site**

This shows the various categories you might have in your Web site, and how they might be linked.

resolution images will bog down your viewers. Check your links to make sure they work.

Break down the overall task into modules, and finish one at a time and post what is finished on line, even if other modules are still to come. Get an Internet service provider to host your Web site and register your domain name. Fees generally run $6 to $25 per month, depending upon the features you want. Have friends review the site as it is developed, and give feedback.

If you hire a professional to build your Web site, look first at the other sites that person has built to see if your tastes match. You will still need to decide on your site's overall plan and provide all the text files and images that will be posted on the site. Indicate other artists' Web sites that you like, so the designer has a sense of where to go with the project. Fees will vary depending upon how simple or complex your site will be. Also, it is important to establish who will be updating and maintaining the Web site. If it will be you, make sure the design makes that practical for you.

Once your site is finished and online, you should plan on updating it regularly. Give visitors current information about your work. After every update, make sure your links still work.

Publicizing Your Web Site

There are several ways to publicize your Web site. Here are a few suggestions:

- Ask other artists to add a link to your Web site on their own.
- Make a links page on your Web site to list other artists and valuable artist resources sites.
- Send out printed cards or emails announcing your new Web site and updates when important material is added.
- Put your Web site address on all correspondence.
- Make sure your Web site appears when someone uses an Internet search engine to find you. Check the list of keywords supported by your Internet provider to find out which are appropriate for your site.

Portfolios to Present Your Work

Many artists send portfolios to museum curators, independent curators, exhibitions coordinators, and gallery directors to inform them about their work. These packets are personalized and specifically directed to a particular situation, in contrast to your Web site, which is a general introduction to your work. The portfolio would likely include:

- Cover letter
- Resumé
- Visual documentation (never send original art)
- Artist statement
- Copies of reviews of past exhibits, if any
- A self-addressed stamped envelope (SASE) for return of materials

Put all this material together in a folder or binder. Use plastic sleeves to hold the papers and images. Organize your material for ease of reading and for clarity. Make sure everything is well-secured and not likely to rattle loose in the mail.

Your original artwork does not belong in a portfolio that you send out. Always use reproductions. Your portfolio should be expendable—in other words, if someone loses it, you can replace it easily. Of course, even though your portfolio is expendable, it should still be professional looking and well organized.

Cover Letter

Purpose of the Cover Letter. The cover letter in your packet introduces you. It is your chance to "talk to" a certain art professional in a direct way. Your letter should clearly state what you want, present you in the best light, and highlight your achievements. The first paragraph can be short, perhaps one or two sentences, and should explain why you are writing. For example, you are requesting funding for a project, or you would like your work to be considered for future exhibitions at that site.

Then your letter should explain why you are approaching this particular person with your request. Possible reasons include:

- Recommendation ("So-and-so recommended I write to you").
- Reputation ("Because your gallery is known for showing video work …") ("Because you provide grants for emerging artists …").
- Past exhibitions ("I was very impressed with your recent exhibit of Chicano painters …").
- Location ("I have a body of work that I want to show in the area where your center is located …") ("I would like to paint a mural on your building that addresses the history of the neighborhod …").

When you know the interests or the history of the person or institution, you have a real reason for approaching them and are much more likely to be successful with them. Avoid writing generic cover letters that sound as if they could have been sent to anyone, and in all likelihood were. Your cover letter must give the impression that you have put some thought into what you are doing.

In the following paragraph, summarize the content of your work and its physical attributes, such as size and medium. If applicable, describe the theoretical basis of your work, or qualitative attributes such as mood conveyed or audiences' reactions to your work.

If they are relevant, highlight your accomplishments, such as your major exhibitions, the video festivals in which you have participated, collections of which you are part, or awards or grants you have received.

Request a meeting with that person to further discuss your work or proposal. Urge them to retain the visual documentation for future consideration. You might ask to be considered for an upcoming opportunity should one arise, for example, a future exhibition or grant.

Conclude your letter with your telephone number and the best time to reach you. Inform them that you will make a follow-up telephone call in one or two weeks, and then do so, to find out if they have received the packet, if they have any questions, or if they would like to see more work. Close your letter by thanking the art professional.

Format and Style for the Cover Letter. The conventional cover letter (Figure 6-2) is one-page long, which should be sufficient. Long, rambling letters simply irritate people. Use standard business letter format: your address and date at the top, followed by the name, title and address of the person to whom you are writing. Use the person's name, not simply "Dear Curator," or "To whom it may concern," which indicates that you have no idea to whom you are writing nor any knowledge of the exhibition space. Of course, you should use the "Mr." or "Ms." in the salutation, so check whether the art professional named "Jean," "Mallory," or "Pat" is a man or a woman. You look bad if you guess wrong. Try to strike a tone that is both professional and personal.

There is no need for personal stationery. Plain white bond with some rag content is fine. If you do vary from the standard cover letter, ask your mentors and friends whether your style seems effective. For efficiency, save your old letter files and modify them for new situations.

Visual Documentation

Send images with your cover letter. Visual documentation should be the highest quality possible. Substandard visuals make you seem unprofessional. Also, send copies! Never send your master image files, master tapes or disks, or original art work.

Use folders or envelopes to hold your visual materials. Simple is usually better than overly-designed packaging. When committees review packets, the contents might be taken from the package, so it is important that your name appear on every paper, disk, and print.

When sending digital files on CDs or DVDs, make sure that your files open on both a Mac and a PC platform. Use JPEGs or PDFs for still images. Use AVI, MPEG, or QuickTime video for moving images.

Images. Most portfolios will have 10 to 20 images. Many artists send both hard-copy printouts and digital files. All prints should have good detail and color, and be on quality paper. If possible, use the same size paper for all images. Below each image, include your name, title of artwork, date, medium, and size.

Digital files are usually sent on a CD or DVD, which should open easily with common software. Avoid putting images in too many different folders. When opened, the images should be clear and rotated correctly. Your name, the title, date, medium, and size should appear under your art. Organize your images in a visually-effective order. Too many pieces or too many bodies of work may confuse your viewers. Generally, show work that is finished, available, or reflective of your current interests.

Lani Chodeesingh
3398 Schuylkill Road
Ardmore, Pennsylvania 19167
email@email.net
www.site.org/~site

12 July 2001

Levering Stern, Director
Helen Warrent Gallery
3235 North Locust Drive
Atlanta, Georgia 30305

Dear Mr. Stern:

Please review the enclosed slides and written material. I would appreciate your considering my work in a future exhibition at your gallery. The critic Hugh Medton recommended that I send slides to you because of the gallery's reputation for figurative sculpture.

For the past few years, I have been working on human-scale sculptures that deal with the body and modern medicine. While this topic could conceivably be very emotional or sensational, I have chosen to focus instead on the increased reliance on machines to augment or sustain the human body. I am interested in reflecting the odd inventiveness of the medical world that hybridizes the body with artificial hearts, joints and other prosthetics. Thus, my sculptures combine organic-looking elements with mechanical devices, some medically authentic, and some taken from engines, home appliances or other such objects. My work was in an exhibit a few months ago at the Mazon-Winter Gallery in Houston. Viewers found it to be fantastic, playful, absurd or chillingly real, all of which are readings that I want the work to have. My web site (http://www.site.org/~site) has more about my work.

If you are interested in my work, I would be happy to discuss it with you when I will be in Atlanta at the end of September. Also, if you are ever in the Philadelphia area, please consider making a studio visit to see the work in person. My studio telephone number is (215) 555-5555, or you can reach me at home in the evening at (215) 555-5556. My email address is <email@email.net>.

If you wish any more materials or have any questions, please call. Also, I will be calling you at the end of July to make sure you have received this packet. I am looking forward to hearing your reaction to my work. Thank you.

Sincerely,

Lani Chodeesingh

FIGURE 6-2 | **Sample Cover Letter**

This is a fictional letter from an artist to a gallery dealer.

Include an image list, which is a summary of all art on the disk, along with identifying information. Number or name your files to correspond to your image list, so that the first file on the disk is also at the top of your image list.

Video, Performance, and Media Documentation. Time-based or interactive artwork is documented with still images, digital video, and text. The still images should capture the essential quality of your video. Show one large still, or a storyboard-like series of small stills for each work. For the digital video itself, send both an excerpt and also the entire piece. Many artists send compilation disks with two-minute-long excerpts of several works.

All video documentation should be supplemented with short written descriptions of the video content. Organize your visual and written elements so that it is clear what goes with what. Carole Ann Klonarides, media artist, and former director of the Santa Monica Museum of Art, commented:

> I am interested mainly in ideas. Along with the tape, I like to receive a proposal and some supplementary material—a description or review written on the tape, or a paragraph where the ideas behind the work are articulated. If the artist hasn't previously written a statement, include in the body of the letter some sort of description of what I am about to see. I am usually looking at a lot of tapes at once, so if within two minutes I don't get the idea of the tape and it has a slow beginning, I fast forward!
>
> I think all artists should know that their work may be viewed on the Search mode. I have more tapes than I can view, so initially I put the tape on search and get a sense of what it is I am about to see. If it is really low end and not an interesting image, I read the description and see if that is part of the concept. If the concept is really interesting and it makes sense with the images viewed, I will go back and look at it in real time and sit through the piece. But the more information that can be included with the video, there is a better chance of understanding the work.

If you make video art, in what kind of environment do you want your art to be presented? Many artists make video installations, in which the video is incorporated within a larger artwork that provides a context for understanding the video imagery shown. Other artists envision the video as simply shown on a monitor without a constructed setting. When submitting a disk of your video work for review, indicate how the work should be presented, either with written description, slides, or drawings.

Compact Disks. Media artists can send out their work on CDs. Digital still images, Web projects, and digital video files can be burned onto CDs at little cost. Many computers now have CD writers as part of their standard configuration, and CD writers as peripherals are now moderately priced.

When sending CDs, make sure that your recipient will be able to open and read your files. Surprisingly, many people still prefer viewing conventional slides to looking at art on a computer screen. If you do send a CD, use standard formats, such as TIFF or JPG for still images and MPEG or QuickTime video for moving images. Bear in mind that when sending a copy of your digital art, you are essentially sending your work itself.

You may want to send a digital catalog of your work. The digital catalog organizes your individual images with links and graphics, much like a Web page. If so, be sure to include the browser software for your catalog, or your audience may not be able to view your work.

Other Materials

In your portfolio, include copies of your resumé and artist statement. If you have any, include copies of past reviews and articles about your work, with the name of the publication, volume number, date, and page typed at the bottom. All copied material should look good and be easily read. Also enclose a self-addressed, stamped envelope for the return of materials, because without that many curators and gallery directors will simply discard the material in which they are not interested.

Responses to Your Portfolio

You will receive responses to the packets you send out. If the response is positive, you should schedule a meeting with your client or the arts professional (see below). If a portfolio comes back with a negative response, do not become disheartened, because a "no" from someone may merely mean "no for right now." If you think there is a possibility for a future connection, then send a packet again in a year or two, when you have new work and more experience.

You can also ask someone who sent a negative response if they would suggest someone or some place that might be interested in your work. Sometimes, this can result in good recommendations.

In the meantime, keep your portfolios in circulation. Have a list of grants, exhibitions, or commissions for which you will apply. Rewrite your cover letter, modify the contents of the returned packet, and sent it out again to the next venue on your list. Eventually, you will get acceptances. You may find that after your first positive response, the next comes more quickly, and the next even more quickly still. With experience, more opportunities present themselves than when you are just beginning.

Other Ways to Introduce Your Work

Many galleries receive several dozen portfolios from artists every week. There is a lot of competition. Many artists have tried other methods to introduce their work to art professionals. Below are a few of the most common.

If you are interested in showing at a space, develop a long-term plan. About a year or so before approaching them about a show, send them mailings about your current activities, including show announcements at other places, press releases, a printed card announcing your Web site, or copies of any reviews or articles about your work. In this way, you will give the curator, dealer, or director a good overview of your work over time, as well as indicating your commitment as an artist.

Curators, gallery directors, and exhibition coordinators might be more receptive to your work if they have met you first when you are not seeking a show. Attending art parties, events, and receptions may put you in contact with these individuals, giving you a chance to become acquainted socially. Writing reviews for the art press (see Chapter 9) or curating group shows (see Chapter 10) are other ways to meet gallery directors under different circumstances.

The best alternative to sending portfolios to commercial galleries is to get the recommendation from other artists who are already represented by that gallery. Many dealers pay a great deal of attention to the enthusiastic reports of artists they already know and respect. You can make yourself known to these artists by going to receptions for their shows, attending art events, becoming involved in organized activities around artist-sensitive issues, belonging to artist organizations, or participating in conferences or seminars where they are speaking. Put yourself forward and make yourself known to them.

Some artists still send packets but hand-deliver them and try to engage the dealer or curator in conversation at the time of delivery to distinguish their work from the mailed packets. This method may work if the art professional is there, unoccupied, and feels like talking. Otherwise, you may find that you spent a lot of time driving all over town, doing nothing more that the postal service does. Some artists call to set up an appointment, but in all likelihood, the curator or dealer will request that you send a packet for review before making an appointment. Other artists have brought the actual work into the gallery with them without an appointment, hoping to get the dealer's attention. You may be occasionally successful with this approach, but in all likelihood you will not be well received.

Proposal Packets

A proposal is a detailed written presentation of an artwork you want to make or a project you want to undertake. You might need to create a proposal packet if you are applying for a public art project, applying for a grant, or working on a commission. Proposal packets consist of:

- Preparatory sketches or models
- Project description or proposal statement (see Chapter 5)
- Budget
- Timetable

The preparatory sketches or models are perhaps the most important part of the proposal, as they translate your ideas into concrete images. They should also indicate the scale of the piece and, if site-specific, its location when installed. Make your visual materials as accurate as possible. More than written descriptions, the visual materials enable you to communicate clearly the essential points of your proposed project.

For two-dimensional work, your model can simply be a scaled-down version of your proposed final work. For three-dimensional work, or site-specific work, you

will likely need to create a model, showing the work installed at the final site. Many artists make actual physical models out of cardboard, thin wood, or foam core board. Others hire architecture students to fabricate models for them, as these students are taught ways to make high-quality models. Still other artists use computer programs to create virtual models. One popular choice in software is "formZ," a computer-aided design (CAD) program, which does require some training before you are able to use it. CAD programs allow you to show three-dimensional models of the site and your work, to rotate it, and to present it from the point of view of someone passing through the space ("walkthrough") or someone seeing it from overhead ("flyby"). Another popular choice for showing proposed work is Photoshop, an image-manipulation program that will only show two-dimensional images.

The purpose of the written description or proposal statement is to clarify any points that cannot be communicated through the drawings or models, such as upkeep and maintenance that a particular piece may require, particular lighting needs, or necessary modifications to the existing space.

The budget should outline the expenses for which you are seeking funding but which you will supply. Include a short description and dollar amount for the following items:

- Your fee for the work, which compensates you for your time, ability, and efforts. Allow for income tax you will have to pay and any fees to agents, consultants, or dealers who helped you get the commission. If working by the hour, a common fee for experienced muralists is $50 per hour. Ask for at least $20 per hour.
- Estimated cost of materials, plus ten percent for cost overruns and price increases.
- Other expenses such as rented scaffolding, rented vehicles for hauling, insurance, assistants' fees, fabricator's fees, and photographers' fees.

In a separate column, list all the items for which you propose that your clients assume total responsibility, such as modifying the existing space to accommodate your work, so that there is no question later about these particular points.

Your timetable should specify beginning and completion dates, plus all internal deadlines, which would include things such as completion of different phases of the project, approval dates, and dates when partial payments are due.

Your proposal should be "packaged" well, that is, its appearance, presentation, organization, and thoroughness should be impressive. This is always important, but even more so when you are dealing with individuals who are not artists or art professionals. The general public often uses presentation and packaging to gauge how creative you are as an artist and how reliable you might be to deliver a satisfactory result. Also, you may be competing against other artists for the commission. Because your sketches and models may be shown to other professionals, you benefit when the work looks good.

Meeting with Clients and Art Professionals

When you receive a positive response to your packet or proposal, a curator, gallery director, client, or some other arts professional is interested in the materials you sent and wants to learn more about you and your work. Be prepared to talk about the work, its theoretical basis, your ideas, your personal motivation, the content, and any important technical issues.

Formal Presentations. In some cases, you will be asked to make a formal presentation of your work or proposal. Often you will have a preset amount of time to talk about the most significant points of your work and its importance or appeal overall. In these cases, you should write a script for your presentation to make sure that you are able to say everything you need to say. Rehearse your speech so that your delivery is polished.

Studio Visits. If you do traditional visual artwork, invite the art professionals to come for a studio visit. There, you can control the environment and set up your work as it would best be displayed. If you do not have a studio, try to borrow someone else's. If you work out of your home and have to show your work there, clear out a room for your work. Display your work against a clean wall. Viewing artwork leaning against the living room sofa or the dinner table is distracting. A separate space, even within your home or apartment, gives a greater impression of professionalism. Offer coffee, tea, or water to your guests while they look at your work. Studio visits usually last thirty minutes to one hour.

An alternative is bringing your art to the art professional where they work, especially if you are showing work that can be easily carried. That may be more convenient for both parties. However, you will not be able to bring large or delicate pieces, are limited to showing fewer objects, and cannot set up the work to show it to its best advantage. You may have to crawl around the floor to spread out the work, putting you in an undignified position while talking to someone you wish to impress.

Casual Meetings. You may want to propose a preliminary meeting at a restaurant or art event to discuss your work in a more informal way with art professionals and clients. You should bring a compact packet of your work to such meetings, with visuals, your resumé and statement, and copies of any previous reviews handy. Bring this even if you have already sent such material to your guests, because they may not have that material with them at the meeting. Be prepared to pay for their refreshments.

Follow-Up. At the end of your meeting, your guests may want to do a project with you or may offer you a show. Or they may express the desire to visit again in six months or so or indicate that they are not interested in your work at this time. Or the visit may end inconclusively from your point of view. Be sure to do whatever follow-up is required, whether delivering work now, sending more slides later, or simply writing a thank-you note expressing appreciation for the visit. Regardless of the outcome of the visit, keep in touch with them. Once even mildly interested, they are likely to remain interested in future work.

artist interview

JOYCE KOZLOFF

Joyce Kozloff is an artist who lives in New York, where she is represented by the DC Moore Gallery.

Will you talk about how you develop proposals for public art pieces or commissions?

This initial stage is the hardest, when the real creative work goes on. I start from scratch with each project and think about who's going to use the site, its history, and what materials might be appropriate to it. Many artists go through a similar process. I have a simple cardboard model made by an architecture student. And I mentally, psychologically, shrink myself down to the size of a person moving inside that model, imagining what I would see from different vantage points. What should be the scale and scope of the piece and how do I want it to be experienced? There are some spaces in which you can get very close to the art, others in which it can only be seen looming in the distance. After I make studies for my proposal, I reduce them down and put them into the model, which is usually just too small to work on directly.

What are your studies like?

I always work in color, usually watercolor on paper, but sometimes collage or colored pencils. I execute them in great detail, which takes considerable time. A lot of research goes into finding the relevant sources and imagery.

What kinds of research might you do?

I have gone through changes since I began making public art in 1979. My early pieces were very much about the history of the site and community, which I evoked through visual imagery—artifacts and patterns associated with that place; its architecture, architectural ornament, decorative arts. Later, I started to work less literally. Sometimes I now make a mental leap or funny associations that are not so apparent.

In what way?

I began layering other kinds of references into my art—metaphors that interest me. For example, I designed two glass mosaic niches in the lobby of Suburban Station, Philadelphia. Both quoted exotic, remote places. On one, I depicted the ornamental entranceway to the famous harem of the Topkapi Palace in Istanbul. A sleek train from a 1920s art deco poster is rushing through the door. I thought that people taking suburban trains to work during the Depression—when this station was built— might fantasize that they were taking the Orient Express to Istanbul. It's quite surreal, and I'm asking the public to come along and make those leaps with me.

Do you develop proposals for free?

No, I will not do a proposal for free.

What happens to your models?

I've tried to keep the models of all my projects. They're what you have in the end: your drawings, proposal, and documentation. I write into the contract that I will keep the proposal: the watercolor studies, the models, etc. Some agencies or cities or developers think that by commissioning an artist, they are paying for an object. I feel they are paying for my ideas.

Once or twice in the early days, I was unable to stipulate in the contract that I would retain my model. I regret that now. Things are changing, and most standard contracts allow artists to keep their proposals, but everyone should make sure of that.

What else goes into a complete proposal package?

It depends. Usually a budget, which is what I hate most. It's hard to anticipate everything, but you don't want to be caught short. This is not creative work. It entails the collecting of fabrication, transportation, insurance, documentation, and installation costs. You must anticipate a range of smaller expenses that add up as well.

Very often I write a statement, a page or two explaining my thought process, how the ideas are evolving, what the images refer to and how I'd like them to be read. Sometimes they will ask you for slides of previous work. When you make a

Joyce Kozloff, *Topkapi Pullman*, 13′ × 16′, glass mosaic, Suburban Station, Philadelphia, Pennsylvania.

Source: Photo by Eugene Mopsik.

presentation with a proposal model, you might want to show slides not only of your own previous work, but of other sources that you want to reference. I created a mural, for instance, on the outside of I.S. 218, a junior high school in New York with a large Caribbean population. As research, I went to Carnaval in Santo Domingo. Although I had read about the festivities and looked at pictures in books, I wanted to experience it in the flesh. My piece encompassed the brightly painted ornament on wooden houses, as well as the costumes and iconography of traditional Mardi Gras characters. It was great fun.

I would imagine your presentation of your proposal is exceedingly important.

It is. My first presentation, in 1979, was for the Harvard Square subway station in Cambridge, Massachusetts. I was very, very nervous. I had some excellent advice from an artist/architect friend, who told me that architects must compromise all

the time in their work. They look upon artists with envy, imagining that we don't have to make those compromises. My friend proposed that if I were to show them I was willing to compromise in some way, even if it weren't true, that would put them on my side.

She said, "How long is your piece?" I answered, "The length of the wall—eighty-three feet." And she replied, "Why don't you say that you've designed a ceramic tile mural that is sixty-five feet long, that you really wanted it to be eighty-three feet, but you had to compromise because of some budgetary or other (I no longer remember) consideration?" So I did that at my presentation, and all of a sudden the architects were demanding, "Let's see how we can restore to her the rest of that wall." I almost laughed. In the end, I was able to do what I wanted, but they believed that I'd compromised.

But it is important for artists to realize that with these proposals, they're dealing with a wide range of people.

For the Harvard Square project, I presented to almost twenty people, including the architects, members of the community, local businessmen, representatives of the transportation authority, and art specialists. So you're pitching to people with different levels of education, different ages, different life experiences. It's important to communicate without pandering.

The citizens will be concerned about safety, and rightly so. At first, I was surprised that the questions raised were not about art! They always ask me about graffiti; none of my pieces have ever been graffitied because street artists prefer to tag on a blank wall. In Boston the committee asked, "What about people hitting the walls with hockey sticks, returning from a game?"

In fact, none of my artworks has been damaged by the public. That particular piece is in disrepair, however, because of cracks in the wall which have come through my tiles. It's an engineering problem, which I have been asking them to repair for years.

I guess there's no one really watching over your work.

That is true. I wouldn't sign a contract that didn't have a good repair and maintenance clause, stipulating that during the artist's lifetime, he or she will supervise any restoration.

I understand that you don't enter public art competitions.

I haven't entered competitions in many years because I can't bear to do all that work for a project that might not happen. I may have fewer opportunities as a result, but I just don't want to spend my time that way. Sometimes I've been asked to create a piece based on my past work. Other programs select five artists, who are invited to talk about the project and show slides of their earlier work. They are not

required to go through the lengthy process of submitting a proposal before being chosen. This is a more acceptable alternative.

Because I just do pieces which were not the result of competitions, they are usually rather modest compared to the major commissions that many artists are getting today.

Some artists enter many big competitions. Yesterday, I heard about one here in New York. There were five finalists who were paid to make and present models. The winner was the least well-known and had produced the least public art, but he made a fabulous proposal. That is an example of how this process can be a wonderful opportunity for new people to enter the field.

What kinds of projects are you doing now?

I just finished a marble mosaic floor for a cultural center in Kurayoshi, Japan. That came through Cesar Pelli's office, an architectural firm I had previously worked with (on Washington National Airport). This is my first permanent project outside the U.S. I loved working with the Japanese architect and mosaicist; and besides, I'd never been to Japan!

For these, do you still have to develop some sort of proposal?

You do the same process.

And they can turn it down?

And they can turn it down. Even if you're the only one they asked, they can say, "We don't like this," and move on to another artist. But generally, if they have some problems with your design, they will ask you to make changes or modifications, which actually might improve the work.

Researching Galleries, Museums, and Other Art Venues

D₀ you want to show your art in established art venues, such as galleries, museums, and media centers? There are many different options available, and you need to do the research to find places that suit your work. You can be actively pursuing shows in these venues, while at the same time self-producing exhibitions or performances.

This chapter introduces you to these kinds of art venues:

- Commercial galleries
- Alternative spaces
- Media centers
- College galleries
- Galleries in community centers
- Cooperative galleries
- Online galleries
- Museums
- Municipal galleries
- Businesses

For each, there is a description of the kinds of artwork they show, the funding for the space, staffing, and the role the site plays in the larger art world. Later, juried exhibitions and festivals are also discussed, and the chapter concludes with brief comments on art advisors.

Which exhibition and performance sites interest you? And how can you determine which spaces are most likely to show your work? The recommendations of mentors and other artists are very helpful. If they know your work well and are already familiar with the existing sites in the area, they can save you much time

and work by recommending suitable places. They may even provide you with an introduction to the curator, gallery director, or exhibitions coordinator, thus giving you a great advantage when you approach them about your work.

Even without recommendations, however, this chapter gives you criteria for evaluating the exhibition and performance possibilities in your area or in another city. Once you have a grasp of the kinds of sites available to you and how they work, you can begin to approach them for a show. Bear in mind, however, that you are part of a living culture, and its institutions are constantly developing and in flux. What you read below may differ somewhat from what you will find in the art world two or four years from now.

How can you get a show at these museums, galleries, and art spaces? First, you do the necessary research to find out which venue is a good fit for your work. Then, you need to make your work known to the curators and directors, primarily through sending them packets of your work or other methods of introduction discussed in Chapter 6. Before sending any material, ask each place what they would like to receive from you.

Commercial Galleries

When talking about art galleries, most people are referring to commercial galleries. Commercial galleries promote the appreciation of art through marketing—the buying, selling, and collecting of art objects. There are really two different kinds of commercial galleries. The older, more established galleries tend to have large staffs, have more upscale locations, and sell more expensive art. But you can find new, small, experimental commercial galleries especially in larger cities. These galleries in many ways resemble the alternative art spaces, which we discuss next.

Generally speaking, most commercial galleries must sell artwork to survive. They tend to show traditional visual artwork, such as ceramics, painting, photographs, prints, and sculptures, in which discrete objects are produced. Fewer commercial galleries deal with video, computer art, performance, or installations. Also, most commercial galleries avoid work that is too controversial, too political, too raw, or too shocking. Of course, you will find exceptions to this.

A commercial gallery will often be specialized to feature a particular style, medium, or look. It becomes known for a specific type of art, such as figurative painting, ceramics, or contemporary Asian artwork.

Well-established commercial galleries have been criticized for catering to the tastes of the affluent and not representing the diversity of U.S. culture today. Ageism can also be a problem at some commercial galleries that may be interested only in younger artists or dump mid-career artists who no longer fit new trends.

Commercial galleries attract an audience of artists and art professionals and the segment of the general public that follow art events. However, commercial galleries rarely draw the public in large numbers.

Staffing. Large commercial galleries may have an array of persons running them, including backers, gallery owners, directors, attendants, and preparators. Backers are usually silent partners who contribute financially to the gallery but take no part in running it. The gallery owner, also called a dealer, makes long-term decisions about the direction of the gallery and works with major collectors. Generally, gallery owners decide what gets exhibited. They consider taking on new artists primarily on the recommendations of other artists and, to a lesser extent, on the images artists send to the gallery. The director is in charge of the day-to-day operation of the gallery and oversees the employees, maintenance, and so on. Directors sometimes also review artwork and make visits to artists' studios to see new work. Gallery attendants handle reception and clerical duties. The preparator is responsible for all physical labor associated with running the gallery: hanging shows, crating, shipping, patching walls, painting, and so on. In smaller galleries, these positions are conflated into one or two positions; in a very small gallery, there may be no backers and one person who does everything.

The Relation of Commercial Galleries to the Art World. Commercial galleries are an integral part of the museum/gallery system. Gallery owners and directors do the work of sifting through the packets and visiting the studios of available artists to select work to show. They are a kind of clearinghouse for critics, collectors, and curators who frequent commercial galleries to selectively review, collect, or acquire art. Prestige varies from gallery to gallery. To be considered first rank, a gallery must have a "stable" of well-established artists and sell works from their exhibitions to prominent collectors.

For artists, a show at a commercial gallery represents the best way for their work to be seen by these critics, curators, and collectors. Shows at commercial galleries often provide artists the best format for selling their work and the connections to arrange subsequent shows. In addition, association with a commercial gallery often facilitates some business transactions for artists; for example, it is easier for billing and for pick-up to get work shipped from a business location such as the gallery. Artists often believe that they will begin their careers at second-rank galleries, then will be "picked up" by first-rank galleries, where major collectors will acquire their work, and then go on to museum shows. But the competition is fierce, and few artists show at the top-ranking galleries.

Locating Commercial Galleries. The magazine *Art in America* publishes an *Annual Guide to Museums, Galleries, and Artists,* with listings all across the United States. To find local and regional galleries, consult the free gallery guides that can be found in many galleries or online. One example with national listings is Internet Art Resources (www.artresources.com). Other online artists resource sites have listings of galleries. Check also the local newspaper calendar listings and yellow pages. Many galleries have their own Web sites.

Researching Galleries. In larger cities, there are many commercial galleries, so you need to spend time researching them to find one that is appropriate for your work. Go to the gallery to see the kind of art they already show. Your first visit should be for gathering information before approaching them about your work. This is relatively easy to do for local galleries but requires extra travel for those in other cities.

If possible, see a summer group show, which should reflect the range of work for which the gallery is known. Does your work seem to fit in? Specifically, is it stylistically and conceptually compatible? Are at least some emerging artists, or are they all well known and well established? What is the price range of the work shown? Is the space suitable for your work: large enough if your work is large, or intimate for small pieces? Is the gallery well maintained, on the exterior, interior, furniture, walls, and floor? How is the lighting?

Also, evaluate the look and style of the gallery itself. Is the gallery attendant attentive and well informed or passive, distracted, and ignorant about the work being shown?

When at the gallery, add your name to their mailing list. Receiving announcements with art reproductions is extremely beneficial when researching galleries in other cities.

Alternative Spaces

Alternative spaces are venues for art that push the boundaries of established genres. They often show work that is controversial, experimental, or difficult to market. Some alternative spaces promote work dealing with political and social issues. Alternative spaces show installation work, performance, and art based on new technologies, in addition to work in traditional media. These venues also are generally conscientious about equal representation for the work of women and members of ethnic minorities.

There is a huge variety of alternative art spaces, and they differ considerably in their mission and purpose. DiverseWorks (www.diverseworks.org) in downtown Houston, Texas, is a 15-year-old alternative space with performance and exhibition spaces and a program that addresses contemporary art, the neighborhood, and world issues. Also in Houston is Project Row Houses (www.projectrowhouses.org), a remarkable alternative space and project founded by artist/activist Rick Lowe (see interview in Chapter 11). Project Row Houses combines art, urban redevelopment, educational programs, and housing and community building. Versions of it have been started in Los Angeles, Detroit, and Philadelphia. No Name Exhibitions (www.soapfactory.org) is an artist group that runs an alternative exhibitions/performance space in an enormous old soap factory in southwest Minneapolis, Minnesota (see interview in Chapter 2).

Alternative spaces host exhibitions by individual artists, as well as large group shows based on a particular theme. Some shows are curated. Some are juried, in which artists are invited through advertisements to submit packets of work around the show's stated theme and a juror selects the show from the work submitted. Others are open exhibitions, in which any artist who wishes can simply bring work to the gallery at a designated time, and the work is hung on a first-come/first-served basis until the gallery walls and floor space are filled.

Some alternative spaces sponsor performances. Exhibition spaces, performance spaces, and/or video screening rooms can vary greatly from place to place.

Alternative spaces often maintain a registry, which is a collection of images sent by artists that represent their work. Curators, critics, and other artists may review the registry to select artists for shows at other sites.

Audience. Shows at alternative spaces attract critical attention and a broad art audience, including artists, museum personnel, and collectors, who expect to see something unusual, controversial, or shocking. Alternative spaces may attract special interest groups, such as a site dedicated to Latino artwork. The general public usually does not attend in large numbers.

Staffing and Operation. Some alternative spaces have a large staff, whereas others are small, with one permanent person plus nonpaid interns and volunteers. All have directors and may also have exhibitions coordinators, events coordinators, publicists, directors of outreach, and so on. At some alternative art spaces, shows are organized by committees of artists and art professionals, either from the image registry or from proposals sent in by artists.

Funding for Alternative Spaces. The funding for alternative spaces varies. Almost all are nonprofit. They do not depend on sales of work. Many are supported substantially through membership dues and through fundraisers, such as art auctions, parties, and events. Some earn revenue from bookstore sales or admissions to events. Alternative spaces may also receive funding through government agencies, private foundations, or corporate donations. Those with less governmental and corporate funding are more autonomous regarding what they show; those with more are vulnerable to outside influences. Almost every space is supported through a combination of sources.

Position of Alternative Galleries within the Art World. Alternative spaces often serve as a testing ground for new artwork. Often, artists who show first in alternative spaces end up showing in commercial galleries. Although some alternative spaces receive a lot of respect and others are less well known, generally they enjoy a high degree of prestige in the art community.

Researching Alternative Galleries. To research what alternative spaces are available in a particular area, go to any one of the artist resources sites listed in Chapter 2. In addition, *Art in America's Annual Guide to Museums, Galleries, and Artists* lists names, addresses, and telephone numbers for more than two hundred nonprofit exhibition spaces across the country. Check the index for the listing of nonprofit spaces. Also, you can check the calendar section in any large daily or alternative weekly newspaper that covers the cultural scene in a city.

To find out if you wish to show in a particular alternative space, you may have to visit a few times to grasp the range of work they show, because the work can vary dramatically from month to month. Ask if the alternative space has a printed policy about the exhibitions, video events, or performances they sponsor. Examine the space to see if your work will fit and if the space is well maintained. Add your name to the mailing list or join as a supporting member to receive all announcements and publications from the space, especially announcements about group exhibits. If you have time, volunteer to help at an event sponsored by the space, to learn from the inside how the space operates. Of course, ask other artists and your mentors their opinions of the space.

Media Centers

Media centers are art spaces dedicated to technology-based arts, such as film, video, interactive art, computer-based art, and Web art projects. Technology-based art differs in many significant ways from traditional visual arts. There is no unique art object that an artist makes, but rather something than can be duplicated almost endlessly. The audience can encounter media arts in many ways, through broadcast, at theaters, through the Internet. Therefore, media centers interface between the artist and the audience in many ways. Most sponsor screenings and exhibitions. Some have libraries of film and media projects. Some serve as distribution centers for artists' media projects. Many sponsor media arts festivals (see below).

Artists working in media areas are often faced with the challenge of learning a lot about technology and the expenses of acquiring equipment. Many media centers seek to assist artists by offering educational programs and grants for artists' projects. Many media centers also do community outreach, by making their instructional programs and technology available to the neighborhoods.

Media art centers are located throughout the United States. The New Orleans Video Access Center (NOVAC) (www.gnofn.org/~novac/) is one example of a media center. Its mission is to foster the creation and appreciation of independent video for a public of diverse ages, income levels, and backgrounds. NOVAC sponsors workshops for using computer software, maintains an archive and collection, working facilities on site, and an exhibition space. The 911 Media Arts Center (www.911media.org) in Seattle, Washington, is a nonprofit art space providing workshops, screenings, editing facilities, and networking opportunities.

Funding and Staffing. Media centers are funded by membership dues, proceeds from their programs, government grants, and support from businesses. Like the alternative spaces and commercial galleries, media centers vary tremendously in their staffing. Some larger ones have a director, workshop coordinator, media services assistants, technicians, and youth project coordinators. Others have regular faculty on staff. Media centers that sponsor media festivals, such as LA Freewaves in Los Angeles (eda.design.ucla.edu/freewaves/), also have festival directors on staff.

Audience. The audience for media art centers can be broad if the center is able to place artists' works in festival sites around town, or on community access cable television, or, of course, on the Internet. Media centers may attract not only the art community but also those in entertainment, advertising, and business.

Researching Media Centers. The National Alliance for Media Arts and Culture (www.namac.org) maintains an online listing of media centers and resources for media artists. For media centers in your state, look at the art sites listed by your state art agency.

College Galleries

Universities, colleges, and junior colleges often sponsor exhibition spaces. All have an educational function, but they vary tremendously in their missions. Some large

universities maintain galleries like small museums, showing high-profile exhibits by well-known artists or important traveling exhibits. Some are dedicated to display-ing the university's permanent collection, which often consists of valuable items or artwork given by trustees or other major donors. Such museum-like galleries may occasionally show the work by emerging artists.

However, most large universities also have other spaces that are open to emerg-ing artists, as do most colleges and junior colleges. These venues often function pedagogically as extensions of the school's art curriculum. Most college galleries show traditional art, unusual or experimental art, and performance, installation, and work in new media. Most feature work by artists of diverse backgrounds.

Audience and Funding. The audience for these exhibitions and performances consists mostly of the faculty, staff, and students of the institution. Members of the outside art world attend college art events in fewer numbers, although a publicized show at a prominent institution may attract many persons.

College galleries are answerable to the college administration and to those who provide its financial backing, whether governmental, religious, or private. Some may be reluctant to show openly controversial work. However, those with a strong tradition of academic freedom will likely respect freedom of expression in the visual arts.

Staffing. Some large university galleries have their own staff with a director who makes the decisions about what work will be shown. Others are run through the art department, with more or less attentiveness, depending on the situation. Some are well run by faculty, volunteers, and student assistants. Others are very slipshod in their operations. Ask your mentor to name college galleries that are well curated and well run.

Researching College Galleries. Because almost all colleges have galleries, find a listing of colleges in the area and call them to find out about their exhibitions pro-gram. Like researching an alternative space, you may have to visit a college gallery a few times to get a feel for the work shown, because again the variation from one show to the next can be great. Is the space well maintained? Is there an attendant watching the space? Will your work fit well physically in the space? If available, add your name to the mailing list.

Galleries in Community Centers

Community centers are multiuse spaces designed to meet the recreational, educa-tional, and social needs of a particular group. In some cases, geography determines the group, like neighborhood community centers. In other cases, the center serves a special-interest population, for example, senior citizens, women, or Japanese-Americans. These centers sometimes have art galleries, theaters, or other areas used to display art.

These centers tend to show artists who reflect the community. The work shown can run the gamut of art styles and media. Although very partisan or political work may be shown, sexual or violent subject matter is often avoided because the

audience may be varied and mixed and frequently includes children. However, the fact that these spaces are used by a very broad audience, much broader than those frequenting commercial art galleries, may be attractive to some artists.

Operations and Staffing. The director of the center may decide what gets shown, or a director of programs or cultural events, if there is one. In some rare cases, the center may have a budget for art exhibits, for invitations and receptions, and so on, but more often artists are responsible for hanging and publicizing their own exhibitions. Community centers themselves are funded either by local government or by the special interest group that the center serves. They reflect the values of their supporters regarding the artwork they show.

Relation to the Art World. Most community center galleries are outside the museum and gallery system. Most of these venues are not visited by critics nor by many art professionals. The exceptions are those community centers that have a history of mounting interesting exhibitions or when the community served by the center has been in the news. For example, a center-sponsored exhibit dealing with the World War II internment of Japanese-Americans may draw attention. For the artist, the benefit of showing at community centers is reaching that particular audience.

If you are considering a community center as a possible exhibition site, evaluate the physical condition of the gallery, the competence of the staff, and the kind of the artwork they show. Are the persons attending the center an audience you want to reach?

You can find community centers in the telephone book or by inquiring with your city or county government.

Cooperative Galleries

Cooperative galleries are exhibition spaces funded by a small group of artists, usually between eighteen and thirty-six artists, primarily for the purpose of showing their own work. These artists are members of the cooperative. They support the gallery by paying a fee, ranging from several hundred to several thousand dollars a year, depending on rent and other gallery expenses. Also, artist-members must work a certain number of hours per week toward running the gallery. One member usually acts as director of the gallery, organizing the efforts of the group and overseeing day-to-day operations. Sometimes, members remain constant at a space, whereas at others, artists rotate out after a specified period, for example, three years and two solo exhibitions.

Although some cooperative galleries show only member work, others dedicate a percentage of their shows to nonmembers. The work shown can encompass the entire range of art. Because the galleries are artist-funded and artist-operated, the only limitations are those imposed by the supporting members themselves. Some have explicit exhibition policies and philosophies and high standards, whereas others do not. The diversity of artists shown varies from one cooperative to the next. But because of the fee, membership may be difficult for low-income artists. Cooperative galleries are great laboratories for artists, educating them on the gallery operations,

on exhibitions procedures, and perhaps even on curating shows. Artists assume control for exhibiting artwork, a role otherwise reserved to art professionals.

Role in the Art World. The best cooperative galleries function much like alternative spaces. They draw artists, art supporters, and arts professionals. Historically, those limited to showing only members' work have relatively low status in the art world. Cooperatives enjoy a better reputation when they regularly include the work of nonmember artists, are community or service oriented, or have nonprofit status and grant funding.

If you are thinking of joining a cooperative gallery, visit the space to judge its physical appearance, the staff, and the artwork shown. Ask for their exhibitions policy and for their procedures regarding the selection of new members. Get explicit answers to the following questions:

What are the minimum and maximum periods of membership?

What does membership cost?

How long must artists be members before receiving their first show?

What is the time interval between shows for each member?

How many hours per week must members work at the gallery?

Do members have the opportunity to curate exhibitions?

What exhibits in the past have been reviewed by critics?

How often are nonmembers included in exhibitions?

Online Galleries

We discussed online art galleries briefly in Chapter 6 in relation to getting your Web site online. Online galleries are Web sites that feature artists' works and offer them for sale. Like regular commercial galleries, online galleries run the gamut in prestige. A site such as Artnet (www.artnet.com) carries the work of many well-known artists. They also become known for a certain look and a kind of art they sell. NextMonet (www.nextmonet.com) features a wide range of traditional visual arts. The Guild (www.guild.com) caters to interior designers.

Online galleries vary tremendously in terms of what they offer artists. Some are really nothing more than advertising space for artists, who pay a monthly fee to be featured at the site, in addition to the commission they would pay when a work sold. Other sites are completely free. Some have screening committees who review work before an artist can be included, whereas other sites are uncurated and therefore open to all. For example, NextMonet asks artists to submit images of current work, a resumé, artist statement, price sheet, and self-addressed stamped envelope to return these materials. Then, a selection committee reviews the submissions and decides which artists will be admitted.

Online galleries are still a relatively recent phenomenon and are still evolving. Like any other gallery, you need to research online galleries well. Which site is most suited to your work? Which features art that you yourself respect?

Museums

By definition, a museum preserves and exhibits objects of historic, artistic, or cultural significance. But generalizations about museums are difficult because the name is used for many different kinds of institutions. Many museums maintain a permanent collection, devoting the bulk of their annual budget to acquiring, maintaining, storing, and displaying art objects. Some museums do not have a permanent collection, only rotating exhibitions much like a commercial gallery. The focus of museums varies, from historic to contemporary, from fine art to decorative arts to cultural artifacts. Any or all may display contemporary art, either on an occasional basis or as their total mission. Museums often will show work in a variety of media, including traditional, new, high-technology, and experimental media. Many support installation and performance art.

Major museums in large cities are institutions at the top level of the art world and thus exhibit work that has been already shown and validated by other means, often through commercial galleries or alternative spaces. Individual exhibitions in major museums are often retrospectives, where the best works from a well-known artist's entire career is displayed. Museums usually do not show the work of emerging artists unless they sponsor a special series specifically for such work. Call the museum's curatorial office to find out. Smaller museums and museums in midsized cities are more likely to be sites for emerging artists' work.

Historically, museums shows were mostly given to white male artists. They are still shown in museums in percentages far greater than in the population of artists as a whole. But because of recent surveys, adverse publicity, and pressure from disenfranchised groups, museums have made some efforts to include more diverse artists. At some institutions, the change has been profound; other museums have resorted to tokenism.

Museums attract a broad band of the population, and often host special groups and students.

Staffing and Funding. Museum directors are generally responsible for the overall operation of museums, whereas curators decide whose work will be shown. Curators look at art in various venues, for example, alternative spaces, commercial galleries, and art publications. They may also visit graduate students' studios at more prestigious schools (see Chapter 16, "The Master of Fine Arts Degree"). Some curators look at images sent in by artists and make studio visits to look at work. By telephoning the museums' offices, artists can discover which ones are interested in contemporary work and their procedures for reviewing it.

Funding for most museums comes from foundations, private donations, and/or tax revenue, including federal, state, county, or city. The private donations are usually sizeable bequests from wealthy persons, either monies or art objects, or both. Other lesser sources of revenue are business donations, grants, fundraisers, member dues, admission fees, and gift shop profits. Recently, some museums in redevelopment areas have received substantial funding from surrounding businesses under the umbrella of public art programs.

Status. Regarding prestige, major museums represent the pinnacle of the museum/gallery system, with small municipal museums and regional museums

falling just behind them in the pecking order. Small museums dedicated to local history have little status. Showing at a prominent fine art museum is advantageous, prestigious, and desirable for artists.

Visit the museum, evaluate the site, and inquire about procedures for reviewing artists' work.

Art Rental Galleries. Some museums operate art rental galleries, which are places where individuals or businesses can rent, lease, or purchase original artwork. Artists who supply work to art rental galleries are paid a modest monthly fee for every piece that is rented. Artists have a large investment up front if their work is in an art rental gallery, because they have to produce the finished artwork, and often pay for framing before the rental gallery will accept the work. That can represent considerable time, materials, and money. But artists may enjoy a very nice monthly income if they can make enough work that is rented most of the time.

To be considered for art rental galleries, artists generally must submit images, resumé, and statement. Call the museum if you are interested in their rental gallery, and find out their selection procedures.

Municipal Galleries

Municipal galleries are city-run exhibition sites, often part of a complex for other cultural events as well. They are not city-run museums, because they house no permanent art collection. Municipal galleries only host exhibitions, promoting the work of the area's emerging and established artists and perhaps also displaying traveling exhibits from other areas. The artists shown tend to be as diverse as the population of the city itself, as the gallery is charged with the mission to represent its citizens. Municipal galleries are funded from city tax revenues, often supplemented by donations from local businesses. As a result, the type of artwork shown is dependent on the overall attitudes of the city itself. Conservative areas may restrict subject matter, whereas cities with more liberal politics may support a gallery showing unusual, experimental, or controversial work.

Shows at municipal galleries may attract a higher percentage of the general public than shows at commercial galleries, partly because of their commitment to local artists, partly because they often sponsor other cultural events on the site, and partly because these galleries may offer educational programming that attracts student groups.

Staffing. Municipal galleries have regular paid staff. The director runs the gallery, overseeing personnel, setting the budget, and maintaining the physical plant. The curator is usually concerned with programming and with art issues only. Curators put together exhibitions and performances, visit artists' studios, write about exhibits at the gallery, and plan related events. In some cases, curators make all decisions unilaterally, or they may work with an advisory committee of art professionals who review images and proposals from artists. At large galleries, the director and curator are two separate positions; at small galleries, one person may do both jobs.

Status. Municipal galleries can have one foot in the museum/gallery and the other in the alternative system. Although they show established artists, they are also interested in local, emerging, diverse, or experimental artists. The prestige of municipal galleries varies, although generally a show at a municipal gallery is considered advantageous for an artist, especially if the gallery is in a major city. Those in very small cities or ones dedicated to local history or pandering to tourists may have less art world stature.

Visit the municipal gallery, evaluating the site, adding your name to the mailing list, and inquiring about their procedures for reviewing artists' work. If researching municipal galleries in other cities, find out whether they are restricted to area artists only.

Businesses as Art Venues

There are some large corporations that have major art collections and impressive exhibition spaces. These sites are operated like small museums or well-established galleries, but are funded with corporate revenues. They often hire an art professional to oversee exhibits and collections.

Smaller businesses, such as furnishing, design, and interior stores, also exhibit art, hoping for sales to customers who are redecorating their homes. Many other businesses want art to display art on their walls. These include banks, restaurants, bookstores, or clubs. In some cases, the owners hope to raise the stature and prestige of the business by association with fine art.

Obviously, large corporations with major collections represent the most prestigious business venue for artists, whereas small businesses may or may not be. Most of what is discussed below pertains to showing in small businesses. If you are considering showing in a business location, evaluate it first to see if it would be a benefit to you.

The range of work shown in businesses runs the entire gamut. Some want low-brow art such as cute kittens and quaint farm scenes, whereas others show the same kind of work that you might see in galleries and museums. Most businesses patronized by the general public will not show controversial, shocking, or experimental art. They favor more conventional subject matter, style, and media. Wall space tends to be available whereas floor space is often needed for the operation of the business. Therefore, small businesses often favor art that hangs, seldom showing space-demanding art such as sculpture, installation, or performance. Artists usually have to display their work around the business' furniture and decor.

Ceramic artists frequently find outlets for their work in businesses, especially if they are production potters. These include gift stores, furniture stores, design centers, and interior design firms. However, these places generally sell the artists' works just as they would sell any other line of products, rather than offering artists a show of their own work.

Benefits and Challenges of Exhibiting in Businesses. The person who determines the exhibitions at the business varies. In some cases, the owners exhibit artists'

work that they like. Or the owners may ask artists they know to recommend other artists to show their work. In a few cases, there may be a formal and/or financial agreement between the owners and an art professional who acts as curator for the space. But most businesses spend no money on exhibitions. The artist usually is responsible for delivering and hanging the work and for printing and mailing any announcements for the show. Thus, geography tends to be a factor determining whose work is displayed, because there are too many expenses and not enough return to make it a worthwhile venture for artists living far away from a business. Exhibitions at businesses rarely carry much prestige or give the artist visibility in the art world. The exception to all this, of course, are exhibitions with those large corporations that collect art.

Despite the lack of art world recognition for most exhibitions in businesses, there are some benefits. More of the public sees the work in these locations than at commercial galleries or alternative spaces, providing artists with a much broader audience for their work. Also, the artist might generate some income by selling work from these places. Recently, some artists have approached malls and businesses for permission to mount exhibitions in empty stores and in storefront windows. With these business-sponsored exhibits, the artists have been able to take over the entire space for both traditional and innovative work. These sites are very attractive to artists who seek a broad audience and may attract critical attention.

Researching Businesses. There are no listings of businesses that sponsor exhibitions. Most artists find out about these places by word of mouth or approach the owner directly. If there is art already there, evaluate its merit. Also, examine the exhibition area. Cleaner, clearer, and more flexible spaces are usually more desirable. Will your art be competing against or complemented by the decor? How effective is the lighting? Is the artwork handled carefully or does it seem endangered by the operation of the business? If there is no artwork in a particular business, you can ask the owners if they would consider some kind of art installation.

Consider whether this space is suitable for your work. Do the people there constitute an audience you want to reach? Is your work enriched by being shown in this environment?

Ask to speak to whoever is in charge of exhibitions. Do they carry insurance on your work while it is on display? Do they take a commission on works that sell, and if so how much?

Other Exhibition Opportunities

There are many exhibition opportunities that are not associated with a permanent space. These include juried exhibitions, media arts festivals, exhibitions sponsored by art organizations, and art fairs. These events may be of short duration, for example, a weekend, or be held on an occasional basis. Where the event is held may change from year to year.

Festivals for Media Arts

An important venue for media artists are festivals, which are multiday events with screenings, installations, and/or broadcasts. These festivals are often sponsored by media arts centers, both in the United States and abroad, especially in Europe. Others are sponsored by universities or museums.

Some festivals are dedicated to certain media or genres. So, for example, the New York Underground Film Festival focuses on films with a subversive edge (www.nyuff.com). Others are open, accepting a wide range of media works. As an example of one festival, LA Freewaves (eda.design.ucla.edu/freewaves/) includes video, film, digital works, Web sites, youth screening, installations, special events, and video bus tours. LA Freewaves festivals are spread over several locations throughout Los Angeles and also broadcast on cable television.

The National Alliance for Media Arts and Culture (www.namac.org) maintains lists of U.S. festivals for media arts. The Association of Independent Video and Filmmakers (www.aivf.org) publishes the *AIVF Guide to International Film and Video Festivals,* by Kathryn Bowser, and also the *AIVF Exhibitors Guide*, both great resources for video artists and filmmakers.

Because their work can be easily reproduced, media artists can enter several festivals with the same work. Media artists also have the opportunity to enter international festivals and thus can develop an international exhibitions record for their resume. Inquire with NAMAC or with your media center about international opportunities.

Exhibitions Sponsored by Art Organizations

Belonging to art organizations often leads to exhibitions opportunities. Many sponsor exhibitions. Sometimes these are open only to members, but frequently anyone can participate. Because art organizations generally have an agenda that they want to forward, they will sponsor exhibitions dealing with themes and issues of concern to the group. Often, they will also have some program, such as a panel discussion, to accompany the exhibition.

The mission of one art organization, Raid Projects in Santa Ana, California, is to foster exhibitions of art in all kinds of spaces. Raid Projects maintains no permanent space of its own but sponsors several curatorial projects every year that are held in alternative spaces and galleries mostly in Southern California but also nationally and internationally. In this case, Raid not only creates exhibition opportunities for artists but also curatorial opportunities.

Juried Exhibitions

Juried exhibitions are art competitions that result in a group show. Artists are invited to submit images of work either based on a particular theme or using a specific medium. The competition may be open to artists in a particular region or may be national or international in scope. A juror, often a prominent artist or art professional, reviews the submitted images, either accepting or rejecting each work. Ju-

ried exhibitions are usually sponsored by universities, regional museums, and art organizations.

Benefits and Drawbacks for Artists. Entering juried exhibitions offers some advantages to artists. Juried exhibits are a good way to get your work seen by a prominent arts professional and by the public if it is accepted into the show. The exhibit can be added to your resumé, giving your work more credibility and boosting your confidence if you are just beginning to show your work. Because the theme of the exhibit is often topical or even controversial, juried exhibits give exposure to work dealing with strong political and social themes that might not be seen in commercial galleries. Artists can see many works dealing with the same theme. Some artists may be given cash prizes for excellence and/or purchase awards for the acquisition of their artworks. Catalogs are published for some juried exhibits, listing all accepted work, sometimes with images.

There are drawbacks to juried exhibits. Many artists object to the cost of such competitions. Most juried exhibitions charge entry fees, usually between $15 and $20 per entry. This forces the artists to subsidize the exhibition, which many see as unfair. It would be somewhat like charging musicians to perform a symphony, which the audience enjoys for free. Artists subsidize the exhibit whether they have been accepted or rejected, so you might be in the unhappy position of paying so that others can show their work. Artists also have to pay for crating and for shipping both ways if their work is accepted in a juried exhibit in another city. Such costs may be prohibitive. Sales out of juried exhibits are rare. Finally, juried exhibitions are not necessarily a stepping-stone toward exhibiting your work in commercial galleries or alternative spaces. Success here does not guarantee you any advantage in other venues.

Entering Juried Exhibitions. If you are interested in juried exhibitions, select only those juried by an artist or arts professional you respect and whom you want to see your work. If possible, enter only competitions in your area, so that you can hand-deliver work rather than paying for shipping and crating. Otherwise, submit images of pieces that will be inexpensive to ship. Enter only those exhibits that will be in reputable, high-profile, and well-maintained gallery spaces.

To submit images, you need a prospectus with essential information. This includes the following: the theme of the show; awards; the juror's name; deadline for the submission of images; fees; size and media limitations; location of exhibition; dates; procedures for delivering accepted work; and an application form. You can find announcements of upcoming juried exhibitions in the classified ads and display advertisements in the back of art magazines. Online, you can check the Art Deadlines List (artdeadlineslist.com) or do a search for "juried competitions."

Art Fairs

Art fairs are another kind of juried competition. Art fairs are usually weekend events that are held in cities across the United States. Artists are allotted spaces, usually about 10 feet × 10 feet in size, to display their art to the public. Artists are responsible for their own set up and tending to their booths, as well as talking to

passersby, finalizing sales, and handling money transactions. They are able to keep all proceeds from their sales.

There is a lot of variation from one art fair to the next in terms of the kinds of work they feature as well as the prices for work. Some of the high-end fairs feature paintings, sculptures, and prints ranging from $1,000 to $15,000. Others, of course, promote less-costly work. To be successful at fairs, artists usually attend the same ones repeatedly to build a reputation over the years.

The advantage of participating in art fairs is the opportunity to display and sell work to a broad segment of the general population. Because the main purpose of these fairs is to give artists an opportunity to sell their work, most art fairs have no stated theme to follow. Some fairs are limited to certain media or a range of media, for example, ceramics and craft art fairs.

Questions to Consider. Research an art fair thoroughly before entering one. How much will it cost you for a display area? How many persons attend a particular fair? What are the general price ranges for art? If the fair is held outdoors, what happens if the weather is bad?

Also, consider all your expenses. If the fair is in another city, you have hotel, transportation, and meal expenses. You may need a truck to transport your work. What about printed materials, such as price lists, artist's statements, business cards, invoices, and receipts?

You can get information about art shows through the ArtFair Source Book at www.artfairsource.com. There is an annual subscription to access this site. You can also find listings for art fairs in books on art marketing at local bookstores. *American Craft* magazine features the Craft Report, which is an excellent resource on all aspects of the craft business.

Art fairs reach a different audience than museums, galleries, and alternative art spaces. There is really not a lot of crossover between the two systems. Your participation in art fairs does not necessarily lead to exhibitions in alternative spaces, galleries, or museums.

Trade Shows

Trade shows are dedicated to a certain trade or product and are held indoors in convention centers. Some are dedicated specifically to art, whereas others are craft or gift shows. Others that might be interested in art are interior designer, office furnishings, or home shows. Generally, booths at trade shows carry high rents, in the thousands of dollars for a week- or weekend-long event, and are not venues sought out by emerging artists. Yet, if you can find a way to make it work for you, showing at a trade show will certainly expose your work to a wide range of the public.

Art Advisors

Like any other area of cultural or commercial life, the art world has intermediaries and facilitators. We look at a few here.

Art consultants are buyers' agents who primarily assist businesses that want to acquire art. For example, art consultants may collect a range of artwork to be placed in a new office building or hotel lobby. They might also assist a business located in a redevelopment area that must acquire art as part of a public art program. Art consultants do not operate an exhibition space and therefore are not a "venue" per se. However, consultants keep images and a large number of art objects in inventory for the convenience of business clients who want to purchase art but are uninterested or unable to search it out for themselves. Art consultants receive a commission from each sale of work.

Many artists seek out art consultants and make their work known to them. Especially in areas where there are a lot of public art commissions, art consultants can find markets for artwork. Art consultants generally favor artists who are reliable and produce work as agreed and on time. They avoid artists who do not follow through.

Working with art consultants is pretty much an all-business proposition for artists, because consultants do not give you an exhibition of your work or access to art critics. The clients are the only persons who will see your work while it is in the hands of the consultants. However, consultants may be able to arrange many sales for some artists. Some artists mass-produce the kind of work that a particular consultant can easily sell and are able to make a substantial amount of money.

The relationship between art consultants and the art world is complex. For artists, however, your business with art consultants is generally separate from your stature in the art world, which is dependent on your exhibitions and critical reviews. One caveat: If you are known to work with a number of consultants, some commercial galleries will not show your work because of overexposure and difficulties in establishing standard prices.

Artists' representatives are agents for artists, helping them promote themselves. Among other services, they advise artists on ways to present their work, approach galleries, and become known to critics. They charge fees that can be as high as several thousand dollars, which is generally a waste of money for artists. Most established art venues want to deal directly with the artist and will not work through a representative. You do not need someone else promoting your work. This book, your mentors, and your friends can tell you how to do it yourself.

artist interview

SALOMÓN HUERTA

Source: Photo by Carla Cummings Peña.

Salomón Huerta is a painter who lives in Los Angeles. His work has been shown in national and international galleries and museums, including the 2000 Whitney Biennial.

How should emerging artists begin to research galleries and other venues for showing their work?

While they're in school, they should be spending time with their professors, getting their recommendations about galleries, how to approach them, and things to watch out for.

And if they are out of school?

Look at the galleries showing work similar to yours or in a gallery you think would support the work that you do, and then try to get in through a referral. Make an effort to meet an artist from the gallery and show them your work. If someone who knows the gallery can recommend you, they will look at your work. But otherwise, it is unbelievable how many slides they get a day. They don't have time to even look at them.

Do some homework on the gallery. Find out about the dealer, and how they treat the artist, in every way, financially or do they just support the artist emotionally? How do they work with the artist; are they interested in moving the work? What kind of shows do they have and how do they treat the show?

In the same way, galleries also do homework on an artist, asking other artists, do you know this person? Is this an artist who's reliable? Are they going to come through? You're basically going for a job interview.

What else can emerging artists do?

I think it may be more difficult now, because the dealers are becoming like scouts, where they just go out and look for people. Some of them already have their lists and that doesn't leave room for anyone else to come in. But getting involved and meeting people is still important.

If nothing else is coming through, what I used to do was completely empty out the living room in my sister's house, paint all the walls and hang the work and have an opening at the house. You want to build up interest in the work and slowly build up a support system. So you follow through, you invite your supporters to events and stuff comes out of that.

How did you find your galleries?

I've been very fortunate that I've gotten in galleries through recommendations.

Emerging artists should be investing time meeting people—the more people they can meet and cultivate those relationships, the more doors they are going to have open.

So it's really about meeting people?

Yes. For me, the openings are never about seeing the art because you can't see the art. It's about meeting people and then following through. At first, I'd just invite them over for lunch—just to get to know them and see what they're interested in. You make the setting comfortable and warm, without being too aggressive or opportunistic. Then you invite them over to the studio or maybe take your slides with you.

You're really out to build a relationship, then? Or a friendship, even?

Yeah. And I don't deny that friendships do come out.

I think for me, the idea is to put them always in a center stage where you're getting to know *them,* instead of "I want them to know me."

And it is important to support their projects. If you want their support, also support them. If they're artists, go to their openings. And at least make an effort to be there and give a response to the work. Or if they're writers, read their reviews and maybe, if the opportunity is there, talk about them, but in a constructive way. Anything that will get you close to these people who do have access to help. Maybe you meet a hundred people but only two really will be able to help, but two can open doors for you.

There's going to be a lot of stuff going on, and you have to find a way to keep it all positive.

Salomón Huerta, Untitled, 1999, oil on
canvas, 34" × 74"

Source: Photo courtesy of Patricia Faure Gallery.

Is it important that the artist keep things positive?

Yes! I heard stories of a certain gallery that is always promoting younger artists. The
dealer puts them in the spotlight. But then they leave for other galleries with better
opportunities, and how they leave is very rude!

If the gallery you're with is not going to take you where you need to go, and the
gallery is aware of that, I would leave in a way that would really show my sincere
appreciation of the dealer. You do have to give something to this person to thank
them for what they did, for believing and investing time to get you through. What
goes around, comes around.

How do you balance doing all the social obligations and protecting your creative time?

Earlier on, when things were moving pretty slowly, I was really comfortable with painting three days out of the week, and I had a lot of time on my hands, even though I was barely making ends meet.

And then I got invited to the show in Mexico City, and I went from painting three days a week to painting every day. Then from Mexico City, to the Whitney to a show in Verona to my show at the Patricia Faure Gallery—it was a very horrible experience because I was painting every day and I was burned out by the middle of it. I started to hate painting. I was having a lot of problems physically, but emotionally, I was driven to just keep on going and I think I made a breakthrough. I finally realized that I do not control the work. And the best way for me to be successful with the work is to just work and not worry about when it's going to be finished or where it's going to go or is it going to sell. Just let it be.

One artist I know told me how he had simplified his life. He has a small circle of friends who he invests a lot of time with—and everything else was about the work. He tries not to do too many errands, no more than two a day. Even though he can squeeze it in, he won't fit it in.

And I have a bad habit of squeezing things in. I say, "I can do it. Let's get it over today." But what happens—that running around carries over to the next day. So I'm trying to avoid doing that.

But you still socialize.

Yes, we have people over for dinner, and we have fun dinners. You can organize your socializing that way, too. In other words, you set aside a certain time when you'll do it, and then you do it with gusto.

I told my sister—because I live with my sister—I told her, "Let's not have these dinners during the week anymore." Just on weekends. I don't want to see people during the week, but just work and maybe hike a bit. If I'm consistently doing this, my body will get into that rhythm.

I'm planning on getting a house, and I want to design it so it's strictly for entertaining people, with maybe two rooms for my private use. The idea is, for me, to continue to have these connections with people so that I can continue doing what I want to do.

And how does your work develop through all this?

The galleries, the deadlines, and the demand for the paintings don't always work side by side with being creative.

I got recognized for a particular image—my paintings of these shaved heads. I've had a lot of shows, and maybe I want to move onto something new. But with painting, if you are going to have that body of work in New York and in Europe, you've got to do it again. It's really a mistake to always try to create something

new. I don't want to risk losing the momentum of people who are interested in the old work.

You want any newness to come out on its own time, when it's ready to come out. In between shows, I try to work on something new. And when I have a new image, I bring out only one painting—the one I'm most comfortable with—and I bring it out slowly. Once I get a positive response from the studio, then I take it to the gallery. Then the gallery does the same thing—showing it to collectors and writers. They have to get approval from them also, because they have to pay the bills. After the approval is there, I will do more.

This can be very difficult, but in the back of my head, everyday, I'm constantly working on a new image. I am always looking for ideas, whether going to the movies or to magazine stands or going to see other artists. I am looking. Every single thing about my life revolves around the work.

That is an incredible focus.

I try to keep it fun. Otherwise, it becomes very dry and very businesslike and very stressful. But I'm trying to enjoy the process and realizing that the end product is not really what you're working for.

What are you working for then?

To enjoy making art. To enjoy today. To enjoy learning about yourself and the work and to celebrate life. And at the end, it becomes the big birthday party or the big wedding or the big something. And at the end, you start all over again.

Anything else?

Yeah, I have one thing: Spend a moment in the evening and the morning meditating or visualizing on what you want. And to be clear about it, be very exact. Visualize in detail so that when it happens, it will be what you visualize and you will be happy with it. In the morning and in the evening. It's a very healthy way to get you ready or to get you closer to what you want.

8

Artist/Gallery
Relations

After sending out many packets and researching art venues, your hard work has paid off. A gallery, alternative space, or institution has expressed interest in showing your work. This chapter covers what you might expect in ideal circumstances from galleries and institutions, and also what to expect in the less-than-ideal, "real-world" circumstances.

First, we look at commercial galleries, what to expect from your first shows with them, and what to expect in subsequent association with them. Discussed later are the concerns for the artist showing at alternative and institutional spaces. Finally, we look at self-promotion in relation to showing in a gallery.

Showing Your Work at a Commercial Gallery

Developing a Partnership

Suppose that a gallery is interested in your work, and you are interested in showing with them. You are looking at not only a chance to have a show but a chance to develop a long-term partnership with them.

The purpose of the artist/gallery relationship is to sell artwork. On one level, it is purely business. However, it is also a personal relationship between the artist and the dealer based on mutual artistic respect, trust, and perhaps also friendship. The dealer is entrusted with the important role of presenting the artist's work to the public, curators, collectors, and the press. The success of the artist and dealer is interdependent; for one to prosper, both must do well. The dealer should be genuinely enthusiastic about the artwork, confident in the artist's worth and able to convince curators, critics, and collectors of its importance. Artists contribute to the

success of the gallery through the strength of their artwork. But also important are the artists' own connections with the press, museum personnel, or collectors that they can bring to the gallery and build its base of support. As New York painter Peggy Cyphers said:

> Dealers really love to be around artists and art, and most of them are living out a dream. They love the whole creative thing that happens around art, and that's a good dealer, someone who is in there out of passion. And artists can't think about this just as a business. It is a way of life. Artists have to initiate creative things. You have to invest in yourself in a way. After you get a gallery to represent your work, you can't just sit back and expect them to do everything. You are always networking. You always have to be out there.

Like any other relationship, the artist/gallery relationship builds over time. The first steps are outlined below.

Consignment

Often, when a gallery director expresses interest in your work, you will be asked to leave a few pieces with the gallery on consignment. Consignment means to ship or send work to a dealer who then pays the artist for what is sold and may return whatever is unsold. The gallery director will then show your work to clients, collectors, critics, and other gallery artists for their reactions. This often happens before you would be offered a show at that gallery.

Several states (including Alaska, Arizona, Arkansas, California, Colorado, Idaho, Illinois, Iowa, Kentucky, Massachusetts, Minnesota, Missouri, Montana, New Hampshire, New Jersey, Ohio, Oregon, Pennsylvania, Tennessee, Washington, and Wisconsin) have laws that regulate consignment. The following points are covered in most of the states' laws:

- The artist retains ownership of works on consignment, despite the fact that they are in the dealer's possession and the dealer has the right to sell them.
- The dealer is responsible for all loss or damage to the artwork while on consignment.
- Artists receive their share of the proceeds of a consignment sale first, before the dealer receives any monies, unless the artist otherwise agrees in writing.
- Artwork left on consignment cannot be claimed by creditors in the case of the dealer's bankruptcy.

Never leave a work with any gallery or exhibition space without receiving a consignment agreement for it. A simple consignment form should clearly identify each individual piece, listing title, media, size, and date, when the gallery received your work, and the agreed retail price (Figure 8-1). Some artists and some galleries prefer using more complex consignment forms that may also list information about the condition of the work, whether it is part of a series, and whether it is framed. There may also be clauses about the time period of consignment, insurance, images, general expenses, whether the retail price could be discounted, whether the artist or the gallery absorbs the discount, and the artist's dealings with collectors (Figure 8-2). If

G W E N D A J A Y **GJA** A D D I N G T O N

To: Margaret Lazzari

Gwenda Jay/Addington Gallery received from you on consignment:

artist _____Margaret Lazzari_____

title _____"July Head Series VIII" 1990_____

date _____1990_____

medium _____mixed media on paper_____

size _____

value _____$700_____

artist _____

title _____

date _____

medium _____

size _____

value _____

artist _____

title _____

date _____

medium _____

size _____

value _____

Gwenda Jay/Addington Gallery will receive __50%__ commission on sales.

Signed _____ _9/23/93_ Date

704 North Wells
Chicago IL 60610
tel 312 664 3406
fax 312 664 3388
www.gwendajay.com
gwendajay@rivernorth.net

FIGURE 8-1 | **Basic consignment form**

All consignment forms should contain at least this much information.

CONSIGNMENT AGREEMENT

Date: _____

1. _____ [Gallery, Dealer or Consultant] acknowledges receipt of the following consigned artworks:

a. Title: _____

Size: _____ Series: _____

Date: _____ Condition: _____

Retail Price: _____ Framed: Yes/No

b. Title: _____

Size: _____ Series: _____

Date: _____ Condition: _____

Retail Price: _____ Framed: Yes/No

c. Title: _____

Size: _____ Series: _____

Date: _____ Condition: _____

Retail Price: _____ Framed: Yes/No

d. Title: _____

Size: _____ Series: _____

Date: _____ Condition: _____

Retail Price: _____ Framed: Yes/No

2. This agreement is applicable only to the artworks listed above. The gallery/dealer/consultant is not a general agent for any other works.

3. Term of consignment is _____ months.

4. Commission to gallery/dealer/consultant is _____%.

5. Discounts may not exceed 15% of the retail price. Discounts shall be split between the artist and the gallery/dealer/consultant.

6. Copyright and reproduction rights to these works are reserved by the artist. No works may be copied or reproduced without consent of the artist. All purchasers will be informed that the artist retains copyright.

7. Artist shall be paid within 30 days of the sale of a work. Artist retains title to works until paid in full. Gallery/dealer/consultant will provide the artist a quarterly statement documenting all transactions.

8. Gallery/dealer/consultant will provide the artist with the names and addresses of all purchasers of the artist's works.

9. Gallery/dealer/consultant is responsible for any lost, stolen or damaged work. Consigned works are held in trust for the artist and are not subject to claim by creditors of the gallery.

10. This agreement may be terminated with thirty (30) days notice by either party. All consigned artwork will be returned to the artist within 2 weeks (14 days) of termination at the expense of the gallery/dealer/consultant.

Agreed:

_____ _____
Gallery/dealer/consultant Date

_____ _____
Artist Date

FIGURE 8-2 | Detailed consignment agreement

Consignment form containing clauses that artists may find beneficial. You may add or drop clauses to suit your particular needs.

there are clauses that you want to change, add, or delete, negotiate to have that happen. The consignment form should represent the agreement you have with your gallery. All consignment forms should be signed by a representative of the gallery; some are signed by both the gallery and the artist.

First Shows at Commercial Galleries

If you are offered a show at a gallery, here is what you are likely to encounter, whether it is to be a group or individual exhibition.

You should discuss the upcoming exhibition at length with the gallery owner. The points below outline the typical artist and gallery responsibilities. But not all galleries are alike (nor are all artists!). Well-established galleries with large staffs will provide you with the most services but also maintain more control over the entire exhibition process. You may be showing with such a gallery. Or your gallery may be very new itself or a hybrid of a commercial gallery, cooperative gallery, and alternative space. In these instances, you may collaborate with the gallery owner to generate press releases, hang shows, or do any of the other tasks below.

- The artist is usually responsible for completing the work in time for installation and for getting the work to the gallery (see "Shipping Art" below).
- The gallery normally generates all publicity for shows including writing and sending press releases, making follow-up calls to the press, and printing and mailing the show announcements.
- The gallery normally pays for all publicity, reception, and staffing costs.
- The gallery should carry insurance covering all work on its premises.
- The dealer sets the retail price of your work.
- The dealer or director has ultimate control over where the art is placed in the gallery and what other work is next to it, although artists often have much input on these points.
- Usually, the artist receives fifty percent for all work sold through the gallery, whereas the gallery retains fifty percent for its profit and to cover its expenses and overhead.
- The dealer should inform you immediately of all sales and give you the name and address of collectors who purchase your work.
- Galleries should remit to artists their percentage of sales once a month, so you should expect to be paid for sold work within thirty days.
- Artists should be paid in full for all installment sales before the gallery receives its cut.
- If you sell work directly from your studio, you and the dealer should discuss this thoroughly in relation to the work sold in the gallery. Issues such as pricing and who gets the best pieces are important.
- Artists generally deal with only one commercial gallery in a metropolitan area. Showing with more than one is usually too much competition for the galleries. You may show your work concurrently in a noncommercial gallery, such as a college gallery, but let your commercial gallery dealer know in advance.

Your agreement with your gallery may vary from this, but be sure you both understand all points before agreeing to the exhibition. At this point, you may or may not be offered a contract with the gallery. (We discuss gallery contracts below.) Your consignment form may be thorough enough to take the place of a contract. If not, draft a letter (Figure 8-3) to the gallery outlining all the points of agreement. Make sure you have your agreement in writing.

By law, the gallery must provide you with an end-of-the-year accounting of the sales of your work. The end-of-the-year accounting may be simply the 1099 form prepared for tax purposes that lists the sum total of payments the artist received from the gallery that year.

Shipping Art

Packing Art. Generally, it is the artist's responsibility to ship art to the gallery and the gallery's responsibility to return all unsold work. If you are taking work across town, you can deliver it yourself in a car or truck. Wrap your artwork to protect it from breakage, scrapes, and friction damage. Bubble wrap, cardboard sheets, and blankets are usually sufficient padding. Place padding on the floor of your vehicle underneath all the artwork. If sending several framed pieces, try to pack them upright rather than laying flat. Arrange them in front-to-front and back-to-back sequence. Do not let the screws and hanging devices on the backs of one frame scrape against the front of the work next to it. Make sure your frames are aligned so that the frame of one artwork is resting against the frame of the next. The frame of one piece may break the glass or Plexiglas covering another and damage your art.

If shipping art out of town, you may have to build a wood crate for the work. Plan your crate so that it is larger all around that the artwork itself, to allow for padding between the crate and the art. Construct the entire box solidly, by using glue and screws, except for the lid, which should come off easily with screws only. Remove any glass from artwork, or tape over it to help prevent breaking. Cover the artwork with plastic to guard against water damage. Pad the artwork with bubble wrap, packing "peanuts," or rolled or wadded newspaper (Figure 8-4).

Before sealing your crate, put in a sheet with the name and title of the artwork, the person who is to receive the work, and the address to which it is to be sent. Screw on the lid of the crate, and put the shipping address again on the outside.

Wooden crates have many drawbacks. They are expensive to build, take a lot of time and special tools, and weigh a lot and increase the cost of shipping. Some artists use a simpler alternative for sending flat artwork such as paintings. They wrap the painting first in plastic, then in bubble wrap, and finally put a layer of cardboard over the bubble wrap. All these layers are held on with packing tape. This kind of wrapping does not give as much protection as a wooden crate but is generally sufficient if you are sending packages via air shippers.

Shippers. Here are some shippers you might use to transport your artwork:

Fine art shippers: These are companies dedicated to packing and shipping high-priced or precious art. They mostly operate in and between large cities. They are the most expensive of all shippers, but they also give the highest quality service.

May 12, 2001

(Artist)
(Address)
(Telephone number)
(E-mail)
(Web site)

(Dealer)
(Gallery)
(Address)

Dear (Dealer);

It was such a pleasure to meet with you two days ago and discuss the details of my upcoming exhibition at your gallery! I am very much looking forward to showing my work with you. I wanted to drop you this note reviewing the specifics of our agreement, to confirm my understanding of our discussion.

(E-mail)

Specifically, you will mount a solo exhibition of my sculpture in your main gallery from February 17, 2002 to March 30, 2002. My drawings will be displayed in the back gallery. You will receive a 50% commission on all sales of work. Discounts of up to 15% may be given, and the discount split between us. We will mutually agree upon and set retail prices for work. All drawings will be framed by the gallery's regular framer, at my expense.

As we discussed, the gallery will pay for the designing, printing and mailing of an announcement with a color image of my work. Both you and I will approve the image used and the design of the announcement. I will send you a complete set of slides two months before the exhibition, for images for the announcement. The announcement will be sent to the entire gallery mailing list and to 200 persons on my mailing list. In addition, you will provide me with 100 extra announcements for my own use. I am sure they will be well used in the future.

All publicity will be generated by the gallery, including a quarter-page black-and-white ad in *Art/Talk* magazine. The gallery will also provide refreshments for a reception on the evening of March 2, 2002.

Please let me know if there are any inaccuracies in this letter, so that we can reconcile them. In the meantime, I will begin documenting the work already completed for the show. I am sure we will be in touch often. Thank you again for this wonderful opportunity.

Best Regards,

(Artist)

FIGURE 8-3 | **Letter of agreement**

Artists can write a letter to verify an oral agreement when there is no written contract with a gallery. Of course, the letter you write will reflect the terms of your particular situation.

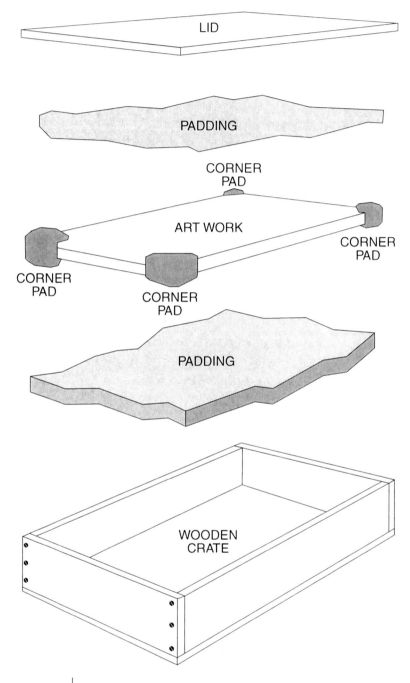

FIGURE 8-4 | Packing an artwork in a wooden crate

Make a wooden crate for shipping any fragile work.

Air freight and package delivery companies: These are companies such as UPS, FedEx, and a host of other smaller firms. They are the more moderately priced shippers. There are size and weight limitations on packages they will handle, so call for specifications. Some refuse to handle artwork at all because of its high price. Some will handle art but with some restrictions. Again, call the companies and find out, as each follow different rules.

Truck freight: With trucks, you can ship heavy and large artwork. Truck service is generally slow and more expensive than air freight. Call for prices and specifications.

U.S. Postal Service: The post office will handle packages weighing less than seventy pounds and less than eighty-four inches combined length and girth. Their prices are moderate.

Moving companies: They will move large, heavy items but may take several days or even weeks.

Shipping is always more expensive if your package has to arrive the next day. With planning, you can take advantage of lower rates with slower service. Once you have explored all these options, check to see if it will be less expensive for you to rent a truck and transport your art yourself. Remember to figure in extra costs you will incur, such as food and lodging.

Finally, remember to factor in packing and shipping costs when you price your work. If it costs you a significant amount to ship your art, you should recoup that in the sale price.

Evaluating Your Experience with Your Gallery

What has been your experience with a gallery after a few months or years?

- Has the dealer shown your work to collectors, critics, and curators?
- Has the gallery informed you of sales and paid you promptly?
- Does the gallery have good business practices?
- Is the dealer interested in the direction your new work is taking?
- Do you respect the other art shown in the gallery?
- Does the dealer speak about your work intelligently?
- Is the gallery well maintained?
- Does the gallery publicize your work well?
- Is your work handled well, or does it suffer slight damages with every handling?
- Does the dealer honor your agreements with the gallery?

There are two sides in building any relationship, so evaluate your performance as well as the gallery's. Have you done your part in building a good relationship with your gallery? Have you visited the gallery regularly and attended as many gallery events as you can? Have you kept your images and resumé updated? You should keep your dealer informed of other shows and sales you have. If your work is showing and doing well in other regions, the gallery dealer may be more enthusi-

astic about your work and perhaps better able to sell it to collectors. Do you know your dealer's own goals and aspirations? Try to get to know the dealer very well.

Keep good records of your dealings with the gallery, retaining consignment forms, copies of correspondence, and check stubs from work sold. Bring in some new work to replace pieces the gallery has had for a while. Insist on timely payment after a sale. Sometimes, galleries experience financial difficulty. You may choose to let them pay you in installments. However, it is not wise to allow the gallery to fall behind on payments for too many months, because you may never be paid at all if they go bankrupt. And on rare occasions, dealers have proven to be dishonest, keeping all proceeds and leaving town.

Hopefully, you have been generally pleased with your gallery. If not, try to correct the situation. If necessary, look for other options. This could mean finding a new gallery. But remember the self-promotion ideas we covered in Chapters 3 and 4.

Long-Term Relationships with Established Galleries

Some artists and galleries enter into long-term relationships that involve representation. Representation means that the gallery will invest extra monies and efforts into your career development, and in exchange you agree to grant them some exclusivity. Before looking further into these terms, please note that only a few artists have this kind of arrangement with a gallery, and the exact terms of the agreement can vary tremendously.

In long-term artist/gallery relationships, the artist generally grants the gallery some degree of exclusivity. The gallery becomes the artist's sole agent in some specified ways. With exclusivity, the artist sells work only through that one gallery, not through any other gallery and not directly from the studio. Exclusivity has limits. So, a gallery may be the only outlet for the artist's work either in a metropolitan area, a region, the nation, or the world. In addition to discussing the geographic limits of exclusivity, the artist and dealer should specify exactly what each means with exclusivity. Some dealers are very loose, encouraging artists to show work at every available opportunity, and merely requesting that the artist notify the dealer of all exhibits outside the gallery. Other dealers are very restrictive with exclusivity, deciding for the artists where else they can show.

With exclusivity, the dealer can claim a commission on the work the artist shows and sells elsewhere. This applies whether that sale was made within the geographic area of exclusivity or outside it. Usually, such a commission is twenty to forty percent.

Exclusivity is advantageous to the gallery when an artist's work sells well. But exclusivity is a point of great concern to artists entering a long-term relationship with a gallery, because it limits other potential outlets for the work. Once they have made such an agreement, however, artists should honor it and inform the dealer of all their activities.

In exchange for exclusivity, the dealer agrees to give the artist regular solo exhibitions, usually one every eighteen to thirty-six months, depending on the artist's rate of output. The dealer also agrees to invest extra energy and funding into the artist's career. Thus, the gallery on occasion may publish a color catalog of work

SAMPLE ARTIST-DEALER CONTRACT

AGREEMENT made the _____ day of _____, 20__, between _____, a [*Corporation*] with principal offices at _____ (the "Gallery") and _____ (the "Artist"), presently residing at _____.

WHEREAS, the Gallery desires exclusive representation of the Artist and the Artist's work under the terms and conditions specified in this Agreement; and

WHEREAS, the Artist desires to be represented by the Gallery under such specified terms:

NOW THEREFORE, in consideration of the foregoing premises and mutual covenants hereinafter set forth, the parties agree as follows:

1. TERRITORY. The Gallery shall be the exclusive representative and agent for the sale and exhibition of the Artist's work in _____ [*city, country, continents, the world*].

2. TERM. The term of this Agreement shall be for a period of _____ years [*one/two/three years; two years preferred*], beginning on _____, 200__ and ending on _____, 200__. This Agreement will renew itself for additional periods of _____ year(s) [*one or two*] each with a new Agreement to be signed by the parties for each additional term, unless either party gives the other notice of an intention not to continue within sixty (60) days prior to the expiration of this contract. During the additional periods, if the parties do not confirm new contract terms in writing, either party can terminate the Agreement as of the end of any month, on a minimum of sixty (60) days prior written notice to the other party.

3. EXHIBITIONS. The Gallery agrees to hold at least one one-person exhibition of the Artist's work at the Gallery during the initial _____ year term of the Agreement. If the Agreement is renewed, the Gallery agrees to hold at least one one-person exhibition of the Artist's work during that term. The Gallery may choose from time to time to include the Artist in group shows at the Gallery and, as the Artist's exclusive agent and representative, shall use its best efforts to obtain both one-person exhibitions elsewhere and have the Artist's work included in group shows in other galleries, museums, and alternative spaces.

4. CONSIGNMENT. The Artist will consign to the Gallery and the Gallery will accept consignment of certain works mutually selected by the parties, and upon receipt, the Gallery shall set forth in writing such acceptance in a consignment letter, in the format of Addendum A (see p. 14), which specifies the title, medium, size, date, and agreed selling price of each work consigned and the length of consignment. If the letter of consignment does not specify the length of consignment, the consigned works may be retained by the Gallery for the initial term of _____ [*six (6) months/one (1) year/through the first one-person exhibition*], unless this Agreement is terminated, in which case the Artist's works will be returned according to the terms set forth in Paragraph 15. At the end of the term of consignment, the works may be individually removed, if so desired by either party, on five (5) days prior written notice. Those works by the Artist that both parties agree shall remain at the Gallery for an extended period of consignment and all new works consigned to the Gallery shall be set forth in an amended or newly executed letter of consignment setting forth the title, medium, size, date, and agreed selling price of each work on consignment. These letters of consignment shall be annexed to this Agreement and considered a part of this Agreement.

5. COMMISSIONS. The Gallery shall receive a commission of fifty percent (50%) of the selling price of each sold work. In the case of discount sales, the Artist and Gallery shall split the discount up to _____ percent [*10%, 15%, 20%—20% is common*] of the agreed selling price. Any discount in excess of _____ *(above specified percentage)* percent of the agreed selling price shall be deducted from the Gallery's commission, unless the Gallery obtains written approval by the Artist. Discounts shall only be given

FIGURE 8-5 | **Sample artist-dealer contract**

Source: Reprinted with permission of Laurie Ziegler.

to museums, foundations, curators, galleries, private dealers, and good clients of the Gallery. Any other discounts may only be given with the Artist's written approval. In the event of studio sales by the Artist that fall within the scope of the Gallery's exclusive territory, the Gallery shall receive a commission of _____% [*30%, 40%, 50%—40% is common*] of the agreed selling price for each work sold in the Artist's studio, unless other arrangements have been agreed upon in writing or, if the Gallery has acted as the Artist's agent and representative and arranged for the sale, the Gallery shall receive a commission of fifty percent (50%). The Gallery shall not receive a commission on the sale of the Artist's work sold to family members or close friends. Works done on a commissioned basis by the Artist shall be considered studio sales in which the Gallery may be entitled to fifty percent (50%) commission, unless the commissioned work was arranged by the Artist's agent and representative from a territory not covered by this Agreement, in which case the Gallery agrees to no commission. If the commissioned work was arranged by a nonexclusive agent, who works with the Artist to obtain such private and public commissions, the Gallery agrees to accept a commission of _____% [*10%, 20%*], unless other terms and conditions are agreed upon between the Artist, agent, and the Gallery and such terms and conditions are set forth in a writing signed by the parties. The Artist may make gifts or donations of his/her artwork as he/she chooses without any interference or commission to the Gallery. The Artist may also exchange his/her works for other Artists' works or barter without the Gallery receiving any commission. The Gallery may not make a gift, donation, or barter of the Artist's work without the Artist's written approval. The Gallery may purchase, on occasion, the Artist's work at fifty percent (50%) of the agreed selling price. The Gallery may not resell such work for _____ [*one, two*] year(s) without written approval from the Artist.

6. PROMOTION. The Gallery shall make good faith efforts to promote and sell the Artist's works at the expense of the Gallery. The Gallery agrees to advertise and publicize the Artist's work, to arrange for other exhibitions that feature the Artist's work, and to work with other galleries to promote the work. [*Optional: to produce a catalogue for at least one of the Artist's one-person exhibitions during the term of this Agreement (depends on such factors as the Gallery's financial ability to produce a catalogue and the Artist's status—first show versus established artist)*]. The Artist agrees to cooperate with and to assist the Gallery in promoting and publicizing the Artist's works, including the furnishing of names and addresses and other data regarding existing collectors of the Artist's work.

7. AGREED SELLING PRICE. The Gallery shall set the retail price on each work and will give the Artist a list of the prices for the Artist's approval. The Artist shall have the right to object to any prices. If the Artist objects to any prices, the Gallery and the Artist shall discuss and reach agreement on the price and upon the reaching of such agreement, the Gallery shall set forth the agreed selling price for each consigned work in a letter of consignment, including the terms specified in Paragraph 4. The Gallery and Artist shall re-evaluate the agreed selling price of the Artist's work at the end of each year, unless either party deems it necessary to do so on other occasions to dictate to the conditions of the market. All such changes shall be set forth in an amended or newly executed letter of consignment.

8. PAYMENTS. The Gallery shall pay the Artist all proceeds due to the Artist within thirty (30) days of payment by the purchaser to the Gallery or, in the event the Gallery is the purchaser, within twenty-one (21) days of such purchase. No sales on approval or credit shall be made without the written consent of the Artist and in such cases, the first proceeds received by the Gallery shall be paid to the Artist until the Artist has been paid all proceeds due, as required in the consignment statute of the state whose laws govern this Agreement. All works are considered consigned until the Artist has been fully paid for the sale of the sold work and no works of art will be released by the Gallery to the purchaser until fully paid for, unless the Artist has given his/her written consent.

FIGURE 8-5 | continued

9. ADVANCE PAYMENTS. The Gallery may, in its discretion, make advance or stipend payments to the Artist in advance of the sale of the Artist's work. Such stipend payments shall be set off against future sales and amounts due to the Artist. If this Agreement is terminated and the Gallery is entitled to repayment of advances in excess of the amount otherwise owed to the Artist as a result of sales of the Artist's work, Artist agrees to repay the Gallery said excess, unless both parties agree, in an informal writing, that the Gallery shall accept an exchange of the Artist's work in lieu of cash to cover the amount owed to the Gallery.

10. SECURITY INTEREST. The Artist reserves title to and a security interest in any and all works by the Artist consigned to the Gallery or proceeds of sale under this Agreement. If the Gallery defaults in making any payment due to the Artist, in accordance with Paragraph 8 above, the Artist shall have all the rights of a secured party under the Uniform Commercial Code. The Artist's works shall not be subject to claims by the Gallery's creditors. The Gallery agrees to secure the artist at the time of consignment by signing and delivering to the Artist a financing statement, Form UCC-1, and such other documents as the Artist may require to perfect his/her security interest in the works. The Gallery agrees to sign the financing statement, Form UCC-1, and return it to the artist for recording promptly after the Artist submits the UCC-1 forms to the Gallery. The Artist agrees to sign and file a Form UCC-3 termination statement for each of the Artist's works sold by the Gallery, after the Artist receives full payment for the work. The Artist shall retain title to all of the works consigned to the Gallery until the Artist is paid in full by the Gallery. The Gallery agrees not to pledge or encumber any of the Artist's works in its possession and not to incur any charge or obligation in connection therewith for which the Artist may be liable.

11. ACCOUNTINGS. The Gallery shall furnish the Artist with a quarterly accounting listing all sales made during that period; the name of the purchaser of each work sold, including the address of the purchaser; the date of purchase; the selling price and the discount given, if any; the allocation of the proceeds between the Artist and the Gallery; the amounts paid to the Artist during the said accounting period; and the amounts, if any, remaining due to the Artist.

12. INSPECTION OF THE BOOKS AND RECORDS. The Gallery shall be responsible for the maintenance of accurate books and records with respect to all transactions entered into by or on behalf of the Artist. The Gallery will permit the Artist or, on the Artist's written request, the Artist's authorized representative, to inspect these books and records during normal Gallery business hours.

13. DOCUMENTATION. The Gallery shall document all of the Artist's work consigned to the Gallery. Such documentation shall include, but not be limited to, photographs and slide transparencies of each consigned work. The Artist shall receive at least one color slide transparency of each consigned work at the expense of the Gallery. The Gallery shall provide the Artist access to and permit him/her to have extra copies of all photographs, transparencies, catalogues, and other materials pertaining to the Artist's work at any time during this Agreement, at the Artist's expense, unless otherwise provided for in an informal writing between the parties. At the termination of this Agreement, the Gallery must provide the Artist with any and all documentation of the Artist's Work at the expense of the _____ [Gallery/Artist].

14. CRATING, SHIPPING, INSURANCE. The Gallery shall pay all crating and shipping expenses of the Artist's works from the Artist's studio to the Gallery and from the Gallery back to the Artist's studio or storage. The Gallery shall be responsible for arranging for the crating and shipping of any and all the Artist's work to be sent to other exhibitions arranged by the Gallery. The Gallery shall be responsible for loss or damage to the consigned work at the gallery and work by the Artist that may be forwarded to other exhibitions arranged by or through the Gallery, unless the third-party gallery has assumed responsibility for any loss or damage while the Artist's work is in transit to, at, or being transported from its Gallery and such responsibility has been set forth in a writing between the _____ [Artist—if the third-party gallery represents the Artist in other territories;

FIGURE 8-5 | continued

Gallery—if the Gallery arranged the show at the third-party gallery] and this third-party gallery. The Gallery shall insure each of the consigned works for at least fifty percent (50%) of the agreed selling price. Such insurance will protect the work from the moment the Artist's work leaves the Artist's studio until the work is sold and paid for in full or returned to the Artist's studio. In the event of loss or if the Artist's work is damaged and the restoration is not an unreasonable expense to or request of the Artist, the Artist shall receive the same amount from the Gallery or the Gallery's insurance carrier as if the work had been sold at its agreed selling price. The Gallery shall insure the Artist's work with an insurance carrier in the State of _____ and rated "A" or higher by _____ [*a reputable insurance company*] or its equivalent.

15. TERMINATION. This Agreement shall be terminated at the end of the specified period, unless both parties enter into a new written Agreement extending or amending the terms of this Agreement. This Agreement may be terminated with sixty (60) days written notice to the other party if the Gallery fails to make prompt payments under the terms of this Agreement; or the Gallery changes its ownership, location, or identity; or if either party fails to act in good faith and/or use reasonable efforts to promote the sale of the Artist's work at the Gallery. Upon the event of such termination, the gallery shall have the sixty (60) days above specified to settle and transfer to the Artist the balance due to the Artist and to return all unsold works to the Artist. This Agreement may be terminated immediately if either party dies or the Gallery becomes bankrupt or insolvent and all works by the Artist shall be returned at the expense of the Gallery, unless it can be proven that the Artist has acted in bad faith and payments due to either party shall be paid within _____ [*7, 14*] days of said termination. In the event the Gallery becomes bankrupt or insolvent, payments due the Artist will be made before other creditors are paid and the Artist's works consigned to the Gallery shall not be subject to the claims of other creditors.

16. COPYRIGHT. The Gallery shall take all steps necessary to ensure that the Artist's copyright to the Artist's works is protected and shall inform all purchasers of the Artist's works that the Artist has retained the copyright and the copyright is not being transferred with purchase.

17. ASSIGNMENT. This Agreement shall not be assignable by either party hereto, provided, however, that the Artist shall have the right to assign money due him/her hereunder.

18. ARBITRATION. Any controversy or claim arising out of this Agreement or of a breach thereof, in excess of the jurisdiction of the Small Claims Court, shall be settled in arbitration in _____ [*city, borough, county*], in the state of _____, by and in accordance with the rules of the American Arbitration Association, and in accordance with the laws of the state of _____. The arbitrators' award shall be final, and judgment may be entered upon it in any court having jurisdiction thereof.

19. GOVERNING LAW. This Agreement shall be governed by the laws of the state of _____.

20. ENTIRE AGREEMENT. This Agreement represents the entire Agreement between the Gallery and the Artist and supersedes all prior negotiations, representations, and Agreements, whether oral or written. This Agreement may not be modified in whole or in part except by written instrument signed by both parties.

IN WITNESS WHEREOF, the parties hereto have executed this Agreement on the day and the year first written above.

[*NAME OF GALLERY*]

By: _____
[*Gallery Owner or Director with contract-signing capacity*]

By: _____
[*Artist*]

FIGURE 8-5 | continued

from the artist's show, an important tool for attracting collectors and for interesting museum curators. The dealer should also promote the artist's work energetically and actively to collectors, critics, and museums and make contacts for the artist for shows with prominent galleries in other cities. The gallery should maintain complete documentation of the artist's work, including a complete set of reproductions, resumé, statements, and reviews, and should duplicate and mail complete packets whenever necessary to further the artist's career. The dealer also may try to "place" the artist's work with prominent collectors rather than simply sell the work to anyone off the street. Thus, the best work should be reserved for important collections. With exclusivity, the dealer sometimes agrees to pay for some expenses that artists usually bear, such as framing, crating, and shipping costs. Commissions may remain the same whether you and the gallery have a long-term agreement or not.

All of the above points are negotiable, especially the area of exclusivity, frequency of solo exhibits, commissions, and covered expenses. The artist and dealer should establish the length of time for which this agreement is in force. Try to get the best terms possible for yourself.

Once you enter into a complex agreement such as representation, you need a contract. Figure 8-5 is a sample artist-gallery contract. It can be modified to fit your particular situation. Take great care before entering into such a contract. Consult your local chapter of the Volunteer Lawyers for the Arts for assistance. Generally, you can find them by adding your state's name to their title, such as "Georgia Volunteer Lawyers for the Arts" or the "Colorado Lawyers for the Arts." Check your state art agency's Web site for listings, or do a Web search for "lawyers for the arts." They are also listed on the National Endowment for the Arts Web site (www.arts.endow.gov).

Such contracts are too rare in the art world, as many artists and dealers rely on good feelings or vague oral agreements. However, both dealers and artists profit when a contract is signed between them. Vague or tentative commitments are made firm, and the possibility of misunderstandings in oral agreements is greatly reduced. Perhaps the greatest value to the contract is that the relationship is given a definite time frame and procedures for evaluating, continuing, or breaking off at that time. Dealers gain because the efforts they make to build an artist's career will not be undermined by lack of exclusivity or by the artist's leaving for another gallery while the contract is in force. Artists gain because they are assured regular exhibits, promotion for their work, timely payment, regular accountings, and the ability to seek another gallery after a specified period of time if they choose. In addition, other issues such as shipping costs, insurance, discounts to collectors, and commissions on studio sales can be worked out to the satisfaction of both parties.

Showing in Alternative Spaces, Museums, and College Galleries

When showing at alternative art spaces, museums, or college galleries, your experience will be different in many ways than showing at a commercial gallery. Opportunities

at these other venues may come at any stage of your career. You are not developing a business relationship with these spaces. Your show with any one particular site is likely to be a once- or twice-in-a-lifetime event.

When offered a show at an alternative space, college gallery, or museum, you are perhaps being offered two opportunities. The first is, of course, the show itself and the opportunity to bring your work to a new audience. The second opportunity is the chance to develop a professional relationship with the staff of that space. All are run by curators, who will be interested in following the subsequent steps in your career. Many spaces have artist advisory committees, who help establish policies and select works for exhibitions. Some of these institutions have artists on their board of directors. These long-term relations eventually may be more important for your career than the show itself. Make sure you build those relationships when the possibilities present themselves.

Now, let's look at the nuts-and-bolts details of showing with an alternative space, museum, or college gallery.

Your Exhibition at Alternative Art Spaces. Once you are offered a show at an alternative space, ask questions about their policies and procedures. Each alternative space has its own distinct staffing and facilities, and therefore you need to ascertain exactly what services they can offer you. Work out all details in the following areas, deciding what is to be done and who is responsible for doing it:

Dates for your event

Installation procedures

Installation and/or rehearsal times

Design of the announcement

Other publicity

Equipment and/or technical support

Expenses, such as shipping, reception costs, insurance, and announcements (designing, printing, and mailing)

Stipends or honoraria for artists

Commissions retained by the space for sold work

Once you have settled on all points, ask for confirmation in a contract or at least in a letter. If not, write a letter to the director spelling out the agreement as you understand it, and ask for confirmation.

Commissions charged by alternative spaces may vary from nothing to fifty percent. Remember, though, that if you have an exclusivity agreement with a commercial gallery (see above), they may also take a commission on works sold outside their space, usually between twenty and forty percent.

Most alternative spaces have a liberal policy about artwork shown and will make no attempt to limit the content. However, the survival of some alternative spaces may be dependent on funding from the government, businesses, or a special interest group. Therefore, tell the space's staff what your work in their space will be,

especially if it is likely to be controversial. If they have a chance to prepare their backers and instruct them on the overall content of your work, the backers are less likely to dispute the work or withdraw support.

College Galleries. College galleries vary from one to the next, with a wide range of funding, staffing, and artist support. On one end, you may find that the college may simply provide a space with no gallery attendant and no insurance for your work. The walls may need patching and painting. The artist may have to do all the work and cover all expenses. Or the college may have a first-rate, well-maintained space and may provide the announcement, mailing, press releases, publicity, delivery of artwork, hanging, and reception for the artist.

When showing at a college gallery, you must work out all the details with the person in charge. Use the checklist above for alternative art spaces. College galleries often request a minimal commission on sold works, usually ten to twenty percent. Recap your agreement in letter form. Also, inquire about the hours of the gallery, as some spaces are open on a very irregular schedule, depending on student help.

Find out what other obligations there may be in exhibiting at a college. Sometimes, artists are asked to conduct educational talks or workshops. Although college galleries usually do not provide a stipend to the artist for exhibiting, they should pay you an honorarium for a talk or workshop.

Museums and Municipal Galleries. Museum and municipal gallery shows usually provide the most services and represent the least cost to artists. Whether large or small, these spaces usually handle all press, invitations, shipping, and hanging work. Neither regularly provides artist stipends, but museums may purchase one piece from the show for their permanent collection. Sometimes, museums will commission a new work to be made, based on a detailed proposal submitted by the artist. In these cases, the artist is paid for the work when completed.

For your exhibition, you may not have the final decision about what work is included and the way the work is displayed. Many museum curators, however, are very willing to work with artists so that all parties are satisfied.

The artist may be asked to participate in extra programming, for example, in artist talks, seminars, or panel discussions. Artists should be paid an honorarium for such events.

Museums and municipal galleries will provide contracts or letters of intent spelling out the details of the agreement. Because they plan so far in advance, they want their schedule locked in and all details ironed out.

Showing at Businesses and Community Centers

These spaces generally provide few services to those who show there. Artists often must write press releases, design and mail announcements, hang the show, and provide for a reception. See Chapter 4 for information about putting together such an exhibition. There are some exceptions to this: A few community centers have exhibition staff and budgets, and a few large corporations maintain a gallery staff. Inquire before committing to an exhibition.

Self-Promotion

Your job as an artist to promote your own work does not end after you have a show at a gallery, museum, or alternative space. As New York-based painter Werner Hoeflich said:

> It's a mistake for any artist to think that once they get a gallery, the gallery's going to take care of things. Showing through a gallery makes it easier to sell paintings and keep your prices going up, there's no two ways about it. But to me, a good gallery relationship is one that you can work hand in hand with, which means you continue to help promote yourself. I enjoy showing my work and I enjoy talking about it because it helps me as an artist, although that's not something I've always felt comfortable with. If the gallery can bring people into my studio, I can take it from there. And if I can sell a painting, I can keep on painting.

Keep looking for opportunities for yourself or making them for yourself. Keep up your mailing list, your visual documentation, and your resumé. Promote your own work whenever possible.

Source: Courtesy Nancy Hoffman Gallery.

interview

NANCY HOFFMAN

Nancy Hoffman is the president of Nancy Hoffman Gallery in the SoHo area of New York City. The gallery was founded in 1972 and specializes in contemporary painting, sculpture, drawing, prints, and photography.

How did you start as a dealer?

During my last year of college in New York, I was studying art history, heading toward a combined MA-PhD program and working for a museum called Asia House. I decided to take a year off between college and graduate school and work full-time. I never went back to graduate school. I moved from PR director to director of a gallery uptown. In time, I met somebody with whom I thought I might open a gallery. She couldn't move forward with the idea, but I wanted to pursue it. I, therefore, decided to take a course called "How to Start Your Own Small Business." One year later, I put together a prospectus, raised the money, and opened a gallery in 1972.

How have galleries changed over those years?

Things have changed enormously. The art world has grown in multiples—there are more artists, more galleries, more neighborhoods to look at art. When I opened the gallery in SoHo, I was among the first of a handful of galleries. And at one point, there were more than three hundred galleries here. Now the gallery world consists

of uptown locations, 57th Street, SoHo, Chelsea, and Williamsburg, Brooklyn. The art world has been expanding and growing and changing all the time.

This is not a static profession. Working with creative personalities means everything is always new and different.

Are galleries less elitist in the kind of work they show?

There is quite a range of work in galleries now. Yes, the galleries are less elitist in the kinds of work exhibited.

Your gallery represents many established artists who have been with you for a number of years. What is your relationship to younger artists?

My relationship is open. I look at all the work that comes through the front door, whether by mail or submitted in person. My decisions are based on the quality of the work, not on age, geography, and so on. We've shown some artists since 1972, some artists in mid-career, and some who are much younger.

Are other New York galleries similarly receptive?

Every gallery has its own policy.

Do you see the influx of new artists as important to your gallery as a whole?

We've built our reputation on loyalty and consistency. I would say that the influx of new artists is an essential part of the fabric. You have to keep revitalizing the mix. So, we do look for some change.

Do artists living outside your area have a disadvantage in trying to show their work in a New York gallery?

Geographic location does not influence the gallery's choice of artists. We show artists from New York, as well as three artists who live in England. We have one artist who lives in France. We have one who lives in Mexico. We have several artists in California. We have one in Australia.

If an artist lives and works around the corner, it is a pleasure to bring clients to the studio. Clients feel privileged when they visit the artist's place of work. This enhances their appreciation of the work and the creative process. In the studio, the art becomes more real.

What advice would you give to emerging artists about the kinds of materials they send to you?

I think artists have to decide what best represents them. It may be slides, photos, or other documentation. It is not in one's interest to send a haphazard presentation of their work.

We have all seen galleries come and go. A younger artist may feel it's important to show their work at any opportunity. But in fact, if a gallery is financially unstable, an artist may be spending time developing a relationship with an entity that may not be around for very long. What do you think of this?

I think that's an individual issue. You say some artists feel they want to get their work out at any price, any cost, any venue. I think most artists these days are savvy and responsible. They weigh the pros and cons of exhibiting in a gallery or venue that may not be a lasting one.

Do you provide more support for artists who have been with the gallery for a long time and less for artists just starting out?

That's an interesting question. We are pretty democratic here and do essentially the same thing for each show. We pay for the framing, photography, and all costs in conjunction with an exhibition. A first show by a young artist is celebrated as much as a show by a well-known artist.

As far as the schedule goes, artists usually request a time slot they prefer for a show a year in advance. If there are conflicting requests, we would give preference to a long-standing artist over a younger artist and find an equally acceptable date for the artist who did not get his or her first choice. There are no bad dates for shows in the calendar—that is a false myth.

What are the rewards for you in the artist/dealer relationship?

The rewards are manifold. Relationships with artists are rich and intense. For me, working with the creative personality is exciting and enriching. Working with collectors is also satisfying, enabling people to open up their minds and souls to a richer life by having art in their environment. The educational aspect of being a dealer is also rewarding. This is just the beginning of the many satisfactions of this profession.

What would you tell students as they're getting out of school and looking at the professional world?

A lot of people nowadays feel they can jump out of school and jump into a gallery. I would recommend waiting until an artist finds his or her own voice. When the work is strong enough to present to a gallery, do your homework and go around to galleries; make sure you only solicit galleries that are sympathetic in sensibility. Some artists find their voice early and can maintain after early success. It takes others more time.

Do you get around to see art in other galleries?

I do try. It's not easy, but I try. I go to several art fairs each year—some including seventy galleries, others including one hundred seventy. These events, with galleries from all over the world, provide the opportunity to catch up on the art that dealers are presenting nationally and internationally.

PART III

Positions
of Influence

Some artists take on the roles of art professionals, even as they continue making their own work. They write for the art press, curate, or operate art spaces in order to influence the kinds of art that is shown in their areas and the discussion of related ideas. These activities are all within the abilities of emerging artists. Although they require time and energy, many artists see them as extensions of their own art practice. These activities are not distractions, then, but important parts of their careers.

The following chapters cover art writing, curating, and creating and running a new art space. Art writing is likely the least costly activity, in terms of time and expenses. Operating an art space is probably the most labor-, time- and cost-intensive. Each chapter outlines the basic procedures, so that you will be well-informed before embarking on any one of these.

Writing for Art
Publications

Many artists write reviews and articles for art publications. Art writing requires a specific set of skills:

- Ability to write clearly
- Research skills
- Strong foundation in contemporary art theory and criticism
- Ability to analyze an artwork and articulate its major themes
- Ability to locate a work of art within the larger cultural and social picture

How can artists acquire these skills? Graduate-level education is extremely helpful in providing sufficient theoretical background to writing (see Chapter 16). To build on that knowledge base and to keep current on new art and theory, artist-writers should regularly read respected art publications or anthologies of important recent articles.

What are the benefits for artists writing for art publications? Most artist-writers find that it contributes to their own careers and allows them to exert some influence on the broader culture:

- They can actively participate in the dialog surrounding art, helping to shape opinions and acting as an advocate on particular issues.
- They enjoy increased visibility in the art community, access to dealers and curators, and contacts with exhibiting artists.
- They have firsthand experience with dealers, curators, and staff and know their particular interests, knowledge about contemporary art issues, and manner of dealing with the press. Artist-writers can make better choices for a venue for their own work.

Despite these obvious benefits, you need to be aware of a few considerations before you begin writing:

- Art writing is time-consuming, requiring attention and research. To gather sufficient information before you write, you need to study the work, talk to the curator, dealer, or artist, and/or read past reviews in an art library. You have to write at least two drafts of the article or review and then perhaps make revisions after the editor has seen it.
- Entry-level art writing does not pay well (see below). It does not cover the time and effort you expend. Some publications may not pay you at all.
- The art press is full of potential conflicts of interest. Two possible conflicts are (1) as art writers, artists may be tempted to slant reviews to gain the favor of a particular dealer or curator; and (2) to meet expenses, many art publications depend on advertising from galleries in addition to subscriptions. Some publications may tend to review the shows of their advertisers more than the shows of nonadvertising galleries.
- A negative review may cause hard feelings toward the writer.

Categories of Art Writing

There are three kinds of art writing:

- Reviews, which are descriptions and critical assessments of current art shows, performances, or festivals. Reviews usually are timely, short (400–700 words), easier to write than articles, and more often assigned to entry-level writers.
- Articles, which are longer pieces, requiring the writer to develop a thesis and use various works of art to "illustrate" the idea. Considerable research is often required for articles.
- Catalog essays, which accompany a catalog of an artist's work. Catalogs are produced by museums and galleries in association with an artist's show. Sometimes artists produce their own catalogs.

Print Publications. The following are hardcopy publications that carry art reviews or articles. Some are exclusively devoted to art news, whereas others run only an occasional art piece among their many other articles. The publications at the top of the list tend to have less prestige in the art world, whereas those at the bottom are more respected, with more writers competing to write for them. Opportunities for emerging writers can be common in low-profile publications and almost nonexistent in high-profile ones.

University newspapers. These represent an opportunity for you to gain experience as an art writer while still a student. Your audience will be limited to the university community, and you will not be paid.

Neighborhood and community publications. These newspapers often cover art events in their area. These publications are definite possibilities for entry-level art writers. However, the pay may be minimal or nothing, and the readership may be limited.

Urban weeklies. In large cities, these free papers often have a very wide following. Pay for writers varies, depending on the health of the publication and its degree of interest in the arts. The art writing in the best-known large metropolitan weeklies can be very high profile and respected, and they are unlikely to use entry-level writers. Small weekly newspapers that serve small cities may also carry art news. They are not as prestigious as the big urban weeklies. Those that use freelance writers may be opportunities for entry-level writers.

Daily newspapers. These cover the arts as part of the area's cultural news. Writers' pay may range from respectable at papers with large circulation to very low at others. Entry-level writers may find opportunities in daily newspapers in smaller cities but will likely find more competition if trying to write for the most prominent paper in the largest cities.

Regional art magazines. These magazines concentrate on art in a particular region, such as the Southwest, the West Coast, or the Midwest area. Some also have limited national coverage. Most of these publications work with a regular set of writers. However, because of the number of articles and reviews they run, these publications often need new writers and will consider submissions from entry-level writers. Examples include *ArtWeek* and *New Art Examiner.*

National art magazines. These are high-profile publications, often printed in full color. Despite their title, most of their coverage is not national, but focused on New York. They have more limited coverage of international, West Coast, or other major art centers. Examples include *ArtForum* and *Art in America.* Their articles are by their regular writers and by prominent freelancers. Although they will review unsolicited articles, they treat them as writing samples and only occasionally publish them. Because of their prestige and the competition to write for these publications, they rarely give writing assignments to entry-level writers.

Research some publications by reading them on a regular basis. Find a few you respect. What are their areas of interest? Are your interests and writing style comparable with other articles published? Is your experience commensurate with those of other writers? If so, then you may wish to approach these publications with your writing (see below).

Online Publications. There are a few kinds of online publications that deal with art issues. Some are connected with Internet sites that sell art, such as ArtNet (www.artnet.com). Because these sites are directly supported by the art they sell, they often look for positive writing, rather than overly negative or critical. They need material aimed for a broad audience.

Internet sites that are dedicated to a specific media may also publish articles and reviews. For example, Rhizome (www.rhizome.org) is an online community space for people who are interested in new media art. The site features writing by members of the Rhizome community.

Universities and alternative spaces support sites dedicated to discussions of art and culture. One example is the Fine Art Forum (www.msstate.edu/Fineart_Online/home.html), hosted by Mississippi State University. To investigate other such publications, review the list of online journals of art compiled by the Tennessee State University Library (www.tnstate.edu/library/journal/onjnart.htm). Another list of electronic journals in art, architecture, and allied fields is available through the University of Florida Smathers Library (www.uflib.ufl.edu/afa/ejournals.htm). Undoubtedly, other lists also exist. In addition, some hardcopy art magazines are developing online versions. For example, *ArtForum* is due to launch an online publication that will differ in its coverage from its hardcopy magazine.

Again, see which of these sites is compatible with your interests and outlook, and consider contributing a written piece to them.

Catalog Essays. A catalog is a booklet that accompanies an exhibition. A small catalog is generally sixteen-pages long, whereas a catalog for a major museum exhibition may be book-sized. Catalogs contain one or more essays on the artist(s) or topics at hand. Writing a catalog essay usually involved interviews with the artist(s) or curator for their points of view and research to place the art within a larger cultural framework. These essays are always supportive of the artwork exhibited and are intended to deepen the audience's appreciation of that work. Catalog essays are often one thousand to two thousand words in length.

Other Outlets. Many publications do not carry art writing now but may consider it if you approach the editor with a good idea. Consider all publications as possibilities. How could your writing contribute to the magazine? What audience would read it? What style or tone would be appropriate?

Pay

What kind of pay do writers receive for their work? It varies tremendously, depending on the publication itself and your experience as a writer.

At the time of this writing, most print publications pay between $50 and $150 for a review. For example, the *Los Angeles Times* pays its reviewers between $90 and $100 for each piece. Articles pay more, with art magazines offering about $500 per piece. Smaller print publications, such as local free newspapers or university papers, may pay nothing.

Online art galleries may pay well for articles, up to $500 for a review, if the site is well known. The pay scale goes all the way down to nothing, as many electronic journals do not pay their writers but offer them merely an opportunity to be published.

The pay for a catalog essay is generally $0.50 to $1 per word.

All writers, except perhaps a very few, consider writing for art publications as only part of their creative work and not something that will earn you a living wage. Many choose to pursue it because it is another forum to present their ideas.

If you wish to write, determine for yourself how important payment is, and whether the experience of writing will be sufficiently valuable to you if you are underpaid or not paid at all.

Approaching Editors

Select a few publications to approach. Try a range from high-profile to more accessible publications. If you know any artists who write or writers at particular publications, ask them to recommend you to the editors. Recommendations are the best introduction into writing. If not, look at the masthead of print publications to find the editors' names and the publications' addresses and telephone numbers. The masthead is usually located on the first inside pages of a magazine or newspaper. Online publications usually tell you somewhere within the site how to submit articles for their review.

Write to the publications. Send cover letters explaining your interest in writing and any past experience. Include copies of any past articles and your resumé. You might also want to send an unpublished manuscript, an article, or a review that you write specifically to attract the editor of a specific publication. The manuscript should fall within the publication's area of interest and match the approximate word length of their articles or reviews. Of course, presentation is important: Your material should be clean, legible, and well organized. If the article is good, it may be published.

If a publication is interested in your writing, the editor will probably assign you an art event to review. You will be given a word length for the piece, the number of images to be used, and a deadline. The editor will probably offer you a fixed compensation that is paid for any review of a certain length. Often, your first assignment with a publication will be on speculation, meaning that your completed piece will be printed and you will be paid only if the editor deems the writing to be usable.

Writing Reviews

When you attend a performance or art event as a reviewer, identify yourself as a writer and name the publication for which you are working. If attending an event with paid admission, request in advance a complimentary ticket. Ask for a press packet, which should include an artist's resumé, statement, copies of past reviews of the artist's work, and an image for reproduction, either a digital file or good print. Request more reproductions of the work if needed. Ask to speak to the artist, dealer, curator, or other knowledgeable persons to get their ideas about the work.

Your writing may be stronger if you examine the writings of others. John O'Brien is an artist who divides his time between Los Angeles and Rome. He is also a writer, curator, artist organizer, and professor. He encourages artists-writers to think broadly about writing:

> I think artists should find concrete models before they begin—people who write like they would really like to write. When I started art critical writing, I looked at books that were of importance written by critics and philosophers, and at the same time got to know the regular writers for the magazines. There are many different ways to approach the written expression about the arts. They used to be called cultural critics—Ken Kesey

has written on the arts, Norman Mailer has written on the arts. Giacometti was written on by Jean Paul Sartre. Samuel Beckett reviewed the work of a painter.

As you write and revise the review, ask a friend or mentor to read it for clarity and interest and to check for grammar or usage errors. Use the spell check on your word processor. Format the final copy double-spaced with easily readable type. Put your name, the name of the article, and the page number as a header on the top of each page.

The Editing Process

Ask the editor how the final article should be delivered. Some will want a disk copy and a hard copy. For others, e-mail submissions are sufficient. Mail or hand-deliver the reproductions to reach the editor by the deadline. Use a large mailing envelope with cardboard reinforcement so the contents remain flat and uncrumpled. Return to the artist or gallery any files or materials that will not be used by the publication.

A good editor will consult writers to approve any cuts or changes to be made to the copy. Some editors make minor grammatical corrections without consultation, which is usually an acceptable arrangement. Some do not consult writers even when they radically change the copy, cutting, rewording, rearranging, and making style changes. Most writers are dissatisfied if a published piece attributed to them differs substantially from what they actually wrote and will not continue to write for that publication.

Your Career as a Writer

You may be asked for copies of your writing in many different circumstances, for example, if approached to curate an exhibition, if applying for a job in which writing skills are important, or if you wish to write for a publication that is not familiar with your work.

Keep copies of all your published writings. If you have written a lengthy and important lead article, keep the entire publication in your files. Otherwise, tear sheets from the publication with your writing are sufficient for your records. Make multiple copies of your articles, masking out nearby extraneous writing. At the bottom of each copy should appear the publication name, date, volume number, and the page number where your writing appeared.

Writers may become contributing editors to a publication after writing regularly or influencing the editorial nature of the publication. The names of contributing editors appear on the masthead of the publication. Contributing editors have more influence and may be paid at a better rate than occasional freelance writers.

Source: Photo courtesy of Chris Miles.

artist interview

CHRIS MILES

Source: Photo courtesy of Mónica Amor.

MÓNICA AMOR

Mónica Amor is a PhD candidate in art history at the Graduate Center of the City University of New York. She writes regularly on contemporary art and is a freelance curator. Christopher Miles is an artist, writer, curator, and teacher living in Los Angeles. He currently writes for *Artforum, Art Nexus, ArtWeek, dArt,* and *Flaunt* and has written for numerous other publications.

How should artists think about being critical writers?

CM: With writing, you get another voice and another entryway into the art world. You add to the discourse.

MA: Writing enlarges your horizon. It exposes artists to other ways of thinking and reflecting about the art object and also about exhibitions. However, I'm wary of artists becoming full-time writers, unless that's what they want. Writing may jeopardize their art practice in the studio because of the time commitment.

CM: It is true that writing requires mental and creative energy. It takes time for artists to get to a point where their writing and the studio activity and whatever else they're doing—maybe curating—becomes one complete body of activity. Then artists can really reconcile it all and make it work for them.

MA: One might think about someone like Coco Fusco, who is a performance artist, and also theorist, teacher, and writer. She has found ways of bringing the writing to her artistic project, and vice versa.

CM: For some artists, writing levels out the times when maybe they're not involved in studio practice or showing, and maybe they don't even want to be. When I got out of school, I did not make artwork for a while. And writing provided a way to stay involved in art but not through a studio practice.

I know other artists who have gotten into writing, because if they exhibit their art only once or twice a year, those are the only times to get their "two cents" in. Whereas if you're publishing monthly, you get to have a more sustained, consistent voice in terms of what's going on.

MA: When you're out of school, you definitely may want to try writing, teaching, or considering a variety of possibilities because, obviously, you may not immediately find a venue to show your work.

CM: If you're the kind of person who's inclined to wear more than one hat, then put them all on. When I was in school, people told me, you want to be an artist? Don't write. You're gonna spread yourself too thin. The more hats you wear, the more complicated it all gets. But for me, at least, the complications have been part of what's kept it interesting.

I think the climate is more open for people doing multiple things. There aren't too many artists I know who are really just artists. Most are also teachers, curators, or writers. Now I've started to know a lot of artists who are becoming art dealers and that seems to be the one thing that everybody has always thought was kind of iffy. But even there, the climate is much more open to it.

MA: Of course, even in the 1980s we found someone like Meyer Vaisman who had a gallery in Manhattan's lower east side and was instrumental in promoting certain artists from that period.

What about the agendas of the publications for which you are writing?

MA: You do see agendas, you do see particular ideologies. There are nationalisms at stake. And of course, the art markets play a role on all this publication structure.

CM: It sounds like a bad line out of a mobster movie, but the truth is that it's just business. I don't mean that it's all about money. It's about understanding that everyone has a bottom line. Artists, galleries, magazines, academic journals, museums, alternative spaces, and so on: They all have different bottom lines in terms of desires, needs, goals, things they want to do, things they have to do, things they can't afford to do. That's not cynical or jaded. It's realistic, and I think it's kind of liberating and helpful in understanding when your bottom line doesn't match up with someone else's.

If you're an artist, your bottom line is that you want to get shown and collected and reviewed. That's just as self-serving as a gallery that wants to pay the rent, a museum that wants to increase ticket sales, or a magazine that needs to keep a certain readership interested. Each publication serves a particular community, whether it's academic, regional, genre-centered, specific to a medium, or market based.

There's a popular idea that magazines always cover artists represented by galleries that buy a lot of advertising. It's a misguided idea that if anything tends to backfire when galleries buy ad space and then expect coverage. Most magazines try to keep advertising and editorial separate in a direct sense, but it an indirect manner, there is a connection. Whether a magazine wants to keep getting funding, or keep selling advertising, or maintain a certain stature: All of this is related to editorial content. Nobody gives money to, or buys ads in, or cares about reading a magazine that isn't of interest to them or others in their sphere of activity. That's just reality.

MA: I find also that most of the bigger magazines are targeted toward an international audience fascinated with New York. Yet the international discourse of these magazines is mainly the United States and Europe. You won't see them discuss an artist that is too local for their standards—an eastern European artist or a South American artist. All these things play very important roles in who gets published, who writes for the magazine, what is shown, what gets reviewed, what's not. What I mean is that art writing for magazines partakes of the same issues of canon formation that we have been discussing for the past twenty years in relation to art history and the art market in general.

What about styles of writing?

MA: To me, critical writing is not very far away from fiction, writing fiction. There are rhetorics and strategies for creating an argument. It's not all objective, verifiable

information. Ultimately, you might disagree or agree with the critic's judgment, but you have to appreciate a well-written piece, a convincing argument, a use of language that appeals!

Some art publications privilege clarity, description, and focus. Others might be more free in their approach, letting writers be more poetic or more ambiguous with their topics. And then, of course, with academic journals you have a very specific type of historical writing where archival research and theory play a key role.

CM: I think it's important to think of it as a creative endeavor. It's not the job of the critic to kind of steal the artist's fire, but I do like the idea of thinking of criticism as a poetic or literary response to visual art. It is not a "thumbs up/thumbs down" judgment.

MA: A writer has to be aware of the trendiness that threatens critical writing. There's a certain jargon associated with it, and a certain bibliographic field that art critics return to over and over—some people get quoted all the time, some references appear everywhere. This is something to consider to avoid the feeling that one has already heard the same argument regarding a number of artists. How do you want to bend that convention or cliché? How can you get away from it to be more creative? How can you convey your ideas without being too restrained by what others are saying?

CM: When writing, it is important to think of an artwork in many ways, so you can address different audiences. If I write for *Artforum*, I know how to address the audience that is likely to be reading it. When writing for a general magazine, you have to try to communicate differently. You can't use certain terminology and assume necessarily that people are on the same page as you.

MA: You are addressing persons who have not seen the work. It is important to do a close reading of your object—looking very thoroughly. When you're doing art criticism, try to be very specific and respectful of the object, the exhibition, the artist. Respectful, not faithful or objective.

How would you suggest approaching editors?

CM: It's good to have a couple of sample writings handy for editors to read and to consider as opposed to saying, here's my resume. If you have a professor or colleague who will recommend you, it never hurts. And whatever it is you want, ask for it. You won't get what you don't ask for.

How does critical theory, personal taste, and the influence of the editor fit into writing a review?

MA: Critical theory is important, but to varying degrees. There are a very few art magazines that allow for a major engagement with theory. In all likelihood, the regular reviews of shows require a lot of description. If you're going to make a conceptual point, you need to strive for conciseness.

CM: I write for magazines where there is more than one writer covering the same area. Sometimes, two writers may want to review the same work, and it may be a question of who makes the first phone call to the editor. That can radically change how a certain magazine can either put the stamp of approval on a body of work or reject it. There have been some situations where I had proposed writing about something, and somebody else had already pitched it to the same editor, and really, our opinions were like night and day.

MA: And an editor might assign one writer to a piece because the editor agrees with your "take" on it. Or maybe Chris is more important a writer, or a writer will better catch the attention of an audience or a readership than the other writer.

There's no objective way of writing reviews, that's for sure. One writer might find an artist absolutely interesting and another writer will find the work just terrible. Hopefully, the writer will articulate or justify his or her opinion in an interesting way, based on historical, formal, or conceptual analysis.

CM: It remains an opinion nonetheless when all's said and done.

MA: Absolutely. An opinion that might be inflexed by the editor.

CM: That's something you need to understand. Artists have very private, personal practices, in terms of what they do in their studio. But if you're looking to publish, inevitably you have to deal with other people getting their hands on your material, changing words around, potentially changing meanings. On the positive side, it can be a really fantastic experience. A good editor should make you a better writer, over time.

MA: And that's exciting.

CM: It's exciting as a writer and an artist because the more you're in practice at deciphering other work, the more you understand your own. Before I got into publishing, I was a lot less analytical about my own work than I am now. It can be stifling to load that much criticality into your studio practice, but I think it's beneficial, and probably only fair, to consider whether your studio work would stand up to your own review. It puts credibility at the center.

Credibility is what being a good art writer is about. The writers I read consistently and the artists whose work I go to see consistently have certain things in common: They don't pull punches and they regularly catch my interest even if I don't like or agree with what they're doing. I don't believe you can look at visual art or writing and measure the sincerity or integrity of the maker, but you can get a handle on the credibility of the work, and it comes down to that when all is said and done.

Curating

Curators create groupings of artworks or performances around provocative ideas, where the juxtaposition of works is thoughtful and powerful. Although professionals do it full-time, some artists curate occasionally while they continue their artwork. The major benefits for artists who curate are the following:

- With curating, artists play a part in determining what artwork will be seen in the art community.
- Curating enables artists to make connections with other artists, writers, and art space directors.
- Curators have the opportunity to deal with potent issues and promote the work of others.
- Curating is valuable experience that can lead to a job as an art professional.

You as Curator

Skills. What do you need to be able to do in the course of a curating project? The following list outlines beneficial skills:

- A good foundation in art theory and criticism. A graduate-level education would be a helpful professional background to curating.
- Good communication skills. You have to explain your idea persuasively to artists and to directors of art spaces.
- Decisiveness. You must determine which works you want to include or exclude.
- Writing skills. You may have to write a curatorial proposal, a catalog essay, and publicity.
- Persistence. These are long-term projects.

Time Commitment. A curating project requires that you develop an idea, find artists, and find a venue. In the early stages, this does not require intense focused effort. You can begin to formulate curatorial projects in the course of your regular professional activities, such as going to art events, reading magazines, or talking with art professionals and artists.

Once a project gets off the ground, curating becomes more time-intensive with studio visits and reviewing work. As you approach the opening, your time commitment will increase if you are involved in physically gathering and installing the work.

The demands of curating can erode the time you spend in art making. If you have the disposition for this kind of work, however, curating can raise your stature in the art community.

Setting Limits to Your Project. Curating projects come in all sizes and in all degrees of complexity. To a great extent, you can determine the amount of time and involvement required while formulating the project. For example, Louis Cameron, an artist now living in the Northeast, undertook a curating project as an undergraduate college student with very little experience, limited time, and no budget.

> What had happened was that I had gotten an internship at a photography gallery called Black Gallery in the Crenshaw district of Los Angeles. The Black Gallery is a privately owned gallery, a commercial space. It deals with mainly black photographers. There was a three-week space between exhibitions at the gallery, and M.B. Singley, the other intern, and I got the idea looking through the archives in the gallery. They had some pictures of the 1965 Watts rebellion. And we got the idea of having an exhibition comparing the two rebellions, the Watts rebellion and the 1992 L.A. rebellion. So, we pitched the idea toward the director of the gallery, and he gave his okay.
>
> And from there we started working on putting together this exhibit. We had limited time and were working on a shoestring budget. Basically we had to do everything. It was a lot of hard work, but it came off well. And the experience was really valuable.

Formulating a Curatorial Project

The three components of a successful curatorial project are:

- Strong artwork
- A sound premise for grouping them together
- An appropriate place to show the work

You can develop all three components simultaneously.

Let's start with the premise. Why would a group of works be presented together? Group exhibitions are generally based on one or perhaps a combination of the following:

- Medium and/or style, for example, computer-based interactive art.
- Geography, for example, sculptors from the South.

- Temporal limits, such as ceramic work from the 1960s.
- Concept, when you are gathering disparate works to support a thesis concerning content, cultural movements, social trends, art making practice, and so on.

The first three, medium, geography, and time limits, will usually result in an overview of work or presentation of the best of what is available in a particular category. In these cases, the successful curator is, in a sense, a diligent detective, who finds the best or most of one kind of work. Curating according to concept is often the more creative approach, in which, like a writer or artist, you have an idea that you are trying to bring to life. With curating, however, your raw materials are not words or paint but the finished artwork of others.

Initially, your curatorial premise may be vague. You develop and hone it by looking at other exhibitions or catalogs, by reading magazines for related work or articles, and by discussing your idea with mentors or close friends. What is the basic idea you want to communicate? How does your concept relate to national trends? Locally and regionally, have there been other shows similar to yours? How does your idea differ? What audience are you addressing?

Start thinking now if you want to have a catalog for your project. Catalogs are wonderful documents of your ideas and valuable for the future. Participating artists will also see the catalogs as a nice bonus to being part of your project. If you plan early enough, you might be able to get funding from the institution hosting the show or to apply for a grant (see Chapter 13).

Researching Potential Artists and Sites

What artworks do you want to include in your project? This is critically important, because you are seeking interesting pieces in and of themselves and also an interaction that makes the works more provocative together than viewed separately. You can start with artwork you know and then look farther based on recommendations or by researching exhibitions, catalogs, and publications.

Once you have clearly articulated your premise, you can begin to approach artists. Bear in mind that you need to make a good presentation of a strong idea before you can interest artists who do not know you. Also, established artists with sufficient outlets for their work may not be as willing as emerging artists to participate in your project.

Be rigorous about selecting only the work fitting a premise that really makes sense. This is especially critical when reviewing the work of friends and associates. You may include your own work in your project if it fits. Let the other artists know your intention.

While developing your theme and selecting participating artists, start looking for possible venues for your project. Ask mentors and friends to suggest spaces they know. Although well-established art spaces with full-time curatorial staff are unlikely to consider outside curatorial proposals, the following places might be receptive to your ideas:

- Alternative spaces regularly have shows with outside curators. Depending on the prestige of the space and strength of your curatorial theme, they may be more or less willing to consider proposals from emerging artists.
- College galleries and performing spaces may be receptive to your proposal.
- Commercial gallery dealers may consider your project if the theme fits with work they generally promote, if the work is saleable, and if they know you. However, if your idea is provocative enough, a commercial gallery may show the work even if it falls outside these parameters.
- Cooperative galleries may be interested in sponsoring group exhibitions or series of performances as a way of raising their stature in the art community and a means of attracting new members.
- Community galleries, especially those that are understaffed or underfunded during recessions, may welcome an outside curatorial project.

If you want to get the work out quickly, you could use someone's studio or a temporary site such as a vacant storefront or office building. Owners of empty buildings are willing to donate available space for one or two months for cultural events that are likely to draw attention to the site, but they may be conservative on content issues. In addition, you may encounter some hidden costs:

- *Insurance.* Building owners may insist you find coverage to protect the building proper and legal liability insurance. Although you may have trouble finding any insurance carrier to cover you at a reasonable cost for such a short period of time, you can ask the building owners about a rider on their policy to cover your art event.
- *Security.* You may be required to hire persons to protect the artwork or to prevent access to other parts of buildings.
- *Preparation.* Unconventional sites rarely meet the wall and lighting needs for either performance or static art.

For more on art events in non-art spaces, review Chapters 3 and 4.

Visit and evaluate the possible venues. For existing art spaces, go to see a few shows in the space. Make a short list of spaces that meet the needs of the work you are selecting. Then call the person in charge of the space and ask if they review outside curatorial proposals. Ask what considerations are important to them in the use of their space. What proposal format is appropriate? Should any special materials be included?

Of course, you always have the option of curating for an online space. Look at other Web exhibition sites, and find one that matches your concept. Or start your own Web site, and curate shows for that.

Writing a Curatorial Proposal

You may have to write a formal proposal to the director of an art space. A basic packet for proposing exhibitions or series of performances includes the following:

Cover letter. Introduce yourself, summarize your curatorial theme, and explain why you want to use that particular space. Your cover letter should be customized for each venue, explaining how the work and the space are a good match, how it fits the space's agenda, and how it serves their constituency.

Concept statement. Write a short document that explains more fully the concept behind the exhibit or performances. List some or all of the artists involved and the kind of work that will be included.

Your resumé.

Images and resumés of participating artists. Get a few images and a one- to two-page resumé from each artist to include in your packet.

Budget. List here all expenses that will be borne by you or the artists, all support that you will receive from donors, and all support you are requesting from the art space. Include printing, mailing, shipping, reception costs, and any special equipment or installation needs. For example, if special walls must be built or video equipment is required, indicate the costs or the source of a donation. For unconventional sites, list expenses that will be incurred for site preparation, insurance, and security if needed. If at all possible, include the cost of a catalog, brochure, or some permanent document of the project.

Self-addressed stamped envelope, for return of materials.

Organize and package these materials in a distinctive binder or folder. Place the cover letter on top, followed by the concept page. Review Chapter 6 for more suggestions on assembling packets. You can send proposal packets to more than one venue at once. Follow up with telephone calls to answer any questions.

Bringing It All Together

Once you have your artists selected and a site for your event, you should make a calendar listing the necessary tasks and when they need to be completed. Again, review Chapter 4 for guidance. You should divide the labor and get help for all this work. If you are showing at an established art space, the staff may do much of the work. If not, you may need to ask for help from your friends and associates. You should not ask for assistance from the participating artists unless you know them well or had indicated to them from the first contact that their help would be needed to pull the project together.

Make a list of responsibilities and deadlines. Circulate it to all your assistants. This written document should clearly specify who will do what and when, including:

- Designing, printing, and mailing announcements
- Preparing and distributing press releases
- Procuring special equipment
- Delivering and installing work
- Preparing the site for the art event
- Providing parking and security, if necessary

- Staffing, such as gallery attendants or house personnel for performances
- Restoring the site after the exhibit or performances
- Planning the reception

Write to all your participating artists, telling them what works you will be including in the project, when the work needs to be delivered to the site, and the length of the exhibition.

Arrange to have a photographer document the projects after it is completed. Keep copies of the exhibition catalog and brochure if they exist. Keep past proposals, announcements, and copies of any reviews.

artist interview

NICOLE COHEN

ARZU ARDA KOSAR

Nicole Cohen and Arzu Arda Kosar are artists living in Los Angeles. They organized and curated the "Survey of Alternative Art Scene," a series of art events in Los Angeles, New York, New Zealand, Turkey, and other locations. The events took place in late 1999 through spring 2000, shortly after they had finished graduate school at the University of Southern California.

How did this idea come about, originally, to do a series of events that would look at alternative art spaces?

AK: At first, I wanted to organize a symposium around alternative events, because I wanted to explore the history, the motivation, function, and audience of alternative spaces, especially in Los Angeles. I was really interested in the late 1980s, early 1990s when the art market was in a recession and how the artists survived this period. It seems really different from now, when certain MFA programs seem to be star makers, and their students get big gallery shows and major visibility while they're still in school. I personally couldn't picture myself in that situation, and so I wanted to know what else there was outside the gallery system.

How did you go from a symposium to a series of events?

NC: We started questioning how we could do the symposium, considering what we were doing in our lives also. For instance, I was traveling to New Zealand after graduate school. How could we take advantage of the fact that I was going there? Could we do an alternative event there? Then we wondered, could we also do some in Los Angeles or New York or Claremont, and then Istanbul, because we were going to be in all these different places.

AK: I think we made the leap from the symposium to the event series because we realized that we had the option of talking about something or otherwise actually doing it. It seemed that doing events would teach us more.

NC: And we wanted to think about it both locally and globally.

AK: While we were trying to figure out how to make these happen, we found out about a grant we could apply for through USC. But to apply, we had to decide how our events would connect to the institution's mission statement. We were being very open and flexible at this time.

We also wanted to think more about the function and perception of alternative events in the art world. During the 1970s they showcased work that otherwise wouldn't get shown. In the recession of the early 1990s, they performed a valuable service and kept the art world going. But at the same time, artist-run events are stigmatized for being self-serving.

Talk about your roles as curators. It was complicated, wasn't it? You chose which events would be part of your series. You curated the actual events themselves. In some cases, you also participated as artists.

NC: That is true. We approached each event a bit differently. Our first event was the video show in New Zealand in 1999. I was interested in looking both at video and also how artists use it.

AK: And it was no coincidence that your own artwork was moving into video making.

NC: Yes. It gave me an excuse to talk to lots of different people that I wouldn't normally have a discussion with. I chose works from video artists from Los Angeles and combined them with videos from New Zealand. I rented two hotel rooms across the street from a major museum in Wellington. It was pretty interesting. I really used the space of the rooms—for instance, one video/performance artist used the whole bathroom for a sound piece with a video component.

I also put my own work in it, because I wanted to show that that was my interest.

Do you think there is a stigma against artist-curators putting their own work into an exhibit or screening?

NC: I think it depends where you are in your career. For me personally, I don't have a problem with it because that's what I'm interested in. It also depends on the concept of the show and the situation.

AK: We also received a grant from Artist Space in New York for an event we sponsored in Williamsburg in Brooklyn with Melissa Photini Lohman. Our grant application stipulated that we would include our work in the show. Therefore, sometimes it is in the nature of your funding that your work is included in a particular project.

Also, I think there is a sense of honesty in it. We were not necessarily doing this from a completely objective standpoint, if there even is one.

Is this because you were providing a context for your work?

NC: Exactly. It represented our own interest.

But in any case, if you are acting as a curator, you're trying to find your main interest, your point of view, using different visual and conceptual connections.

AK: I think a lot of curatorial projects represent the curator's opinion that is usually being justified by putting all these works together. So what really is the difference, I don't know.

As curator, I do a lot of work creating a context for showing other people's work. Why not use my work if it is already perfect for the concept I want to develop through this show?

How did you fund everything?

NC: We got the Artist Space Independent Project Grant, and the "Southern California in the World and the World in Southern California (SC/W)" exposition grant from USC. They really helped the whole thing come together.

AK: Some of our projects were very expensive. In some cases, we had to pay for airfare and rent spaces. In other cases, we made use of resources closer to home. One event took place in a friend's loft in Los Angeles.

NC: But the whole project was a lot of work because we were doing it for the first time and it was so ambitious.

AK: I think we were really invested with this idea, and we wanted to do a lot of events.

NC: We were really invested in trying to make sense of it too, because it seemed like an impossible idea. And we really wanted to somehow put a net over it so we could understand it.

Did you enjoy the whole process?

AK: I don't think we would have done it unless we enjoyed it because it was insane. Every event needed about three months of preparation, and we were doing a show every other month. So it was always overlapping. Nicole and I are friends, but during that time our conversations completely turned around the shows.

NC: We wanted to do something and we made this up on our own. And it incorporated a lot of the materials we had studied in graduate school, which was an enormous amount of information.

So you had to organize each event, do studio visits for some, do publicity, pull together the work, install it—

NC: We were having quite busy lives, making the transition out of graduate school at the same time. It was very hard organizing and coordinating everything. Ideally, we would have done more things, but it was too difficult because we were doing things independently also.

I think we both are very resourceful and are able to give a lot to each other. When you do something that you've never done before, it's going to take twice as much energy and it's going to be hard because you're inventing something. If we did it again, we would be efficient about it.

You also did an event in Turkey.

AK: We also tried organizing events in Thailand, too—I won't get into that, that will get too long.

In Turkey, I worked with a childhood friend, Telga Sudor Mendi, who lived in Istanbul, to set up the event. There was a lot of extra work—getting the right site, dealing with officials. But we got very good reviews for that show, and I think one

of the reviews is going to be in an art history book! There have been a lot of shows and alternative spaces in Istanbul, but always as part of a biennial or something bigger than itself. Our show was an individual effort, and therefore, the author of the essay wrote that our show was the only truly alternative show. It was not the project of some professional curator from European or North American who goes to a Third World country, bringing all their resources and structure and looking for local artists to take part in it and intermix them with international artists. In those cases, the structure, everything, is completely brought on them by somebody who is a foreigner. Those are never grassroots event.

For you, was curating a matter of taking power, or did it seem natural?

NC: For me, it seemed very natural because I wanted people to get involved with the idea and I wanted people to get excited about it.

AK: If you have an idea you want to get out, you have two choices: You can either wait around to be picked or you can go ahead and do your thing. I don't know if it's an empowerment thing, but I'm sure it has that side of it.

NC: I think that, for me, curating is also about being resourceful and thinking about things that you've learned as you've gone along. And the people who have been involved or invested in those ideas. So we used all kinds of professional contacts, friends, family and did our own research. We incorporated our own interests and plans into it, like the travel that we were already planning to do. And being open to things that come up at the last minute.

Curating can be tedious. But you can spread it into a lot of different events and take advantage of what resources you have. I think that your attitude can make all the difference.

Creating a
New Art Space

Artists have frequently begun new art spaces when they perceive the need for it. The benefits are similar to those already listed for writing and curating. You make important connections, raise your own visibility, and have some power in determining what artwork gets shown. In small cities, suburbs, or rural areas, you may provide the only viable site for artists' work.

Artists have begun many different kinds of spaces, and have invented as many different ways to support them. Each solution was the result of the unique factors and circumstances that faced the artists, coupled with their own creativity, tenacity, and resourcefulness. The discussion below describes some of the major issues entailed in starting an art space, to give you some guidance as you approach the problem.

Artist-Run Spaces

Starting an art space should be undertaken with much more caution than writing or curating because it requires a greater investment in time and money.

Goals. You should have some clear mission when starting an art space or an articulated philosophy about the work you want to show. What is your purpose in opening a new space? What are you trying to accomplish? What kind of work do you want to show?

Your mission or philosophy may be media determined; for example, you show video art. Or your gallery may be theme oriented if it were dedicated to African-American art, for example, or to feminist art. You may aim for a particular market or for a particular audience or showcase a particular group of artists. As another option, your space may feature shows that are all developed by outside curators.

Costs. Consider how much money you could invest in the start-up and operations for the first year. Although you may plan to make money from sales, performance admissions, or donations, you should be able to support the space even if you have no financial return for several months. To start a space, you may incur expenses in the following areas:

- Site selection, both because of your time invested and also any fees you may have to pay to agents
- Legal advice on lease agreements
- Rent due after signing a lease, usually first and last month and deposit
- Site preparation or renovation, for example, walls and lighting
- Utilities and telephone service, including deposits and hook-up fees
- Signage, stationery, and consignment and sale forms

Your ongoing responsibilities, the ones that face you continually, include:

- Monthly costs, including rent, utilities, and payroll for personnel if any
- Gallery maintenance
- Publicity and advertising
- Correspondence
- Bookkeeping and tax records
- Reviewing packets from artists
- Selecting work for exhibition
- Gallery sitting during open hours
- Cost associated with exhibitions or performances, including printing announcements, installation of artwork, mailing, receptions, and maintenance expenses

Options for Space. The following are models artists have used for establishing artist-run spaces:

The "extra-space" space. Many artists have begun exhibition and performance spaces in their garages, in extra rooms in their home, or in partitioned areas of their studio. This represents the easiest and least expensive option for art spaces, but as the most informal, it requires a strong concept and strong work to get respect and attention. The month-to-month responsibilities continue to be costly in time and money even at these sites. However, there is no added rent, site preparation may be minimal, and you can tend the space while continuing with other living and working activities. In larger art markets, dealers sometimes operate out of their homes.

Temporary borrowed sites. Once you start, you do not have to run an art space for the rest of your life. In fact, it may be healthy to operate an art space for a fixed period, such as a year. With some searching and diligence, you may find someone to lend you a space or rent it to you at a reduced rate for a limited time, especially in commercial or industrial areas with high vacancy rates. The building owner might also pay you to renovate the space if it is made more attractive and thus more easily rented in the future. The month-to-month responsibilities and expenses remain.

Permanent art space for which you are solely or partially responsible. In this situation, you, your backers, and/or a group of associates put down the rent on a space and renovate it to become a permanent exhibition or performance space. Permanent art spaces can be operated either as commercial galleries or as nonprofits. This type of art space is the most costly up front and requires that you make commitments such as signing leases. The month-to-month responsibilities and expenses continue, also.

Cooperative gallery. A group of artists, usually between eighteen and thirty-six in number, band together to create cooperative galleries, or "co-ops." The primary purpose is for showing their own work and, secondarily, for showing other artists. Membership rotates, with new artists coming in and others leaving as their interest in the space diminishes. With cooperative galleries, you have the satisfaction of seeing the space continue after you leave and not simply fall apart and disappear into oblivion. Start-up costs, month-to-month expenses, ongoing responsibilities, and decision making are shared among members. Have good programming and exhibitions, and avoid appearing too self-serving.

For more on two artists' experience with starting a commercial gallery, see the interview with Michael McCaffrey at the end of Chapter 4.

Outside Support

You may need to offset your expenses and get assistance in running a new art space. Some possibilities are suggested below. Remember, however, that although these sources of assistance are extremely beneficial and important, they may not always be available to you. Volunteers may not be able to come when you need them, donations and grant sources may dry up during a recession, and your free space may disappear once a paying tenant comes along. Additionally, all these forms of assistance require your time to manage or pursue them. In the end, final responsibility for the space always falls to you.

Financial support:

Grants (see Chapter 13)

Corporate cash and in-kind donations (see Chapter 14)

Special interest groups: You may solicit help from organizations whose mission or philosophy match that of your art space

Professional assistance:

Legal: Volunteer Lawyers for the Arts in New York provide artists and art organizations with limited free legal assistance and educational materials. These organizations are most often consulted on contracts, agreements, rental disputes, and incorporation for nonprofit status. To find a chapter near you, consult your state art agency or do an online search for "volunteer lawyers for the arts."

Accounting: To find accountants who provide free accounting services and professional assistance to individuals and organizations, ask the local chapter of the Society for Certified Public Accountants. Also, many volunteer lawyer chapters also have accountants, such as the St. Louis Volunteer Lawyers and Accountants for the Arts, so check with the Volunteer Lawyers for the Arts.

Business advice: The Business Volunteers for the Arts provides management consulting and business advisory councils for art organizations, plus sponsors educational programs and publishes educational material. To locate a chapter, go to the Business Volunteers Web site at www.artsandbusiness.org/bvahome.htm

Other help:

Arrange for college students to be interns on a semester-by-semester basis.

The Nonprofit Art Space

Becoming Nonprofit

If your art space is created for public benefit, you may wish to establish it as a non-profit, tax-exempt organization. Such entities are regulated by state and federal laws, and thus there are legal requirements concerning their formulation and sub-sequently their annual operation. You will need assistance to complete the arduous process and required paperwork. You can:

- Seek legal or professional advice, as with Volunteer Lawyers for the Arts.
- Follow the directions in handbooks, such as *How to Form a Nonprofit Corporation,* by Anthony Mancuso.
- Review general guidelines such as those provided by the Foundation Center (www.fdncenter.org).
- Follow closely the model of another similar art space that successfully completed all the paperwork and requirements.

Ask for help from local businesses or other potential backers. Suvan Geer is an artist who, along with four others, started a nonprofit artist space called Orange County Center for Contemporary Art, which is still thriving after twenty years. She recalls:

Six months after we opened, I went to a backer who knew me and knew my work and I said, "Look, I am doing this, I think it is worthwhile, but we are having trouble be-coming nonprofit." He had his own company and had a lawyer on retainer and said, "Oh hey, my lawyer just set up the nonprofit for Fedco. Go see him." So we did, and within six weeks, we had our nonprofit. He basically set us up to be a cathedral for art. We fit right in and have kept it ever since. Nonprofit status helps us when we want to solicit funds and ask people for donations. One of our biggest expenses was mailing, and the nonprofit helps us because you can mail in bulk at the nonprofit rate.

Before you begin, you need to find out whether nonprofit status is appropriate for your organization. Although being a nonprofit may seem like an obvious plus

to anyone, in fact there are advantages and disadvantages, depending on each individual set of circumstances. Seminars given by volunteer lawyers for the arts and *How to Form a Nonprofit Corporation* discuss the pros and cons of the nonprofit tax-exempt status. Research the amount in fees that will probably be levied in this process. Fees vary from state to state, but in some locations can be as high as several hundred dollars.

Nonprofit tax-exempt organizations can take several forms, but the most common form for art-related operations is as a nonprofit corporation for public benefit. There are two distinct steps involved in establishing such an entity: (1) organizing the corporation and (2) applying for tax-exempt status.

Incorporation is regulated by state law, usually through each state's Office of the Secretary of State. Thus, the legal requirements in forming a corporation vary, depending on your location. Check the specific law for your state. Generally, the major tasks you must perform include:

Selecting and filing for a corporate name. A state office regulates filing procedures and name availability to determine whether your proposed name can be used.

Preparing and filing articles of incorporation. This generally includes listing the name of your corporation, the form of your corporation, statement of corporate purpose, and the name of a person who will be the initial agent for service of process. Because you will also seek tax-exempt status for your corporation, you must use specific language in your articles of incorporation. Again, consult legal advice or a handbook.

Writing the corporate bylaws, which specify among other things the internal rules by which the corporation operates, the make-up of the board, the duties of officers, and the rights and duties of members, if any. State law places few requirements on what bylaws must actually contain, so there may be considerable leeway in what you write. The bylaws, however, should be appropriate for your particular corporation.

Calling the organizational first meeting of the board of directors. Certain tasks necessary to begin corporate operations must be accomplished, such as naming the principal executive officer, authorization of the bank account and signatory power, and accounting procedures. Minutes for this meeting must be retained in a corporate record book.

After incorporation, you then apply for tax-exempt status. This must be done on the federal level, with the Internal Revenue Service (IRS), and also on the state level, generally to the state tax board. Each requires forms and paperwork and copies of the corporation's articles of incorporation and bylaws. Again, legal advice or handbooks will step you through these procedures. The IRS and state boards will then accept or reject your application.

Even after nonprofit, tax-exempt status has been granted, your corporation must follow certain procedures to maintain its status, such as holding regular meetings, keeping separate bank accounts, filing necessary tax returns, having board

ratification of significant changes, and documenting board proceedings with minutes that are retained in the corporate book. In addition, members of the board of directors must be attentive to their duties and avoid conflict of interest in their dealings with the corporation. Legal advice or handbooks will tell you how to proceed.

Keep good records.

Maintaining a Nonprofit Space

Arts Wire (www.artswire.org) has an online resource for nonprofit organizations called the "Nonprofit ToolKIT." Its articles and columns contain helpful advice on many aspects of running a nonprofit space.

There are a number of sources for grant funding for nonprofits. See Chapter 13.

artist interview

RICK LOWE

Rick Lowe is a Houston-based artist and founder and director of Project Row Houses, a public art project involving artists in issues of neighborhood revitalization, historic preservation, community service, and youth education.

What was your background in art before Project Row Houses?

I'm trained as a visual artist—a painter—and slowly evolved into three-dimensional works and then into installation. Now, I guess I am carrying on the tradition of social sculpture.

I've always looked at alternative exhibition opportunities, instead of doing traditional exhibitions in galleries. When I first moved to Houston, I moved in with a group of artists that were trying to renovate a 28,000-square-foot warehouse as an artist living and studio space in a part of Houston that there wasn't a lot going on. Later with another group of artists, we started another place. And each of those places that we started is still in existence now.

That's a great record.

Yeah, but along those lines, I started to figure out how to take those experiences of transforming space for the convenience and needs of artists to transforming space for the convenience and needs of low-income communities.

So it was artistic thinking that got you from the studio to Project Row Houses?

Absolutely. Neighborhood development is the same creative process, for me, that I would use when working on a series of painting and sculptures.

Before I started Project Row Houses, I had a group of high school students visiting my studio one day. One of the students was looking around at my billboard-size political paintings and sculpture and said, "I really like what you're doing, you know, you're hitting a lot of the issues that are going on in our community." But a few minutes later, he said, "But we don't need people to tell us what the issues are in our community. We know what they are. If you can create, why can't you create solutions?"

That made me think that maybe I need to work more directly and specifically into the community.

What happened next?

I started doing a lot of volunteer work in this predominantly African-American community. I was trying to figure out what, within this community, could I contribute. I went on a tour with one of the neighborhood groups to see the dangerous places and eyesores in the community.

At one stop, the organizer of the tour pointed out a place that had been abandoned for years, near a school. Children walked through it to get home, but it was a haven for drug transactions and prostitution. It certainly seemed that it should be demolished.

Project Row Houses

Source: Photo courtesy of Project Row Houses

Well, shortly after that, I studied the works of John Biggers who is a senior African-American artist concerned with African-American heritage and culture. He digs into negative stereotypes and tries to turn them around to show them in a positive light, and from his perspective, in a more truthful light. One of the things that he talked about in his work is shotgun communities.

What is a shotgun community?

The shotgun community is a group of small houses clustered together around a courtyard. According to one tradition, shotgun houses were slave quarters designed for the convenience of a slave master who could kick open the front door and shoot a runaway slave escaping out the back, because all the doors were lined up.

But John Biggers had grown up in a shotgun community that was a very nurturing environment with lots of creativity and supportive people. The houses were so close and so small that the courtyard became the "Talking Room"—the living room of the little village there. And the doors of shotgun houses were all in line for ventilation purposes, not for somebody shooting! The design comes originally from West African architecture.

Suddenly, I realized that that site near the school that was such an eyesore—that had been a shotgun community! This suggested a creative act to me. How can we take a dangerous place—but at the core has something that's really beautiful—and transform it?

How did you proceed?

John Biggers' work was a guide and something to strive toward. But how to make it happen here, in this particular location, we had no idea at all. It was very difficult to get people to think about the site as something to save and treasure. We needed legal expertise of people to block the demolition and media people to give us public recognition and architects to work on architectural issues.

Was it easy for you to work collaboratively? A lot of artists like to maintain control of their work.

If the task is so huge and so great, you have no choice. The law, real estate, code and compliance, architecture I knew nothing about that. When you're out of your comfort zone, it's much easier to open up and allow other people to come in and make the process more public.

I bet you have acquired a few skills you didn't have before.

Oh, absolutely. Seven years ago, Project Row Houses started with the twenty-two little shotgun houses on a block and a half. All have been renovated. Eight houses are for artist projects, where artists do installations, use it as studio space, or

whatever on a six-month rotating basis. Then there are seven for transitional housing for young, single mothers. Five houses are for educational programs.

Since then, we have gotten three additional blocks of property, eight more housing units, two commercial buildings. We've moved some of our offices there and also have a public space like a meeting hall that is sometimes used as classroom space. The new houses are basically for neighborhood residents. The last site we got is still in the early stages of development. Two renovations are for artists-in-residence, one for the site manager, and two senior citizens that live on-site.

And has it worked? Has that courtyard space become the living room again and the community dynamics returned?

Yes. I see it everyday. In these little shotgun communities, people activate and use the space. The architecture is designed for people to interact.

The courtyard is full of children with the after-school programs and that kind of stuff, and the front porches are great, because people are accustomed to sitting on these porches. Not only the residents, but people walking by or waiting for the bus.

Do you think the presence of artists really makes a difference? Couldn't the same community have happened without them?

I don't think that it would have been as successful without artists. Artists bring a higher consciousness of where we are and who we are. So, for instance, when young mothers come into this space as residents, they enter into something that is elevated, and that elevates them and their thoughts about where they are. It completely changes how people think about it. Also the artists bring in a multitude of different ideas and approaches to life.

We want a mixture where the artist exists and lives within a community. Sixty years ago, these shotgun communities had a lot of people who were artisans and artists. They were the people who would creatively figure things out, repair things, and so on. They provided the creative whip for that neighborhood.

It's not so much about bringing in art world artists, but it's much more about the experience of free thinking and experimentation.

I heard that there are efforts to recreate Project Row Houses in other cities, such as St. Louis, Philadelphia, and Los Angeles. How does that work?

Well, I am an artist, and Project Row Houses is like one canvas. There is a desire and a need for me to continue to explore this work so that I can learn from and share and enrich myself. And so, I am looking at the possibility of community-based work in different neighborhoods. And I'm learning a lot. I have found that one key element to this work is that the individuals involved must be fully engaged in the community that they're working. There are no prescriptive methods of how

you do it. You need the desire to participate in a public process, to listen, and to learn how to respond to the things that you hear. And to infuse creative ideas and notions to that process.

So you really don't come in providing answers.

There are no absolute answers. It's all about exploring and finding opportunities. I've been working on a project in Watts, and it has come to the point at which it needs some artist or some individuals within that community that wants to live and breathe it and bring it into being.

Project Row Houses has been a collaborative project. But really, you are the person who "lives and breathes it." Even a big project like that is still "attached" to a single person—to you.

It is. That's where the individual artist comes in. Not just anybody could have done Project Row Houses. And I certainly couldn't do what Lily Yeh is doing in Philadelphia with the Village of Arts and Humanities. She brings her special personality and skills as an artist to what she's doing. And the same will happen in Watts if the idea has strength enough to stand. Eventually, some artists will attach themselves to it and assert their personality, who they are and how they work, and it may become something completely different than what it set out to be.

PART IV

Financial
Concerns

This part covers the very practical side of being an artist, including the financial, legal and administrative aspects of your career. Chapters 12, 13, and 14 cover many ways to raise money to continue your artwork: jobs, grants, donations, public art projects, commissions, and so on. Chapter 15 deals with the internal business of your career, including maintaining a studio, insurance, record keeping, billing, inventory, taxes, contracts and copyright. For each topic, basic issues are discussed, and where applicable, references are given for more information.

Many artists are unenthusiastic about dealing with these issues. But if you are practical, organized, and consistent, financial concerns will not consume you.

Jobs

Few artists live exclusively off their artwork. Many hold other jobs, supplementing their art income with income from another source. The ideal job for an artist would have the following qualities:

- Adequate pay to cover living and studio expenses.
- Benefits, including health insurance and savings plans.
- Flexible working hours. A strict 9-to-5 Monday-through-Friday job would make some aspects of your art career difficult, for example, meeting curators, soliciting corporate support, researching grant possibilities, seeing some exhibitions, or writing reviews. You can try to work an evening shift, a four-day/ten-hour schedule, or flexible or reduced hours. If your job has a slow season, you may request several weeks off without pay.
- Work that feeds into your art career or informs your art making.

Many jobs meet some of these criteria, as you see in the list below. Consider which ones might work for you. But before you take any job, figure out what would make it even more agreeable to you, and negotiate with your employer to suit your agenda. You may be able to work out compromises that benefit you and still meet the needs of your employer.

Full-Time Jobs with Long-Term Commitment

The jobs in this category are all in established institutions or businesses, such as museums, universities, schools, and galleries. They are relatively stable, with benefits. With most of these jobs, you must work full-time. Most want you to commit to stay for at least a year or so.

There are art-related jobs with high visibility and prestige in the art world. The very nature of this work keeps you involved in the art world. Only some of the following positions are entry-level jobs, but all are available to artists who work through the ranks and gain appropriate experience.

Museum and gallery personnel. Some positions such as curator, director, fundraiser, or education coordinator are intense and demanding. Other positions are less prestigious, such as registrar, librarian, preparator, or gallery attendant. But they may be less demanding.

Arts administrator, including those who work for artists' organizations, nonprofit groups, public art programs, government art agencies, foundations, or state or local cultural affairs offices. Positions of responsibility, such as director, are most prestigious and also most demanding.

University teaching. An MFA is almost always required to get these jobs. Full-time tenure-track positions tend to be relatively rare, whereas part-time adjunct positions are fairly common in large cities.

Art restoration work. Specialized training is required.

Some of these jobs require skills in many areas, as well as a strong commitment to the position. The artist Kathy Vargas described her job as director of the Visual Arts Program at the Guadalupe Cultural Arts Center in San Antonio:

> I curate a couple of shows every year, where I'll pick a theme and select artists. I have a Visual Arts Advisory Committee, mostly made up of local artists, that selects a lot of exhibits. I'll also book shows that are from touring exhibits. We have community-oriented things, some forums, symposia, and classes. I supervise classes and I teach a photography course a couple of times a year. We do grant writing, development, fundraising, budgeting. So there's a lot going on. I work probably between forty-five and sixty hours depending on what's going on. Before a major fundraiser, we might put in nearly one hundred hours a week.

Other full-time jobs can be found at universities that hire many persons in support positions. With these jobs, you often work only nine or ten months out of the year. You have the potential to build a strong network with faculty and graduating students.

Lab and shop technicians, such as shop supervisors, darkroom supervisors, and computer technicians.

Image librarians and photographers.

Office staff, including counselors, admissions personnel, and office supervisors.

Art librarian. A Master of Library Science degree is often required.

Fundraisers. These are demanding jobs.

You might consider non-art teaching jobs. They all give you blocks of free time between teaching sessions. These positions in and of themselves bring you no added stature in the art world, but they give you time to continue your work.

Grade school or high school teaching. A teaching certificate is required.

Substitute teaching. Your time commitment is more flexible than with a regular teaching position. Most states require a BA degree.

State-sponsored art instruction. Some states have artist-in-residence programs that hire artists to produce art and teach in schools, in community centers, or in prisons.

Continuing education. There are teaching opportunities in art courses or in English as a Second Language (ESL) courses in areas with high immigrant populations.

Community-outreach jobs are sponsored by museums, religious institutions, special interest groups, universities, and local government. In these positions, artists develop various kinds of art programming that benefit specific audiences. This programming varies, depending on the audience and the agenda of the sponsoring institution. Community work may be satisfying and rewarding. Some positions may also benefit your professional career, for example, if you were employed by a major museum to do community-outreach programming.

Part-Time Employment

Perhaps part-time work is better suited to your needs as an artist. There are, of course, a large number of non-art part-time jobs, as you can discover with a search of the local classified ads.

You might want to consider one of the many artist-support jobs. Artists often hire assistants on an as-needed basis. These jobs are most common in a major art center. You can build up a clientele that regularly uses your services.

Writer for hire. There is a regular demand for persons who can write effective artists' statements, organize a resumé, and write grant applications for institutions, organizations, and individuals.

Photographer, documenting artists' work with digital images, stills, or video. Galleries and museums also need this kind of work. Or you can do darkroom work for artists who use photographic images in their work.

Printmaker, assisting artists in producing editions of prints or operating a printshop that artists can rent for their own use for a day, week, or month.

Supplier, including making custom-ordered canvases for other artists; fabrication work in plastic, wood, and metal.

Management jobs, such as the supervisor of a colony of artists' studios or residences.

Artist assistant, working with established artists in their studios.

Some artists do freelance or part-time work in design or the entertainment industry.

Design-Related Work

Design jobs may interest you. They can be full-time positions, regular part-time work, or freelance. You may choose to start your own small business doing design-related work.

Graphic and commercial artwork, including illustrator, layout artist, and designer. Illustration work requires a high degree of accomplishment in painting and drawing. With most graphic design work, you must become competent with computer applications.

Web designer, designing and building Web sites.

Computer/video work. Video editing for CD-ROM production, and illustrating and layout for CD-ROM texts.

Design fabrication, for upscale or trendy businesses. You may make unique objects, such as signage and fixed furnishings including entries, bars, counters, and wall decor.

Decorative murals and custom painting work, such as faux finishes.

Display design, such as window displays for stores, and booth design for fairs, conventions, "home shows."

Interior design, both for offices and residences.

Prints, photographs, or watercolors produced in large numbers for hotels or office buildings. This work is usually available through interior designers or art consultants hired by businesses.

Commercial photographer for portraiture or commercial publications; or as an in-house documentary photographer who photographs persons and events for magazines and annual reports for hospitals, corporations, universities, and so on.

Entertainment industry work. There are many peripheral jobs around movie, advertising, and television production, although special training may be required for some. Preproduction work includes set painting and prop construction. During shooting, script consultants check for continuity, and there is a range of go-for jobs. Editing jobs include both editing raw footage and postproduction editing, where existing video or film is re-edited for a general audience or for dubbing into another language. In television, cable-TV companies are required to staff and maintain public-access studios and programming.

Jobs for "Getting By"

There is a range of jobs that require very little commitment on your part, but which may be sufficient to make ends meet. These jobs have flexible hours, reduced hours, or seasonal work that give you large blocks of time for pursuing your art career. Housepainters work only in good weather. Likewise construction work

tends to be seasonal, except in warm climates. Agricultural work is obviously seasonal. In urban areas, you may want to consider landscape design.

The classic "getting by" jobs for artists, actors, and writers are in the food industry, including catering, bartending, or waiting tables.

Job Listings

Information sometimes passes quickly by word of mouth in art communities. Asking friends and associates may be the best way to find out about art-related jobs in your area. Determine what you are looking for, and tell people what that is.

In addition, you should monitor the following hard-copy resources for potential jobs:

Newspaper classified ads list a wide variety of jobs.

University career centers, where corporations and businesses interested in hiring college graduates can advertise openings.

Personnel offices of government entities, corporations, universities, and cultural institutions list all current openings.

Regional and local art publications often have jobs advertised in their classified ads.

Publications of professional organizations. Members of these organizations receive these newsletters and job bulletins as part of their membership. The College Art Association's *Careers* lists university-affiliated jobs, including teaching, administrative, technical support, and university museum positions, from all over the United States and some international positions (www.collegeart.org). The publications of the National Art Education Association list professional opportunities (www.naea-reston.org). *Aviso,* the monthly newsletter of the American Association of Museums, lists entry-level and higher openings in museums (www.aam-us.org). In their newsletter and online, the Art Libraries Society of North America lists job openings related to library work (www.arlisna.org).

Popular architectural magazines often feature the work of fabricators, decorative muralists, and custom interior painters. Through them, you can find who works in these fields in your area. Many of these painters and fabricators run large operations and are looking for apprentices.

There are also a number of online job listings. Check your regular online art resources sites and also the sites of alternative art spaces and artists organizations. Below are just a few to get you started:

- Arts Wire (www.artswire.org) lists teaching jobs, arts professional jobs, and craft/skill/technical jobs.
- Art Deadlines List (www.artdeadlineslist.com) has job listings available for a modest subscription fee.
- ArtHire (www.arthire.com) is a job-related resumé-posting site.

- ArtJob (www.artjob.org) lists national art jobs. There is a subscription fee.
- Online publications such as Rhizome (www.rhizome.org) list jobs of interest to their readers.

Applying for Jobs

Job listings only summarize a job. Ask for a complete job description for any position that might interest you. If possible, get the organization to send you their publications outlining their mission, budget, internal structure, or programs. After getting more information, apply for the best possibilities. Give yourself as many options as possible. Wait until after an interview, when you know more, to decide that something is not for you.

To apply for a job, you will usually send a cover letter and resumé. Review Chapters 5 and 6 for more on writing cover letters and resumés. You may also need to send visual documentation of your work. Again, Chapter 5 would be most helpful here.

Make sure that the material you send for an application is well written, clear, and to the point. Organize the material for easy viewing.

Letters of Recommendation

Many job applications require that you supply letters of recommendation. These letters are supportive documents that others write about you. Also called reference letters, they should describe your strengths in relation to a particular situation and so may cover your artwork, academic record, job experience, professional involvement, and character. You use these letters not only for a job but also for application for promotion, for graduate schools, for scholarships, and for some grants.

Types of Letters of Recommendation. You may be requested to supply a particular kind of letter of recommendation. Below are the basic categories:

- *Confidential,* meaning that you have waived the right to see them.
- *Nonconfidential,* in which case you may know what your referee wrote about you.

Although you may prefer the accessibility of nonconfidential letters, you may benefit in some cases from letting the letters remain confidential. For example, the employer, school, or granting agency that requested the letters places more weight on confidential recommendations than on nonconfidential ones. Or some potential referees may not write on your behalf without confidentiality. In addition, letters of recommendation may be general or directed.

- *Directed letters* are written specifically to the person(s) who will be evaluating your application and cover many of the concerns of that particular situation. They are one-of-a-kind letters and, as such, can be impressive testimonials because of the thought and effort the referee put into the writing.

- *General letters* of recommendation are addressed to "Dear Colleague" or "To whom it may concern" and discuss your strong points more broadly. Your referees then give you the letter, which you can photocopy and distribute as needed.

Directed letters of recommendation undoubtedly carry more weight. However, there are advantages to general letters. With them, you know exactly what the referees says about you and you have the letter available when you need it, without having to contact your referees and wait for results. They are beneficial if your referees will be away for an extended period of time. General letters are sufficient as preliminary references, especially if you are just beginning your professional career and sending out a large number of applications.

Letters in placement files are another kind of recommendation. Some universities offer placement services for their current students and recent graduates. Each teacher who recommends you may choose to write one letter that is placed on file with the service. You then request copies of your file be sent wherever you need it. Such letters may be confidential or not.

Getting Good Letters of Recommendation. You generate your own resumé and cover letter and thus have control over them. Because other people write letters of recommendation, you are somewhat at their mercy regarding what they say about you. However, there are ways you can help ensure that letters of recommendation present you in the best possible way. When soliciting letters of recommendation, first make a list of persons whom you think would make good referees. Select individuals who meet at least some of the following criteria:

Art professionals, whose opinions will be respected in the art world

Current or former teachers

People of stature who regard you favorably

Persons who know you in more than one area of your life

Professionals with experience in the situation to which you are applying

Second, try to determine what kind of recommendation your references will write for you. Ask the potential reference whether they think they know you well enough to write a letter of recommendation that covers the range of your accomplishments. Mention how important strong recommendation letters are for you to achieve the situation you want. Be very attentive to their response. If they seem ambivalent or half-hearted about writing the letter, you may consider asking someone else.

Third, provide your references with the necessary materials to write an excellent detailed letter for you. Make an appointment to give them copies of all relevant documents, such as your resumé, artist statement, visual documentation, academic transcripts, and/or a description of the job, grant, or school to which you are applying. Be ready to point out your strengths regarding a particular application.

Asking for Letters. Remember to respectfully request a letter. Do not offend potential references by expecting them to write for you. Regardless of how long or

how well you know someone, that person is under no obligation to recommend you for anything.

Give your references plenty of time to write the letter, two weeks or longer if possible. Effective recommendations take time to compose, and some individuals have very busy schedules. Provide each with stamped, addressed envelopes to send their letter to the appropriate party.

You can ask your references to write as many directed letters as you need. There may be circumstances in which you can envision requesting several letters every week over a short time. In such cases, as a courtesy, let them know up front that this will be happening. Then they can prepare a basic letter on a word processor and customize it into several different directed letters. If they cannot write directed letters because of time constraints, suggest that they write one general letter that is reproduced directly onto letterhead and individually signed. These appear more impressive than a photocopied letter with a photocopied signature.

Write a thank-you note to your references, expressing your appreciation for their support.

Evaluating Letters of Recommendation. If you have a chance to see letters of recommendation written for you, evaluate them for their effectiveness. A good letter of recommendation should indicate how the referee knows you and speak of your past experience and/or your future potential, being detailed and specific on these points. The letter should address your merits as a person and qualities that make you particularly suited for the situation. Most letters are one or one-and-a-half pages in length, single-spaced, and should look good. Letters of recommendation are expected to be documents that support you and therefore, to be effective, need to be strong and enthusiastic. Consider getting another reference if the one mentions too many of your weaknesses, even if accurately, or is so lukewarm as to "damn you with faint praise."

Interviews

For many jobs, employers conduct interviews with the top candidates before making their final choice for hiring. There are some things you can do to prepare for an interview. Good preparation will help you learn more about your prospective employer and also make a better impression in the interview.

- Research the organization or firm where you hope to work. Ask mentors and friends what they know about it.
- When salary is advertised as "negotiable," find out from friends and mentors what salary range is likely.
- Practice interviewing with a mentor or with someone who has a similar job, to learn the questions you are likely to be asked.
- Prepare a list of questions. A pertinent and appropriate question not only reveals your intelligence but also can be quite flattering.
- Prepare a presentation. If you are showing visual materials, they should be compact, easily managed, and fit under your arm. All visual material should be absolutely professional looking.
- Consider personal appearance. How should you dress for this occasion?

When interviewing, be punctual and arrive on time. Try to meet not only with a personnel officer but also with potential supervisors, co-workers, and subordinates. Remember that the interview process is a two-way street. Not only are prospective employers deciding if they want to hire you, but you should be critically considering whether you want to work for them. There should be a lively exchange during your interview. Avoid monopolizing the conversation, and also waiting passively for each question. Your interview should be a stimulating conversation.

Career Planning

There are a number of online career planning sites that can help you with job hunting, applications, interviewing, and salary negotiation. An online search would reveal many, but here are a few suggestions:

Career Counseling for Massachusetts Institute of Technology (http://web.mit.edu/career/www/handbook/)

University of Maine Career Center (www.ume.maine.edu/~career/)

Dave Jones, right, with Gary Hill and Nam June Paik

Source: Photo by Mark McLoughlin

artist interview

DAVE JONES

Dave Jones specializes in products for artists and museums involved in electronic media and multichannel video. His firm is called Dave Jones Design, located in the middle of New York state. His devices have been used by many artists, including Laurie Anderson, Gary Hill, Nam June Paik, and Diana Thater.

What do you do in your work?

I build equipment for supporting video installations. I've been involved in the video world since the early days, when most artists just made videotapes that were just shown on monitors. Then it slowly evolved to where the museums really wanted to have installations, not just a tape. So video work now is about moving things around and creating physical objects.

I make equipment, and occasionally I'm also involved in setting up the installation. I used to travel quite a bit, with several international trips a year. Now it's probably down to about one a year. But that's also partly because I've gotten so busy building machines for everybody else.

Does an artist come to you with an idea that you then make a reality?

It varies. I have some standard support products that are useful to a lot of artists, such as laser disk- and DVD-synchronizers, that control multiple disk players to

allow a multichannel installation to run synchronously. And some artists come and buy one for their installation. Sometimes I do custom-made things. The artist would come to me with some idea, and I'll say what I can do, and it goes back and forth until the two ideas are working together. Then I will build whatever it is that's required and send it to them.

But my focus at the moment is shifting away from doing the custom work toward coming up with things that are a little more generic, that a lot of different people can use in their work, though not necessarily the same way.

So your work is really very inventive.

Yeah.

Who are your clients?

I've worked with many of the major artists involved in video installations. And I have worked for museums all over the world.

Also, I like working with emerging artists because every once in a while one of them turns into a major artist. I get e-mails from artists who are either students or just out on their own and they say, oh, you know, "I need to do this, I need to do that, I can't afford much; what can I do?" So I'll suggest a few things and maybe point them in a direction to figure out stuff on their own. Maybe I will build a small $500 or $1,000 box for them. If it goes well, then a few months later, they might come back and buy something else.

I don't always end up making much money working with emerging artists, but I have a good time doing it. These days I'm able to do that, and at the same time, do stuff for industrial and corporate video, and museums, which do have money.

Why do you prefer working for artists?

I worked for industry for a little while doing electronics just to be able to pay the bills, but that wasn't enjoyable. That's a very dry kind of a world. There's very little creativity, and I ended up spending a lot of time developing technology for something that I have no mental relationship to. Being able to use my creativity to come up with ideas for artists that then use them to manipulate their own creativity—that's much more enjoyable.

Also when I'm working with artists, there are usually pieces of ideas that I would like to develop further on my own.

What do you give artists that they can't get from a regular tech person?

Artists have the artistic skill and often are missing the technical skills. But if their support person just knows technology but doesn't understand art, that support person can't really visualize what the artist is trying to do.

Dave Jones building an image-processing machine for the artist, Alan Berliner

I can explain the technology to an artist who is not technical, so they then understand where the limitations are. At the same time, I can understand them. Artists communicate well with other artists as long as their egos don't conflict.

You yourself are a video artist.

At the beginning, I was building machines to support my own art. But working for others quickly became a full-time occupation, and at this point, I have had very little time for any of my own art.

It's satisfying to be able to help out artists and get their installation working the way they want. But it's frustrating when there's no time left over to work on my own stuff.

How did you get your business to grow?

As with most self-employed businesses, you have to have a certain amount of knowledge and expertise just to start, and then the time to get it to grow.

There was a lot of pure chance. I knew video technology was an area in which other artists would need help. But it was up and down, with long dry periods of

not having anything to do. Then suddenly someone would call out of the blue and say, "Hey, I'm working on this project and I need to do this." And I would do it. Eventually, more calls started coming in. But it took time for the word to get around that I knew what I was doing and could produce what they wanted.

Word-of-mouth is so important! Getting the word out is definitely the big deal. Even after this much time, I feel like I haven't done it enough. Even corporate clients, who are buying my products for trade shows and corporate lobbies, basically hear about me by word-of-mouth.

Have you had to learn a lot about operating a small business?

I have. And that's fairly boring to me. I'm definitely not getting as much sleep as I should because of having to deal with all the business side, as well as the creative and the engineering sides.

It helps if you're working with others. I know some support people who have gotten into partnerships with a couple others, and then they can share the business work. If they each take care of some of the business overhead, they can each spend more time on the creative work. Plus, you and your partners can share knowledge about the different subjects that your customers want. Then you can be creative without having to know everything yourself.

I wrote software for my own accounting system, for order-taking, invoices, and everything. It was something that I could understand and use quickly. Anything that you can do to shorten the amount of time spent doing the things you don't like to do—!

I would like the business to grow to the point where I can get somebody else to deal with the accounting and record keeping and maybe even running the business. I don't want to be a CEO. I just want to get back to designing new machines, and my own art.

Do you recommend that artists consider artist-support jobs as a way to support themselves?

I think that it's a way to keep doing your art without having to go get a straight nine-to-five job in an unrelated field.

Anything else?

Well, to me, when finding a job, the most important thing is finding something you enjoy.

Grants

Many artists look for outside funding that will help further their art making, their careers, or a project they want to do. Grants are one possible source of such funding, and that is what is covered in this chapter. Donations from businesses and corporations are another source, and that will be covered in Chapter 14.

Granting Agencies

A grant is an award or a gift for a particular purpose. Grants are given to fulfill the aims of the granting agencies. One way to think about it is this: Grant agencies have money and want to accomplish a particular purpose. They then need to have organizations and individuals whose programs and projects will fulfill the ends sought by the agency. Thus, there is partnership between the donor and the recipient to get something accomplished.

Two important caveats: First, set your own priorities before looking into a grant. Your ideas should be the driving force behind your grant search, even as they evolve over time. The second caveat: Grants cannot meet all of your financial needs. They may make a particular project possible, however, and may provide a great temporary benefit to you as an artist or to the larger community.

Researching Grant Makers. What kinds of agencies make grants? There are two basic categories:

Foundations: either private or public, which have a principal fund or endowment. A private foundation's money usually came from a family or a corporation. A public foundation received its money from contributions from the public.

Government grant agencies: tax-supported entities that distribute grants and are part of the federal, state, or local governments.

For our purposes here, we want to focus on grant makers with the mission to foster the arts, cultural life in general, or the work of individual artists. There are thousands of foundations and many government grant agencies. Only a small percentage support the arts. How can you find them? The government granting agencies are limited in number and are identified in the sections below. Foundations, however, are a different story. You need to do research to identify possible funding sources. The Foundation Center is a good place to start. It is an organization dedicated to helping grant seekers and promoting philanthropy and corporate giving. The Foundation Center maintains a helpful Web site (www.fdncenter.org) with lists of grant sources, online tutorials, and an extensive bibliography.

In addition, there are books and online resources that can lead you to foundations, which are listed at appropriate places in this chapter. Also, many hundreds of grant makers have Web sites with pertinent information about their mission, grants, and policies. Go to the Foundation Center Web site, which maintains a list of links to grant makers' sites.

As you are researching foundations, you want to compile a list of the most likely prospects. Three factors should be considered:

What is the mission of the grant maker, and what has been its recent history in giving grants?

Which granting agencies have already supported projects like yours?

Which grant makers are located in or serve your geographic area?

Keep a list of those that seem to match your situation. Once you have a list of prospects, do further research on them. If available, obtain copies of the grant maker's publications, such as annual reports, newsletters, or lists of grants programs and recipients. When you find a good prospect, follow up with a telephone call or letter to the foundation's staff asking whether your proposal falls within their area of interest. Ask for advice on ways to proceed.

Although these sources will give you a lot of information on larger foundations, there are also small foundations that operate on a strictly local level, with little endowment, limited budgets, and no staff. These foundations are simply known by word of mouth within certain communities. If you hear about such a foundation, you need to do further research on it. One way to find out about a foundation's granting history is to examine their Internal Revenue Service (IRS) return, Form 990-PF. Every private foundation must make an annual report to the IRS, with basic financial data and a complete grants list. Form 990-PF lists what grants that foundation made in the previous year, to whom, and for how much. These forms then become part of the public record. You can find copies of these 990-PF forms through the libraries of the Foundation Center. Some are also available online through the Foundation Center's Web site.

All this research takes time and energy to find grant makers who represent real possibilities for you! You should pursue those grants for which your goals already

match or nearly match those of a particular agency. Don't waste time on hopeless "prospects." Also, make sure that your project meets the grant maker's guidelines. Foundations and government agencies are obliged by law to adhere to their published guidelines for application.

Now, let us look into different kinds of grants, starting first with grants to individual artists and then grants to nonprofit arts organizations.

Individual Artist Grants

For individual artists, grants fall into one of two categories:

Fellowship or stipend grants, which give an artist a sum of money in recognition for past accomplishment or future promise. No particular performance is required in exchange for an artist accepting a fellowship. Artists are encouraged to simply pursue their own work.

Project grants provide money, service, or equipment for clearly specified purposes, such as pursuing a research topic or creating a particular work of art. If you accept a project grant, you must complete the project as proposed or else return the funds to the granting agency.

Fellowships are undoubtedly the most sought-after grants for artists. But there are not too many of these opportunities. Much more common are the project grants. Now, let us take a look at foundations and agencies that make grants to individual artists.

State art agencies support artists through a variety of programs, such as grants, fellowships, commissions, and residencies. Opportunities vary from state to state, and some are open to residents only. Let us take one state as an example. The Minnesota State Art Agency offers fellowships to artists in all stages of their careers, with awards of $8,000. In addition, they offer Career Opportunity Grants for state artists, ranging from $500 to $1,500, to allow artists to pursue some advancement for their careers, such as an individual exhibition or study with a mentor. The Minnesota State Arts Board also administers the Percent-for-the-Arts in Public Places Program (see Chapter 14 for more information). To find out what grants your state art agency offers to artists, visit its Web site. Listings for agencies are available online through the National Assembly of State Arts Agencies (www.nasaa-arts.org).

Local governments sometimes support artists through grants and commissions. The City of Los Angeles gives grants to individual artists to the sum of $10,000 each. Other cities and counties have programs for grants, for purchasing art, for residencies, and so on. For local art agencies and their programs, search the Web site of your state art agency.

Arts organizations and alternative art spaces may have grant programs for artists. For example, Artists Space in New York City has an Independent Project Grants program, awarding up to $500 per application. Check your local artists organizations for opportunities they provide.

Foundations also support artists and art organizations through grants. Among many different foundations, only a small portion of them gives funds to individual

artists. The Foundation Center publishes *Foundation Grants to Individuals,* which has a section dedicated to arts and cultural support for individual artists.

There are a number of large, comprehensive directories and online resources that list grants to individuals in all kinds of fields. Look through them for sections devoted to funding for the arts. *The Directory of Research Grants* lists more than six thousand private foundations and governmental agencies that give grants to both individuals and organizations in all fields. The subject index helps you identify foundations that give to the arts. Again, entries include names, addresses, brief descriptions of grant programs, and some application requirements. The *Directory of Grants in the Humanities* is another such resource, as well as *The Annual Register of Grant Support 2000: A Directory of Funding Sources.* The *Catalog of Federal Domestic Assistance* lists one thousand four hundred federal programs that provide assistance to U.S. organizations and individuals. Again, search for those agencies that support the arts.

Also, online resources such as the Art Deadlines List (artdeadlineslist.com) keeps you up-to-date on what grant makers are accepting applications and when to apply.

Faculty and graduate students can apply for project, travel, or research grants available at their universities, especially large research universities. The likelihood of making successful application for such grants is greater than with other funding sources because of less competition. The granting programs vary from institution to institution, as do funding guidelines and amounts given. Request more information about grant programs at the graduate school, academic dean, provost, or university research offices. The *Grants Register 2000* lists grants, fellowships, and scholarships for all levels of graduate study.

Getting Grants through Nonprofit Organizations

Far more grants are offered to nonprofit arts organizations than are ever offered to individual artists. Many foundations and government agencies prefer to give grants to organizations rather than to individuals. Therefore, many artists fund their projects through nonprofit organizations. First, define your project. Then, find an organization whose mission is complemented by your project. For example, if you want to organize a lecture or exhibition series, try to find a nonprofit organization whose members would benefit from them. Then you could apply to foundations and agencies that fund nonprofit entities (see below). This vastly increases your possibility of finding support. In this case, the nonprofit organization acts as a fiscal agent and may charge a management fee for their services. Check in advance. For more, read *Fiscal Sponsorship: Six Ways to Do It Right,* by Gregory L. Colvin. Also, some grants to organizations are matching or challenge grants, which means that the grant maker will match every dollar raised from other sources for a particular project.

If you do have organizational sponsorship, ask the staff to recommend sources to which you can apply for grants. Or consult the *National Guide to Funding in Arts and Culture,* published by the Foundation Center, for foundations that have a

proven history of giving to arts organizations. This guide is arranged by state, listing the foundation name and limitations on funding. Following that are the recent grants the foundation has made, including the organization funded, the amount given, and a short description of the use of the grant money, which is helpful in targeting the foundations that are likely to support your project. You can also visit the Foundation Center's Web site. You will find far more possible donors for nonprofit spaces than you will for individual artist grants.

Likewise, there are more options for you among government granting agencies. On the federal level, the National Endowment for the Arts offers grants for projects sponsored by nonprofit entities. Also, your state arts agency has a program of grants for nonprofits. Many local arts commissions do the same.

Writing a Grant Application

Application Forms. Government granting agencies usually provide application forms and guidelines for supporting materials to anyone applying for grants. Some foundations also have application forms and formal instructions.

If you are applying for an individual artist grant, you may be required to fill out a short application form. Figure 13-1 is an example of a 1999 preliminary grant application form from Creative Capital Foundation in New York City. This will give you an idea of the kinds of questions that may be asked. In some cases, you will be asked to submit supporting material, such as a resumé and images of your work. It is absolutely essential that your images are top quality, clear, and adequately show your work.

If you are applying for a grant through a nonprofit organization, you may need to write a much more detailed proposal. The organization itself should assist you in completing such an application. Some government agencies and large foundations sponsor seminars instructing applicants on the ways to structure an application. Gather as much information as possible before you begin. Get copies of the proper application forms and instructions and follow them rigorously.

Grants with No Application Forms. Other foundations have no application forms. If so, call the foundation to find out what they want. Use the following suggestions to structure your proposal for such a foundation. Modify them to fit your needs.

Cover letter: This letter is not, strictly speaking, part of your proposal but should name the grant for which you are applying, explain the purpose of your proposal, identify prominent persons if they recommended you to this foundation, and include necessary details such as where you can be reached. The cover letter is also your chance to make a personal appeal.

Identification of the proposal: At the beginning of your proposal, or on a separate title page, indicate (1) the name of your proposal; (2) the foundation to which you are applying; (3) your name, address, e-mail, and telephone number; and (4) the date.

1999 Creative Capital Preliminary Application Form

Maya Sara Churi
123 Street Road
City, State ZIP
Phone (xxx) xxx-xxxx
Email email@email.org
URL http://www.site.org/~site

Category: New Media
Total Project Budget:
$42,000
Amount Raised to Date:
$21,000
Creative Capital Request: (Maximum request: $20,000)
$20,000
Where are you in your project's overall time-line?
Film: Post-production
Website: Pre-production

1. Tell us about your project.
While cleaning out my attic two years ago, I came across a box full of notes I received from friends while in high school. I quickly sat down and read every single letter. Aside from bringing back a flood of memories, I found many to be extremely intimate, present-day windows into the lives of adolescent girls, and began plans to stitch them into a film. A fellowship to the MacDowell Colony allowed me the opportunity to flesh out the idea and, one month after my return, I went to my old high school and shot the film using actual students. Entitled *Letters from Homeroom*, the film is currently in post-production and tells the story of two sixteen year-old girls, as narrated through the letters they write to each other in class. It is 24 minutes long and consists of approximately fifteen, 1.5 minute segments (one segment = one letter). Shot on digital video, the film will be available to the audience through the internet and will serve as the primary component of a website devoted solely to high school girls - www.LettersFromHomeroom.com. On the site, the audience can view the film through many different platforms: streaming video, an audio-only tour through a photo gallery, or text and photos. In addition, the site will host a chat room where the audience can talk about the film and an "auditorium" where there will be audio of celebrities and role models reading from or speaking about their letters during their teenage years. There will also be an extensive and edited links page and scenes of additional characters not in the original film.

2. In what tradition do you work? How does your work contribute to the evolution of this tradition?
American youth culture has consistently played a big role in all of my work. As a first generation American, born of Indian and Argentine/French descent, and having spent time in

FIGURE 13-1 | **Sample 1999 Preliminary Application Form for a Creative Capital Foundation Grant**

The applicant is 1999–2000 grantee Maya Churi. This preliminary application form was one of more than one thousand eight hundred applications received that year. Based on this information, the artist was chosen as a finalist for a more extensive second-round process. After reviewing her subsequent support materials, a panel selected Churi as one of seventy-five artists to receive Creative Capital funding for their projects.

Source: Creative Capital

my parents' native countries, I look upon the adolescent lives of American girls (myself included) as a culture all its own, a culture that is making its presence known all over the Internet. My 16 year-old sister can spend six hours at a time talking with friends through the computer, visiting websites and chat rooms. Because artistic expression on the web is still in its infancy, its traditions are only now being formed. My goal with *Letters from Homeroom* is to combine the two means of expression I love most - film and new media - with a subject matter that is only now being tapped.

3. What resources, financial or other, do you need to realize this project?
Music recording & rights
- On-line edit
- Web hosting
- Web design and maintenance
- Create partnerships with other sites
- Create a broad-based sponsorship package
- Grassroots promotion
- Embark on national tour to high schools

4. What do you think would be appropriate venues for your work? Do you have existing relationships with any such venues?
Beyond personal computers, the film will be exhibited at high schools, coffee shops, cyber cafes, and movie theaters around the country. The New York City, all-girl band *Moxie* is releasing their second CD in the winter and will be doing a national tour to high schools around the country. The tour will include the exhibition of the film/site. With a laptop computer, we will go to high schools and take students on a tour of the site, show them how it works, and encourage them to create their own sites. Other venues would include local art house movie theaters/coffeeshops where teenagers would come for a listening/visual tour. Having worked in a theatrical film distribution for two years at Artistic License Films, I have solid relationships with many of the smaller art houses around the country.

5. Who would be the ideal audience for your work? What are your thoughts on how you might develop such an audience? Could any of your current contacts help you to do so?
The ideal audience for my work is teenagers ages 12-18, and grassroots marketing will play a big role in reaching them. In addition, we will create partnerships with other websites and companies that target the same audience, and will embark on a national tour of high schools. Also, because the film is on the web, kids can e-mail the site to their friends - instant distribution. I will also use an eclectic and still-growing advisory committee for guidance, promotion, and contacts. To date, the committee consists of: Sande Zeig - President, Artistic License Films; Sarah Jacobson-Filmmaker, *Mary Jane's Not a Virgin Anymore*; Michael Jones-Managing Editor of *Filmmaker Magazine*; Eugene Martin-Filmmaker, *Edge City* and *Two Plus One*.

FIGURE 13-1 | **Continued**

Abstract or summary: For long proposals in excess of six pages, prepare a one-page summary of all important points.

Objectives: This should be a brief description of the specific benefits to come from the particular research, project, or work you want to do. Avoid generalizations and platitudes.

Background information: Describe your background and competence in relation to this proposal. Why is your project stimulating, necessary, or beneficial? If others are doing work like it, how is yours different?

Project description: This section should answer the following questions: (1) who will do the project? (2) what will be done? (3) for whom will the project be done? (4) why will the project be done? (5) where and when will the project be executed? You may use a combination of written descriptions, diagrams, drawings, photographs, or other visual material. If applying to a foundation interested in enhancing social welfare through art, identifying your host venue and anticipated audience and showing how they will benefit from your project are very important.

Technical support: List the equipment, personnel assistance, and facilities you already have for the project, and also what you still need in these areas.

Budget: Submit a total budget, listing every expense item and cost. Indicate which items will be covered by donations from other sources. Allow ten percent extra for materials and supplies in case of cost increases. Any fee you intend to pay yourself for your time and talent is taxable income, so allow extra to ensure yourself fair pay after taxes.

Evaluation/conclusion: How will you evaluate if your project is successful? Do you envision any follow-up projects to it?

Supporting documents: Include pertinent materials such as your resumé, resumé of other participants, a letter of support from the host venue, or letters from other donors to the project.

Style and Presentation. Your proposal should be as brief and concise as possible. Two to five pages are usually adequate, although very complex ones may run as long as ten pages. It is easier to write long proposals than short ones, but your donors will appreciate short, well-written text.

Avoid obscure jargon; your purpose is to explain your idea, not to mystify your reader. Equally important, avoid generalizations. If you are proposing to paint a mural for a community center, "bringing culture to the masses" is too general an objective for your project, whereas listing specific benefits that are pertinent to your situation may be better. Be positive, emphasizing the benefits to come from your project versus dwelling on inadequacies.

Organize your material into logical sections. Break up big blocks of solid type with indentations, titles, and subheadings.

Be sure to answer all points and check that your project conforms to time frames and allowable cost. Submit the requested number of copies, and collect the mandatory signatures from sponsors.

Presentation is important. Your proposal should be well packaged, on nice paper, with clean readable copy. Send originals, or photocopies if you are requested. Never send faxed or e-mail grant proposals, unless, again, you are instructed to do so. All visual materials should look professional. Have friends or art professionals review your proposal for content issues and proof it for grammar and spelling errors before you submit it.

artist interview

ALYSON POU

Alyson Pou is program/services director for Creative Capital Foundation, a grant and artist support agency. She is an artist who produces her own installations and performances in major venues in New York City and other U.S. cities. She has taught at several colleges and universities and has worked as an arts administrator for more than twenty years.

What are the most important things for artists to know when applying for grants?

Grants are only one piece of the pie for artists. They are just one part of a whole strategy that you come up with for yourself.

Before you begin looking anywhere for funding, spend time to find your own objective. Always stick to it. That's the first step. Artists sometimes make the mistake of wanting to mold themselves to what they think the needs of the grantor are. But it's actually just the reverse! You need to know your objective first.

The second step is doing research and identifying resources that match your objective. Sometimes, grants are the answers to that and sometimes they're not.

The third key step is follow-up. In some cases, you may have to ask over and over again for funding. One piece of advice I give artists is not to take rejection personally. You cannot ever really know what people's motivations are for supporting a certain project. They have their own reasons. And sometimes it's really not about you at all.

What should artists ask for?

Identify your objective. Then figure out what your needs are and how to ask someone so that they can give you a "yes." Or so they can give you a "yes" or "no" to let you move on to your next step. The corporate world knows how to do this. But in a lot of art-related conversations, artists talk around the subject. Potential supporters might come to the table wanting to help you, but they get confused because they don't know what you're saying to them or what you're asking.

So the delivery just isn't there.

Yes. Maybe because art sometimes seems to have so little value in the eyes of the culture that we are almost apologetic.

Should artists look at both grants and other funding sources if they have a project they want to fund?

Yes. Not every successful artist is going to get a grant. If you look at just our statistics, Creative Capital received almost three thousand applications this year, and we're maybe going to give fifty grants. That's less than two percent. Artists need to look at things like corporate giving programs and in-kind donations as sources of funding, too.

Nevertheless, I say it's always worth it to write a grant application if it fits your objectives.

Why?

Because it helps you hone your objectives and your writing skills. I might complain about having to write an application, but once I've done it, I am usually several steps forward in my own thinking about my work.

While we're on the topic of writing about your work, I think that every artist needs to learn to do this—even if they feel it's hard and even if they can afford to hire someone else! Grant panelists can immediately recognize something that a second party has written, or a grant writer who knows "grantese" has written, or whether it's really coming from the heart of the artist. So, I always emphasize to artists that it is to their advantage to write about their work. It's not a waste of time.

How can artists build on the grants they have received? You mentioned corporate giving programs and in-kind donations before.

People will often be interested in a project if they see that someone else is already signed on and has put the money on the line for it. If you receive a grant, you can use that to approach other grant agencies for more funding. If you don't need to raise more money, you can still use that as leverage for your career.

Performance title, "Black Rocks, Pearl Buttons" at Performance Space 122, New York City

But I think that most artists don't focus enough attention on donations of in-kind goods and services. For example, if you're doing a big public art project at the local school, you can ask the local scaffolding company to donate the scaffolding you need. This is where you can really get creative in your thinking as an individual artist and also build a great constituency and audience for yourself. There are a lot of businesses and individuals out there who would really love to have contact with artists and what they're doing.

I met an incredible husband and wife theatrical team, whose productions were related to specific issues, like women aging, and they were booked solid all year round touring their pieces. They would target a particular region or constituency as the audience of this piece, and then they would methodically get in touch with all the organizations that were associated with that topic. It goes back to the objective. They set their objective and they found the resources for it—totally outside of the art community. They reach their audience so that they don't have this false removal from the public.

Every commission, every residency, every exhibition is based on relationships. Someone, a real human being, wanted to help you. So, a lot of it is about how you build relationships with people.

You've talked a lot about setting objectives. How do artists do that?

Artists need to do strategic planning. It makes a huge difference, but it's not something that we're ever trained to do. You can hire someone to help you make a strategic plan.

What would be in it?

We all know the standard preparatory questions: What do you want to accomplish in one year? Name one or two goals in relationship to a project. What do you want to accomplish in five years? These questions begin the process of very specific time management and financial planning.

We have been doing strategic planning with our funded artists, and it's just unbelievable what it's doing in their lives. It gets them out of the negative realm ("I can't do this" or "Everything is impossible") and into the realm of concrete actionable steps—"I have a plan here." You can continuously change and modify the plan, but you're working with a structure.

I guess strategic planning could really change an artist's career.

You don't lose your creativity. You're gaining perspective and gaining ways of getting help. It really makes people get focused and bring all the parts of their life into the picture.

Some artists live by crisis management. Like, "OK, I just got this commission to do this project. Now I'm going to throw everything I have into it. I'll put whatever I need to on my credit card; I'll stay up until three o'clock in the morning, just to get this to happen." You can survive that way. But you can't project out a whole life of that and see yourself moving from point A to B to C with any control.

It also helps artists to recognize where they are, too. In the United States, we live in a market economy that is driven by the conventions of capitalism. If you want to enter the gallery system, then you have to acknowledge that it's based on producing and selling products. It has its limitations and advantages. Do they match your objectives? Base your decision on that. But if you're the kind of artist who has a strong social conscience or doesn't want their works in the marketplace or wants total control, then don't even enter the gallery system. It's a waste of your time to say the system is a mess, or the system abuses me, or I don't get what I want out of the system. The system just is what it is. You're either going to choose to function in it or you're going to choose to be outside of it and do something else.

And planning can also influence the course of a single project?

We funded one artist who had an incredible, interesting, community-based project. She was gung-ho to finish it within four months. But we could see that if she gave it a couple more years to develop, she could have this project go to a much bigger scale than she ever considered! By working with us on strategic planning, she extended the project two or three more years, got more contacts in the community to fundraise for it, found a good producer, got the backing it deserved. It was a great retraining, reeducation process for her.

What are some other Creative Capital programs?

We are really trying to think creatively about money. One arm of the organization is the traditional grant-giving arm. We accept and process proposals, a panel reviews them, and we award money.

After this process, the funded artists work with the Artist Services arm of the organization. They meet with Creative Capital staff to talk and strategize about their project. Where are they with the project? Do they need fundraising or PR assistance? How can we help them find the help that they need? We have an annual retreat for all funded artists, with workshops on such topics as fundraising, strategic planning, and legal issues for artists. Additionally, we invite arts professionals to act as consultants. This helps to open doors of communication and opportunity for our funded artists. After the initial grant and meetings, artists can apply for supplemental support, up to $5,000 for strategic needs related to the project such as purchasing equipment, hiring consultants, or developing promotional materials. The positive effect of this targeted money has been exponential.

And finally, funded artists can come back and request up to $20,000 related to their project. This time, the key word is impact. If you get this money, what kind of impact will this money have, not just on the project but on the community at large?

Your agency really provides some great opportunities and services!

Yes. We have very hands-on contact with our artists. They have a lot of access to us as a resource.

Other Financial Support

We have already explored ways for artists to support themselves through art sales, jobs, and grants. This chapter covers a few more areas that offer financial support for artists, including public art programs, commissions, state and local art agencies, art organizations, and business support. We look at them one at a time.

Public Art Programs

Under the umbrella of public art programs is a whole range of agencies, projects, and programs that are generally concerned with the cultural enhancement of public spaces. Artists participate in public art programs in a variety of ways. This section outlines the major areas of public art programming and indicates sources of more information.

Before beginning, let's get a sense of what kinds of spaces are involved in public art programs. They include:

- Government administrative buildings
- Libraries, fire stations, police stations, community centers
- Transportation centers, such as airports or train stations
- Transportation systems, such as highways, light-rail systems, or bike paths
- Waterways, ports, and harbors
- Schools
- Parks
- Private developments in urban renewal zones

In addition, design teams continue to identify and define new kinds of spaces for public art programs. The field is growing tremendously, especially in areas of

big development. Public art programming is sometimes offered to the population to mitigate the negative effects of overdevelopment.

Percent-for-the-Arts Programs

Percent-for-the-arts programs are government-funded or governmentally legislated art acquisition programs for new construction or major renovation projects. These programs are funded through general tax revenues, hotel taxes, or capital improvement project bond issues.

Types of Programs. There are different levels of percent-for-the-arts programs, each governed by different agencies and engaging different audiences.

On the federal level, public art programs are part of the General Services Administration (GSA). The GSA's Art-in-Architecture Program mandates that all new-construction, newly purchased, or renovated federal buildings set aside 0.5 percent of the cost toward acquiring and installing art in or around the building. Artwork made for federal projects is generally durable and permanent, designed to last for decades. The work generally must represent values held by the majority of U.S. citizens. Artists participating in the GSA's projects usually have national reputations, excellent ties with fabricators, and an ability to work on a large scale.

Many states have percent-for-the-arts programs designed to place art in all state construction projects. State programs are generally modeled after the GSA's. The state programs are run by the state art agencies and are regulated by state policy. The art produced through these programs addresses the citizens of that entire state.

Some counties and cities also have percent-for-the-arts programs to provide art for their construction or renovation projects. These programs may be administered by cultural affairs departments, local arts commissions, community services offices, or even parks and recreations divisions. Most projects at this level must actively engage or address the local community. Artists with little or no experience with public art commissions will likely be awarded their first commission on this level. Although some public art pieces at the local level are intended to be permanent, many are expected to last only five years or so.

Each level and each governing entity is allowed to interpret how art will enhance their new construction or renovation. Often, it means the purchase of an art object to be placed in a public location or the commissioning of a site-specific art piece that is incorporated into the very design of the site. However, public art programming also funds temporary festivals, musical performances, or educational outreach.

In addition, legislation for funding for public art has been expanded into the private sector. Each state, working with municipalities, can identify areas within its borders as community redevelopment zones, which means that private developers receive a tax break or incentives on any new construction or major renovation done within the zone. The redevelopment of the zone is managed by a community redevelopment agency (CRA). Developers in these zones must spend one percent of all construction costs on public arts. There are many ways that developers can satisfy

that requirement. A piece of sculpture in front of a building is one example. A more complex example is the redevelopment of the Bunker Hill area in Los Angeles, where the various developers of adjacent high-rise residences and office buildings formed a business association and assessed themselves a tax to build the Museum of Contemporary Art amid their structures. Another example of a massive redevelopment project was Battery Park in New York City.

To become a redevelopment zone, an area has to be declared "blighted." This designation causes property values to plunge and so is not used except for the most debilitated areas within cities.

All these government-funded and privately funded public art projects are associated with new building construction, renovation, or redevelopment. But there are also various community-based organizations that sponsor their own public art projects, both permanent and temporary, separate from any construction. Festivals bring art to certain city areas for short time periods by providing funding for artists to do performance, temporary installations, and/or educational or promotional materials (banners or bus-stop graphics). Artists may also be commissioned to produce a "portfolio," which is a collection of imagery that a city can use in connection with a public event or program. On the more permanent side are publicly or privately funded mural programs. Some of these are artist initiated, such as Pro Arts, a New Jersey organization that actively promotes the painting of murals around Jersey City.

Public Art Competitions. Every year, many public art projects are initiated across the country. In most cases, consultants are hired who help the public or private agency identify artists to participate. They generally invite artists who have a proven track record for executing public art projects. For privately funded projects, the developers have the right to select public artists. Some do choose their own, whereas others use private consultants, hold competitions, or work with public art administrators in their area.

However, open competitions are held for approximately 20 percent of all state and federal public art projects. These are publicly advertised, and artists are encouraged to enter. Generally, the process of awarding a public art commission to an artist in an open competition is a two-step procedure. In round one, all artists who wish to enter the competition submit a cover letter, a short written concept statement for the project, a resumé, and ten to twenty images of their artwork or of previous public projects. Three to five entries are selected as finalists by a panel of artists, art professionals, and representatives of the sponsoring entity.

In round two, the finalists develop a proposal and present it to the panel, usually as in-depth oral presentations. If a consultant has been hired by a private developer, the consultant may make the presentation of all finalists' work to the developer. In either case, finalists almost always have to do substantial research of the site and of the local community to make an effective proposal. For some, finalists must develop extensive written material and visual aids for their presentation, with models, architect's drawings, timetables, and detailed budgets. If such an elaborate preparation is required, finalists should receive an honorarium as partial compensation for their work, whether or not their ideas were chosen in the end.

For more on developing a proposal, see the section "Proposal Packets" in Chapter 6 and also the interview with Joyce Kozloff at the end of that chapter.

Entering Public Art Competitions. For emerging artists, the best way to enter the public art field is by making your art known to the art consultants in your area who deal with public art or by joining a design team. Many public art projects are complicated, with aspects of architecture, engineering, or urban planning. You may need professional experience to make an effective proposal. If a particular competition presents design problems and regulatory hurdles outside your expertise, join with architects, engineers, or others with experience to create design teams for public art projects. Kim Yasuda, a California artist who has been involved in a number of public art projects, commented:

> For public art projects, I highly recommend to not think you can do it yourself. It is a misleading and frustrating experience if you are not trained in the field. Not to say that you couldn't come up with an incredible idea, but to actualize and argue your idea through the entire bureaucracy and be convincing and be respected, you really need support, you need to know this is a team effort. There are approvals, plan checks, engineers, and a million different bodies that have to review things. For example, in one project we had to work with state architects, and it was very difficult to argue with them for the added cost, time, or skill it may take to make something relevant and aesthetic, in addition to functional.

You should enter only those competitions for public art projects that play to your strengths as an artist. For example, if you produce freestanding sculpture, enter those competitions that request objects. If your work entails research, look for commissions that are research oriented. Find a project in which the content interests you.

Artists who are new to public art frequently have great difficulty developing realistic timetables and budgets. Even those with experience have trouble anticipating the pace of regular construction, not to mention the havoc that bad weather, labor disputes, and budget shortfalls can wreak. The cost can easily run up higher than expected. In addition, the nature of the project may be changed on you, even after your design has already been approved. Again, it is most helpful to work with a team of artists or designers experienced in public art before venturing out on your own.

Many artists have professional fabricators make most of a public art piece, because of the large scale of many such projects and also to meet building code standards. In such cases, artists then produce detailed maps, drawings, or plans for fabricators to follow. To expedite this process, some artists repeatedly employ the same fabricators, who then become familiar with the artists' aesthetic and way of working.

Contracts. If you are awarded a public art commission, you will be asked to sign a lengthy contract drafted by the sponsoring agency. Review this contract with a lawyer before you sign. You should realize that provisions within the contract may carry hidden obligations. For example, one artist who was awarded a public art project for a new light-rail train station was surprised when "supervising

installation of the artwork," as stipulated in her contract, also meant that she had to attend a four-hour training session to learn how to emergency-stop a train.

Information Sources. Several sources are available to artists to find out about open competitions for public art projects:

> Cities' cultural affairs departments, cultural centers, and CRA's maintain mailing lists and publish newsletters for those interested in notification about competitions. The telephone numbers can be found through directory assistance, through state art agencies, at libraries, at city or county government offices. Some are administered through parks and recreation offices. In addition, you can contact the Americans for the Arts, an organization of local art agencies that lobby for the arts. Their Web site is www.actsusa.org.

> The GSA Art-in-Architecture Program maintains a registry of images and resumés of artists who wish to be considered for a public art commission. Contact the GSA for information on current competitions and guidelines for appropriate visual and written material.

> State art agencies maintain mailing lists of artists interested in receiving notices about upcoming public art project competitions. Some state-funded public art projects are open only to state residents, but for many, any U.S. artist is eligible to submit a proposal. Go to the state art council's Web site to find out how to be added to their mailing list.

> *Public Art Review,* issued twice a year, has short articles, results of recent competitions, and listings of new ones.

> Art or architecture magazines publish minimal information about competitions in the announcement or classified section. You can write away for complete information.

Design and Planning Teams

Some artists involved with public art programs are parts of advanced planning teams who participate in a project from its very inception. These planning teams deal with the early phases of a project, when fundamental architectural, urban planning, land use, and landscape architectural issues are being decided.

These artists are part of the process whereby locations for public art are identified. They are not focusing on making a particular art object but rather on how the entire project is being conceived and designed. Such artists are generally experienced in the public art realm and are familiar with the language of civics, architecture, and landscape planning.

Commissions

Another source of funding for artists is private commissions, in which an artist agrees to produce a special work for a client. Before the 17th century, almost all

artists worked on commission, that is, they produced art in response to someone's request for a specific piece. Only in modern times have artists made volumes of work with the hope of later selling it. Yet even today, many artists still work on commission.

When you sell an already-existing piece, the buyers see what they are getting and the transaction may be simple. By contrast, a commission is a more lengthy relationship between artist and clients in which both parties must communicate and agree on a number of points, including the nature of the piece being made, the timetable for completion, approval procedures, and payment schedule. Without this understanding, you run the risk of disappointment, failed expectations, and alienating a potential backer.

The following steps will greatly increase the probability of a happy conclusion to your commission: (1) Artist and clients hold preliminary meetings to thoroughly discuss the potential commission; (2) the artist develops a proposal, including description, budgets, and preparatory sketches or models (see Chapter 6); and (3) all parties sign a written contract specifying the work to be done and approval procedures. For elaborate commissions, these steps are essential; for simple work, you can eliminate unnecessary procedures.

Preliminary meetings should include all persons who need to be pleased with the final results of your work. Meeting with only some of the decision makers may waste time until you have a sense of the entire group's tastes. At these meetings, bring samples of your own work or reproductions that can be easily seen. Good-quality color prints of your work, as large as 11 inches × 14 inches, in a compact portfolio, make a good presentation. Alternatives include 4-inch × 5-inch transparencies, photo-quality computer printouts, and catalogs of your work or show announcements. 35-mm slides are least desirable for immediate viewing, because holding a sheet of slides to a window will not give your clients an adequate idea of your work. If you must use slides, bring a portable viewer or projector. With all visual material, be prepared to verbally describe your work.

If at this point your prospective clients express enthusiasm or interest, try to elicit a description of the kind of artwork they desire. This may not be easy. Some clients think they should give you artistic license. Some may be terrible at knowing and expressing their ideas. Nevertheless, ask how they would like the commission to look, what qualities they want communicated, and whom they envision as the audience for the work. In your conversation, try to get specific meanings for casual remarks. For example, does "impressive" mean big or the use of expensive materials? Does "colorful" mean a few bold colors or the spectrum in pastels? Ask them to identify other works of art that they like.

You need to know the approximate budget for the project, so you can plan accordingly. What is the timetable? How soon does the client want the completed work?

If site-specific, visit the location where the piece will be installed. Does the site need to be modified, and who will be responsible for that work and expense?

In some cases, you may never meet your clients if they have hired art consultants or designers to oversee a project, including select artists for commission work.

All communication may go through these intermediaries. In these circumstances, getting a sense of what the clients want may be more difficult. But good communication is essential.

Go no further than preliminary meetings if you are not qualified to do the work, not interested in making what the client wants, cannot get sufficient information from the clients to proceed, or feel that you would be drastically underpaid for the work requested. Do not proceed on the hope that they will change their minds or that things will work out in time.

Proposals and Proposal Fees. If you decide to proceed, make a simple pencil sketch to indicate your ideas. If your client likes the general direction of the work and wants to proceed, you are ready to develop a full proposal, with models, written descriptions, budget, and timetable. Again, see Chapter 6 for more on compiling a proposal.

These proposals may require your creative efforts and a considerable amount of time. Well-established artists with reputations can request fees for developing proposals because the demand for them is great. Emerging artists sometimes do not have sufficient position to request a proposal fee or may offer to apply it toward the total commission cost if their proposal is accepted. However, you should definitely be paid separately for the proposal in the following cases: (1) the clients specifically request a substantial investment in time, effort, or materials; or (2) the preparatory work will become part of the final commissioned piece, for example, if you are to produce a series of twenty-five photographs and complete three in advance as samples.

If you expect to be paid for developing a proposal, draft a short contract or letter of agreement, specifying what you will deliver and how much you are to be paid, before you begin any work. Indicate also the charge for revisions. After reviewing your proposal, your clients may want some changes. Minor ones can probably be easily accommodated, but you should receive an additional fee if substantive changes will require you to make new drawings or models to ensure that the clients are not just fishing around.

Specify that all parts of a proposal, whether it was accepted or rejected, are to be returned to you and that you retain ownership and copyright on the materials.

Contracts. As soon as your proposal has received final approval, have a commission contract drafted and signed by both parties. The commission contract should specify the product to be made and the approval procedure to be followed. The primary reason for commission contracts is to avoid disputes. The process necessary to reach a written, signed contract ensures a more solid understanding than most oral agreements can. Sample commission contracts are available through local Volunteer Lawyers for the Arts. Consult a lawyer before entering into any agreement with substantial consequences.

Figure 14-1 gives you some of the important points for a contract for a private commission. You may want to cover different points, depending on your circumstances. Commissions for works in public locations may have more requirements than works in private residences. For example, if you are commissioned to paint a mural in a bank lobby, you may encounter added costs in legal liability, workman's

CONTRACTS FOR PRIVATE COMMISSIONS
SOME POINTS TO INCLUDE

☛ **Parties to the agreement**
the artist
the persons offering the commission (the clients). Specifically name everyone with
decision-making power
☛ **The artwork to be made**
Describe fully what is to be made
medium
size
where installed if site-specific
List the preparatory sketches and models that were approved by the clients, and when
☛ **Obligations of each party**
List what the artist will contribute
for example, labor, materials, etc.
List what the clients will contribute
for example, insurance, modifications to the site, etc.
☛ **Timetable**
Specify starting and completion dates for the work.
Schedule specific dates when your client is to review and approve work-in-progress.
Reserve the right to extend the deadline if you become ill or temporarily disabled.
☛ **Pay and payment schedule**
List the amount you will be paid and what the payment covers.
Specify if you are to be reimbursed for expenses.
Refer to the proposal budget which the clients approved.
List dates when partial payments are due
First payment due when contract is signed
Partial payment due every time your clients review and approve the work
Final payment due upon delivery of the finished work.
If at any time your clients fail to pay you, reserve the right to terminate the agreement
and retain all prior payments and all completed work.
☛ **Procedures for changes**
Limit the amount of revisions your clients may request on the work-in-progress. Your
benchmarks are the preparatory drawings and models the client approved.
Stipulate extra payment for substantial revisions, to cover redesign costs, added material
costs, and extra time.
☛ **Procedures for cancellation** (if your clients abandon the project once you have begun)
You retain all prior payments
Specify a kill fee you receive to compensate you for having made a time commitment to
this project when you could have been working on others.
Reserve the right to sell the rejected work to another buyer if possible.
☛ **Copyright and moral rights**
Even though you have copyright and moral rights protection by law (see Chapter 15), the
average client may not know or understand these laws. Spell them out in your
contract.
☛ **Ownership of proposed materials**
Retain ownership of all your proposal materials, including models, sketches, and any
written text.

FIGURE 14-1 | Drafting a Contract for a Private Commission

These are points to consider when formulating a contract covering a private commission.

compensation insurance, or compliance with building codes. Again, consult a lawyer to find out how to deal with these points in a contract.

State and Local Art Agencies

In Chapter 13, we saw that many state and local art agencies offer grants for artists. They also may provide artists with other kinds of financial support. Here are a few examples:

Art purchase programs: Some agencies, such as the Seattle Arts Commission, purchase art on a regular basis. Seattle's program is called the "Portable Works Purchase,"and they welcome submissions from artists around the country in the media they are featuring that year.

Internships: The Colorado Council on Arts offers internships in arts management programs for current or recently graduated university students. There may be similar programs in your state.

Artist-in-residence programs: Many states hire artists to teach and produce their own art in schools or community centers. For example, the Ohio Arts Council offers residencies in schools and in programs for youth at risk. Residencies can be as short as two weeks or as long as nine months.

Registries and exhibition spaces: Some, such as the Delaware Division of the Arts, maintain registries for artists and exhibition spaces in the state capital for artists' exhibitions.

Each state and local agency has its own programs. Find out what is available where you are.

Arts Organizations

Artist organizations generally do not provide financial support to artists, but they can help you get to other sources of funding or acquire services or donations. If an arts organization sponsors your project, then you have its reputation as backing. Emerging artists sometimes lack a track record, a proven history of successful projects, and an established reputation. Therefore, trying to pull together a project as an individual may be frustrating and difficult. If you work through an established organization to realize your project, you borrow the reputation of the organization, which may give you added clout when dealing with

- Foundations, when applying for grants (see Chapter 13)
- Businesses, when requesting donations (see below)
- Local government, when applying for permits and waivers
- Communities and individuals, when asking for their cooperation or participation

Thus, association with an arts organization may enable you to garner outside financial backing, while providing you with various forms of intangible support, and in some cases actually provide monetary support themselves.

Your project should fit with or help realize the mission of the organization. To ask an organization to sponsor your project, prepare some written material: a summary of your project, its objectives, a complete project description, and budget, along with your resumé tailored to emphasize your competence to complete the project. Make an appointment with the director of the organization. Present your proposal, and ask specifically for the support you want.

Support from Businesses

Many artists who are working on projects look to the business community for support. Small businesses and large corporations do contribute to artists' projects, especially those firms with executives who have a long record of art patronage. Even firms that have never donated to the arts may support your project provided it meets one of the following criteria:

Publicity: Projects that are public in nature, reach a wide audience, or are likely to be widely publicized are attractive to businesses. Such projects must have generally good effects that can be associated with its backers. Examples include exhibitions, installations, murals, public monuments, historic markers, playgrounds, educational programs, lectures, and technology-based interactive works.

Community relations: Businesses may support projects executed in the immediate area where the business is located or where its customers live.

Research and development: Your project may be attractive if you innovatively use a product or process provided by the firm, and there is further marketing potential in your application.

A note before preceding: Some large corporations have their own foundations as conduits for their philanthropic activities (applying for funding through foundations is covered in Chapter 13). However, you can still ask a corporation for help, even if it also sponsors a foundation.

Identifying Possible Donors. Make lists of possible businesses to approach, paying particular attention to small companies. Although their donations may be modest compared with the corporate giants, they may be more likely to contribute if they identify with your community.

Start locally to find small businesses and corporations to support your project, as you are more likely to receive aid from them than from out-of-town firms, even those known to support the arts. If your project is aimed at a particular population, such as adolescents or freeway commuters, make a list of firms that supply goods or services to that population. Some businesses will be easy and obvious choices, but with some imagination you might uncover more, for example, your audience's food suppliers, their insurance companies, or their favorite radio stations.

If your project is site-specific, such as a mural, note the names of small businesses in the vicinity. Make lists not only of retail stores and service-oriented businesses, but also manufacturers, construction companies, warehouses, and wholesalers.

For leads on larger corporations, consult geographic directories of corporations. The most beneficial are those covering your area only, because most corporations donate primarily near their plants, headquarters, or customers. Among these more local directories, some cover an entire state, whereas others cover regions or municipal areas. For example, if looking for corporations in Santa Monica, California, you might consult the *Southern California Business Directory* for a listing of businesses in the southern half of the state, the *California Manufacturer's Register* for manufacturing companies, the *California Service Register* for service companies, or most immediately the *Directory of the Santa Monica Chamber of Commerce.* Other states and cities have comparable publications. Also, look online for chambers of commerce, as many of them post their directory of members.

There are also national directories of corporations, such as *Ward's Business Directory of U.S. Private and Public Companies* and the Dunn and Bradstreet *Million Dollar Directory,* which list simply the corporation's name, address, the CEO, its worth, number of employees, and a few sentences about the company. These and other corporate directories are available through local chambers of commerce or in reference sections of large public libraries.

Another strategy for selecting corporations to approach is to find out which corporations have executives who are interested in the arts. Once you have a list of local corporations and their CEOs, check the *Who's Who* in large public libraries to find out if these executives have any connection to the arts or to the community where you will do your project. Also, check the annual reports, publications, or stationery of arts organizations, museums, or alternative spaces for the listing of their board of directors. The businesspeople on these boards may work at or own corporations that are receptive to the arts. *The Guide to U.S. Foundations, Their Trustees, Officers and Donors,* published by the Foundation Center in New York, lists the names of trustees and managers of more than thirty-four thousand foundations. Again, the trustees of foundations that fund the arts may also be executives of corporations that also support the arts.

Types of Gifts. You can ask for all kinds of things from businesses, including any of the following for projects they choose to support:

Funding: Some will make outright gifts of money.

Materials and supplies: Businesses will make gifts of materials. Perhaps it would be what you need for making an art object or for constructing an art space. Food suppliers or retailers may donate food or beverages as refreshments for receptions or fundraisers. Some firms may lend needed supplies, such as tables, chairs, lighting, and scaffolding.

Space: Realtors or landlords may give free use of vacant spaces for a limited period of time. Businesses or schools may make available meeting rooms, theaters, or lecture halls, with seating and audio-visual equipment, for lectures, workshops, or performances.

Access to equipment: A manufacturer may allow on-site use of some special fabricating equipment needed for a project.

Personnel assistance: Staff with special skills may spend time working for a project. Examples might include accountants or lawyers to help a nonprofit organization, electricians, events organizers, or publicists.

Concerning cash gifts, some businesses are willing to make modest donations without your exerting tremendous amounts of effort to woo them. Therefore, you might break down your needs into "bite-size pieces" and plan to ask several firms for support, rather than hoping for everything from one. Concerning gifts of materials and supplies, some businesses have policies against giving gifts out of inventory. So, although asking for a needed video camera from a video manufacturer or retailer may seem logical, some firms may refuse you because their existence depends on selling such equipment, not giving it away. When approaching such businesses, be prepared to ask for other gifts, such as cash donations, use of space, or assistance from their personnel.

Proposal Packet. Prepare complete written documentation of the project. Included in the written materials should be:

Description of your project, including its purpose, the targeted audience, its duration, and the expected impact. This part is the heart of your proposal. Emphasize your project's aesthetic merit, and social merit if applicable, to avoid the appearance that it is merely a ploy to get goods and services that you are not willing to buy

Timetable for the project

Budget, with list of other donors, if any

Visual materials

Your resumé, and an information sheet on any other individual or organization involved in the project

Acknowledgment: Specify the manner by which your donors will be acknowledged, for example, plaques on public sculpture or murals, credits at the end of videotapes, or donors' lists on performance programs

Keep all items brief, definitely no more than one page. Format all written material so that the essential points can be seen at a glance. Organize all material in a folder or binder, and be prepared to leave the material with your possible donors. For more on proposal packets, review Chapter 6.

Soliciting Gifts. The actual request for support is almost always made during a person-to-person meeting. Make your proposal to someone within a company who has the authority to make donations or gifts. Get the name of that person and some background on them, if possible, from your sponsoring organization. Or try calling the firm directly and asking secretaries or receptionists for information. It never hurts to ask to speak to the president. Be courteous to secretaries and receptionists, or your inquiries may get no farther than them.

Set an appointment for a half-hour if possible; you actually need at least fifteen minutes. During that time you have fundamentally three tasks: (1) to convince

your prospective donors of the worth of your project; (2) to explain the importance of their contribution; and (3) to show the long-term benefits for the business. You should prepare an oral presentation, in which you introduce yourself, concisely explain the purpose of your project, identify the audience it will reach, and ask explicitly for a donation of a specific cash amount or specific equipment and supplies. Conclude with the benefits the business will realize by being associated with your project. Bring your visual materials to make your project more concrete. Leave other documentation with the prospective donors for their future reference; they should not be reading this material while you are making your presentation.

Give donors a chance to ask questions. If you get a positive response, ask them to recommend others who might support the project. If you get "no" for an answer, ask for suggestions to help you in future solicitations. After each meeting, write a thank-you note, regardless of the response you received.

To a great extent, your success in soliciting business donations is dependent on your own credibility and the impression you make. Mention past experience that indicates that you are capable of the project. Already having donors helps when making subsequent requests. To increase your credibility, get sponsors for your project, such as art organizations, alternative spaces, colleges, civic groups, or churches. Ask for letters of introduction from all sponsors.

When meeting prospective donors, be articulate and concise, make eye contact, and try to establish rapport. Try to know something about them before you meet. Be direct, and ask without waffling for what you need. Naturally, your appearance, style of presentation, and the professionalism of your supporting materials are critical for your success. Friends and mentors can be particularly helpful as you work on these questions of style.

artist interview

JENNY HOLZER

Jenny Holzer's public texts address issues such as power, abuse, war, greed, and death. She has used posters, stone benches, electronic signs, and television broadcasts as media. Holzer represented the United States at the 1990 Venice Biennale.

Will you describe your process in conceptualizing your work and communicating your ideas to fabricators?

I usually begin by closing my eyes, and when I'm lucky I can see how the piece should be. Once that happens, I sometimes will make a drawing, and other times, I go straight from whatever I've seen to a conversation with the person who will fabricate the piece. I have a great working relationship with an engineer who makes my electronic signs, and often I can take my image to a test model by talking to him.

Because most of the works are site-specific, we don't have a chance to fine-tune until we are in the space. So, for instance, before the Dia Foundation show, we came to the site and I realized that all my programming was wrong. My engineer had to synchronize the signs and I redid the programs.

For the installation at the Guggenheim, I went to the museum a number of times, and by standing there and walking around and staring, I decided where to place the spiral sign, and figured out where the benches should go. I did that in advance of the opening, but some of the essential stuff like making the sign work and doing the programming happened in the last twenty-four hours. It was a

cliff-hanger! The sign didn't function immediately, and then we had to program it in the few hours before the opening. I can look at this now and laugh, but it was unbelievable, because if the sign didn't work, then there was no show.

When you do site-specific pieces that are *really* specific—I don't happen to have a studio that is the size and shape of the Guggenheim—you do it when you have access.

What is your "studio time" like?

It's funny, not since I was in undergraduate school have I had much time, be it studio time, or whatever you want to call it. When I was in graduate school, I never had enough hours in the day because I had jobs. And then after I graduated, I was working x number of nights and days and it was hard to find peace. I thought this would be solved when I became a professional, but now I have no time because I do all kinds of things like being my own secretary. It is a machine that feeds on itself.

The equivalent of studio time for me is sitting at my desk and writing, and then I decide where the writing should go. Finally there's the administrative part about contracts and trips and site visits.

Jenny Holzer, *Truisms,* 1982 Installation, Spectacolor Board No. 1, Times Square, New York.

Source: Courtesy Barbara Gladstone Gallery, New York.

What kinds of agreements do you make with clients for commissioned work?

It really depends on the project. For some, it can be absolutely casual, and there is nothing in writing, and a handshake will do. Even a handshake is not always necessary. But, for example, if I work for a municipality, I need and want an elaborate contract to spell out who does what, who has what responsibilities and liabilities, when I am paid, you know, all that kind of stuff.

Responsibility for budget items, deadlines, insurance, publicity.... Do you also specify protections like copyright and moral rights, even though they may be covered by law?

It's better to have that. Without being ridiculous, you try to put everything into the contract.

Who generates the contract?

The all-new me generates the contracts, and lets the client modify it. Because then it's much closer to what I need. It's not a negotiating technique, it's that the city might not think of what I require. I perhaps am more familiar with what works best than they might be. You know, a contract is not always adversarial. It's just for clarity.

Do you get legal help in doing this?

Yep. And now that I've done a number of contracts and the attorneys have explained what they mean, I often can modify them myself. I would say get the most intelligent and knowledgeable attorney possible to make the first draft, and then read it until you understand (and not be embarrassed to ask questions until you do), and add whatever else might be desirable. Then realize that the other party may have different requirements, and that you'll have to go around a few times.

Do you find the process of working on a commissioned piece challenging or interesting?

More often than not, it is, but it's time consuming. It's a lot different than cooking up something at home and being autonomous—you know, being able to do exactly what you want when you want. It's laborious, sometimes frustrating, but usually, if both parties have goodwill and want the project to happen, it's fun. And often I learn something.

You started out making street posters. A cursory overview of your work may indicate that it is becoming more materialized, for example, the marble used for the installation at the Venice Biennale. Do you see your work that way?

Yes and no. Some of my stuff doesn't exist at all other than as an electronic impulse. Other things, like the installation for the Venice Biennale, did use materials that certainly are heavier and more baroque than street posters. But it's funny, even the museum installations have disappeared because they're up for a certain period of time and then they're broken into fragments. The Guggenheim piece probably is gone for good.

My career began in the streets for a number of reasons. The big one was that that's where I thought the work should be. Another reason was there were no galleries or museums interested in this sort of work.

Some things I do are nonexistent except when they are passing through a computer network. The museum and gallery installations indeed are clunkier than the street posters, but I'm not attached to tons of marble. I was trying to be site-specific in Venice which is the home of excess, but I don't foresee being in the stone business forever.

What process is involved in representing the United States in the Biennale?

As I understand it, and my understanding is imperfect, there is an international exhibitions committee that invites a number of curators to submit proposals for a show of an artist or artists. And then, from those proposals, the committee picks a curator and his or her artist. For 1990, they selected Michael Auping. Auping was the curator of the Albright-Knox. I didn't know him, which was interesting. I think I met him once before.

Venice was funded a number of ways, and I don't know all of them. I'm not sure about government money. I believe the organizations in charge approached a number of foundations. I think the Pew Charitable Trust, and the Rockefeller Foundation gave money, and I could be forgetting some others. My gallery threw in money; I spent money. And Albright-Knox did, because they were the sponsoring institution.

You do take on provocative and difficult issues—war atrocities, AIDS, child abuse—and deal with these themes in public works.

I often write things on electronic signs that are considered unspeakable if I feel that these issues make the world turn, and in particular, turn for the worse.

I'll broadcast something unmentionable if I feel it's a particularly bad brand of psy-chopathology harmful to people at large; I might try to hang that on the line so people can stare at it and recognize it for what it is. Sometimes I may talk about something tender and desirable that needs attention or recognition.

I concentrate on the horrific because I think, for the most part, good things take care of themselves. Occasionally, I celebrate something that I find wonderful.

Any advice for emerging artists?

My advice would be to make art only if you really must, and if you're prepared to have another job. It would be smart to acquire some kind of skill that's relatively high-paying so you can work half-time, so you can fit art in.

Do it for love. Don't do it unless you feel compelled. If you're at all halfhearted, don't try. Go be a useful person of some other description, because art is such an odd thing—odd but wonderful. Do this if you're possessed, so that the work will be good enough, and you'll survive all the baloney you'll encounter.

15

The Business
End

Artists have many business concerns associated with their careers. This chapter looks at several of them.

Finding a Studio

Many artists look for the following qualities in studios:

- Large workspace
- Low rent
- Good lighting and/or high ceilings
- Oversized doors or loading docks for moving materials or finished works
- Convenient location for curators, critics, dealers, or collectors
- Proximity to other artists

To meet these requirements, many artists have gravitated to older industrial, manufacturing, and warehouse sections of large cities. Having outlived their usefulness as business structures, the buildings there can be recycled as studios because space is plentiful and cheap and the amenities are adequate. When many artists live and work in the same area, a sense of community can develop, and the location becomes familiar to art professionals.

Finding such areas in large cities should be fairly easy, as they are well known to artists and art professionals. Ask around, or check the classified ads in regional art magazines or in alternative papers. In small towns without a comparable clumping of artists, you should investigate small vacant commercial or retail sites for possible studios.

The least expensive spaces are generally "day" studios, meaning that they are work-only spaces with minimal plumbing and possibly no heat. Although some artists secretly live in day studios to save money, conditions are often unappealing and they risk eviction if discovered. More costly are live/work spaces, where the buildings have more amenities and meet local codes for residential dwellings or have received waivers to be used as artist lofts.

When looking at a possible studio rental, check for adequate water, electricity, and heat. Try to meet other tenants. Check the environment to determine whether your activities are likely to offend others, or theirs offend you. This includes whatever is next door or even across the street. Consider fumes, traffic, and noise pollution. Check building and parking security if in a marginal neighborhood.

Leases. When you find a studio that you want, both you and your new landlord should sign a lease for that space that spells out your agreement. Rent and the term of the lease should be specified. If you are planning to use the space for a long time and rents in the area generally are rising, you should try to negotiate as low a rent for as many years as you can. If rents are falling, sign for as short a time as possible. Your lease agreement should cover when rent is due, what activities are permitted in the space, and any other important points. What utilities are provided and who pays for them? Who covers insurance? Can you sublease your space or get a roommate, if you choose? Are pets allowed? Who takes care of rodent and pest problems? If you want to use a loading dock or a storage area in the building, but they are located outside your space, add language to your lease to ensure your access to them. If you make considerable noise in the course of your work, make sure the lease reflects that you have permission to do so.

Standard lease agreements are available in business supply stores and can be modified to cover your agreement. Remember that all points are negotiable, so get the best deal possible for yourself. Also, many Volunteer Lawyers for the Arts have published guidelines for leasing studio spaces. For example, check the one online at the St. Louis Volunteer Accountants and Lawyers for the Arts (www.vlaa.org). Nolo Press also has some good books on landlord/tenant relationships (www.nolo.com).

Studio Improvements. Because many studios had been raw manufacturing spaces or warehouses, artists sometimes improve the spaces by adding sleeping lofts, storage racks, or living areas or finishing the walls. Any permanent improvements you make in a rented space become part of that space, and the landlord benefits from your labor and investment. If you envision adding a kitchen or installing a shower or whatever, negotiate with the landlord in advance for rent reduction or reimbursement for your expenses and a lengthy lease. Artists have sometimes paid the entire cost of improving rented spaces, only to find their rent raised when the lease expires because the space is now "nice."

If you are contemplating renting a studio that has already been improved, you can expect to pay a higher monthly rent. In some areas of New York City, you might also have to pay a one-time-only fixture fee to the previous tenant as compensation for the improvements they have made. Fixture fees can be modest or can be substantial, as much as several thousand dollars. In fact, the expense of studio space in any large city can be costly.

In some instances in which artists have lived in and improved older manufacturing buildings, the areas become chic and desirable to non-artists, whose demand for such spaces may raise the rent beyond what artists can afford. The end effect of this phenomenon, called gentrification, has been that artists have been driven out of areas where they have lived, worked, and built a community. Some cities have attempted legislative protections for artists' live/work spaces, but with limited success. The only ways to safeguard against gentrification are to take the risk of entering into a very long lease or of buying a structure, if you can manage the financial burden and can make that kind of long-term commitment.

Heather Becker, a figurative painter in Chicago, relates some of her experiences with studio/living situations:

> My husband and I have been living in lofts for about five years, which are plentiful in Chicago and offer the combination of finished and raw space. Usually we finish off the rest of the space by building lofts and walls as needed. The first build-out project we did was tedious, but it is much more economical to learn to do it yourself. Many times the work has been a loss for us because we were always renting, but at least we had an environment we enjoyed. The owners are generally thrilled with the upgrades because artists usually do a really nice job.
>
> We recently bought a house on the west side. It needs a lot of work so we will probably tear it down to the bricks and rebuild the interior by ourselves—we enjoy doing it. It was important for us to get a house because over the years it is amazing how much money is wasted on renting. The biggest artists' community in Chicago, just ten block away, is getting too popular. It's becoming so congested that artists are going to get pushed out because they can't afford the rent anymore.

For more on studios, see the interview with artist Carol Kumata at the end of this chapter.

Health and Safety

As you move into a new studio or continue to work in your old one, you must be constantly vigilant to protect your health. Certain art materials and processes pose hazards, so exposure to them should be minimized or totally avoided. The following are the ways materials and processes are dangerous to health:

> *Chemical threats:* Solvents, dust, fumes, acids, and sprays are all chemical threats. They can enter your body in one of three ways: (1) through your lungs, (2) through your digestive system, and (3) through your skin, especially broken skin.
>
> *Kinetic threats:* Repetitive motions stress the body. High noise levels damage the ears. Various postural problems can result from working long hours on a computer.
>
> *Radiation threats:* Kilns and metalworking equipment pose threats to the eyes and skin.

Chemical threats sometimes come in unexpected forms. Harmful dusts include dry pigment, ceramic clay dust, glaze dust, sawdust, fiberglass particles, metal particles, cloth fibers, and other fine airborne particles. Solvents to avoid include fiberglass solvent and resin, oil paint solvents, and printmaking solvents. Photography chemicals pose a threat.

Your own reaction to any particular material or process will be unique, based on a variety of factors. It could range from nothing at all to severe, depending on the following:

Toxicity, or the relative degree of harmfulness of any one material.

Exposure, or how often and how much you are exposed to a material or process. Can your body detoxify between exposures?

Age, because young children, older persons, and pregnant or breast-feeding women are particularly at risk.

General health and environment: Allergies, heredity, stress, smoking, and drinking may make you more susceptible to hazards. Industrial waste, smog, and other pollution may compound your reaction to a particular substance.

There is no need to quit being an artist. But you should be prudent and take care. There are a number of books available on safe studio practices that contain lengthy descriptions of hazards and ways to avoid them, for example, *Artist Beware,* by Michael McCann, *Making Art Safely: Alternative Methods and Materials in Drawing, Painting, Printmaking, Graphic Design, and Photography,* by Merle Spandorfer, Deborah Curtiss, and Jack Snyder, MD, or *Safe Practices in the Arts and Crafts: A Studio Guide,* by Julian A. Waller, MD, MPH. Read them and follow the rules. Another resource is the Center for Safety in the Arts which can be accessed through Arts Wire at www.artswire.org. Look also at Arts, Crafts, and Theater Safety (ACTS) at www.caseweb.com/acts/ index.html

Taking the following steps to improve your studio environment will help limit your exposure to harmful substances:

- Ensure adequate ventilation.
- Build a wall (not just a partition!) between your workspace and your eating/sleeping space. Keep fumes and dust from your work area out of your living and eating area.
- Make sure your studio can be wet cleaned with a damp mop or wet cloths. Do not sweep or dry vacuum, which raises dust.
- Have sealed storage for all solvents, acids, dirty rags, and so on. Clean out toxic substances, and substitute less harmful ones whenever possible.
- Avoid loud places.

Persistent headaches, fatigue, nausea, chronic coughing, skin irritation, or dizziness can be early signs of toxic exposure. If you succumb to an unidentified malady, take note of your symptoms and inform your doctor of unusual materials or processes you have used recently or the regular ones you use on a day-to-day basis.

Insurance

Health Insurance. All self-employed persons or part-time employees are faced with the problem of finding medical insurance for themselves. Although large medical insurance providers such as Blue Cross will write policies for individuals, you will pay much more than someone on a group plan. Professional organizations frequently offer group-rate medical insurance plans to its members. Although membership is required, the cost of annual dues is offset many times by the savings realized through group rates. Coverage varies from full medical insurance to major medical expenses only, and sometimes a very large deductible may be required. Art-related organizations that offer medical insurance include the College Art Association (www.collegeart.org). The Actors Fund of America also offers the Artists Health Insurance Resource Center at www.actorsfund.org/ahirc/.

Some artists without organizational affiliation have individual policies with health maintenance organizations (HMO) and pay a monthly premium to avail themselves of the HMO's services. The application forms for HMOs can be lengthy and the review process protracted, with delays up to a year between submitting your application and actually being enrolled.

Life insurance may be a priority if you have children or other dependents. Term life insurance covers you only during the years when you are likely to have dependents. It may be financially more feasible than "whole life," which pays benefits regardless of your age at death but which carries higher premiums. Life insurance is available through many organizations, such as the College Art Association, and through independent agents in any city.

Keeping Good Records

The careers of many artists become small businesses. Do you generate income from your artwork? Or do you want to take deductions for your art expenses on your taxes? You must keep good records of all your financial transactions as an artist. Specific areas include:

- Income and expense records
- Income tax
- Inventory records
- Billing and collection

Keeping Track of Income and Expense

You must keep income and expense records for tax and budgeting purposes. Your records must be "good" records, which means that they are consistent, accurate, organized, and legible. They must be substantiated with receipts, cancelled checks, credit card statements, and/or notations in an appointment calendar or travel logbook. Art-making expenses and income should be kept separate from regular living expenses and entered into a record dedicated to your art business. Ledgers or

notebooks can be used or computers with spreadsheet, tax-assistance, or financial-planner programs.

Art-making income may include:

- Proceeds from the sale of your work, performance revenues, broadcast revenues, or income for rented work
- Wages or salary paid for work as an artist, including payment for commission work, honoraria, visiting artist fees, and stipends
- Copyright royalties for published works
- Advanced payment for work to be completed in the future, such as publications or public art commissions
- Prizes or awards
- Grant and fellowship monies

Keep the income items grouped together in your ledger, with the following listed for each item:

Date

Amount

From whom received

Reason received

Check number or indication of other form of payment

Expenses. Below are some expenses you may have as an emerging artist. The list is not definitive:

- Mortgage interest or rent for studio, if separate from your residence. If you have a studio space within your home that is regularly and exclusively used for art making only, you may in some circumstances consider that an expense also.
- Utilities for your studio, including electricity, gas, water.
- Telephone costs for calls attributable to art activities, whether made from your studio or home phone.
- Supplies and materials that are used for making art objects.
- Car and truck expenses for your own vehicle when used for art-related activity, other than normal trips to and from your studio. Keep a logbook in your car to record the date, the art-related purpose, the beginning odometer reading, and total mileage for such trips.
- Depreciation on work-related equipment.
- Repairs and maintenance of work-related equipment.
- Rent or lease of machines, vehicles, equipment, or other business property when used for your art activities.
- Special clothing other than uniforms that is not adaptable to ordinary use. Examples would include costumes for performance only or protective clothing for welding.
- Insurance on art-related spaces or on art objects.

- Taxes and licenses for art-related work.
- Wages and other benefits paid to regular assistants or employees, or fees paid to other professionals, such as musicians for a performance.
- Legal and professional services, for example, lawyers, accountants, or photographers who render services related to your art career.
- Conferences, seminars, workshops, training sessions, professional publications related to art.
- Visual documentation of your work, including digitial stills, videos, and hardcopy prints.
- Advertising, including publicity photos, materials, and fees.
- Office expenses, including postage.
- Shipping costs.
- Dues to professional organizations.
- Travel, meals, and entertainment, when furthering your career.

For expenses, you need to keep the corresponding receipts. Organize and keep them in labeled envelopes. These items should be directly related to your art career or your art-making activities and not personal expenses. In your ledger or spreadsheet, list expenses in a separate section from your income. Each expense entry should include

Date

Amount

To whom paid

Reason for the payment

Check number or indication of other form of payment

Tax Concerns

Paying Taxes. This section discusses tax issues specifically related to art making as emerging artists brace their finances for the April 15 hit. Only federal tax issues are covered, as laws differ for each state. Complete tax information is beyond the scope of this book. Also, tax laws and tax forms change every year, so up-to-the-minute comprehensive information is not possible. But this will give you an idea of what is involved.

For tax purposes, most artists consider themselves self-employed and their art making a business. Even if they hold another "regular" job, they are also self-employed in reference to their art career. The only exception is when artists' entire art output is for a regular employer who pays for their work, controls what they make, and provides them with space, equipment, and materials.

If you are a self-employed artist, the Internal Revenue Service allows you to deduct the "ordinary and necessary" art expenses against your art income. You thus pay less in taxes. If your expenses exceed income, you have a loss for that year, which can then be deducted from other non-art income. However, the IRS limits the number of years that a small business can declare a loss. Check current IRS

rules for these limitations. Use Schedule C, Profit or Loss from a Business, to report art-related income and expense.

In any year you have a profit as an artist, you may have to pay self-employment tax. This tax corresponds to the social security taxes that are normally levied on employers and withheld from employees' paychecks. If your net self-employment income is more than $400, you will have to pay this tax, even if you have another job where social security taxes are withheld from your pay. Use Schedule SE to compute your self-employment tax.

You will have to pay quarterly estimated tax on your income as an artist if you expect to owe more than $500 in taxes. By paying estimated taxes four times per year, self-employed persons do not have a large tax bill when they file their April returns. Estimated tax is due January 15, April 15, June 15, and September 15. Use Form 1040ES to pay estimated tax, with a worksheet for figuring your tax liability.

Self-employed artists may also be interested in establishing Individual Retirement Accounts (IRA) for themselves as a means of lowering their taxes now and saving for retirement. Information on IRAs is available at commercial banks, investment planners, and stock brokers.

Audits. Retaining records is necessary in case you are audited by the IRS about your tax returns. The IRS recommends that you keep records for three years after filing each return or two years from when you paid the taxes, whichever is later. This includes all records of the income, deductions, and credits shown on your return, all worksheets, W-2 forms, 1099 forms, and copies of your tax return. Some other tax advice books recommend keeping records at least seven years or longer, in case there is some dispute about unreported income in past years. Although any taxpayer may be subject to an audit, certain items on artists' returns may increase their chances of an audit, including:

- Deduction for your studio in your home, called the "home office deduction" when filing tax returns. The IRS may question whether the space is used regularly and exclusively for business purposes. Check current IRS guidelines.
- Persistent or excessive losses, making your art career appear as less a business and more a hobby.
- Excessive travel and entertainment expenses.

You can substantiate the business-like nature of your art activities by keeping good records, reviews of past exhibitions, and old appointment calendars showing meetings with art professionals and attendance at art events.

Getting Help. Tax guides are available from January to April every year in almost every bookstore. The Tax and Accounting Sites Directory (www.taxsites.com) can also lead you to more information. You may want to consult a professional to address your total tax picture.

When you are preparing your income tax forms, carefully read current IRS instructions and guidelines, because their rules change. For example, in 1986 and again in 1988, the IRS changed the rules concerning how artists deduct the cost of materials and supplies necessary for their work. Also, regulations on charitable

deductions for donated artwork have changed. Every year, the IRS publishes booklets containing current information and tax guidelines that are available online at www.irs.ustreas.gov. These booklets will answer most questions if you take the time to plow through them. Look for publications on:

Taxes for small business

Travel, entertainment, and gift expenses

Estimated tax

Self-employment tax

Business expenses

Business use of your home

Business use of a car

Inventory Records

If you make and sell objects, you must keep inventory records so you know where the objects are at any one time and whether payment has been received for sold work. If your work meets one of the following criteria, inventory records are especially important:

- You have artwork consigned to more than one gallery or art consultant, and you often change what work is placed with which dealer.
- You consistently produce many works, or you work in multiples.
- Many of your works are untitled or are similarly named.

Performance artists, video artists, or those whose work is few in number, large scale, or site specific may not need an inventory record. Keeping good inventory records requires that you can accurately identify each art object visually and by name and know its location. Each entry should contain:

- Picture of the work
- Title of work
- Name of series, if part of one
- Completion date of work
- Size
- Medium. For flat work, note also the support, for example, canvas, paper, or panel
- Identifying code, if you use one
- Dealer or consultant to whom the work has been consigned
- Date consigned; if returned, the date returned
- Final disposition of work, for example, if sold, rented, destroyed, lost, or donated. Record the name and address of persons who own sold work

With inventories, you know where your work is at any time. It also helps if someone wants more work in a particular series or in a particular medium or if you need several pieces of a particular size for a show.

The inventory record is probably best kept on a computer by using database software similar to what you might use for your mailing list. Additions to computer inventories are easily made. You can quickly search the entire computer inventory by any entry; for example, by dealer to find everything that is consigned to one person, by series to list all unsold pieces in a particular group wherever they are, or by date to have a record of all pieces finished in a particular year. Doing such searches in a ledger or notebook inventory would be much more tedious and time-consuming.

Billing and Collection

Artists who sell their work need to establish methods of billing and collection. Like any self-employed person, you want to be paid promptly for the work you have done, and you want to avoid the grief, hassles, and headaches of trying to collect money from someone who owes you.

Sales from the Studio. When you sell work directly from your studio to individual buyers, you should retain the purchased work until full payment is received. Exceptions can be made if the buyer is someone you know well and trust. No billing should be necessary as long as you hold the work until completely paid. If the buyer is paying in installments, you should receive partial payment immediately. Never hold a work without money down. Without some commitment, buyers may experience a change of heart, and you may miss the opportunity to sell the work to another person.

You should provide a bill of sale for all work sold from your studio. Figure 15-1 shows a sample, specifying what was sold to whom, when, and for how much. Although legally you retain reproduction rights unless you specifically transfer them to someone in writing, the general public may not know that, so including such language on a bill of sale notifies your buyers. List terms of payment if the work is not purchased outright. Make two copies of the bill of sale, one for yourself and one for your buyer.

Sales through Art Consultants and Galleries. When selling through an agent, such as a gallery or an art consultant, artists should be notified shortly after the sale of their work and paid in full within thirty days. In theory, artists have no need to send bills, although some art consultants may request an invoice from the artist. Galleries do not request invoices.

Unfortunately, financial difficulties sometimes beset dealers and consultants, and they may neglect to notify you of sales, or you may not be paid for sold work in a timely manner. The situation is difficult to remedy, because the artwork is already out of your possession; a sale was made, and suddenly you have neither the work nor the payment. If you are uncertain about the disposition of work you have consigned to a dealer or consultant or believe work has been sold for which you have not been paid, try the following steps:

Keep in regular contact with the dealer or consultant, asking about any recent sales or interest in your work.

From your inventory records, make a list of all pieces consigned to the person in question. Call to schedule a convenient time to check your list against the

BILL OF SALE
[Your name]
[Your studio address or place of business]
[Your telephone number]

Date: _____

ARTWORK
Name: _____
Date: _____
Size: _____
Medium: _____

SOLD TO
Name: _____
Address: _____

Telephone: _____

PRICE: _____
TERMS OF PAYMENT:

All copyright and reproduction rights are reserved by the artist.

(Signature of Purchaser)

(Signature of Seller/Artist)

FIGURE 15-1 | **Sample Bill of Sale**

Use a form like this when you sell your work from your studio.

actual pieces. Bring paperwork to the gallery when you check your work. The computer is particularly helpful here because inventory printouts look more impressive and carry more authority than handwritten lists, even though both may be equally accurate.

Request payment, verbally and in writing, for all sold work. If excuses are made, persist in your requests. If they promise to mail a check, offer to pick it up in person.

Polite persistence is often sufficient to receive payment. If you find that it has not worked and want to apply more pressure, contact your lawyer or call the local chapter of the Volunteer Lawyers for the Arts to find out what legal options you have. Several states have consignment laws that require a dealer or consultant to pay you within thirty days of a sale; in these cases, withholding payment is illegal. Additionally, if you have a written contract with your dealer or consultant, you can sue for breach of contract.

If a dealer or consultant owes you a relatively small amount, you can press your claim against them in small claims court and avoid the cost of a lawyer to represent you. Limits vary from state to state, usually between $3,000 and $7,500. In circumstances with more at stake in which you are considering a lawsuit, consult a lawyer. You should bear in mind that legal remedies may be time-consuming and expensive. In some cases, legal remedies may be ineffective. For example, if your dealer or consultant has kept the entire proceeds from your sales and then declares bankruptcy, you have no remedy if you are an unsecured creditor. For more, check the Nolo Press site at www.nolo.com.

Try to avoid bad situations with dealers and consultants by starting slowly with someone with whom you have not worked before. Check regularly on your work, and make sure you are paid in a timely fashion.

Legal Issues

Contracts and Other Agreements

As an artist, you do business with dealers, clients, collectors, promoters, or producers. To keep these dealings smooth and satisfactory, you and the other party must agree on some exchanges or some actions that each will do, and these agreements constitute contracts. Legally, a contract is a binding agreement between two or more persons or parties, in which (1) all parties are competent to enter into the agreement; (2) the agreement in no way breaks the law; (3) all parties concur beforehand on the terms of the agreement; and finally, (4) an exchange of money, services, or articles of value is to occur. Contracts may be oral or written.

This kind of language may sound oppressive to many artists, but, in fact, it describes the many agreements they make regularly in their careers, including selling a piece, being represented by a gallery, leaving work on consignment, or exhibiting work at any existing art venue. In the art world, these agreements are often oral only, and they work smoothly much of the time. However, oral contracts are not binding in the same way as written ones and may be harder to have recognized in court. Formalizing your agreements in writing can avert disputes or protect you should one occur.

We saw a sample of an artist-dealer contract in Chapter 8. Also, the Nolo Press Web site is a great resource for legal issues.

Copyright

Description of Copyright. Copyright is the legal right to copy, publish, display, or sell reproductions of an artistic, literary, or musical work. The Copyright Act

protects "original works of authorship fixed in any tangible medium of expression …" To be eligible for protection, your work must be an uncopied and unplagiarized pictorial, graphic or sculptural work, film, audiovisual work, dramatic work, or sound recording. It must exhibit a degree of creativity ("authorship") and be "fixed" in some material form.

Ideas, procedures, processes, systems, principles, discoveries, and concepts do not fall under the Copyright Act, but the unique concrete expression of ideas may. Names, titles, and short phrases cannot be copyrighted but, if used in commerce as trademarks, may be protected by the Lanham Act and the Trademark Law Revision Act. Utilitarian objects are covered by patent legislation.

Three aspects of copyright are of particular interest to artists:

- Protecting your own original work from being copied illicitly by someone else
- Avoiding infringing on someone else's copyright if you appropriate their imagery as part of your work
- Ensuring the integrity of your work by preventing unwarranted distortions, mutilations, or modifications

Reproduction rights to their work are critically important to artists. Whoever holds a copyright to a work has exclusive legal control over the reproduction of the work and the sale of those reproductions. Specific rights are:

- *Reproduction.* The copyright owner is the only person who legally can make copies of an artwork in any medium at all or who can give permission for another person to do so.
- *Adaptation.* The copyright owner can prepare derivative works of the original, in which the work is translated, reformed, or recast in a different medium and the derivative does not duplicate the original.
- *Distribution.* This is the sole right to sell, rent, lend, or distribute copies of the original work.
- *Performance.* This is the right to perform a piece publicly, which includes recitation, display, or live staging of a work. This provision applies to performance, video, and film.
- *Display.* This is the right to publicly display copyrighted work. The right is extended to the copyright owner and to any person who owns a lawful copy of the work. In copyright legislation, the word copy can mean both the original work of art and a reproduction of it.

You automatically own the copyright to your art, both as you are making it and when it is finished. Exceptions to the artist-owned copyright are (1) when the art was created as "work for hire," or produced by regular employees in the normal course of their job while under the direction and control of an employer; or (2) when an independent artist makes a specially commissioned work for which there is a written "work-for-hire" contract and where the work is part of a larger collective work. In these cases, the copyright is owned by whoever commissioned the work.

Duration. Copyright protection lasts as follows for all works created after 1998:

Lifetime of the artist plus seventy years for all works created by one artist

Lifetime plus seventy years after last artist's death for collaborative works

Ninety-five years after the date of first "publication," or one hundred twenty years after creation, whichever expires first, for anonymous and pseudonymous works and for works for hire

For copyright purposes, "publication" has a particular meaning. In this case, publication generally means the public distribution of copies or phonorecords of a work to the public through sale, rent, or loan. For works of art that exist in only one copy, selling or offering it for sale through a dealer or from your studio does not constitute publication. A work of art is only considered published when reproduced in multiple copies that are publicly distributed through sale, rent, or loan.

Selling Copyright. You can sell, donate, or license your copyright for a specific artwork. It is personal property. You can transfer the entire bundle of rights or make only a partial, or "nonexclusive," transfer of rights to others. For example, the owner could grant permission for many persons to simultaneously reproduce a work. Or rights might be granted geographically, so that one person might have North American reproduction rights while another has European. The transfer of rights could be for a limited time, for example, for one time only or for ten years, or the transfer may be applicable in one medium only, such as either photographic or lithographic reproductions. With the exception of granting nonexclusive license, you must sign a written document to specifically transfer your copyright ownership to another person. An oral agreement is not legally binding for selling a copyright.

The physical artwork is distinct from the copyright to it. Artists can sell works of art they have created, but they retain the copyright to it unless they also sell its copyright, in writing. Conversely, artists may sell the copyrights to works while retaining the original object.

Copyright Notice. The Copyright Act automatically protects all your work from being illegally copied. However, if you wish to have the full protection of the law for your works, you must follow certain procedures, namely, copyright registration. This involves affixing a proper notice to each artwork and by submitting certain forms, fees, and materials to the U.S. Copyright Office.

The basic form for a copyright notice is "© [date] [your name]." For sound recordings on formats such as cassette tapes, compact disks, or records, the formula is the same, except the letter "P" for phonorecord is used inside the circle, instead of "C." Examples of acceptable notices are as follows:

© 2001 Maria Rodriguez. Use this for works created by an individual artist. You may use an abbreviation or alternate designation of your name, if you are known by and can be identified by it.

© 2001 Maria Rodriguez and John Lee. This notice is for joint owners of a copyright, used when artists collaborate on a work.

© 1997, 2001 Maria Rodriguez. This notice is used for published works in more than one edition.

© 2001 Maria Rodriguez (lithographs) © 2001 John Lee (photographs). This double notice is fixed to single works in which artists have made separate contributions.

The notice must be legible and visible on the work. It may appear on the front or back of a painting or drawing but not on a removable frame. The notice should be placed on some accessible surface of a sculptural work, but cannot be placed inside a sealed work or on the bottom of a large, heavy piece. Notice may be placed at the beginning of a video.

Copyright Registration. If you want the fullest copyright protection for your work, you must register it with the U.S. Copyright Office, in addition to affixing a proper notice to each copy. If someone illegally copies your fully protected work, the Copyright Law allows you to seek the following:

- Court-ordered injunction to cease the infringement.
- Impoundment of the actual articles that infringe on your copyright.
- Awarding you damages and/or profits from the infringement.
- Reimbursement of your costs and attorney's fees.
- Criminal penalties against the infringer for willfully copying your work and/or removing your copyright notice. Most such cases, however, are settled between the involved parties without criminal proceedings.

Normally, you should complete registration within three months of publication.

Copyright Forms and Procedures. The U.S. Copyright office provides a number of free circulars and publications to explain the copyright process. These helpful publications are clearly written, informative, and instructive. The following are a few you can request or download from the Copyright Office Web site (www. loc.gov/copyright/).

Circular 1: Copyright Basics, briefly covering many aspects of copyright protection.

Circular 3: Copyright Notice, which discusses the proper placement and use of the copyright notice.

Circular 7d: Mandatory Deposit of Copies or Phonorecords for the Library of Congress.

Circular 40. Copyright Registration for Works of Visual Art.

Circular 40a: Deposit Requirements in Visual Arts Materials.

Circular 55: Copyright Registration for Multimedia Works.

Circular 56: Copyright for Sound Recording.

The following forms are used when you wish to register a specific work with the U.S. Copyright Office:

Form VA, with instructions, for visual artworks. You should also request Circulars 40 and 40a for more complete information.

Form PA, with instructions, for performing arts including all performance, film and audiovisual works; also Circular 55.

Form TX, with instructions, for nondramatic written works, such as exhibition catalogs, directories, theses, or articles.

Form SR, with instructions, for sound recordings including dramatic recordings or lectures; also Circular 56.

Complete the copyright application form, enclose a $30 fee for each registration, deposit copies of the work or "identifying materials," and return to the Register of Copyrights, Library of Congress, Washington, DC 20559. All forms, fees, and deposit materials for each copyright registration must be in one package. Read Circular 40a for more on the "identifying materials" needed when copyrighting visual artworks. It gives in-depth instruction on what is needed and how to label and package it.

Nonregistered Artwork. If your work has been widely reproduced and distributed, and you place no copyright notice on it, your work may fall into the public domain. Works in public domain have no copyright, belong to the community at large, and can be used by anyone at will. Read Circular 3 if you wish to remedy such a situation.

However, you have copyright protection for unique artworks or artworks produced in multiples of less than two hundred works, even if you do not affix a copyright notice or register the work. Someone copying such work without your permission infringes on your copyright. However, without the copyright notice on a piece, the copying is likely to constitute "innocent infringement," and the offender likely to receive only a token fine because the infringement was the result of ignorance rather than willful intent.

Sometimes, artists affix the copyright notice to their work without registering the work. Because registration is not mandated for copyright protection, this is perfectly legal. But such artists would not be entitled to the full range of remedies provided by law in case of infringement.

However, for any work published in the United States after March 1, 1989, you must deposit two copies of the work with the Library of Congress, whether or not you actually register the work with the Copyright Office. This is called the Mandatory Deposit Requirement for published work. Refer to Circular 7d for more information.

Further Reading. For more information on all aspects of the Copyright Law and copyright registration, consult the helpful publications from the U.S. Copyright Office. *The Visual Artists' Business and Legal Guide,* by Gregory T. Victoroff et al., also discusses copyright issues and procedures. Additionally, an informative book on copyright and a host of other legal issues surrounding art is *Art Law in a Nutshell,* by Leonard D. DuBoff.

If a work of yours has been illegally copied, get legal advice to investigate your options, for example, with the local Volunteer Lawyers for the Arts.

Fair Use, Parody, and Appropriation

With the proliferation of copying machines, scanners, and cameras, making copies of existing work is easy and common. Many artists use existing artwork as raw materials for their own work. However, it is illegal to reproduce copyrighted work unless you have the copyright owner's permission. Making copies can violate

the copyright owner's right to make, use, and profit from reproductions. However, there are exceptions to this.

Fair use defines certain circumstances in which you can copy a copyrighted work without permission. The Copyright Act lists four factors to be used in determining whether a specific act of copying constitutes "fair use":

> *"Purpose and character of the use, including whether such use is of a commercial nature or is for nonprofit educational purposes."* The more commercial in purpose your copying is, the less likely it falls under fair use. Criticism, news reporting, teaching, or research may constitute valid reasons for copying a work without permission.

> *"Nature of the copyrighted work."* For example, copying an image in an out-of-print book for research purposes may constitute fair use.

> *"Amount and substantiality used in relation to the copyrighted work as a whole."* The more of the original work you copy, the less likely the copying constitutes fair use.

> *"Effect of the use on the potential market for or value of the copyrighted work."* Your copying is unlikely to be fair use if it competes with or undermines the copyright owners' market for the work.

None of these factors exonerates copying without permission but merely outlines circumstances when such copying may be excused.

Parody is an instance of fair use of copyrighted material without permission. A parody imitates some aspect of an original work for comic effect or ridicule. Although a parody is a separate creative work, it heavily references the original for its effect, and that original may be copyrighted. The distinction between a parody and a derivative work may be fuzzy, and derivative works are covered by copyright protection. A general guideline is that the parody should contain as little copyrighted material as possible to make the reference clear and the parody effective.

Appropriation. For the most part, fair use cannot be used to condone appropriation in visual art. Appropriation, in which existing imagery is taken intact and incorporated into new works created by another artist, became popular in the 1980s and continues to be common. The proliferation of new technologies makes it easy to incorporate another's work into your own. Appropriated material adds layers of meaning to a new work, as both have unique subject matter, context, and social associations. Appropriation can be effective in deconstructing or critiquing aesthetic or social standards.

If you are interested in appropriation and want to incorporate existing imagery in your own work, you could limit yourself to images in the public domain. The records of the Copyright Office are open to public inspection, and searches can be made by the name of the copyright owner or by the name of the work in question. The Copyright Office will conduct a search for you, charging an hourly fee and costs (request Circulars 22 and 23 for more information). Documents created by employees of the U.S. federal government as part of their official duties may be freely copied. If you wish to appropriate copyrighted imagery, you must get written permission of the copyright owner.

Some artists take existing imagery, copyrighted or not, as a basis for their own artwork but transform it to create a new work that is obviously not the original copyrighted work. However, if a jury were to decide that your new work was substantially similar to the original, your new work may still infringe on the original's copyright. "Substantial similarity" is not precisely defined but represents a judgment call.

A recent famous copyright suit was brought against the artist Jeff Koons. Koons took a copyrighted image by the photographer Art Rogers and had it made into a sculpture. Rogers sued for copyright infringement and won. Defenses for Koons included parody and the creative transformation of source material; Koons had turned the small photograph into a large sculpture, changed the color, and altered some details. None of these arguments was effective. In 1992, the court decided that Koons was motivated by profit rather than parody and there was "substantial similarity" between the Rogers photograph and the Koons sculpture. Rogers sought $2.8 million in damages.

There are no fixed guidelines or set of conditions that stand as absolute criteria for copyright infringement. If a case is contested in court, a jury will be presented with arguments and evidence and use their collective judgment. It should be noted, however, that legal suits generally do not arise unless money can be made or in circumstances with high visibility.

Moral Rights

A final area covered by copyright law are moral rights. These protections cover issues of attribution and integrity. Attribution is the right of artists to be credited for the works they have created and not to be identified with works made by others. Integrity is the right of artists to protect works "of recognized stature" from being mutilated, modified, or destroyed when these acts negatively affect their honor or reputations. The law covers only willful and intentional mutilations and exempts modifications that result from the passage of time. Moral rights are covered in Section 106A of the Copyright Law and are limited to unique works of visual art and artworks reproduced in limited numbered editions of two hundred or less. When a work of visual art is incorporated into a building and the building owner wants it removed, the owner must grant the artist the opportunity to remove the work rather than simply destroy it.

Moral rights are not like the other copyrights that are concerned with personal property. Generally, these rights have no financial considerations attached directly to them and, in fact, are somewhat antagonistic to the concept of personal property, which allows property owners to do as they choose with their possessions. The person who owns a work of art "of recognized stature" is obliged to respect the integrity of that work as long as its creator lives. These rights belong to the artists for the extent of their lifetimes and cannot be bought or sold, even when the original work and its copyright have been transferred. Artists can waive the rights in writing, but they cannot belong to anyone else.

Although these and other moral rights have been long recognized in other countries, notably France, they are relatively new in the United States, having been

incorporated into the federal Copyright Law in 1990. Thus, the actual interpretation of terms and the implementation of the law itself have been little tested by courts. Moral rights are covered more thoroughly in state laws, most notably in the California Art Preservation Act and the New York Artists' Authorship Rights Act. Other states protecting the moral right of integrity include Connecticut, Louisiana, Maine, Massachusetts, Nevada, New Mexico, Pennsylvania, Rhode Island, and Utah.

Freedom of Expression Issues

Artists have always used their artwork as a vehicle to express ideas. Sometimes, these ideas have run afoul of certain U.S. social or legal standards. Segments of the population or of the government have sought to repress art that they considered subversive, obscene, or religiously offensive. Recent examples have included withdrawn funding for Robert Mapplethorpe photographs based on accusations of obscenity, Andres Serrano's "Piss Christ" for offending a number of Christians, and several examples of U.S. flag desecration in artwork as a form of political protest.

Although freedom of speech is often cited as a defense in these situations, the speech protected by the First Amendment is "pure speech," or verbal or written communication. The courts extend this protection to other forms of expression, including artwork and conduct, as they approach "pure speech," but exact extent of the protected categories is not clear. Although freedom of speech is a constitutional right, the government always has the overriding right to outlaw advocacy that may incite a lawless action. In addition, the courts may classify some material as outside the protection of the First Amendment, such as child pornography or hate speech. Also, commercial speech used in advertising is not protected because it is not "pure speech."

There have been recent cases of artwork being removed from an exhibit for having offended someone or some group; often the removal is met with protest. A recent example occurred when some city council members removed an unflattering painting of Chicago's former mayor Harold Washington from a gallery. More stifling to freedom of expression is the behind-the-scenes censorship imposed by some art professionals and community leaders who opt to not show some work because they fear possible reactions to it. They simply skirt the issue by showing something else. Artists have sometimes practiced self-imposed censorship, in some cases never creating or showing work they would have otherwise done, for fear of closed doors, pressures, or reprisals. Social pressures can be great, but artists and art professionals need not succumb to it.

For a more complete discussion of the legal issues surrounding freedom of expression, see *Art Law in a Nutshell,* by Leonard D. DuBoff. Organizations that may be helpful on this issue are the American Civil Liberties Union (www.aclu.org), the National Campaign for Freedom of Expression (www.ncfe.net), and the People for the American Way (www.pfaw.org).

artist interview

CAROL KUMATA

Carol Kumata is a sculptor and installation artist who has exhibited her work throughout the United States and Europe. She is a Professor of Art at Carnegie Mellon University, in Pittsburgh, Pennsylvania. Here, she talks about her experience in renovating studio space.

As a sculptor, you must have considerable needs in terms of studios.

When I got out of grad school, I wasn't working very large. I needed a lot of small equipment and ventilation for working in metals. Luckily, our school provides small studios for their faculty. But I started to need a larger space. So then I had this opportunity to buy a living space that also came with studio space.

Pittsburgh has a lot of empty, formerly industrial, spaces. So, my colleague, Jon Beckley, who teaches printmaking and painting, found this space, which was the old Oldsmobile warehouse, and he needed partners to go in with him. There were four of us, and we each bought basically a quarter of the building. I have the third floor, and it's about seven thousand square feet.

That's a lot of space!

Empty, too! It had nothing on it, not even a bathroom. I could make my own plans for it. I eventually subdivided it into my own space, and two others that I rent out.

When did you get plumbing, electricity, and walls?

Well, the place was very, very cheap to buy. I mean, much less expensive than a crummy house. But we had to upgrade the electrical and the plumbing for the

whole building and put on a new roof. That expense was equivalent to buying the building.

For the rest, I became a contractor and kept my cost down. Sweat equity, you know—instead of putting in money, I put in time. I finished off the drywall, changed the windows, and painted the place.

We have this funky old freight elevator that is meant for hauling up cars, so it is big and carries a lot of weight. That made life easier for us moving stuff onto the floors.

What about complying with building codes?

Two of the partners in my building had several other buildings in the area and so knew something about that. We used a master plumber and electrician because they also knew about what was code and what wasn't. Basically, I ended up learning how to do it while we went along. We had to conform to the code for a light industrial zone, which is more rigorous than residential. You have to use copper plumbing, metal conduits for electricity, and metal studs in walls. All of that was really expensive. We had to go down to the city to get the plans approved. We had to get a hearing to get variances to live in the space.

Did you have to install special ventilation systems?

Most of the artists in the building have moved to water-based or nonacid media, so it's not so toxic. But if you live in the same space that you work, you have to be aware of cumulative toxic effects.

How long did this whole process take? Was it disruptive to the rest of your work?

I didn't get a lot of artwork done. It probably took about a year, with buying it, constructing it, and renovating it. I moved in before hardly anything was done and camped out. I had no kitchen or anything.

But now, I've been here long enough that I'm ready to start a second phase of renovation.

What do you want to do?

Put in a real kitchen. I have this ad hoc kitchen, with stainless steel quasi-cabinets from an industrial place. It's all very piecemeal. Back then, when I was first starting here, I had to get things really cheap, which you can do if you spend the time to look for them and don't mind getting used stuff.

You're a landlord, too. How is that?

It's worked out really well. I've really never had any vacancies. I only have two spaces, and I don't charge very much. But it's enough to meet the cost of the mortgage and the condo fees.

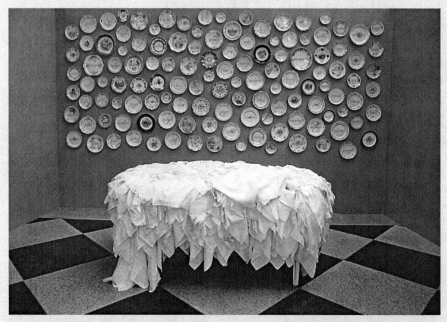

Carol Kumata, untitled installation, 16″ × 8″ × 8″ found, altered ceramic plates, table, and tablecloths

So you don't have to pay for your living space?

I still have to pay the taxes and the electrical and whatever for the floor. But it's so much less than if I didn't have anybody sharing the floor with me. And it's a deal for them, too.

It has a lot to do with the fact that Pittsburgh has a fairly low cost of living anyway. And there still are such buildings around Pittsburgh.

You said something about condo fees.

We started as a partnership, but with a partnership, you don't have any equity. You own shares in the building, but you don't own a specific space in it. So if you wanted to sell out, you're basically trying to sell your share. That's very hard to do. Usually, people don't want to buy into a partnership.

And also, if you wanted to buy another space, then the lien on the loan would go on the entire first building, which screws all your partners. So we thought it would be better for all of us if the building became a condo, which basically meant we own our own floors. We belong to a condo association, which is not any different from our partnership, but legally it has different implications. It is more straightforward to sell it.

Of course, it costs money to write this agreement, with the lawyers and everything. But it had to be done.

Are all the people in your building artists?

No, there is a design firm, a software company, and a small video company on the lower floors. On the other two floors, everybody's an artist.

Has that created a community of artists?

I don't know if it's a community or just neighbors. I plant a nice garden on the roof, with roses, irises, and a big cherry tree. It's like a common space. In the summer time, everybody goes up to the roof and hangs out, talks to each other, sees what everyone is doing. People have their meals up there sometimes, and others come and go. It's casual and nice.

Is there a lot of paperwork associated with buying, renovating, and landlording?

If you're doing your taxes, you should be keeping your records anyway. And of course, there is a great tax benefit to buying versus renting. So definitely, keep a record of all the income and all the expenditures.

You should keep forever the records that deal with the physical building and what you are putting into it, which becomes a capital gains issue when you sell. Don't throw away those records after five years or whatever the tax manuals say.

Getting an old building and renovating it could be a great financial benefit. Or it could be a horrible money pit. How is someone to know?

You need to able to break it down and predict a little bit how much you're gonna end up spending in the long run. Buying a building is one thing, but getting it livable, and especially if you have code issues, is another.

Most people go in with others so they can pool their resources and their knowledge. If you're doing it by yourself, you really better know something ahead of time before you make the commitment.

Even so, it is hard to anticipate all the hidden costs. For example, in Pittsburgh, if a building is more than three stories, you need a sprinkler system. Well, you might not think to ask about that when you are looking at buildings, and sprinkler systems are incredibly expensive. Luckily, we had a system, but weird stuff like parking became an issue. To get an occupancy permit, we needed a certain amount of parking that goes with the building. So we ended up having to rent some nearby parking space to get our permit.

Also, we had a terrible time finding a loan because it was an industrial space—no bank would give us money. I think things are different now because

banks are finally waking up and saying, yes, a loft, ok, that could be resalable. But at the time, we had to go to this loan broker to get a 16 percent loan. It was really horrible.

In the end, is this a good thing for other artists to try?

Oh, I definitely think so. There's a lot of different ways to do it. I think the major thing is if you're gonna do it, you need some idea of how much money you're getting into and you need the energy to do it. If you have the energy, you can do a lot of things yourself.

PART

V

Education

There are examples of artists of distinction who were self-taught. Most artists, however, receive formal training, usually as undergraduate college students. Many go on to seek further training after finishing their bachelor's degree.

In this part, Chapter 16 describes the benefits of pursuing the Master of Fine Arts Degree. It provides guidelines for helping you decide if graduate school is for you, and if so, how to choose a good school.

Chapter 17 focuses on other educational opportunities, such as residencies, workshops, online instruction, and art academies. It also covers information on a variety of Master of Arts degrees and courses at community colleges.

The Master of
Fine Arts Degree

The Master of Fine Arts (MFA) is the advanced degree for studio art making earned in graduate school. Relatively unknown before 1950, the MFA degree became very popular in the 1960s and 70s and continues to be so. The MFA degree is now common among artists.

Description of the Degree

Most MFA programs are two or three years in length. While you are enrolled, you can concentrate intensely to develop a personal body of work. In the MFA program, your own ideas, momentum, and enthusiasm dictate your art making within an environment that should challenge you. Graduate study is much more focused and self-directed versus the generalized and instructor-directed undergraduate experience.

In graduate school, you learn contemporary theoretical and conceptual issues surrounding art making. Art making is a critical activity, and artists should understand how their art responds to or develops from others' art and how it fits with major art developments, social changes, or political issues. The MFA curriculum will help you develop the conceptual framework and language you need to relate these issues to your own art making.

Benefits. Graduate school is a good choice for you if you want to spend a few years intensively making art, honing your intellectual and technical skills, studying critical theory, building alliances, and beginning to develop long-term involvement in the art world. It gives you access to many opportunities and makes you part of an art-making community.

On the practical side, you can use the MFA to place yourself in the professional art world. In addition to the education you receive, the MFA helps validate you in the art market, provides you with personal recommendations, and leads to professional contacts. This process begins even while you are still in graduate school if curators, gallery directors, and writers visit your program. You work closely with faculty members who may become friends or mentors and may assist you in your career even after you finish your degree. You can form alliances with your fellow graduate students. You can "learn the ropes" in an art center in a new city, if you have moved to earn your MFA. Although this degree does not guarantee you an art show, it can help you make the necessary connections.

An MFA program also provides material benefits. These may include a free studio for you, access to metal-fabricating and woodwork shops, access to photography darkrooms, computer labs, and painting and drawing studios, perhaps with figure models. If you study at a college or university rather than at an art institute, you may also take courses in other academic areas, such as history, gender studies, urban planning, or film studies. A good art school or department should have an extensive library.

Job Opportunities Related to the MFA Degree. The MFA is the highest degree, or "terminal degree," for art making offered in academia. Thus, an MFA qualifies you for a college-level teaching job, which may help your career as an artist and give you enough free time to pursue your art making. Although on rare occasions prominent artists without degrees may be hired to teach, almost all universities, colleges, and junior colleges require the MFA of their studio art instructors. However, full-time college teaching jobs are rare and hard to get. Part-time teaching positions at junior colleges are more plentiful and more available to recent MFA graduates, especially in large cities with extensive junior college systems. But part-time instructors are paid by the class, have little job security, and usually receive no benefits.

Artists frequently take other art-related jobs, such as curator, art writer, arts administrator, gallery worker, designer, or fabricator. Although not necessary, the MFA nonetheless provides good background training for any of these positions.

Master of Arts Degrees. Many universities offer masters degrees in areas related to art, including art administration and museum studies. These are covered in Chapter 17.

Some colleges and universities offer Master of Arts (MA) degrees in studio art. These programs cover much the same material as an MFA program but give a lesser degree on completion. These are sometimes one-year programs but more often take eighteen months or two years to complete. Studying for an MA in studio art provides you with many of the benefits of the MFA degree, such as the opportunity to focus on your work, interact with faculty members, and use the resources of the institution.

However, the MA does not qualify you for college-level teaching jobs in studio art. Yet, the MA degree may be nearly as costly and demanding as an MFA. If you decide you want an MFA after completing an MA, many schools will not count your MA studio credits toward your MFA requirements. Essentially, you would

have to start over. Therefore, enroll in an MFA program rather than an MA program in studio art.

When to Consider Graduate School

After Undergraduate School. Some students apply for graduate school during their undergraduate senior year and begin graduate school the following September. However, many students take a break before graduate school. Graduate students in studio art are often in their late twenties or thirties; students in their early forties are less common but certainly not rare.

There are several advantages of waiting a few years before going to graduate school:

> You can use the time to work in a professional art-related job, to better understand the professional art world before returning to school. Hopefully, the job will put you in good financial shape; graduate school can be expensive, even with scholarships, assistantships, and living stipends.

> You have more time to develop and focus your artwork. The more mature, coherent work gives you a better chance to get into the best graduate schools. Your undergraduate work is likely be somewhat disjointed, having been produced in different classes, in a wide range of media, exploring disparate themes.

> In the extra years, you can more thoroughly research graduate schools, a task that can at times feel almost like a part-time job!

> A few extra years' maturity helps as you begin school. Graduate school can be intense, with teachers challenging you and other students competing against you. With more art-making background and professional experience, you may be less buffeted by the rigors of school than younger persons just out of undergraduate school.

Financial Considerations. Graduate school should come at an appropriate financial time. Graduate school can be expensive, so you should receive some kind of financial aid package (see below) before you begin the program. You should avoid incurring massive debts during school, because after school you will be burdened with repaying those debts. At the time when you are most prepared to make art, you may be forced to work long hours to keep up with your loan payments.

Setting a Timetable. If you decide to go to graduate school, you need to start working toward it a full year before you plan to attend. Each school has its own admission deadlines. Some schools admit students in September only, whereas others admit at the beginning of any semester or quarter. For September admissions to a few schools, you may have to apply as early as the previous December! The majority of better-known schools have deadlines of February 1 through April 1 for September admissions. Some schools have "rolling admission," which means you

can apply at any time, and if accepted, you may enter at the beginning of the next semester/quarter in which there is room for you.

Even before applying anywhere, you will need about five months to research schools and prepare your applications (see below). Use the first three months to research schools, get advice, read directories, write for catalogs, and visit schools. Take any necessary standardized tests at this time. The last two months will be devoted to collecting letters of recommendation, ordering transcripts, preparing images, and working on application forms, statements, and financial aid forms. A single application, with images, application fee, test fee, and postage, will probably cost between $35 and $50.

Making Preliminary Choices

How do you choose among the more than two hundred MFA programs currently offered in the United States? You might simply pick the one nearest to you. But with some research, you are likely to find programs that would better challenge you, with faculty members more suited to help you with your specific art concerns, with favorable financial aid packages, in cities with thriving art communities, and so on.

Make a list of priorities to help you decide. It should include:

- Strength of the faculty members and the program
- Cultural life around the school
- Location

Investigating MFA programs is serious, time-consuming research. But, it is important that you make good choices. MFA programs are not all alike. Once you start a program, you want to be excited about finishing it. When you transfer from one institution to another, you lose time and money. Take the time to do good research now.

The Program and the Faculty. Ask your undergraduate teachers, your mentors, or other artists for suggestions on universities with good MFA programs. Where did they study for an MFA, or do they know any particularly strong programs? Talking to those who know your work and know about various MFA programs is the best way to find a program appropriate for you. Ask them to name artists whose work has an affinity to yours, with whom you should study, and where these artists are currently teaching. Studying with a strong faculty is more important than where you study or how many labs you can use.

Cultural Life. Also, ask your advisors about the cultural life in areas surrounding the school and about the facilities available to graduate students. Your mentors' recommendations can greatly decrease the amount of research you have to do to find a good school. Word of mouth is often the most effective way to find the best program for what you want to do.

Location. Where do you want to live while you study? If you plan to stay in the United States, choosing a region that appeals to you is another step in narrowing

the scope of your research into MFA programs. The Northeast and the West Coast have the greatest concentration of art centers. Beyond that, the decision is a matter of personal choice, based on factors such as weather, political climate, and local culture. Choose an area where you believe you would be happy.

Do you want to live in a big city? Again, this is a personal decision. The largest art centers in this country are New York City, Los Angeles, and Chicago. However, other large U.S. cities have art communities and distinct political and cultural scenes, including Boston, Miami, Minneapolis/St. Paul, Philadelphia, Washington DC, Baltimore, New Orleans, Pittsburgh, Houston, Dallas, Seattle, San Francisco, and San Diego. Before deciding on a particular city, investigate its art community. Size alone will not always be the best indication. The following are some important signs:

A good museum, several galleries, and alternative spaces. The *Annual Guide to Museums, Galleries and Artists,* published every year by *Art in America* magazine, will quickly provide you with this information.

At least two good colleges/universities in the city. It is not absolutely necessary that both have strong MFA programs, but both should have good art departments.

Other social, cultural, and political events that represent diverse lifestyles and points of view.

Daily and alternative newspapers. Look for signs of thriving local scenes by checking the calendar sections. You can find newspapers from other cities in almost all university and large public libraries.

Sources for art supplies and for raw and industrial materials. Check that city's telephone directories, which are usually available at large public libraries.

At the other end of the spectrum, you may choose to pursue your MFA at an isolated university, outside of any major city, where there are few distractions to keep you from concentrating full-time on your work. Choose major universities with many cultural resources to help overcome the limited urban opportunities. Small colleges in small towns have limited resources and few art faculty.

There are cost implications in your choices. Living in large cities is likely to be more expensive than in small towns. A private university in a major metropolitan area will probably entail the highest tuition and highest cost of living. State-supported public universities will be less expensive if you establish residency in that state, but nonresident fees may be as high as private university tuition. In fact, private university tuition offset by financial aid may end up costing you less than paying nonresident fees at public institutions.

If you study in a foreign university, you will not be working toward an MFA. An advanced degree in art from a foreign institution is not equivalent to the MFA and will not be honored by most U.S. colleges and universities. The only exceptions are the MFA's offered by some Canadian institutions. Consider enrolling in an MFA-granting U.S. university that has "study abroad" programs, if you want that experience.

Researching Your Final Choices

You have gathered your mentors' advice on MFA programs and have made your geographic decisions. Now, your next task is to research and evaluate the available MFA programs.

Directories. There are a few directories that list MFA programs in the United States and give short descriptions. They will provide you with the names and addresses of schools on your short list. These directories should be available in college or large public libraries.

The most comprehensive directory is *M.F.A.: Directory of Programs in the Visual Arts.* In addition to the factual information such as the institution's address and kind (private or public), *M.F.A.: Directory of Programs in the Visual Arts* lists admission requirements, faculty members' names and areas of expertise, and numbers of students. Also included are areas of concentration, requirements for graduation, opportunities to study abroad if available, and lists of resources. This directory is available through the College Art Association (www.collegeart.org).

Peterson's Guide to Graduate Programs in the Humanities and Social Sciences lists all MA- and MFA-granting institutions in the United States, U.S. territories, and Canada. In addition to the school's address, telephone number, unit head, and application contact, the directory lists possible media areas of concentration, accreditation status, availability of part-time programs, number of faculty members with gender breakdown, number of students with gender and ethnic breakdown, degree requirements, entrance requirements, application deadline and fees, tuition and fees, and available financial aid. All this information is heavily condensed. Peterson's also has a Web site for online searches at www.petersons.com.

The National Association of Schools of Art and Design (NASAD) publishes evaluations of its member-schools. Any NASAD-approved program is likely to be reputable and stable. However, other excellent MFA programs are not NASAD-approved, because some schools choose not to be members.

These directories should give you some useful information:

How many faculty members are working in your area? There should be more than one working in your medium or area of interest, so that you will be exposed to broad input and criticism about your work.

Is the faculty composed of actively producing artists? Look up their names in a periodicals index to see whether their work has been recently reviewed or whether they have written articles. See whether they are listed in *Who's Who in American Art.*

What is the average completion time for the degree?

What are the requirements for graduation?

Is the department well equipped? Look for a metal shop, wood shop, photo lab, private studios, and computer facilities.

Catalogs, Application Forms, Financial Aid Information. Write away to the top five or ten schools on your list, requesting their catalogs and other admissions

CHECKLIST OF QUESTIONS ON M.F.A. PROGRAMS

The faculty
✔ Which faculty work in my area of interest?
✔ Do prominent faculty work with students? Well-known artists may rarely be on campus due
 to career commitments.

The facilities
✔ Are studios provided for graduate students?
✔ Are studios private or communal, and are they lockable and secure?
✔ What labs are available?
✔ Do graduate students have 24-hour access to studios and labs?
✔ What exhibitions spaces are for graduate students?
✔ What are the resources of the library?

The curriculum
✔ How long will it take to complete the MFA?
✔ How many hours and what specific courses, papers, and exhibitions are required to complete
 the MFA?
✔ Do graduate students take specific courses of instruction, such as Painting, or do they work
 independently in their studios?
✔ Can graduate students easily cross media areas? For example, could a photography student
 also work in another medium, or are they restricted to photography?
✔ What is the philosophy of the art institution? Do they promote a particular conceptual, criti-
 cal, social, or political agenda? What is the general philosophy of education?
✔ What resources are available to students through the university or institution as a whole?
✔ Is there a visiting artist and visiting curator program? Who came last year?

Financial Aid
✔ What kinds of Financial Aid does the school offer?
✔ Does a Teaching Assistantship provide tuition remission, a stipend, or both?
✔ What are the responsibilities and obligations of a Teaching Assistant?
✔ What does a Fellowship provide, and in return for what on my part?
✔ What loans or work-study programs are available?
✔ How many Teaching Assistantships are available?
✔ How many Teaching Assistantships are given to first-year graduate students?

The Admissions Process
✔ What does the admissions committee want to see in an applicant's slide portfolio?
✔ What is the basis for choosing students to receive a Teaching Assistantship?
✔ How many people do they accept, out of how large a pool of candidates?
✔ When are applicants notified about whether they have been admitted and if they have
 received a Teaching Assistantship?

FIGURE 16-1 | Checklist of Questions on MFA Programs

Use this checklist when you visit an MFA program or talk to an admissions counselor.

materials. Or visit their Web site. Read the catalog thoroughly to find out about the institution as a whole, its resources, and the faculty. Carefully study the curriculum and the requirements to complete the MFA. Read about available financial aid and note admissions requirements and application deadlines. Look at the curriculum in other departments for related courses that will expand the scope of your studies.

Visiting Schools. If possible, visit your top school choices. It is impossible to overemphasize the importance of this! Your visit will tell you which schools are right for you better than any catalog, Web site, or anything else. Use the checklist in Figure 16-1.

Before you go, set up appointments in advance with faculty members and admissions counselors. Bring images with you and talk to the faculty about your work. Try to determine whether you want to work with this faculty, how accessible they are, how interested they are in students in general and you in particular, and what they think about your work.

Look at the labs and facilities. Does the equipment work? Are the studios large enough, well lit, ventilated, and secure? Are the studios on or close to campus?

Visit the library, looking over the selections of periodicals and the size of the art book collections. The collection should include contemporary theoretical books and scholarly publications, in addition to books with good reproductions. Visit and evaluate the university museum, gallery, or student exhibition space.

Talk to students currently enrolled in the MFA program. Ask them what they think of the faculty, the quality of the teaching, the curriculum, and the facilities. Is the program working well? What are the topics discussed in seminar? Are the faculty members available for individual critiques? Does the student work seem strong? Is there variety?

Admissions Applications, Financial Aid, and Other Requirements

Degree Requirements. To apply for an MFA program, you need an undergraduate degree, although a few places indicate that they would make exceptions for students with "comparable experience."

A number of schools require that applicants have a Bachelor of Fine Arts (BFA) degree. Others accept a BFA or a Bachelor of Arts (BA) degree with at least sixty hours of studio credits, or "the equivalent." A few will accept students with other undergraduate degrees. You must have your undergraduate school send your transcripts directly to the graduate schools to which you are applying.

Some schools require that you score at a certain level on the Graduate Record Exam (GRE) and others require the Test of English as a Foreign Language (TOEFL) for international students. Test scores must be sent to the schools to which you are applying. Further information is available through your undergraduate student advisor, graduate school admissions counselor, or by contacting GRE or TOEFL directly.

Admissions Materials. Complete the application form provided by the school. University-based art schools sometimes require two application forms, one to the graduate school and one to the art department.

Apply to six to eight schools if possible. This gives you a better chance of being admitted at one school at least, and at best, lets you choose the most favorable offer if several institutions admit you.

You must send a portfolio of your work, usually with twenty images. The images are almost always the most important criteria for admission. Make sure they are as strong as possible, well framed, properly exposed, and clearly labeled (review Chapter 5). Read the application form carefully to find out how each school wants the images presented. Schools may request images on a CD in a certain order, and a printed list of slides. For time-based work, a compilation disk is usually required, with at least some full-length pieces. Include a self-addressed stamped envelope if you want your portfolio returned.

Almost all schools require three letters of recommendation (see Chapter 12). Most require an artist's statement (Chapter 5), supplemented with reasons why you are interested in graduate school and your long- and short-term goals. Have your mentor read your application essay and make suggestions before you send it. A few schools require a personal interview with you.

Most schools charge an application fee. If you cannot afford the application fee for each school, you can request a fee waiver based on limited financial circumstances. Either write a personal letter requesting the waiver, or ask your current department counselor to write one if you are still in school.

Financial Aid. Apply for all possible financial aid packages to receive as much assistance as possible while in school. Tuition, art supplies, raw materials, and living expenses can be tremendous, and you want to incur as few debts as possible while in graduate school. These are the general categories of financial aid:

Scholarships defray the cost of tuition and are based on merit. Scholarships generally carry no work obligation with them. Recipients usually must maintain a high grade point average.

Grants defray the cost of tuition but are based on need, with generally no work obligation, but often a GPA level to maintain.

Fellowships provide money to graduate students for tuition and also stipends for living expenses. There is generally no associated work obligation.

Assistantships provide stipends that help defray the cost of living and/or provide tuition remission, which is a cancellation of tuition. In exchange, students work a number of hours for the school. Most are teaching assistantships, in which graduate students work with undergraduate classes for ten to twenty hours per week. In some schools, teaching assistants (TA) are completely responsible for a class; at other institutions, regular faculty members are in the classroom with TAs. Much less common in art are research assistantships, in which graduate students assist faculty members in their research.

Work-study programs pay students to work a limited number of hours weekly on campus, usually in clerical or technical support jobs.

*For time-based work, a compilation disk is usually required, with at least some full-length pieces.

Student loans are monies lent at low interest rates but must be repaid. Loans should be the last-resort financial aid; borrow only what you absolutely need to keep your debt to a minimum.

Often, there are sources of aid for underrepresented, minority, disadvantaged, and disabled groups. If you belong to one of these groups, identify yourself as such to the financial aid officer at the schools to which you are applying to find out whether special funding exists.

Most schools offer a range of financial aid, and often students are provided aid from various categories, making up their particular financial aid package. It is impossible here to give specific information about financial aid that covers all institutions, because each school has its own resources and application procedures. Read the instructions from each institution and fill out and return all forms well in advance of their deadline if possible. Keep copies of all forms, because most institutions ask for similar information, and some require you to reapply for financial aid every year you are enrolled in their program.

Admissions Process

Most schools follow something like the following admissions screening process. After the application deadline, admissions counselors review all applications for completeness. Then, the faculty members review the images, letters of recommendation, and statements to choose whom to admit to the program. Teaching assistantships, scholarships, and other financial aid are awarded to students who seem the most promising, plus a list of runners-up is compiled.

Letters are then sent to applicants, informing them that either (1) they are admitted to the program with financial aid, (2) they are admitted to the program and on a waiting list for financial aid, (3) they are admitted to the program, (4) they are on a waiting list to be admitted to the program, or (5) they have not been accepted into the program.

Once a school has admitted you, you have a limited amount of time to either refuse admission or to accept and pay a deposit to hold your place in the program. You will be receiving responses from the various schools over a period of weeks or even months, because each school's application deadline is different. This may put you in the difficult position of having to decide to accept one school's offer before you have even heard from other schools. Or you may be on the waiting list for admission or financial aid at your preferred institution and wonder whether to accept a definite offer from another school.

You absolutely should accept the one best offer you have received at any point in time. If a better offer comes later from another school, go for it and then decline on your first acceptance. Of course, you should never accept the offers of two or more schools simultaneously. Take your best choice, and free your space at your second choice for others who are on the waiting list at that institution.

artist interview

JOHN GORDON

John Gordon is a sculptor, educator, and arts administrator. His works have been shown in museums and galleries around the nation, and he is the recipient of a National Endowment for the Arts Individual Artist Fellowship. He currently serves as Provost of Pratt Institute in New York City.

How should prospective students decide which MFA program is best for them?

I think that the potential graduate student has to weigh carefully both the location of the institution and their personal fit with that institution. What are their goals and aspirations, and how does that compare with what the institution is either noted for or is likely to be able to offer them? Sometimes that's not easy to figure out. A campus visit is a good idea—it will give you a chance to view the work of current students, talk with them about their experiences, and perhaps meet some of the faculty members.

I am an advocate for students going to one of the major art centers: New York, Los Angeles, Chicago. I think that almost from day one, students need to start building relationships in the art scene that they're going to enter upon graduation. That is not to say there aren't very, very fine faculties and schools located through-out the country. And the major art centers aren't for everyone.

What about their fit with the institution?

In terms of the fit, you need to know what each kind of institution has to offer.

Research universities clearly offer greater access to other disciplines outside the arts. At least in theory—although I don't know how easy it is to gain that access. The faculty is usually well-known and that has both positives and negatives. On the positive side, you can align yourself with a faculty member's fame, notoriety, or distinction and benefit from their contacts. On the downside, sometimes people get those faculty appointments regardless of their teaching abilities. They're not always the easiest people to be around or to engage with. So it can be a rude awakening for a student who has rosy views of the world and what the arts should be.

Research universities usually offer the greatest number of teaching opportunities for a potential graduate student. Students can quickly find themselves teaching entry-level classes because, often, these name-brand faculty don't want to teach those classes. So, if part of your aspiration is to teach, you might get there faster in a research environment.

Another generality: Research universities are likely to be more theoretically-based than practice-based. They may be more engaged with the dialog around art than hands-on doing. In contrast, generally the art faculty in state colleges are excellent artists and craftspeople. Graduate students at state colleges may need to be more self-reliant, because state colleges are focused primarily on undergraduate teaching, not graduate teaching. The state colleges also, in my experience, are usually equipment and facility rich, so if you need space or you need access to equipment, you can frequently do well at a state college.

What about art institutes?

The art institutes—the independent schools of art—often have a greater focus and a greater depth of faculty in specific disciplines. They also tend to emphasize practice over theory. So if you really want to be hands-on, I would send somebody to an art institute, where you are most likely to find an atelier approach to teaching.

I think that art institutes tend to be more savvy in helping students understand the marketplace and get connected. They also can help a student continue in the tradition of that particular institution. The art institutes also tend to offer a greater sense of community among students and faculty.

Anything else to look for?

I would advise that students look for opportunities for collaborative experience, either in the institution or in the community. I'm realizing that we don't provide students with enough opportunities to collaborate either amongst themselves or with other faculty. I think the art world is increasingly about collaboration on many levels.

A lot of problem-solving is no longer dependent on one creative voice. Problem-solving is becoming more collaborative, probably because of the complexity of the work. The expertise required can't always be found in one individual anymore.

John S. Gordon, "Three Prominent Points of View," Cast Iron, Steel, Wood, Glass; 26" × 15" × 19", 1991

I came up in a generation that was focused on the individual and his or her creative talents. My hunch is that institutions will increasingly seek new ways to provide students with opportunities to collaborate.

What do you see as the long-term benefits of graduate education for artists?

First and foremost, I think you are buying time—from two and three years—to focus and mature in your work. You are not likely to have that time again. In graduate education, you have a community of both faculty and fellow students to bounce off of. And then of course, establishing the networks and contacts that will serve you as you leave the institution and enter the real world of commerce and survival. Hopefully, you will deepen and broaden your general body of knowledge.

The richer that pool of knowledge is, the more you have to draw on, especially if you hit a dry spell.

And there are the expectations and formal benchmarks of accomplishment that are part of a graduate education, during which you are either going to be critiqued or reviewed. It takes a very dedicated and mature person to provide that for himself or herself outside the academy.

Ideally, when does graduate school fit into an artist's career?

I think younger, clearly, is better. You have more time on the other end to use what you've accumulated. But whenever you have that opportunity, you ought to seize it and I certainly don't have any quarrel with somebody who's in their forties or fifties pursuing graduate education.

The overwhelming majority of graduate students are going to be in their twenties and thirties. When you're a little older, it's harder to get the same benefits from your peers. The age difference makes things more complicated. But I certainly wouldn't try to discourage anybody from doing it.

After completing my undergraduate degree, I wasn't ready for graduate school—I was tired of being in school. I went to work in a factory, and it only took a few months before I realized what a precious gift it was to be in an educational environment and how hungry I was to be in that world again.

What aspects of your graduate education were really important to you?

Within the institution, it was mostly specific individuals and what they had to offer. I had some powerful teachers, including Roland Reiss, Michael Brewster, James Turrell, and Helen Winer. These people had a great influence on my thinking

And I've already mentioned the importance of location—I think it is critical. As I began my undergraduate education, I was headed toward law, because of my family background. But after living in Chicago and New York, rubbing elbows with the arts and the museum world, I realized that I wanted to be an artist. I went on to do my graduate education at the Claremont Graduate School, at a time when Los Angeles was really coming alive in the arts. Being part of an active art scene as a student adds fuel to the fire and accelerates the growth of your own work. Certainly it also provides opportunities in terms of shows or interactions with other artists. I think that's an absolutely crucial parallel to graduate art education.

Is graduate school worthwhile overall?

I definitely think it's worth the investment. I'm sure there are students or their parents who look at the cost and worry about it. But looking back, from where I am right now, I think it was a very powerful time and well worth the expense.

Other
Educational
Opportunities

After a few years of working as an artist, you may decide to seek some ways to increase your skills, enlarge your range of ideas, or expand the circle of persons with whom you network. Further education, workshops, and residencies may provide you with exactly what you need.

Graduate Education in Art-Related Fields

In Chapter 16, we took a long look at Master of Fine Arts programs in U.S. universities. Now, we focus on other graduate-level programs in art-related areas. The fields most related to fine art include curatorial programs, art administration, public art studies, museum studies, art therapy, and theory and criticism. In addition, there are a host of design-oriented fields of study. Let's take a few in depth now.

Curatorial Studies, Museum Studies, and Critical Studies. There are programs that prepare you for curatorial careers or museum careers. One is the graduate program at the Center for Curatorial Studies at Bard College, which focuses on the history of contemporary visual art, institutions and exhibitions practices, and art theory and criticism. Another extremely well-known program is the independent study program associated with the Whitney Museum of American Art. There is a curatorial program, which works closely with the museum personnel, and also a critical studies program, with individual scholarly research and critical writing projects. The Art History Department at the University of Southern California offers a museum studies program for those interested in studying all aspects of the museum profession.

Art Administration and Public Art Studies. More than twenty-five institutions offer degrees in art administration. The programs vary considerably from one to

the next. Some are quite broad in their coverage of all the arts (theater, music, and visual arts), and others are more focused on visual arts only. Some are very specialized. For example, the public art studies program in the School of Fine Arts at the University of Southern California concentrates on training students to be effective administrators and problem solvers within the public art realm.

Art Therapy. Art Therapy programs provide training in the use of art as therapy for mentally, socially, or physically challenged persons. There are more than twenty institutions across the United States offering programs in this field.

Finding These Programs. You can find listings of universities offering these programs of studies through Peterson's online listings of graduate and professional study in arts and architecture (www.petersons.com). Peterson's lists basic contact information and descriptions of degree programs for several hundred institutions. There is a lot of information online, which should help you focus and narrow your search.

Residencies

Residency Programs and Sponsors

Residency programs give artists the opportunity to concentrate on their art while living in a stimulating, challenging, or supportive environment. Some residencies are like retreats, located in remote or rustic settings, whereas others enable artists to live and work in major art centers either in the United States or abroad. Different institutions sponsor residency programs for artists.

Art Colonies or Artist Communities. These are professionally run organizations with living accommodations and work facilities that are often located in retreat-like settings. Some are devoted to the work and exchange of ideas among visual artists only, whereas others mix artists with writers, musicians, and so on. The interaction among the residents creates a rich and stimulating environment. Some artist communities have an open-application policy, whereas for others, such as ArtPace in San Antonio, artists are invited to participate by a special nominating committee. One famous program is the Skowhegan School of Painting and Sculpture, with intensive nine-week summer residencies for sixty-five artists, designed to foster creativity and interaction. It is located in the lake district in central Maine.

Industry-sponsored residencies are offered by a few businesses that produce utilitarian or decorative items in a specific media, such as ceramics, or using a particular process, such as mold making or casting. With these residencies, artists have access to industrial-scale fabricating equipment. The Kohler Art Center in Sheboygan, Wisconsin, is one such residency program open to artists interested in ceramics and casting.

Government-sponsored residencies, usually state or city funded, place artists in schools or other tax-supported centers. Artists give demonstrations or lectures or work in open studios to be accessible as resources for students or citizens. These programs are fairly common around the United States. We discussed these also in Chapter 12 under the topic of "Jobs," because, in fact, these residencies are more like regular teaching and employment.

Features of Residencies

What can a residency offer you in terms of support, benefits, facilities, and so on? That varies tremendously from program to program. You should research each carefully to get one that best suits your interests. Although no program offers a complete range of benefits, all residencies offer some of the following:

Studios, either private or shared

Access to equipment or information, such as a sculpture shop, photography darkrooms, video equipment, printmaking facilities, libraries, or archives

Exhibition opportunity, sometimes with catalogs

Opportunity to work with other artists in residence

Housing, sometimes with accommodations for families

Meals

Costs to artists vary even more. Some residency programs are well endowed, and thus not only pay the cost of residence but also provide artists a small to substantial monthly stipend while they are in residence. A few even give extra funds for art materials or for airfare to and from the residency. On the other end of the spectrum, some programs charge for housing, meals, or access to labs. These fees range from minimal to considerable. Usually, government-sponsored residencies pay the artist, especially when teaching or an open studio is required. Art colonies may charge fees, but many offer options to offset costs. For example, some offer scholarships or fellowships, and some allow residents to work a certain number of hours a week in exchange for residency fees. In these cases, the benefits of the facilities and the advantage of working with other artists in residence must be weighed against the cost.

The sponsor sometimes fixes the length of residency. In other cases, the artist chooses a time period between a set minimum and maximum. The shortest residencies are two weeks long. Much more common are those that are one to six months in length. A few last as long as two years.

There may be media, content, geographic, or career-level restrictions on those applying for residencies. Thus, some residencies are media-specific, for example, for photography, printmaking, or book arts only. Some focus on a particular theme. Some are open only to artists living in a certain geographic area. Some are available only to students, to emerging artists, or to those in mid-career. Requirements on residents varies, with some programs mandating that artists-in-residence hold open studio days, give lectures, or teach courses, and others listing no specific requirements.

Researching Residency Programs

The Alliance of Artists Communities (www.teleport.com/~aac/) provides a listing of artists communities in the United States and some overseas.

Listing of residency opportunities can be found in a number of periodicals and books:

Artist resource books and publications list names, addresses, and brief descriptions of residency programs, for example, *Money for Film and Video*

Artists, Money for Performing Artists, and *Money for Visual Artists,* all edited by Suzanne Niemeyer, and *Money to Work II: Funding for Visual Artists,* edited by Helen M. Brunner and Donald H. Russell.

Directories, such as *Organizing Artists: A Document and Directory of the National Association of Artists' Organizations* and the *Directory of Research Grants,* give names and addresses of residency programs.

Professional publications, such as the College Art Association's *CAA News,* the bimonthly newsletter of the College Art Association, lists names, addresses, and brief descriptions of some residencies when an application deadline is upcoming.

National and regional art magazines also list some residencies in their announcement and classified sections when the application deadline is upcoming.

Online information sources, such as Art Deadlines List (artdeadlineslist.com) lists residencies when an application deadline is upcoming.

The Visual Artist Information Hotline has information on colonies and residencies.

Your state arts agency, local art agency, or city cultural affairs department will have information on residency programs they sponsor.

College and university art departments often post brochures and posters of residency programs on bulletin boards.

Most listings merely inform you where to write for complete descriptions and application forms. Once received, review all material carefully to evaluate which residency program suits you. If the residence site is unknown to you, request pictures or descriptions of available housing, equipment, and labs. Get a list of artists who have previously been in residence. Ask mentors and friends about the reputation of various programs.

Residencies usually require that applicants send written and visual materials that attest to their art making, experience, and vision. For example, you may be required to submit some combination of resumé, images, statement, project proposal, or letters of recommendation. Some ask you to complete questionnaires or interview you by telephone.

More Sources for Further Education

Workshops

Workshops are excellent ways to increase your skill set in a particular area. Artists may be interested in career counseling seminars that are held especially by art organizations but also sometimes at universities or museums. Watch art listings in your area for more information, or become a member of your local museum or art organization. Workshops are also posted on the Art Deadlines List (artdeadlineslist.com).

There are a number of workshops that focus on new media, especially digital imaging, image processing, video mixing and editing, film editing, and sound. Media centers (see Chapter 7) frequently offer workshops in these areas. Check the Web site of the National Alliance for Media Arts and Culture (www.namac.org). They maintain an online listing of media centers and resources for media artists. For media centers in your state, look at the art sites listed by your state art agency. There are a number of online workshops and instruction, especially around the topic of building and maintaining Web sites. Review Chapter 6 for sources of online instruction.

Art Academies

Art academies are institutions that focus on studio practice. They encourage students to spend great blocks of time every day acquiring skills in art making. The training that artists receive in academies is very different from the relatively brief art courses offered at universities or colleges. Academies more closely model the methods used to teach artists during the nineteenth and early twentieth centuries. Some academies also have a limited general education courses, so that their graduates finish their schooling with a college degree. Others have only studio courses, and give their graduates a certificate on completion of the program.

Although academies have programs that extend for many years of study, students have some flexibility about how much they wish to study or how long they wish to remain enrolled. Sometimes, artists enter academies for specific courses or to work in a particular studio.

Two famous academies are the New York Studio School in New York City and the Pennsylvania Academy of Fine Art in Philadelphia.

Community Colleges

Sometimes artists need to learn very specific skills, such as bronze casting, working with Adobe Photoshop, or silkscreen printing. If you are in this situation, check the course listings at your local community colleges. Many have very fine art departments and for minimal cost will give you excellent instruction in an area you need. Most are open to all applicants residing in their area, even those who might already have a bachelor's degree from another institution.

Source: Photo courtesy of Tryon Center for Visual Art.

artist interview

SUZANNE FETSCHER

Suzanne Fetscher is president of Tryon Center for Visual Art in Charlotte, North Carolina. For three years, she was chair of the board of the Alliance of Artists' Communities and is currently on the board of Res Artis, an international consortium of residency programs. She has taught college-level design, drawing, painting, and printmaking in central Florida.

What is the history and structure of artists' communities?

Almost ninety percent of artist communities use the McDowell or Yaddo models, which are more than one hundred years old. They are a retreat or forum that provides artists with the chance to get away from it all and go off into a beautiful, isolated location. Artists can be by themselves or with other artists. They focus on their work and get as much done as possible in a very supportive, nurturing environment. Everything would be provided: housing, a studio, meals, so you have nothing to worry about but your work. It's an amazing gift of time.

Also, you have the opportunity to meet colleagues from around the country or around the world who are also pursuing their work. You learn about other people's approach to the creative process and you, consequently, learn about your own at the same time. Some become lifelong friends.

And the other communities?

There are rich variations on the standard model. The other ten percent of artist communities are more of urban artist-in-residence programs. Some are by invitation

only, such as ArtPace in San Antonio, and focus on the artist's productive time. Others invite certain master artists, and then other artists apply to work with them.

There are others that are designed to connect the artist with another community and have this be a new resource for ideas and projects, possibly. Tryon Center is one of these. Artists can just do their research and be in their studio during their residency here. And we respect that. But we also want artists who will be part of the community in some form or fashion. We are in many ways an asset and a resource to the community.

We've just established a relationship with the Carolinas HealthCare System. They have many hospitals and clinics in the area. And they have contributed to our endowment to sponsor an artist a year who will focus on the arts and healing. It's a fascinating project. This situation provides artists-in-residence an opportunity to work on significant projects in a community and to have a positive impact through their work. Those are the sorts of things you can do when you're in a city that you can't do otherwise.

How does the public respond?

Really well. We are raising the level of perception that the community in general has of artists and the role of artists in society. We're trying to make people understand the value, the importance of having artists in the community and involving them in these sorts of discussions. Not just the discussions of what the art museum programming might look like but everyday aspects of our society. Artists can really bring another perspective and help us think more broadly. After all, artists are creative problem solvers.

Are artist communities for visual artists only?

Some are, and others are multidisciplinary, with composers, choreographers, visual artists, and others all in the same place, with opportunities to collaborate. There are programs that are just for writers. Others are more for senior artists—or not necessarily the art stars—but for older artists. Some are for emerging artists. There is a real mix.

What do artists say about their experiences in artist communities?

These sorts of experiences are very stimulating. Because there is no product required, one has the chance to explore a new direction, medium, or technique. One also is involved in intellectually challenging conversations with one's fellow residents and that may be a centering or internalizing aspect to the experience. In your everyday life, you've got mail to answer, calls to return, e-mails, laundry, deadlines to meet. It's so hard to get into the creative moment.

Tryon Center for Visual Art, Charlotte, North Carolina

Source: Photo courtesy of Tryon Center for Visual Art.

Artists talk about it as a profound, life-changing experience. The work is so concentrated and leaps forward in a way that you could never imagine. It's the sort of experience that has resonance for the rest of your life.

How does an artist really research residency programs?

The Directory of Artist Communities is put out by the Alliance of Artist Communities. You can get it through Barnes & Noble. It is thorough. Each artist community has two pages of description. And it's got all the contact information and the Web sites. It's got descriptions of the programs, the lengths, and what the artist's responsibilities are, because some of them do have the artist doing outreaches or helping with the cleaning, things like that. A whole range of requirements. Some don't require anything. They just want you to be there. Some, like Tryon, pay you to be there. In other cases, you have to pay to go.

This directory helps artists begin their initial investigation. After that, I think you have to make phone calls. You have to have conversations with the staff.

When does a residency fit best in an artist's career?

It all depends on you personally. I think typically an artist searches for this when they're going through their own artistic and intellectual redirection—when they are challenged by something that's going on within themselves, artistically, and they need to get through it. It could be when they get out of graduate school and are trying to figure out where they need to go next, or maybe it's mid-career. I think it happens for different people at different times.

I was an artist-in-residence at Atlantic Center for the Arts. I had been out of graduate school for several years, teaching part-time, and doing my work, but it was a really difficult time. I did not know what I was going to do with my life, as an artist and a professional. The atmosphere was so conducive to the creative process.

The residency was a wonderful way to connect with colleagues and talk and get a broader sense for what my options might be. And I got so much work done. It was a very short residency session, but in three weeks I did at least three months worth of work.

I would discourage somebody from just going from residency program to residency program to residency program. You need to do it when you can take advantage of that time at the optimal level. Now, it's not easy to get away for two months or whatever. You really do have to put your life on hold and make arrangements. And if you have family members or anything like that to be responsible for, it's going to take you some work to get there. And yet, at the same time, they are then helping you further your artistic career. So it's an investment on both parts, in many respects, but it's something then that everybody is part of.

I know you have researched what artists have said about residencies. Any testimonials?

I was talking to the artist Donald Sultan yesterday. He had been a master artist at the Atlantic Center for the Arts, and from that he has two associates he remained in contact with. He got one into graduate school, and that person has gone on to do major things. And the other one is also doing really well. And he's helped them along. Not just as a mentor but as a friend. He respects their work, and this is a perfect example of how it works.

Nick Cave from Chicago was an artist-in-residence at Tryon Center. He completed three separate bodies of work and is exhibiting it nationally.

Are artists communities growing?

Oh, it's amazing. The Alliance of Artist Communities has an annual meeting, and there are always three, five, or more new communities represented at each of the meetings. They're popping up all over the place.

There is a rich history of artists' communities in the United States, and the rest of the world is just now catching on to that. They see what a resource it is for artists, and they're responding to the need to assist artists to do their work.

So there are increasing international opportunities. Tryon Center established a relationship with a residency program in South Africa. The State of North Carolina is sponsoring two artists to go annually to South Africa for a one-month residency. I think those things are happening more and more.

Appendix: Organizations, Agencies, Resources, and Services for Artists

Art Organizations

Alliance of Artists Communities
2311 East Burnside
Portland, OR 97214
(503) 797-6988
www.artistcommunities.org

AAC is a consortium of artists colonies, communities, and residencies. It produces *Artist's Communities*, a directory with profiles and information on all art residency programs in the United States.

American Association of Museums
1575 Eye Street, NW
Suite 400
Washington, DC 20005
(202) 289-1818
www.aam-us.org

The AAM is an organization that serves the museum community. Its monthly newsletter and Web site lists entry-level and higher job openings in museums.

American Civil Liberties Union
125 Broad Street, 18th Floor

New York, NY 10004-2400

www.aclu.org

The ACLU is dedicated to litigation, advocacy, and public education concerning censorship in the arts.

Americans for the Arts
1000 Vermont Avenue NW
12th Floor
Washington, DC 20005
(202) 371-2830
www.artsusa.org

This is an advocacy group of individuals and organizations that support the arts.

Art Libraries Society of North America
329 March Road, Suite 232
Box 11
Kanata, Ontario K2K2E1
Canada
(800) 817-0621
www.arlisna.org

ARLIS/NA promotes the profession of art librarianship and visual resources curatorship. It posts job openings in art libraries on its Web site.

Association for Independent Video and Filmmakers
304 Hudson Street, 6th Floor
New York, NY 10013
(212) 463-8519
www.aivf.org

AIVF is a national service organization for independent media producers. It produces resource books and publications for media artists.

Business Volunteers for the Arts
Arts and Business Council, Inc.
121 West 27th Street, Suite 702
New York, NY 10001
(212) 727-7146
www.artsandbusiness.org/bvahome.htm

BVA assists nonprofit arts organizations in managing areas such as marketing, strategic planning, and financial systems.

College Art Association
275 Seventh Avenue
New York, NY 10001
(212) 691-1051
www.collegeart.org

The College Art Association is an organization dedicated to high standards in the teaching and practice of art and art history. Important publications include (1) the *CAA News*, a bi-monthly newsletter with articles and information about grants, residencies and other opportunities for artists; (2) *Careers*, a listing of college-level teaching and teaching-support jobs; and (3) *MFA: Directory of Programs in the Visual Arts,* a comprehensive listing of MFA programs in the U.S. Also, group-rate insurance is available to CAA members.

Foundation Center
79 Fifth Avenue
New York, NY 10003-3076
(212) 620-4230
www.fdncenter.org

The Foundation Center provides information on private and public foundations by publishing a number of foundation directories, which can be accessed through the Centers' five libraries, and at numerous cooperating libraries throughout the United States. The Foundation Center's Web site contains listings of many grant resources and instructional material on grant writing. The center offers free educational programs at its libraries in Atlanta, Cleveland, New York City, San Francisco, and Washington, DC.

National Alliance of Media Arts Centers
346 9th Street
San Francisco, CA 94103
(415) 431-1392
www.namac.org

NAMAC is a national association of organizations and individuals dedicated to promoting media arts, including film, video, audio, and multimedia production. It publishes a newsletter and books and sponsors conferences of interest to media artists.

National Art Education Association
1916 Association Drive

Reston, VA 20191-1590

(703) 860-8000

www.naea-reston.org

The NAEA represents fifteen thousand art educators at all levels, and promotes quality teaching through professional development. Its newsletter lists grant, fellowship, and teaching opportunities in the arts.

National Assembly of State Arts Agencies

1029 Vermont Avenue, NW

2nd Floor

Washington, DC 20005

(202) 347-6352

www.nasaa-arts.org

NASAA is a membership organization representing the fifty-six art agencies of the fifty states and six special U.S. jurisdictions. The NASAA's Web site has links to all state art agencies.

National Association of Artists Organizations

1718 M Street NW

PMB#239

Washington, DC 20036

(202) 347-6350

www.naao.net

NAAO supports and serves artists' organizations and publishes *Organizing Artists: A Document and Directory of the National Association of Artists' Organizations.*

National Association of Schools of Art and Design

11250 Roger Bacon Drive

Suite 21

Reston, VA 20190

(703) 437-0700

nasad.arts-accredit.org

NASAD is the only accrediting organization of MFA programs in the United States, and publishes a directory on MFA programs.

National Campaign for Freedom of Expression

1429 G Street NW

PMB#416

Washington, DC 20005-2006

(202) 393-2787

www.thefirstamendment.org/ncfe1.htm

NCFE is an educational and advocacy network of artists, organizations, and concerned citizens for freedom of artistic expression.

New York Foundation for the Arts
155 Avenue of the Americas, 14th Floor
New York, NY 10013-1507
(212) 366-6900
www.nyfa.org

NYFA offers financial and informational assistance to individual artists and to organizations serving artists. It operates Arts Wire and the Visual Artist Information Hotline, in addition to its grant program, educational program, and many other opportunities.

Volunteer Lawyers for the Arts
One East 53rd Street
New York, NY 10022
(212) 319-2787
www.vlany.org

A national network of nearly fifty VLAs throughout the U.S. and Canada provide legal services, assistance, and educational programs for artists and arts organizations. Most VLAs publish state-specific educational material such as tax and legal guides for artists. Some VLA chapters also offer accountant services. Addresses and telephone numbers of all affiliates are available through the New York VLA chapter.

Women's Caucus for Art
P.O. Box 1498
Canal Street Station
New York, NY 10013
(212) 634-0007
www.nationalwca.com

WCA is a nonprofit women's professional and service organization for visual artists. More than twenty chapters operate across the United States.

Online Resources and Information

Art Deadlines List
artdeadlineslist.com

This is a monthly e-mail newsletter with information on upcoming art competitions, grants, jobs, internships, calls for proposals, residencies, fellowships, and so on. There is a subscription fee for the complete listings, and also a free monthly e-mail edition featuring only some listings.

ArtFair Source Book

www.artfairsource.com

A comprehensive guide to juried art and craft fairs in the United States, along with reviews and discussion groups. There is a subscription fee to access information from this site.

ArtNet

www.artnet.com

This is a commercial site for selling art, but it also offers listings of artists, galleries, articles, and features that give advice to emerging artists.

Artnetweb

www.artnetweb.com

This site is devoted to new media in the practice of art. It contains articles, resources, artists' projects, and news.

Arts Wire

www.artswire.org

Arts Wire is a great source for art-related news, programs, workshops, job listings, Web resources, and so on. Arts Wire is a program of the New York Foundation for the Arts.

Internet Art Resources

www.artresources.com

Listings of galleries, museums, and artists, along with articles on art and discussion groups.

Nolo Press

www.nolo.com

A great resource for legal information. Nolo Press publishes many helpful legal books.

Peterson's

www.petersons.com

Peterson's provides comprehensive listings of Master of Art and Master of Fine Arts programs, and other educational resources.

Postcard Printers
www.1800postcards.com
www.clarkcards.com
www.modernpostcard.com

Printers who produce low-cost color postcards for exhibition announcements.

The Visual Artist Information Hotline
www.artswire.org/nyfa/vaih

The Visual Artist Information Hotline provides information on funding organizations, artist colonies, residencies, and artist organizations and services. It is operated by the New York Foundation for the Arts.

World Wide Art Resources
www.wwar.com

Art news, discussion groups, listings of galleries, artists' Web sites, research sources, classified ads, and more.

Web-Authoring Resources

Artnetweb
www.artnetweb.com

Beginner's Guide to HTML
www.ncsa.uiuc.edu/General/Internet/WWW/HTMLPrimerAll.html/

Lynda.com
www.lynda.com

Virtual Library of WWW Development
www.stars.com/Vlib/

Web Reference
www.webreference.com

Website Tips
www.websitetips.com

World Wide Web Consortium

www.w3.org

All of these sites contain helpful instructions on Web site development, and links to more resources.

U.S. Government Agencies

General Services Administration

Art-in-Architecture Program

1800 F Street

Washington DC 20405

(202) 501-0800

www.gsa.gov

The GSA commissions public art projects for new federal buildings. Visit the Web site for more information.

Internal Revenue Service

www.irs.ustreas.gov

The IRS Web site posts instructional booklets and tax forms that can be downloaded.

National Endowment for the Arts

1100 Pennsylvania Avenue NW

Washington, DC 20506

(202) 682-5400

arts.endow.gov

The NEA is the federal agency that supports visual, literary, and performing arts organizations.

U.S. Copyright Office

Library of Congress

100 Independence Avenue SE

Washington, DC 20559-6000

www.loc.gov/copyright/

The federal office for the registration of copy protection for original artistic, literary, or musical works. For information on copyright legislation and procedures, or to fully protect work from illicit copying, visit the Copyright Office Web site.

Annotated Bibliography

American Art Directory 1999–2000. 57th ed. New York: Jacques Cattell Press, and New Providence, NJ: R.R. Bowker, a Reed Reference Publishing Company.

Extensive listings of art organizations, art publications, art institutions, and art schools, colleges, and universities offering graduate and undergraduate degrees.

Annual Register of Grant Support 2000: A Directory of Funding Sources. 33rd ed. New Providence, NJ: R.R. Bowker, 1999.

Details of grant programs in all disciplines funded by government agencies, foundations, corporations, community trusts, educational groups, and so on.

Arntson, Amy E. *Graphic Design Basics.* 3rd ed. Fort Worth, TX: Harcourt Brace College Publishers, 1997.

A discussion of the visual decisions to make when designing exhibition announcements and performance programs.

Art in America. "Annual Guide to Museums, Galleries and Arts." New York: Art in America, 2000.

A comprehensive, state-by-state, alphabetical listing of U.S. museums, commercial galleries, galleries, alternative spaces, university galleries, and the directors, dealers, and artists associated with them. The guide, published every August, is available through Art in America, 575 Broadway, New York, NY 10012, (212) 941-2800.

Blum, Laurie. *The Complete Guide to Getting a Grant: How to Turn Your Ideas into Dollars.* Rev. ed. New York: John Wiley and Sons, 1996.

Introductory guide to grants for individuals in all disciplines, with information on finding funders, working with sponsors, and writing grant proposals.

Bolton, Richard, editor. *Culture Wars: Documents from the Recent Controversies in the Arts.* New York: The New Press, 1992.

Discussions on contemporary cultural controversies.

Caplin, Lee Evan, editor, and the National Endowment for the Arts. *The Business of Art.* 3rd ed. Englewood Cliffs, NJ: Prentice-Hall. 1998.

A general guide to an artist's studio practices and the mainstream museum/gallery system.

Catalog of Federal Domestic Assistance. Executive Office of the President. Office of Management and Budget. Washington, DC: U.S. Government Printing Office, 1999.

Official directory of almost one thousand four hundred federal programs providing assistance in all disciplines to U.S. individuals, organizations, and institutions. Includes programs in the arts and culture.

Cohen, Herb. *You Can Negotiate Anything.* New York: Bantam Books, 1980.

Negotiating strategies for individuals.

College Art Association. *MFA: Directory of Programs in the Visual Arts.* New York: College Art Association, 1999.

An in-depth listing of Master of Fine Arts programs in the United States, with information on admissions, financial aid, curriculum, facilities, faculty, and students. The directory is updated every five years, and is available in many university libraries, and through the College Art Association.

Colvin, Gregory L. *Fiscal Sponsorship: Six Ways to Do It Right.* San Francisco: The Study Press Center, 1993.

An important source of information for artists with projects funded through arts organizations that are acting as fiscal receivers.

Crawford, Tad. *Business and Legal Forms for Fine Artists.* New York: Allworth Press, 1999.

Forms and contracts for artists to use if their careers are small businesses.

Cruikshank, Jeffrey L. and Pam Korza. *Going Public: A Field Guide to Developments in Art in Public Places.* Amherst, MA: Arts Extension Service, 1988. Published in cooperation with the Visual Arts Program of the National Endowment for the Arts.

A helpful introduction to public arts for artists, covering topics such as developing projects, contracts, insurance, maintenance, and preservation available through AES Publications, Arts Extension Service, Division of Continuing Education, University of Massachusetts, Box 31650, Amherst, MA 01003-1650, (413) 545-2360; www.umass.edu/aes.

Directory of Research Grants. 25th ed. Phoenix, AZ: The Oryx Press, 2001.
Directory of Grants in the Humanities 1997/1998. Phoenix, AZ: The Oryx Press, 1998.

Brief listings of some of the art-related research grants, state art agency grants, public art programs, and foundation grants in the U.S.

DuBoff, Leonard D. *Art Law in a Nutshell.* 3rd ed. St. Paul, MN: West Group, 2000.

An accessible, informative, and often entertaining guide to art law, including tax law, copyright, trademarks, moral and economic rights, and freedom of expression issues. Available only in law libraries and at legal bookstores.

Edelson, Phyllis, editor. *Foundation Grants to Individuals.* 12th ed. New York: The Foundation Center, 2001.

Contains listing of residencies and foundation grants to individual artists.

Guide to U.S. Foundations, Their Trustees, Officers and Donors. New York: The Foundation Center, 2001.

A beneficial fundraising tool for arts organizations. Introductory material contains a bibliography of local and state foundation directories.

Hackwood, Sara, editor. *The Grants Register 2000.* 18th ed. New York: St. Martin's Press, 1999.

For those pursuing graduate-level studies, a listing of grants, scholarships, and fellowships from regional, national, and international sources.

Harrison, Charles and Paul Wood, editors. *Art in Theory 1900–1990: An Anthology of Changing Ideas.* Oxford, UK: Blackwell Publishers, Ltd., 1993.

Hundreds of important twentieth-century essays about art.

Hoover, Deborah. *Supporting Yourself as an Artist.* 2nd ed. Oxford University Press, 1989.

A guide to grants and corporate giving for visual artists, media artists, performing artists, and writers.

Kahn, Si. *Organizing: A Guide for Grassroots Leaders.* Rev. ed. Washington, DC: National Association of Social Workers, 1991.

Tips on organization and communication for people who find themselves in leadership positions.

Lippard, Lucy. *Mixed Blessings.* New York: New Press, distributed by W. W. Norton, 2000.

A cross-cultural survey of contemporary artists from many different ethnic backgrounds.

Mancuso, Anthony. *How to Form a Nonprofit Corporation.* 4th ed. Berkeley, CA: Nolo Press, 1998.

Step-by-step information on procedures and papers necessary to form a nonprofit corporation.

McCann, Cecile Nelken. "Guerrilla Talk: A Conversation with a Member of Guerrilla Girls West." *Artweek,* Vol. 22 no. 22, June 20, 1991: 1+.

A discussion from the inside of a guerrilla art group.

McCann, Michael. *Artist Beware.* New York: Lyons Press. 1993.

McCann, Michael. *Health Hazards Manual for Artists.* New York: Lyons Press, 1994

Health hazards from art materials and unsafe studio practices.

Michaels, Carol. *How to Survive and Prosper as an Artist: Selling Yourself without Selling Your Soul.* 4th ed. New York: Henry Holt, 1997.

A general introduction to supporting yourself as an artist and maintaining a career by selling work, especially through commercial galleries.

Mirzoeff, Nicholas, editor. *The Visual Culture Reader.* London and New York: Routledge, 1998.

A collection of recent critical writings that analyze art and mass media and their impact on everyday life.

National Association of Artists' Organizations. *Organizing Artists: A Document and Directory of the National Association of Artists' Organizations.* 4th ed. Washington, DC: National Association of Artists' Organizations. 1998.

A very helpful resource with listings for local, national, and regional art organizations, governmental art agencies, service organizations, residencies/colonies, and alternative spaces.

> *National Association of Schools of Art and Design Directory 2001.* Reston, VA: National Association of Schools of Art and Design (NASAD), 2001.

A brief directory of Master of Fine Arts programs accredited by NASAD.

> *National Guide to Funding in Arts and Culture.* 6th ed. New York: The Foundation Center, 2000.

A Foundation Center publication focused on funding sources for the arts.

> Niemeyer, Suzanne, editor. *Money for Film and Video Artists.* American Council for the Arts and Allworth Press, 1991.
>
> Niemeyer, Suzanne, editor. *Money for Performing Artists.* American Council for the Arts and Allworth Press, 1991.
>
> Niemeyer, Suzanne, editor. *Money for Visual Artists.* American Council for the Arts and Allworth Press, 1991.

Three guides for residencies, foundation support, corporate funding sources, and governmental funding sources for individual artists in various disciplines.

> Jacobs, David, editor, and Jeffrey A. Falkenstein, compiler. *The Foundation Directory.* 23rd ed. New York: The Foundation Center, 2001.

Helpful fundraising information for arts organizations.

> *Peterson's Graduate Programs in Art and Architecture 2000.* Princeton, NJ: Peterson's Guides, 2000.

In-depth profiles of Master of Art and Master of Fine Art programs in art, art history, design, and new media.

> Pindell, Howardena. "Artworld Racism: A Documentation." *New Art Examiner,* March 1989: 32–36.

Survey results indicating under-representation of African-American, Latino, Asian, and Native American artists in museums and galleries.

> *Public Art Review.* St. Paul, MN: Forecast.

Public Art Review is a semi-annual publication on public art programs and current competitions, published by Forecast Public Artworks, 2324 University Avenue West #102, St. Paul, MN 55114, (651) 641-1128.

> Smith, Constance. *Art Marketing 101: A Handbook for the Fine Artist.* Cincinnati, OH: F & W Publications, 2000.

A general guide to the business practice of art, focusing in particular on selling art through various venues.

Snell, Tricia, editor. *Artist's Communities: A Directory of Residencies in the United States That Offer Time and Space for Creativity.* 2nd ed. New York: Allworth Press, 2000.

This directory has detailed information on the features and costs of nongovernment-sponsored residency programs in the United States.

Spandorfer, Merle, Deborah Curtis and Jack Snyder, M.D. *Making Art Safely: Alternative Methods and Materials in Drawing, Painting, Printmaking, Graphic Design and Photography.* New York: John Wiley and Sons, 1995.

A guide to safe studio practices.

Staniszewski, Mary Anne. *Believing Is Seeing: Creating the Culture of Art.* New York: Penguin Books, 1995.

An introduction to thinking critically about art in our culture.

Victoroff, Gregory T. *The Visual Artist Business and Legal Guide.* Englewood Cliffs, NJ: Prentice Hall, 1995.

An in-depth examination of copyrights, contracts, and other legal issues, with sample forms for artists to use.

Vitali, Julius. *Fine Artist's Guide to Marketing and Self-Promotion: Innovative Techniques to Build Your Career as an Artist.* Lakewood, NJ: Watson-Guptill, 1997.

Marketing, self-promotion, and survival advice to help artists build successful careers.

Weintraub, Linda. *Art on the Edge and Over: Searching for Art's Meaning in Contemporary Society 1970s –1990s.* Litchfield, CT: Art Insights, Inc., 1996.

A collection of short essays on prominent contemporary artists, their work, and their biographies.

Who's Who in American Art 1999–2000. New Providence, NJ: R.R. Bowker, a Reed Reference Publishing Company.

Brief biographies of U.S. artists and arts professionals.

Ziegler, Laurie. "The Ties That Bind: The Importance of Artist-Dealer Contracts." *New Art Examiner,* Vol. 20, No. 10. Summer 1993: 12–17.

A discussion of troubled artist-dealer relationships, and the necessity for written agreements.

INDEX

CPSIA information can be obtained
at www.ICGtesting.com
Printed in the USA
FFOW03n0533291216
30819FF